Netherlandish art
IN THE RIJKSMUSEUM
1400–1600

Henk van Os
Jan Piet Filedt Kok
Ger Luijten
Frits Scholten

WITH CONTRIBUTIONS BY
Reinier Baarsen
Thomas Belya
Jan-Daan van Dam
Ebeltje Hartkamp-Jonxis
Guido Jansen
Wouter Kloek
Jan-Rudolf de Lorm
Pieter C. Ritsema van Eck
Marijn Schapelhouman
Peter Sigmond
Arie Wallert

WAANDERS PUBLISHERS
RIJKSMUSEUM, AMSTERDAM

NETHERLANDISH ART IN THE RIJKSMUSEUM

volume 1: Netherlandish art in the Rijksmuseum 1400-1600
volume 2: Netherlandish art in the Rijksmuseum 1600-1700
volume 3: Netherlandish art in the Rijksmuseum 1700-1800
volume 4: Netherlandish art in the Rijksmuseum 1800-1900

Editors: Jan Piet Filedt Kok and Annemiek Overbeek
with the assistance of Hinke Wiggers
Translation: Michael Hoyle
Design: René Staelenberg
Photographs: Photographic Department of the Rijksmuseum
(Peter Mookhoek), unless otherwise specified
Printing: Waanders Drukkers, Zwolle

ISBN 90 400 9376 8
Nugi 921/911

Cover (front):
Pieter Pietersz, *Man and woman by a spinning-wheel* (detail), c. 1570 [83]
Cover (back):
Mechelen, *Antler woman (Leuchterweibchen)*, c. 1525 [26]
Frontispiece:
Lucas van Leyden, *The dance around the golden calf* (detail), c. 1530 [47]

The numbers in square brackets refer to
one of the works of art discussed in this
book; for instance, [19] refers to 19, Master
of Alkmaar, pp. 82-83

Contents

Foreword

The collection of art in the Rijksmuseum is the result of two centuries of gifts, bequests and deliberate collecting policies. It is a compliment to my predecessors and to the many generations of curators that the Rijksmuseum outshines all other institutions in its ability to present, from its own holdings, a fascinating and high-quality overview of five centuries of Dutch art and decorative arts. Four large volumes will provide the reader with a broad panorama of the achievements of Dutch painters, draughtsmen, sculptors, gold and silversmiths, glass engravers, weavers, potters and cabinetmakers. Gone are the days when we would intentionally (or naively?) dare pretend that this overview is representative of the artistic output of centuries gone by. The past has only come down to us in fragmentary form, and we are only too well aware of the restrictions that are inherent in collecting. The Rijksmuseum can nevertheless state unreservedly that nowhere else is Dutch art from the late middle ages to the beginning of the 20th century presented at such a superb standard and in all its diversity. Each volume in the series offers the interested museum visitor an up-to-date insight into the significance, context and origins of the works of art in the period examined.

This first volume contains a selection of one hundred works of art covering the late middle ages, through the Renaissance, and up to the years after the Iconoclasm -- a span of almost two and a half centuries. By the end of the 16th century, after an intense dialogue with the southern Netherlands, our country had evolved into an independent nation, and in a parallel development had also established its own artistic character.

The idea for this series came from my predecessor, Henk van Os, and we are delighted that he is also one of the authors of this first volume. Most of the contributions are from the pens of the curators responsible for the objects discussed. It is partly due to the efforts of the editorial committee under our Director of Collections, Jan Piet Filedt Kok, assisted by Fennelies Kiers, and to the museum's excellent Photographic Department, that the book has become such a shining example of the team spirit of the Rijksmuseum staff. It is thanks to their collective expertise that the book is not only a feast for the eye but also a treasure-house of knowledge accumulated over many years about the objects in our care.

This history of early Netherlandish art in the Rijksmuseum brings together one hundred choice works of art, most of which are scattered over the museum's various collection departments. The form of the book thus anticipates our plans to integrate the collections and present them to the public in a way that enhances their significance in an enriching context. The reader is therefore being given a virtual foretaste of the enhanced value to be gained from the abundance of riches housed in the Rijksmuseum.

RONALD DE LEEUW *Director-General*

Introduction

The idea for this book came from England in the shape of *Giotto to Dürer: early Renaissance painting in the National Gallery* (London 1991), a fascinating survey of the development of 15th-century European painting woven around the fabled collection of paintings in the National Gallery in London. The Rijksmuseum cannot offer such a well-nigh complete overview of European painting, but the picture it can present of Dutch art with the aid of paintings, drawings, prints, sculpture and the decorative arts from its collection is unparalleled anywhere in the world. That collection will now form the basis for a four-part series of books about Dutch art, which opens with this volume.

The aim of the series is to paint a picture of Dutch art from the late middle ages to the beginning of the 20th century, and is intended first and foremost for the interested visitor to the Rijksmuseum. Each volume will provide an up-to-date insight into the significance, context and creation of the art-works from the period covered.

This, the first volume, examines Netherlandish art from the middle of the 14th century until around 1600--in other words the late middle ages, the Renaissance and the years following the Iconoclasm.

Until around 1570, the southern and northern Netherlands were a single political and territorial entity. The production of art was firmly centred on the southern Netherlands in the 15th century. The establishment of the ducal court in Brussels and the wealth of great cities like Bruges, Ghent and Antwerp generated a vast output of luxury goods. Painting and sculpture blossomed as never before. The northern cities, by comparison, belonged to a remote province. Alongside imports and commission to southern artists, there was a modest local art industry. Every city had gold and silversmiths, cabinetmakers, a few painters, wood-carvers and often a printer, and they worked for an urban and regional clientele. The close ties they maintained with their southern colleagues is reflected in the influences they absorbed, but in general the north lagged behind. It was only in the early decades of the 16th century that the output of art in the northern Netherlands began to match that of the south, and painters' workshops sprang up in Amsterdam, Haarlem, Leiden and Utrecht. Although altarpieces and devotional works predominated, the influence of the Reformation and humanism led to changes in the types of subject depicted. There was a greater emphasis on narrative biblical scenes, and a growing interest in allegory and mythology. The latter was due to the effects of the

Italian Renaissance, which began to make itself felt around 1520, primarily in the sphere of ornamentation. A close eye was kept on developments in Italy, and an increasing number of artists worked there for varying lengths of time. Despite these changes, the types of object and their method of manufacture differed little from those of the late middle ages. There was also a continuing and intensive interaction between the artistic production of the northern and southern Netherlands, with Antwerp as the main centre.

The Iconoclasm, the Dutch Revolt and the northern cities' conversion to the Protestant faith between 1573 and 1580 put an end to the close ties between north and south. Works of art were removed from the churches in the north. The rise of the cities and the immigration of artists and craftsmen from the southern Netherlands provided a powerful impulse for the production of art. New patrons emerged from the ranks of the nascent burgher elite. Most works of art had formerly been made for churches, but now there was a growing number of wealthy collectors and art lovers who commissions were designed to embellish their homes. The Italian style that had dominated Europe in the later 16th century culminated in the northern Netherlands in Dutch Mannerism, a short-lived style that made way just before 1600 for the 'realism' that is such a distinguishing feature of 17th-century Dutch art.

As far as the 15th and 16th centuries are concerned, the focus in the Rijksmuseum's collection of paintings is on the work of artists from the flowering of northern Netherlandish art in the 16th century. Because painting matured late in the north, the first picture to be included in this book only dates from around 1480. There are almost no works by 15th-century southern Netherlandish contemporaries in the museum. Sixteenth-century Flemish painters, on the other hand, are reasonably well represented. Fortunately, statues and other objects from the northern and southern Netherlands do provide a good picture of earlier developments in the 15th century. The modest size of many late-medieval objects in the Rijksmuseum's collections gives a slightly distorted idea of overall production. There are no large sculpted or painted altarpieces, merely fragments of them--often lacking their original paint. This does not do justice to the monumental grandeur that late-medieval and Renaissance art certainly had in the Low Countries.

The rearrangement of the Rijksmuseum after the Second World War resulted in the 15th and 16th century works of art being

displayed in three separate locations. On the first floor the paintings are housed in the eastern cabinets, and sculpture and the decorative arts in the western cabinets. On the ground floor of the east wing, a small group of art objects of historical importance opens the Department of Dutch History. One of the intentions of the impending renovation of the Rijksmuseum is to concentrate the art and history of the 15th and 16th centuries in a mixed display on the ground floor of the east wing in order to reinforce the integration of the works of art in different media while setting them within their historical context. That is precisely what we have endeavoured to do in this book, with its combination of works in different techniques.

Its core consists of 100 works of art executed between 1360 and 1600 from the museum's collections. Each is illustrated and discussed at length, with the spotlight falling on one or more distinguishing features. The works are arranged more or less in chronological order in three sections, each of which opens with a brief introduction sketching the historical and art-historical outlines of the period. Here and in the four main essays the reader will find illustrations of key works from outside the Rijksmuseum.

The first introductory essay takes a number of examples to show how the function and meaning of works of art change when they enter a museum. The second essay explains how the picture of early Netherlandish art presented by the Rijksmuseum has evolved in the two centuries of its existence. The two closing essays deal with such matters as how the works of art came into being, and how and for whom they were made and traded. The illustrations in the essays are largely of objects in the collections of the Rijksmuseum.

JAN PIET FILEDT KOK
GER LUIJTEN
HENK VAN OS
FRITS SCHOLTEN

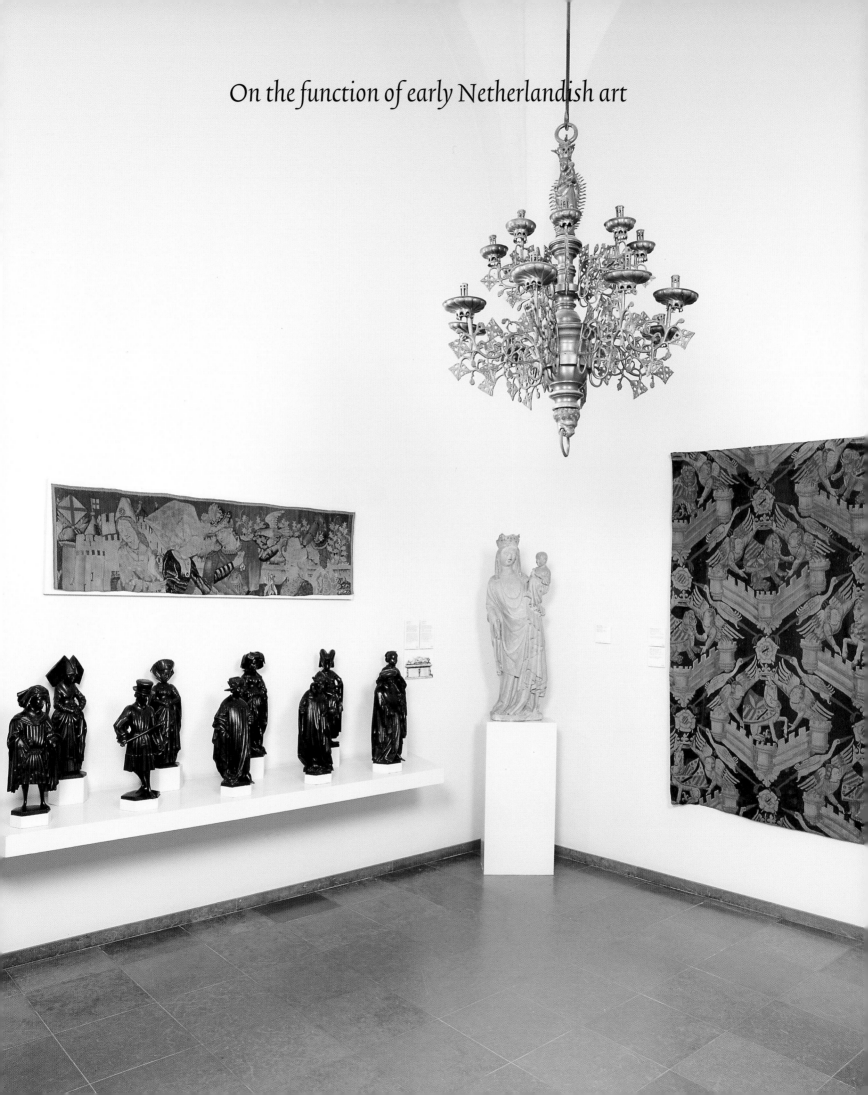

On the function of early Netherlandish art

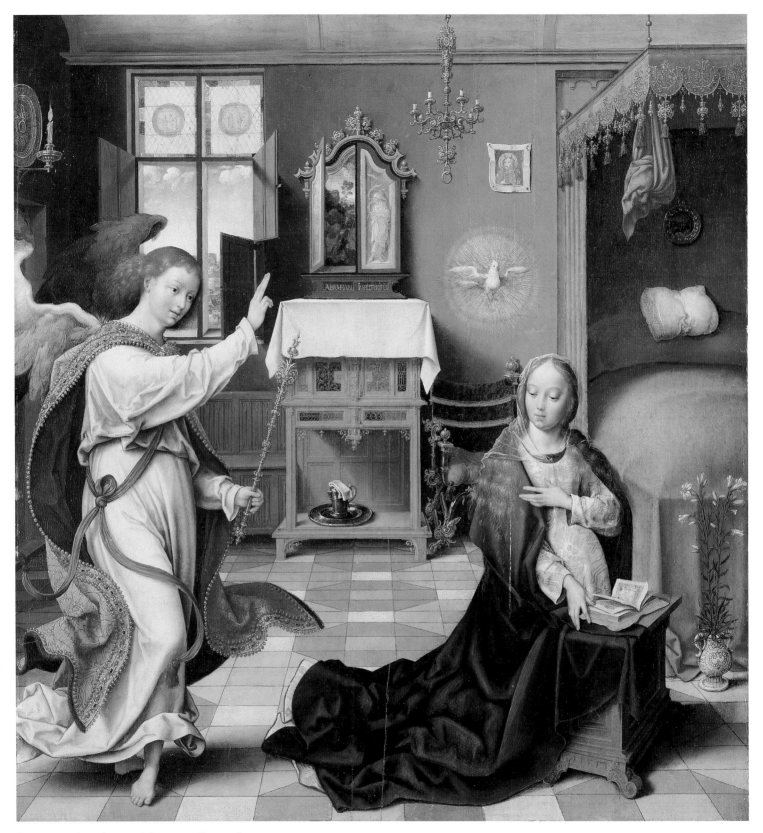

fig. 1 Joos van Cleve, *The Annunciation*, c. 1525; oil on panel, 86.4 x 80 cm.
New York, Metropolitan Museum of Art, The Friedsam Collection, Bequest of Michael Friedsam, 1931 (inv. no. 32.100.60).
Photograph © 1989 The Metropolitan Museum of Art

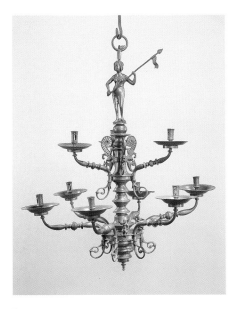

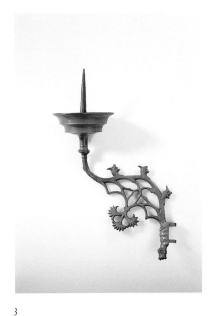

2

3

4

fig. 2 Northern Germany, mid-16th century, *Chandelier*; brass, h. 95 cm, ø 85 cm. Amsterdam, Rijksmuseum (inv. no. BK-NM-3512)

fig. 3 Southern Netherlands, late 15th century, *Wall bracket with candle-holder*, brass, h 44 cm, w 30 cm. Amsterdam, Rijksmuseum (inv. no. BK-NM-2410)

fig. 4 Germany, early 16th century, *Basin*; brass, h. 5.4 cm, ø 23 cm. Amsterdam, Rijksmuseum (inv. no. BK-NM-1314)

fig. 5 Bruges, 15th century, *Prie-dieu*; oak, h 60 cm, w 52 cm, d 30 cm. Bruges, Gruuthuse Museum (inv. no. 517)

AN UNLIT CHANDELIER

A chandelier in a museum gallery no longer needs to light the room. It has lost its function as a domestic object. The museum's task is to explain the significance of a late-medieval chandelier to the modern museum visitor. One can choose to present it by focusing on its beauty, documenting the history of the craft in question, illustrating the history of domestic lighting, giving an example of a particular idea of style, or inspiring modern designers. Each new investment of meaning demands a different arrangement within a different context. Today the chandelier hangs in the second gallery of the Rijksmuseum's Sculpture and Decorative Arts Department as a fascinating example of late Gothic art, with the lavish ornamentation typical of the period.

The carefully arranged collection of objects in a museum gallery makes it easy to forget the setting in which they originally served a purpose. Sometimes paintings supply some information, in this particular case an *Annunciation* by Joos van Cleve from the early years of the 16th century (fig. 1). The angel Gabriel's announcement to Mary that she is to be the mother of the Messiah takes place in a fully furnished, 16th-century bedchamber. There is a bed, a prie-dieu (fig. 5), a chair, a dresser [cf. 22], a sconce (figs. 3, 4), a pewter dish and jug, a stone vase, a cloth, and exactly the same kind of chandelier as the one in the museum (fig. 2), but now in its original setting.

FROM ABBEY CHURCH TO MUSEUM

The first object that one comes across in the first gallery of the Sculpture and Decorative Arts Department is one of the earliest works in the Rijksmuseum (fig. 6). It is a sandstone relief. Three half-length figures are set within a flat, arch-shaped frame with a

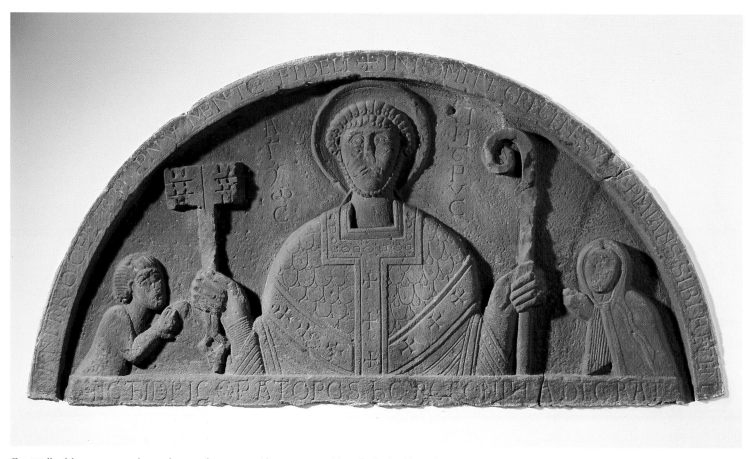

ffig. 6 Holland, between 1112 and 1132, *The Egmond tympanum, with St Peter, Count Dirk VI of Holland and his mother, Countess Petronella*; relief, sandstone, h 88 cm, w 275 cm, d 12.5 cm. Amsterdam, Rijksmuseum (inv. no. BK-NM-1914)

fig. 7 Back of the tympanum *(fig. 6)*, lid of a sarcophagus

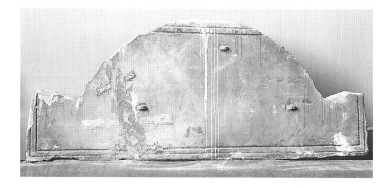

plinth. In the middle is St Peter with a huge key and the crosier identifying him as the Bishop of Rome. His head is flanked by the Greek words ΑΓΙΩΣ ΠΗΤΡΥΣ, or St Peter. On the plinth are the names of the two people venerating him. The one on the left reads: 'HIC THID(E)RIC ORAT' (Here prayeth Dirk), and on the right: 'OPUS H(O)C PET(R(ONILLA DEC(O)RAT' (Petronella adorns this work). The individuals are Petronella, Countess of Holland, and her son, the later Count Dirk VI, for whom she acted as regent after the death of Count Floris II in 1121. The sandstone relief must have been made during her regency.

It is known that the tympanum came from the Benedictine abbey of Sts Peter and Adalbert at Egmond-Binnen, where it served as a relief over the main portal of the former church. This explains the text on the arch: 'IANTOR O CELI TIBI P(RO(MV(M) MENTE FIDELI + INTROMIT(T)E GREGEM SV(PER)VM PLACANS SIBI REGEM' (O door-keeper of Heaven, with a faithful heart allow the flock kneeling before you to enter, and reconcile them with the king of the celestial beings). Petronella and her son were the intercessors for all entering the church, asking Peter if he, in his turn, would intercede with the Almighty on their behalf.

The combination of text and image reveals the original function

of this relief. But a look at the back shows that this piece of sandstone had already had a much older purpose. It was once the trapeziform lid of a sarcophagus that a stonemason refashioned into a tympanum (fig. 7). The grooves in the stone indicate that this is a gravestone. It is perfectly conceivable that Petronella encountered a Benedictine in the monastery who had some knowledge of stonemasonry. She wanted herself and her son immortalised above the main entrance to the prestigious abbey's new church. But where to get the stone for a tympanum? Fortunately, there were graves in the monastery churchyard that were covered with sandstone from northern Germany. Thus it was that an old gravestone underwent a radical change of function at a very early date.

The scene of Peter, Petronella and Dirk in that location was a very effective declaration of the countess's political ambitions. She was, to use a later term, an ultramontane—a north European Christian who had made herself totally subservient to the ecclesiastical authority of Rome, far away on the other side of the Alps. At the time, Pope Innocent II was continuing Gregory VII's work of pushing through reforms designed to tighten the reins of ecclesiastical and doctrinal authority. The countess actually changed her name from Geertruid to Petronella in order to proclaim her allegiance to the pope in Rome. Her new patron saint was a Roman martyr who was believed to be St Peter's daughter. The saint is depicted on the tympanum not as an apostle but most emphatically as pope. Petronella had a clear intention with this unequivocal proclamation of her submission to papal authority. The object of what is known as the Gregorian reforms was to place all abbeys under the pope's authority. If that could be done in Egmond, the countess could prevent the powerful prince-bishop of Utrecht from controlling the abbey. She could not have made her and her son's position clearer than it is on the relief. Here, then we have a piece of sandstone changing function from gravestone to religious scene with political implications. The tympanum continued to be a very effective adornment of the entrance to the abbey church, even after the deaths of both mother and son.

The next alteration in the function of the tympanum was the result of the radical religious changes that took place in the 16th century. With the arrival of the Reformation, monks were publicly exposed as spiritual frauds. Monasteries were closed and churches plundered. The abbey at Egmond was burned down by the dissidents who sparked off the Dutch Revolt, and the tympanum gradually became nothing more than a piece of decoration in a gateway (fig. 8). In the course of the 17th century, however, it took on a new significance. When the Netherlands became the Netherlands, people naturally wanted to learn about the earliest works of art of their new country, if only to provide themselves with an origin in art. This is why, from the beginning of the 18th

century, the relief was described, discussed and depicted as one of the earliest creations of Dutch art.

Many works that had not been destroyed or removed in the name of Protestantism were savaged in the name of reason at the time of the French Revolution. The motives, though, were rather different. It is true that a great deal of art was destroyed or damaged, but the fury was directed not so much at the art as at its owners. Tombstone reliefs were stripped of the portraits and coats of arms of noble gentlemen and ladies, of abbots and bishops. Relatively speaking, however, people now had more respect for art; it was just that it belonged to the wrong people. Sweep them aside, they no longer had a right to all these beautiful objects. Art belonged to the nation. Works lost their original functions on a grand scale. The first public museums opened their doors.

The tympanum was removed from Egmond shortly after 1801. By 1842 it was in the Rijksmuseum, which was then housed in the Trippenhuis on Kloveniersburgwal in Amsterdam (fig. 9). Visitors wandering in the leafy garden of this 17th-century canalside mansion suddenly came face to face with a remnant of a far distant past. They could sink into romantic reveries about nature, art and the brief span of man's life on earth. The tree-shaded sandstone relief could also lend wings to historical fantasies. No other 19th-century artist put his imagination so much at the service of Dutch history as Charles Rochussen, one of whose watercolours centres around the Egmond tympanum (fig. 10). The abbot is seen receiving the countess and her son in the masons' workshop in order to show them the finished tympanum. Two chairs await the distinguished guests, and a massive easel supports the relief (without its crack, of course). In the left background is the church portal on which the tympanum will be installed. Rochussen opened a gateway onto a far-off, fanciful past.

The tympanum was given a fresh chance to take on yet another meaning when Pierre Cuypers built the new Rijksmuseum. This was an initiative launched by Roman Catholics, who had been openly professing their faith again since the middle of the 19th century. The church hierarchy was restored thanks to the leader of the Dutch Liberal Party, Johan Thorbecke, and Catholics set to work rescuing the nation's badly neglected cultural heritage in order to demonstrate that they were true and loyal Dutchmen. Cultural policy provided them with an opportunity to make a vital contribution to the Dutch nation, which had finally accepted them. Victor de Stuers, one of the leaders of the Catholic revival, wrote a passionate article titled 'Holland op zijn smalst' (Holland at its meanest), in which he called for the preservation of the nation's historic monuments.

De Stuers, the most senior civil servant at the Ministry of Culture, awarded the commission for the Rijksmuseum to Pierre Cuypers, the architect of the new Neo-Gothic Catholic churches

fig. 9 Gerrit Lamberts, *The relief from Egmond Abbey in the garden of the Trippenhuis*, 1845; wash drawing, 18 x 32 cm. Amsterdam City Archives

fig. 8 Christiaan Theodorus Tinne, *'Precise drawing of the bas-relief placed in the gateway between the two ruined towers of Egmond Abbey'*; watercolour. Leiden, University Library, Bodel Nijenhuis Coll. (P314-IV N17)

fig. 10 Charles Rochussen, *Countess Petronella of Holland and her son Dirk VI visiting the workshop where the Egmond tympanum is being displayed*, 1881; watercolour, 38.5 x 61.5 cm. The Hague, Huis ten Bosch, Royal Collections, with the permission of Her Majesty the Queen of the Netherlands

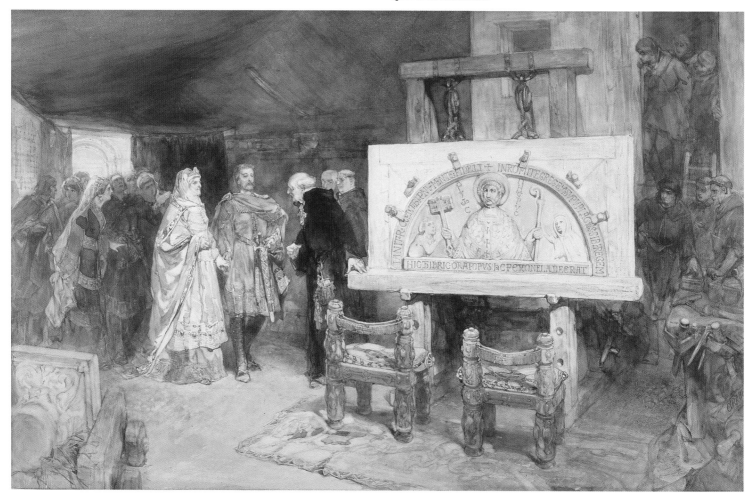

springing up in the Netherlands. It was thanks to Cuypers that the Rijksmuseum got a Gallery of Honour that has the aura of a cathedral. He also turned Rembrandt's *Nightwatch* into the nation's high altarpiece. The Rijksmuseum was felt to be such a Roman Catholic edifice when it was completed in 1885 that King Willem III actually refused to carry out the official opening of the 'papist palace'. The Catholic builders of the Rijksmuseum regarded the Egmond relief as a cornerstone of their temple. It was artificially rehabilitated in its original function in what was known as the Gothic Gallery (*fig. 11*). It was even given a new portal, which in a symbolic sense was the gateway to the nation's cultural history. According to the founders, the cultural identity of the Dutch did not develop during the Reformation or the war against Spain, but with the foundation of the monasteries. This view is reflected in the tile picture on the facade of the museum, which shows the foundation of the Cistercian abbey at Aduard.

Today, the tympanum has again been deprived of the ecclesiastical setting that Cuypers wanted to reinstate (*fig. 12*). It now gives little cause for romantic reveries. What remains of its significance is that it stands at the beginning of a chronological development. The viewer is invited to make comparisons, for example with the two other monumental sculptures on the same wall: pilasters with apostles of circa 1200 from the portal of the church at Odiliënberg. The comparison reveals just how primitive the Egmond relief is. The figures were simply cut out of the sandstone, without any attempt at modelling.

The Egmond relief takes us back to the beginning of the history of art in the Netherlands. All the other connotations attached to the tympanum down the years have become invisible. We could perhaps enumerate them with the aid of wall captions, and audio and conducted tours. That would enable us to explain that this erstwhile gravestone from Egmond is one of the most interesting objects for cataloguing the constant change of function of a work of art over the course of time. Every object in a museum has its own history, but few have such a fascinating and well-documented one.

CHURCHES WITHOUT ART, ART WITHOUT RELIGION

The full width of the long wall in the second gallery of the Paintings Department is taken up by a polyptych illustrating *The seven works of mercy* (*fig. 13*) [19]. The hungry are being fed, the thirsty given drink, the naked clothed. Travellers are being provided with shelter, the sick are visited and prisoners are freed from their misery. These are the good works listed by St Matthew (25:31-46). A further scene was added in the middle: burying the dead, which was also regarded as a work of mercy in the middle ages. At the top, Christ appears on Judgement Day.

The two inscriptions state that the painting was executed in 1504, and until 1918 it hung in the Great Church in Alkmaar. Water

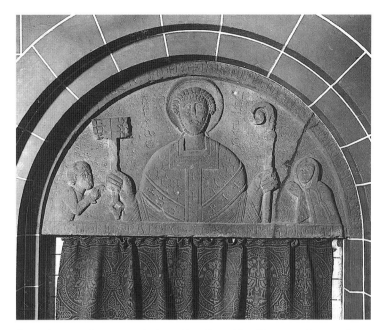

fig. 11 The Egmond tympanum in the Gothic Gallery of the Rijksmuseum (room 208), c. 1900. Photograph: Rijksmuseum

fig. 12 The Egmond tympanum in the western cabinets of the Rijksmuseum, flanked by apostles from the portal of Odiliënberg Church (room 238), 1998. Photograph: Rijksmuseum

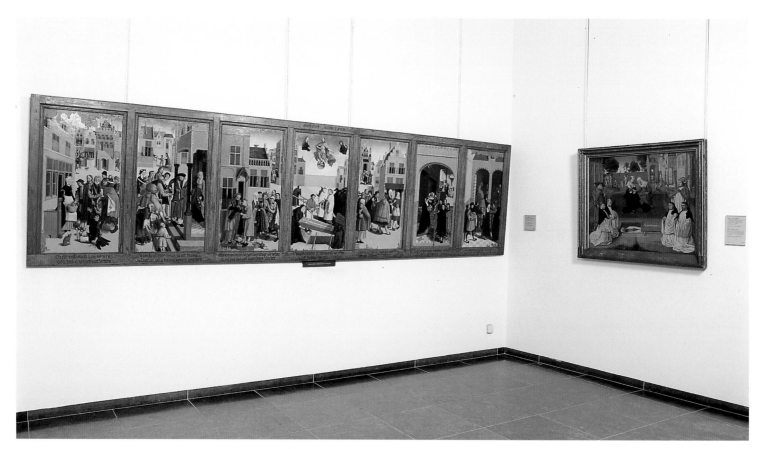

fig. 13 The Master of Alkmaar's *Seven works of mercy* [19] in the eastern cabinets of the Rijksmuseum (room 202), 1998. Photograph: Rijksmuseum

damage resulted in major paint losses, mainly around the edges of the scenes. In the course of a restoration campaign carried out between 1971 and 1975 it was decided to allow the lost areas to remain bare rather than camouflage them. Such areas of damage are not uncommon in old paintings. What is unusual about this polyptych are the traces of deliberate mutilation. Those carrying out the charitable deeds were the main targets (fig. 14). Someone viciously hacked at the face of the man clothing one unfortunate, and deep cuts make a group who want to help a traveller largely unrecognisable (fig. 15).

It is only when one looks at photographs taken during the restoration, of the central scene in particular, that one realises how viciously the panels were attacked (fig. 16). The painting was severely gashed with a sharp implement—a knife or chisel. In some places the panels were gouged so savagely that the wood splintered, leaving gaping holes. When the painting was cleaned, a piece of iron was found that had undoubtedly broken off the implement and become embedded in the wood. Research has shown that the damage must have been done before 1582. In all likelihood, it was not due, or not solely at any rate, to the pathological frenzy of any one individual, but to an outburst of popular fury about the religious function of art that came to a head with the Iconoclasm of

1566. It was because of the restoration team's decision that traces have been preserved of this widespread vandalism that had such dramatic consequences for Netherlandish art. The images suddenly confront us with a violent protest against art that took place more than four centuries ago.

Equally if not more shocking is the damage done to the Ros family memorial, which was made for the Great Church in Wageningen around 1550 by the sculptor Arnt van Tricht (fig. 17). It shows God the Father presenting his suffering Son to the faithful, with the dove of the Holy Ghost above his head—a form of the threefold godhead known as the Mercy-Seat Trinity. Those pleading for mercy are members of the Ros family. As was so often the case, the iconoclasts vented their rage on all the heads in the composition, which are either severely damaged or smashed off. One wonders, since this is a memorial honouring a prominent family, whether social factors were also at work here.

A great deal of thought has been given to the causes and effects of the Iconoclasm. One author may stress the social background, another the theological motivation, while yet others believe that late-medieval developments in art and the practice of devotion ultimately provoked the iconoclasts to embark on their mass

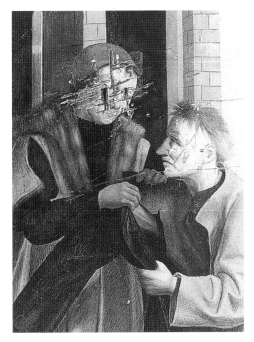

fig. 14 Detail showing the damage to the third panel of the *Seven works of mercy* [19], photographed during restoration. Photograph: Rijksmuseum

fig. 15 Detail showing the damage to the fifth panel of the *Seven works of mercy* [19], photographed during restoration. Photograph: Rijksmuseum

fig. 16 Fourth (central) panel of the *Seven works of mercy*, with the burial of the dead and the Last Judgement, photographed during restoration. Photograph: Rijksmuseum

16

destruction of art. Whatever else, though, the Iconoclasm had everything to do with the religious function of art. We have seen that the function of a work can alter, but the approaches mentioned above really do seem rather mechanistic to those who know something about the Iconoclasm. It is a way of smoothing out awkward blips of the past in order to present it as a process of historical evolution. The aim of the Iconoclasm was to force a break with the past. Art was not permitted in churches. It led to idolatry. Rabble-rousing hedge preachers incited the mobs to destroy all the art in their churches, and that they did with a vengeance, sometimes singing their own version of the Old Testament commandment: 'Thou shalt not make unto thee any graven image of anything whatsoever; any who honour or cleave to it make God jealous'. Most reformers believed that too much money was being invested in art, money that could be far better spent on good works. The irony of history is that traces of that furious reaction against art are now visible on a painting lauding acts of charity.

What was the future of art after the Iconoclasm? Most of it, after all, had had a religious function. Where Roman Catholics regained power there was much to be restored. New altarpieces were needed. The ideas about what they were to portray was not seldom influenced by the more moderate criticism of ecclesiastical art, which stressed the avoidance of idolatry and the prime importance of theological orthodoxy. There was a clear preference for visual narratives over devotional subjects, for the latter could give rise to misplaced veneration. All the same, the market for church art had shrunk considerably. Artists, though, were prepared to meet the

fig. 17 Arnt van Tricht, *Memorial tablet with the Mercy-Seat Trinity and donors*, c. 1550; stone, polychromed, h 144 cm, w 104 cm. Amsterdam, Rijksmuseum (inv. no. BK-NM-3099)

altered demands of the market, and indeed helped create it. New subjects were depicted for a rapidly growing number of customers—mythological scenes, still lifes, landscapes and more and more portraits. Was the Iconoclasm the main motive force behind the development of secular painting in the northern Netherlands, which was unparalleled in Europe? That is a question for which there is no hard-and-fast answer, but it is indisputable that the fury unleashed on ecclesiastical art did play its part.

The criticism of the function of church art is often implicit in works of art themselves. For example, there is a suite of prints designed by Maarten van Heemskerck illustrating scandalous instances of idolatry (fig. 18). It was published in the period of the Iconoclasm, but the artist was most emphatically not one of those who rounded on ecclesiastical art, either in thought or deed. He moved in humanist circles and painted altarpieces for Roman Catholic patrons. His prints of the destruction of the material world of idolatry, which had a wide circulation, do have a moralistic slant, but in no way could they have incited people to destroy church art. Perhaps even more interesting in this respect is the triptych with the *Dance around the golden calf* by Lucas van Leyden of around 1530 [47]. The shape suggests that the painting was used in church or for private devotion, with God being venerated when

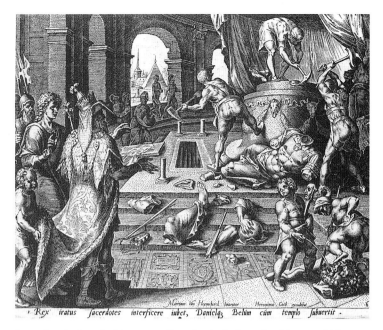

fig. 18 Cornelis Cort after Maarten van Heemskerck, *The destruction of the statue of Bel,* no. 6 in the series *The story of Daniel, Bel and the dragon,* 1565; engraving, 20.4 × 24.8 cm. Amsterdam, Rijksmuseum, Rijksprentenkabinet

fig. 19 Circle of Jacob Cornelisz van Oostsanen, *Triptych with the Last Supper and donors,* c. 1525; behind-glass painting, 32.8 × 36.2 cm, wings 33 × 12 cm. Amsterdam, Rijksmuseum (inv. no. SK-A-4294)

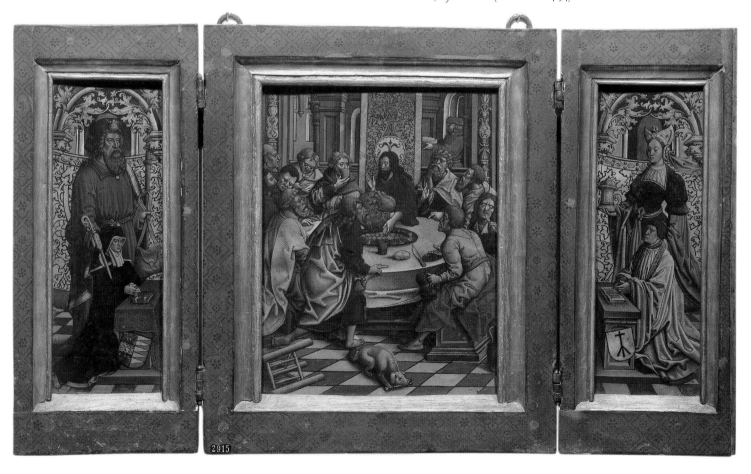

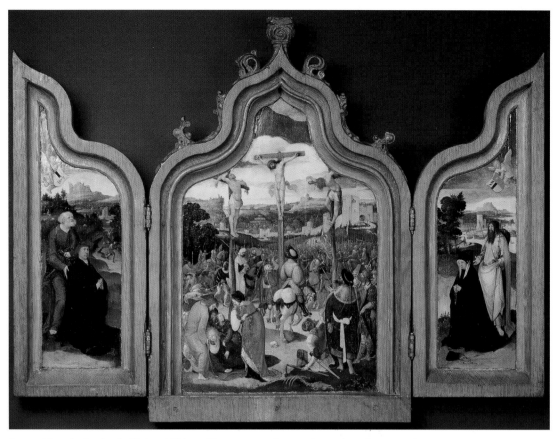

fig. 20 Leiden School, *Triptych with the Crucifixion and donors*, c. 1525; oil on panel, central panel 37 × 25.5, wings 32.5 × 10 cm.
Amsterdam, Rijksmuseum (inv. no. SK-A-1598)

the shutters were opened. But that was the last thing that could be done. Celebrating the Eucharist in front of a depiction of the adoration of the golden calf would have been blasphemous in the extreme, and anyone praying before this triptych would have been an accomplice to idolatry. Lucas van Leyden evidently used the traditional triptych form to express something completely different. He is toying with the viewer's expectations. The opened painting displays a single scene, not three, and it is one that negates the original function of triptychs. It is not a question of adoration or veneration, but of warning people of the risks attached: the depraving effects of idolatry and its catastrophic consequences. This is evidence that the criticism of the use of religious art as expressed by Erasmus, among others, was also reflected in an early painting by an artist of genius. The triptych's shape may suggest adoration, but the scene itself turns it into a moralistic lesson.

In general, it is remarkable that most 16th-century, northern Netherlandish church and domestic altarpieces have narrative scenes in the central section. They are not Old Testament stories, like the one about the golden calf, but the most important events in the New Testament. Devotional subjects like the Virgin and

Child and the Man of Sorrows are few and far between. Donors in a prayerful pose often accompany these New Testament stories, and are presented to the viewer by their patron saints. Two cases in point are a triptych with a behind-glass painting of *The Last Supper* from the circle around Jacob Cornelisz van Oostsanen (fig. 19) and a small Leiden triptych with the *Crucifixion* (fig. 20). The donors are not venerating a central image. There is no question of veneration, or of pleading for intercession. The donors merely wish to be present at an event that will enable them to attain salvation. There is no idolatry here; at most it is a question of self-glorification.

The effect of the Iconoclasm must be sought first and foremost in what the iconoclasts set out to achieve, namely the destruction of the greater part of the art produced in the northern Netherlands. But the criticism of the use of religious art, which was both their justification and incitement, is evident in works of art produced throughout the 16th century, even in Roman Catholic church art from after the Iconoclasm. Portraying God was no longer a matter of course.

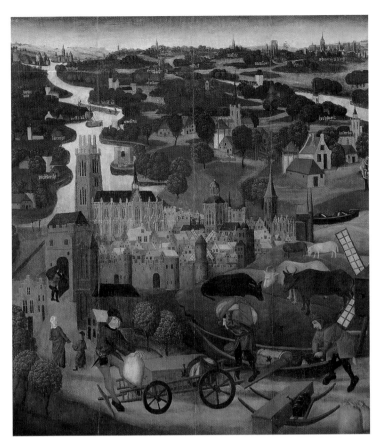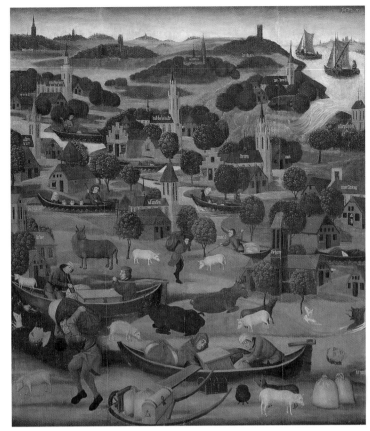

fig. 21 Master of the St Elizabeth Panels, two wings of an altarpiece with *The St Elizabeth's Day Flood with the city of Dordrecht in the background, 18-19 November 1421,*
c. 1500; oil on panel, 127 × 110 cm. Amsterdam, Rijksmuseum (inv. no. SK-A-3147a/b)

ARS LONGA, VITA BREVIS

The critical stance towards religious art had a major influence on the changing function of art. But are there also constant, specific features of art from the Low Countries that span the entire period of two centuries covered in this book? Is there something unique about the function of Netherlandish art when seen in a wider, European context? Such an ambitious question is almost doomed to go unanswered, if only because so little of that art has survived. Nevertheless, I would like to make a few remarks that are prompted by that question, even if they can be no more than isolated observations. A great deal has been written about the descriptive nature of Netherlandish art that supposedly sets it apart from Italian art. A marvellous example of that descriptive fascination with the real world is the sheet of drawn studies of a frog by Jacques de Gheyn II [99]. Another work that has to be mentioned is a unique altarpiece of around 1500, the outside shutters of which display an astonishingly detailed representation of the St Elizabeth's Day floods of 1421 (*fig. 21*). There has been considerable debate about the validity of such a characterisation of Netherlandish art, although it cannot be denied that there is at least some truth in it. I would like to add just one or two

comments, although I realise that it is concerned more with the individual nature of Netherlandish art than with its concrete function, which is the subject of this essay.

One of the earliest Netherlandish paintings to have come down to us is a heavily restored memorial tablet for the Lords of Montfoort. Today it can be seen in the Dutch History Department of the Rijksmuseum (*fig. 22*). Against a blue background sprinkled with stars, St George is presenting four companion knights to the Virgin. The inscription translates as follows: 'In the year of Our Lord one thousand three hundred and forty-five, on Sts Cosmas and Damian's Day, perished at Frisian hands Count Willem of Hainault, Holland and Zeeland and Lord of Friesland, Lord Jan van Montfoort, Lord Roelof van Montfoort, Lord Willem van Montfoort, together with many of their kinsmen, companions and underlings; pray for all souls'. The four men fell victim to the famous 'stubbornness' of the Frisians at the Battle of Warns.

An epitaph of this kind was usually sculpted, but on this occasion the commission may have been awarded to a painter because a picture was cheaper than a sculpture. The iconographic features suggest that the artist may have been a miniaturist who decided to take on a monumental commission for a change, or a

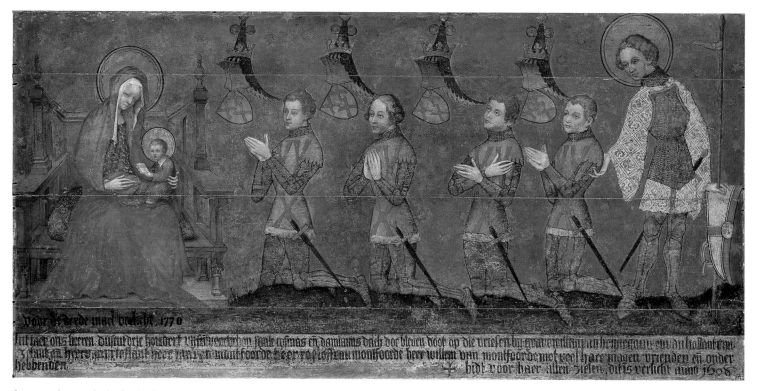

fig. 22 Northern Netherlands School, *Memorial tablet for the Lords of Montfoort*, c. 1380; oil on panel, 69 × 142 cm. Amsterdam, Rijksmuseum (inv. no. SK-A-831)

court painter who was accustomed to painting both miniatures and coats of arms, such as Jan van Eyck. Many European panel paintings were made in imitation of works in less malleable or more costly materials like stone or precious metals.

It is not known for certain which church this memorial was intended for, but in the 16th century it served as an altarpiece in Montfoort Church. A prominent local citizen gave it a home when the church was Protestantised in 1598. My point is that the earliest known Netherlandish painting to have survived to the present day depicts individuals. They were put in the public eye on an altar, a location that would have been out of bounds to them anywhere else in Europe, and were given such prominence because they were dead. Art as a means of immortalisation. It is a use of art that one frequently comes across in the Netherlands, and in many different guises.

'A thousand figures meet us, each in its own special shape and dress', remarked Jacob Burckhardt in his *Civilisation of the Renaissance in Italy*. That is certainly the experience of the viewer of early Netherlandish art. Although there are too few works to furnish a thousand faces, six of the eight paintings in the first gallery of the Rijksmuseum's Paintings Department do contain portraits. That of Lysbeth van Duvenvoorde speaks for itself [2]. The first king in Geertgen's *Adoration of the magi* is a real person [12]. Kneeling beneath the Tree of Jesse is a nun, and opposite her there is an

individualised male figure with an open book [14]. Looking on in the background of the *Virgin and Child with female saints* [16] by the Master of the Virgo inter Virgines are two figures who must have been identifiable at the time the picture was made. Kneeling before St Agnes in a work from the Dordrecht School is a nun who is attempting to acquire the saint's innocence through her prayers. Mostly it is monastics who are depicted. A nun appears as the donor on an early Gelderland retable of c. 1435 with scenes from the life of Christ (fig. 23). Here it is a miniaturist who produced a monumental painting imitating a work in another material, which explains the painted gemstones. The cloister-garth in the altarpiece by the Master of the Spes Nostra [18] is presented as a 'garden close-locked', where death is vanquished in a life of prayer. The corpse is saying 'I am what thou wilt be, what thou art I have been, I beg thee, pray for me'. Here, too, individuals are portrayed in their longing for eternal life. All those faces are of patrons, which leads to the cautious conclusion that there were very few institutional commissions in early Netherlandish art. In Italy, for example, ecclesiastical and urban authorities were very often the main patrons. In the Low Countries, evidently, it was individuals or corporations that ordered works of art, even when they were destined for public locations.

THE OLDEST MUSEUM

The most beautiful dog ever painted is by Cornelis van Haarlem [95]. He looks out of the large painting with an expression of loyalty tinged with sadness. There are convincing depictions of all sorts of other animals, but they are not looking at the viewer. The dog is gazing at us as if to say that there is nothing more he can do, now that everything is falling apart at the seams. Eve is giving Adam an apple from the tree of the knowledge of good and evil. They have succumbed to the devil's crafty temptation, and are eating themselves out of Paradise. An ape embraces a cat beneath the tree. Everything that is going on is utterly stupid and foolish. It was in vain that the loyal dog guarded over the souls of the first two human beings. Sin has come into the world.

Such a large painting (it measures 273 by 220 cm) executed in 1593 with a biblical subject would almost certainly have been an altarpiece. The Fall of Man, though, would never have formed the central section of an altarpiece. It was occasionally depicted on the wings, with Eve and her apple of sin as the opposite of the Virgin in the middle with the fruit of God's mercy. One woman caused him to withdraw his protection from mankind, the other restores us to his grace. The Fall of Man as the principal subject of a painted decoration for an altar is inconceivable. But for whom and why was the painting made?

The 1593 accounts of the Haarlem treasury contain the following entry. 'Master Cornelis, painter, for two fine paintings, one very large and containing many artful poetic fables, the other of Eve and Adam, both executed for this city to be hung in His Excellency's court in order to adorn his chambers.' It has been established that one these works was this *Fall of Man*. But what 'Excellency' would really want something like this in one the rooms at his court? Haarlem was the most important urban centre in the province of Holland, and had fought for its independence. In 1590, the city had started rebuilding the western section of the former Dominican friary. It occupied a central position beside the town hall, and that alone made it highly suitable as the stadholder's quarters when he visited the city.

fig. 23 Gelderland School, *Eighteen scenes from the life of Christ*, c. 1435; oil on canvas on panel, 103 × 167.5 cm. Amsterdam, Rijksmuseum (inv. no. SK-A-1491)

fig. 24 Cornelis Cornelisz van Haarlem, *The marriage of Peleus and Thetis*, 1593; oil on canvas, 246 × 419 cm. Haarlem, Frans Halsmuseum, on loan from the Mauritshuis, The Hague (cat. no. 59)

The second painting mentioned in the accounts has also survived. It is a vast *Marriage of Peleus and Thetis*, with the Judgement of Paris in the background (fig. 24), and is now in the Frans Halsmuseum in Haarlem. All is happiness on the right. It is a paradisal life. In the left background, though, Discord goes about her malign task. The Judgement of Paris is taking place in the right background, and will lead to the Trojan war. Here it is not an apple of sin but an apple of discord that brings misfortune on the world. 'Only wise leadership, O Stadholder, can preserve us from disaster', is what the Haarlem authorities were pointing out to their eminent guest. And above all he should not be high-handed or self-opinionated. Art had found a new function in biblical and mythological subjects.

Cornelis van Haarlem's two 'apple paintings' were not the only pictures in the prince's quarters. Cornelis was commissioned to paint another two by the city fathers. The stadholder was going to be shown that Haarlem had its own Michelangelo. In 1603, the leading Haarlem painters Hendrick Goltzius, Hendrik Vroom and, once again, Cornelis were commissioned to produce one painting each for the Prinsenhof, 'to commemorate their art'. The subject was evidently no longer considered important; what counted was the fame of Haarlem's painters. Urban chauvinism attached itself to the artistry of the works produced in the city. A new function for art and a new location for art, in an urban gallery. Karel van Mander wrote in his *Schilder-boeck*, which was published in Haarlem in 1604, that his city had brought forth great painters like Ouwater and Geertgen from a very early date. It was from here that 'the finest painters of all the Netherlands' come and came.

Civic pride, in other words, did not just take contemporary painters to its bosom. 'Old art' that had been robbed of its original function by the Iconoclasm acquired new connotations in the stadholder's quarters. Former altarpieces bore witness to the city's great history, which is why works by Maarten van Heemskerck and Jan van Scorel were obtained for the city's collection, along with many painted portraits of historical importance. Works confiscated from the disbanded religious houses that were too blatantly 'papist' were sold off. But Haarlem did get a kind of institution in which works of art helped reinforce urban self-assertion. After the slogan 'Down with art', the stadholder's quarters resounded to the cry of 'Long live art'.

FURTHER READING

On the collections in the Rijksmuseum: sculpture, cat. Amsterdam 1973; copper and bronze, cat. Amsterdam 1986; paintings, cat. Amsterdam 1976 and 1992.
For the Egmond tympanum, Klomp 1993; on the damage inflicted on the Master of Alkmaar panels, De Bruyn Kops 1975; on the Iconoclasm, Freedberg in exhib. cat. Amsterdam 1986, pp. 39-69; on the prints by Maarten van Heemskerck, Veldman 1995; on the Lords of Montfoort, Plomp 1977; on the Prinsenhof in Haarlem, Van Bueren 1993

Early Netherlandish art in the collections of the Rijksmuseum

INTRODUCTION

The survey of 15th and 16th-century Netherlandish art presented in this book is based on the Rijksmuseum's holdings from that period. The diverse provenances of the 100 selected works show how the collections were formed in the past 200 years from old princely or municipal ownership and from private individuals, augmented with donations and purchases. Chance, the availability of funds and changing art-historical and historical perspectives—all played an important part in determining what the museum acquired down the years.

The collections that the new Rijksmuseum had to house from 1885 were extremely varied. In that year, the contents of the old Rijks Museum voor Schilderijen (State Museum of Paintings) in Amsterdam, and its printroom, were transferred to their new home. From The Hague came the holdings of the Nederlandsch Museum voor Geschiedenis en Kunst (Netherlands Museum of History and Art), and the City of Amsterdam contributed its own rich collections. Subsequent years saw the addition of numerous purchases, loans and gifts. After 1945 the museum began pursuing an active acquisitions policy that aimed at filling the gaps in its presentation of northern Netherlandish art.

If the provenances tell us something about the history of taste before the works entered the museum, the successive rearrangements of the galleries reflect the fluctuations in art-historical thinking down the years. This essay is a brief account of how the collection of early Netherlandish art in the Rijksmuseum has grown in the past 200 years, and how its presentation has altered in that time.

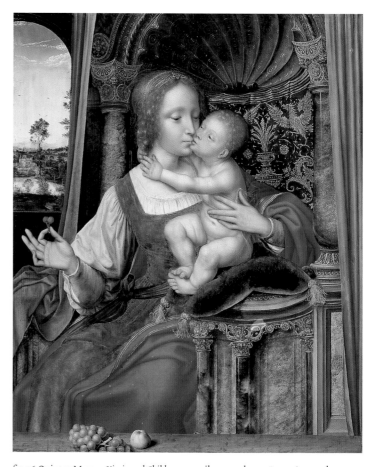

fig. 26 Quinten Massys, *Virgin and Child*, c. 1529; oil on panel, 75 x 63 cm. Amsterdam, Rijksmuseum (inv. no. SK-A-247); on loan to the Mauritshuis, The Hague, since 1948 (cat. no. 842)

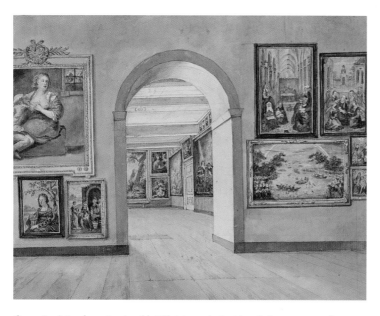

fig. 25 Gerrit Lamberts, *Interior of the Rijks Museum in the Trippenhuis*, 1838; watercolour, 25.5 x 32 cm. Amsterdam City Archives

THE RIJKS MUSEUM IN THE TRIPPENHUIS

The Nationale Konst-Gallerij (National Gallery of Art), which was the immediate forerunner of the Rijksmuseum, opened on 30 May 1800 in Huis ten Bosch in The Hague. It contained a rather arbitrary group of pictures and artworks from the palaces of the former stadholders and from the state: a grand total of 96 paintings and 38 'rarities'. Among the latter was the chair thought to have belonged to Jacoba of Bavaria, Countess of Holland and Zeeland (1401-1436) [69], which was displayed in the museum's 'Monuments Room', along with her portrait and two white, Jacoba jugs. The National Gallery was divided into two parts: Dutch history (under which most of the objects fell) and paintings, which were further subdivided by school and genre. There were French and Italian as well as Dutch and Netherlandish works (the latter including the Flemish School). The scope and calibre of the collection improved considerably under King Louis Napoleon, and in 1808 the museum was transferred to Amsterdam's Royal Palace, the former town hall on Dam Square, where it joined five civic guard portraits belonging to the City of Amsterdam (among them Rembrandt's *Nightwatch*).

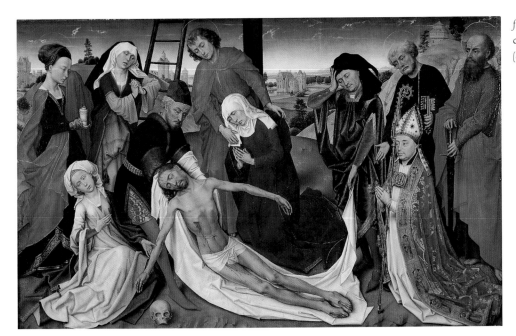

fig. 27 Rogier van der Weyden, *The Lamentation of Christ*, c. 1450; oil on panel, 80.7 x 130.1 cm. The Hague, Mauritshuis (cat. no. 264)

Eight years later, under King Willem I, the Rijks Museum and the Royal Academy moved to the Trippenhuis on Kloveniersburgwal. In order to create more space, the antiquities, 'rarities' and sculptures were removed in 1825 and distributed among the Rijksmuseum voor Oudheden in Leiden and the Koninklijk Kabinet voor Zeldzaamheden in The Hague. The Rijks Museum in the Trippenhuis became a museum of paintings with a printroom as annex.

On the second floor, adjoining the large gallery with history pieces, was a small room containing 'paintings by Old Masters from the earliest days of Painting, together with some from the Old Italian, Brabant and Flemish Schools'. That room (fig. 25), with its 39 pictures, was a modest introduction to the Rijks Museum's main subject: the flowering of Flemish and Dutch 17th-century painting, which was illustrated with more than 400 works. Both the interest in and knowledge about what painters had produced before this Golden Age was slight. The museum believed that it had three paintings by Hubert and Jan van Eyck [13, 16], and attributed several early portraits to Hans Holbein and Lucas van Leyden (fig. 45a). Quinten Massys's *Virgin and Child* (fig. 26) masqueraded under the name of the Italian artist Francesco Mazzuoli (Il Parmigianino). There was Jan van Scorel's *Mary Magdalen* [51], and *The massacre of the innocents* of 1590 [94] and the *Fall of Man* of 1591 [95] and by the 16th-century Haarlem Mannerist, Cornelis Cornelisz van Haarlem. The museum's 1809 catalogue says about the latter painting: 'The skilful and precise drawing and the astonishing expression of the passions of cruelty, rage, fear and sorrow are evidence that this master was one of the pre-eminent artists of his age'. Scorel's *Mary Magdalen* was described as 'painted most beautifully in the manner

of Raphael'. The three so-called Van Eycks [13, 16] were supposedly among 'the first paintings to be executed in oils'—a reference to the stubborn tradition that the Van Eyck brothers discovered the technique of oil painting.

Little was added to the collection of early pictures in the following decades. Purchases under King Willem I were mainly restricted to 17th-century and contemporary art, which was bought for the Rijks Museum and the Mauritshuis in The Hague. When it came to allocating his acquisitions between these two galleries, the king displayed a distinct preference for the Mauritshuis, which

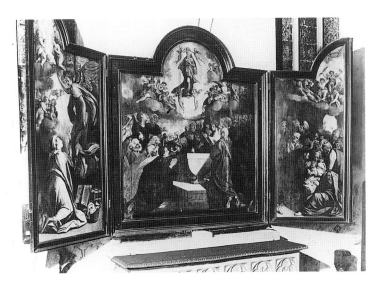

fig. 28 Anthonie Blocklandt, *Altarpiece with the Assumption, the Annunciation and the Adoration of the shepherds*, 1579; oil on panel, central panel 285 x 245 cm, wings 246 x 89 cm. Bingen am Rhein, Katholische Pfarrkirche Sankt Martin

received Rogier van der Weyden's *Lamentation* (*fig. 27*)—still the most important Flemish primitive in Dutch hands. Despite the repeated urging of the directors of both galleries, the government was not prepared to bid for Anthonie Blocklandt's monumental *Altarpiece of the Virgin* (*fig. 28*) when it came up for auction in 1820 and again in 1829. Unexpectedly, though, the king did give the Rijks Museum a picture in 1839: Pieter Aertsen's *Egg dance* of 1552 [80].

The purchases ended with Willem I's abdication in 1840. Willem II was only interested in his private gallery, and the Dutch government took the view that it was merely the administrator of the art that was already in the country's museums. The period 1840-1875 was therefore one of stagnation for the Rijks Museum. The superb collection that Willem II had put together in the early decades of the 19th century contained a remarkably large number of early Netherlandish paintings by such artists as Jan van Eyck, Rogier van der Weyden, Hans Memlinc, Gerard David, Barend van Orley and Jan Gossaert. After the king's death in 1849 the entire collection was put up for auction, and almost all the paintings disappeared abroad. The Minister of Home Affairs, who was responsible for the Rijks Museum, was the Liberal leader, Johan Thorbecke, who did not believe that the arts and sciences needed any government support.

The rediscovery of the Flemish primitives around 1800 may have left its mark on Willem II's private gallery, but it was not evident anywhere else in the country. Major collections of early painting were being built up in Frankfurt, Munich, London and Berlin, but there was only a modicum of interest at home. The situation was different in Belgium, which gained its independence from the Netherlands in 1830. The Brussels museum regularly bought early Netherlandish works to add to its collection, and the Memlincs in Sint-Janshospitaal in Bruges became an important tourist attraction. Nationalist sentiments must have contributed to this reappraisal of the Flemish primitives, for Belgium could pride itself

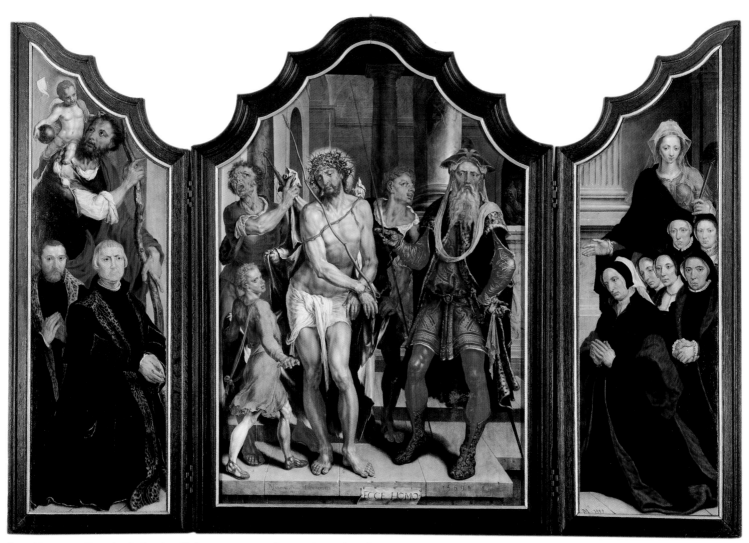

fig. 29 Maarten van Heemskerck, *Altarpiece with the Ecce Homo*, 1559; oil on panel, central panel 218 x 149 cm, wings 218 x 67 cm. Haarlem, Frans Halsmuseum (cat. no. 155)

not only on Rubens, its supreme 17th-century master, but also on what was believed to be the discovery of oil painting in the 15th century.

The Dutch government was utterly uninterested in the art of the celebrated Golden Age. One of the all-time lows in the appreciation of early Netherlandish painting came after the 1860 auction of several major 16th-century altarpieces that had hung in Delft town hall for well-nigh three centuries. When the buyer—the historian and connoisseur Jonkheer J.P. Six—offered two of them to the Rijks Museum, including an *Ecce Homo* altarpiece at cost price (a little under 1,000 guilders for the two), the minister refused to release the funds (*fig. 29*). In 1871, Six and some of his friends donated both these works by Maarten van Heemskerck to the Frans Halsmuseum in Haarlem.

There was growing criticism of the cramped and cluttered space in the Trippenhuis. The views that Theophile Thoré, the famous connoisseur of Dutch painting, expressed under the pseudonym of Willem Bürger in his *Musées de la Hollande* of 1858 were scathing. In his opinion, the only way to do justice to the 17th-century Dutch works was to house them in a new building, rearrange the hang, and produce a new and detailed catalogue. He himself judged the Van Eycks to be poor copies [13, 16].

An improved catalogue correcting unrealistic attributions was published in 1858, the same year as Thoré's book. The 'Van Eycks' were downgraded to 'Unknown masters'. The construction of a new building, though, had to wait another quarter of a century. In that period, there was increased public interest in the art of the country's glorious past as well as a realisation that it was the government's task to preserve it. When the lower house of parliament decided in 1872 that a new Rijksmuseum should be built, an active acquisitions policy for the state museums gradually got under way. The key figure in these developments was Victor de Stuers, who wrote a blistering article for the periodical *De Gids* called 'Holland op zijn smalst' (Holland at its meanest) in which he appealed for closer government involvement in the preservation of the country's cultural heritage. From 1875, when he was appointed head of the Department of Museums and Monuments at the Ministry of the Interior, he threw all his weight behind this policy. His activities embraced cultural heritage in a broad sense: painting, drawing and printmaking, architecture, sculpture, applied arts and Dutch history. All these areas were given a place in the new Rijksmuseum.

COLLECTING SCULPTURE AND THE APPLIED ARTS

In Amsterdam in 1858, several antiquarians, among them Jonkheer J.P. Six, Daniël Franken Dzn and David van der Kellen Jr, founded the Koninklijk Oudheidkundig Genootschap (Royal Antiquarian Society) with the aim of 'promoting knowledge of antiquities, notably as sources for history, art and industry', collecting 'ancient relics', and making them accessible to the public. The ultimate goal was the foundation of a national applied arts museum. The society's collection grew steadily in the first decades of its existence through purchases and bequests. In the summer of 1862, for instance, it bought a Gothic dresser from the Paling and Van Foreest Almshouse in Alkmaar, which is still one of the highlights of the Rijksmuseum's Sculpture and Decorative Arts Department [22].

In 1875, Victor de Stuers founded the Netherlands Museum of History and Art. It was housed in The Hague pending the completion of the new Rijksmuseum, to which it moved in 1883. The nucleus of the museum consisted of objects of Dutch origin from the Koninklijk Kabinet voor Zeldzaamheden (Royal Cabinet of Rarities). De Stuers sent the museum many 'ancient relics' of very variable importance and quality that he came across in the course of his work. The collection also grew rapidly through purchases and gifts. Its director was David van der Kellen Jr, one of the founders and curators of the Royal Antiquarian Society. In 1873, shortly before he took up his post, the Dutch state bought a group of objects from him—mainly locks, keys and small iron chests, but also some late-medieval oak statues [8, 25]. The museum subsequently acquired a few large collections of late-medieval art. From the point of view of quality, the most important acquisition was the group of medieval statues from the Bridgettine convent at Uden [5], which originally came from the Mariënwater convent in Koudewater.

This marked interest in medieval art, which was now acknowledged for the first time to be an essential element of Dutch culture, was undoubtedly connected with De Stuers's Catholicism. As will become apparent, medieval architecture and sculpture was given a prominent place in the new Rijksmuseum. The collections there were augmented with those of the City of Amsterdam, which included the small wooden statues of the counts and countesses of Holland from the Tribunal in the town hall, and the group of bronze mourners [3], as well as the holdings of the Royal Antiquarian Society. Together this was enough to fill much of the ground floor of the new Rijksmuseum with artistic and historical exhibits.

THE NEW RIJKSMUSEUM BUILDING

The decorative programme on the outside of the Rijksmuseum, which takes the form of reliefs, tile pictures and inscriptions, traces the origins and flowering of northern Netherlandish culture, The Golden Age admittedly takes pride of place, but considerable attention is also paid to the middle ages and the Renaissance. It reflects some of the ideas expressed by Conrad Busken Huet in his

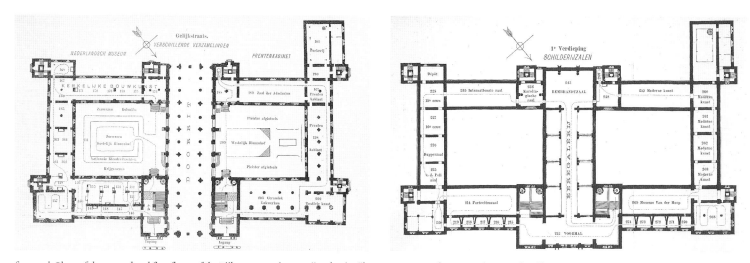

figs. 30a-b Plans of the ground and first floors of the Rijksmuseum, in *Wegwijzer door 's Rijks Museum te Amsterdam*, 1898. Photograph: Rijksmuseum

Het Land van Rembrand: studiën over de Noord-Nederlandse beschaving in de zeventiende eeuw (The land of Rembrandt: studies on northern Netherlandish culture in the 17th century). As in that book, the Rijksmuseum's decorative programme places the Van Eyck brothers and the sculptor Claus Sluter at the origins of realism, which was regarded as a key feature of Dutch art, and presents the painter and graphic artist Lucas van Leyden as the central figure of the 16th century. In the central relief, the Maid of Holland crowns Claus Sluter and the Haarlem artists Dirc Bouts and Lucas van Leyden as representatives of the late middle ages and the Renaissance, while a second relief lauds Rembrandt amidst a group of other 17th-century artists. The tile pictures record several important moments in the history of Dutch art. For the 15th century it is *Jan van Eyck working at the Court of Holland, 1420-1424*, and for the 16th *Albrecht Dürer being received by the goldsmiths and artists in Den Bosch in 1520* (the latter including Hieronymus Bosch and Lucas van Leyden).

Medieval and Renaissance architecture was also taken as the model for the design of the Rijksmuseum. It has rightly been pointed out that the building was the fruit of the rehabilitation of the Roman Catholic community in the Netherlands. It was no coincidence that the person chosen to build it was P.J.H. Cuypers, the most important architect of the Catholic revival and the designer of numerous Neo-Gothic churches. He, his brother-in-law J.A. Alberdingk Thijm and Victor de Stuers were responsible for the decorative programme and layout of the museum, and there too the middle ages were given an important part to play, notably in the Netherlands Museum of History and Art on the ground floor (*fig. 30a*).

fig. 31 The Aduard Chapel in the Rijksmuseum, 1999. Photograph: Rijksmuseum

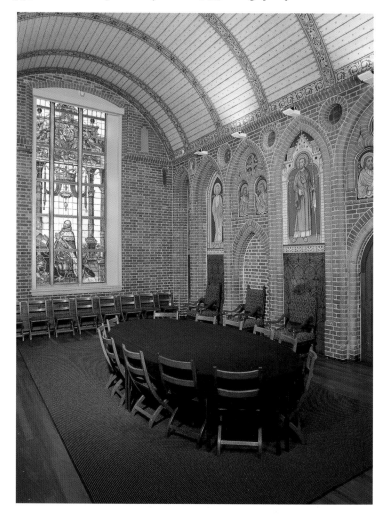

THE NETHERLANDS MUSEUM OF HISTORY AND ART

In addition to galleries with textiles, local costume, ceramics and objects associated with Dutch history, the Netherlands Museum had a series of rooms 'that have been built and decorated such that they present a picture of Dutch Art in the realms of both ecclesiastical and civic architecture and decoration from the 9th to the 18th centuries'. The exhibits comprised masonry fragments, statues and objects, as well as copies and casts. Almost all of the ten galleries containing church architecture were devoted to the middle ages. All that remains of them today is what is known as the Aduard Chapel (fig. 31). The first room contained the tympanum from Egmond Abbey (fig. 12). Those with civic architecture looked more like period rooms, with decorative objects and sculpture. Standing in the 'gallery of domestic objects from the middle ages' (fig. 32) were the bronze mourners from the tomb of Isabella of Bourbon [3] and the late-Gothic dresser mentioned above [22]. De Stuers and Cuypers were responsible for the design and arrangement of the medieval, ecclesiastical galleries, but the layout of the civic rooms reflected David van der Kellen's exhibitions of objects belonging to the Royal Antiquarian Society at various Amsterdam locations in the 1870s, which were in the form of mixed presentations.

The displays of ecclesiastical and civic art did not last long. Around 1900 Aart Pit, Van der Kellen's successor as Director of Netherlands Museum, made changes to the galleries, removing the casts and reconstructions and covering over some of the obtrusive copies of murals, which naturally led to conflicts with Cuypers and De Stuers. In 1900, Pit unveiled a gallery with a series of sculptures that traced the development of northern Netherlandish sculpture from the Renaissance, connecting up with the medieval works in the ecclesiastical section. He hoped to make the public aware of the importance of 'the nation's' sculpture. In his 1903 catalogue of those in the Rijksmuseum, which was the first ever published, he gave a more detailed account of developments in the northern Netherlands. Around the turn of the century, he also added a number of late-Gothic sculptures to the collection. Between 1899 and 1904 he acquired four fragments of an altarpiece of the Virgin [6], which were described as 'Northern Netherlandish School' but were later convincingly attributed to the Utrecht wood-cutter Adriaen van Wesel. He bought two of them at the sale of Heeswijk Castle, where a large, early 16th-century Passion retable from Antwerp also came under the hammer. It is now in St John's Cathedral in Den Bosch (fig. 33). Despite the proddings of the minister and the readiness of the Vereniging Rembrandt to supply the necessary funds, Pit was not prepared to consider buying it, because in his opinion the carving was inferior and the piece lacked its original polychrome decoration. To this day the Rijksmuseum lacks a complete retable.

fig. 32 'Gallery of domestic objects from the middle ages' (room 147), illustration in *Wegwijzer door 's Rijks Museum te Amsterdam*, 1898. Photograph: Rijksmuseum

One important purchase made in 1899 was the *Reliquary with the bust of St Frederik* of 1362 [1], which is the earliest work in the Rijksmuseum by a named artist. The basis of the collection of 16th-century stained-glass panes [37, 38] was laid in 1894, when several were bought from Jonkheer J.P. Six. The bulk of the collection, however, was acquired between 1920 and 1932 from N. Beets.

THE RIJKSMUSEUM PRINTROOM

The print collection of Baron van Leyden, which King Louis Napoleon acquired for the Koninklijke Bibliotheek (Royal Library) in 1807, was transferred to the Trippenhuis in 1817. It forms the core of the present printroom, and is an impressive and sweeping survey of European printmaking from the late 15th to the late 18th centuries. Northern prints of the 15th century are typified by a unique group of 80 drypoints by a German artist who has been given the *ad hoc* name of the Master of the Amsterdam Cabinet, and

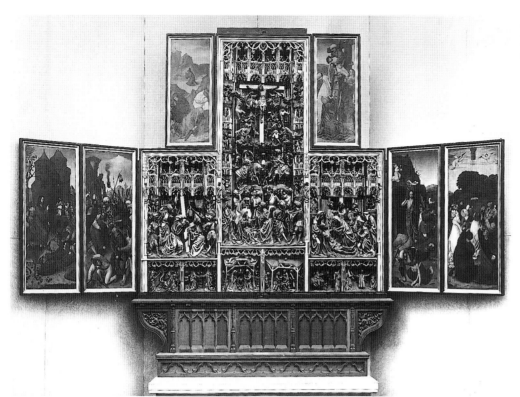

fig. 33 Antwerp, c. 1510-1520, *Passion retable*; oak, polychromed, 254.6 × 251.4 × 29.5 cm. Den Bosch, Sint-Janskathedraal

by engravings by Martin Schongauer and Israhel van Meckenem. It contained only a handful of Netherlandish prints of the same period, but the 16th century had a far better showing. The complete engraved work of Lucas van Leyden [44, 45] came from the 17th-century collection of Johannes Wtenbogaert. Lucas's contemporaries, Dirck Vellert and Jacob Cornelisz van Oostsanen, were also well represented. The emphasis in Baron van Leyden's collection was on the great printmakers, and there were very few woodcuts and little of later Antwerp print production.

An active purchasing policy began in 1876 with the appointment of J.P. van der Kellen as director of the Rijksmuseum Printroom. From then on, the collections of prints and drawings were systematically added to whenever the possibility arose. The location of the printroom in the west wing of the new building, together with the museum's rapidly expanding library and documentary collections, provided sufficient space for all these acquisitions, which included a large group of historical prints known as the Frederik Muller Atlas. The prints and drawings could be examined in the study room beside the library (as they can today), which supplied the relevant literature. A selection of prints was on permanent display until 1896, when a system of rotating, three-month displays of prints and drawings was introduced. They were exhibited in the print gallery in cases were that had been erected between the storage cupboards designed by Cuypers (fig. 34).

Although the collection grew rapidly through purchases and

fig. 34 Printroom with display cases (room 198), c. 1900. Photograph: Rijksmuseum

donations, there were insufficient funds to buy expensive early prints and drawings, particularly in the period between the two world wars, when the acquisitions budget was very tight indeed. One fortunate exception was the procurement of a large group of 16th-century Netherlandish woodcuts, most of them hand-coloured, consisting of dozens of unique portraits of royalty and allegories by Cornelis Anthonisz [72] and the Kampen publisher Warnersoen. The group was bought in 1930, along with *The ship of St Stonybroke* [48] (which at that time was attributed to Lucas van Leyden), with assistance from the Vereniging Rembrandt at an auction in Leipzig of the centuries-old ducal collection at Gotha.

THE RIJKSMUSEUM OF PAINTINGS

The collection of paintings to be housed in the new building had almost tripled through bequests and the addition of pictures from the holdings of the state and the municipalities, with the result that the galleries occupied the entire top floor. The route began on the left of the *Nightwatch* gallery (fig. 30b). As in the Trippenhuis, the walls were completely covered with paintings exhibited in serried rows, one above the other. The smaller works in the two rooms with early art (fig. 35) were hung quite low down, and in a new departure the 16th-century civic guard pieces from the City of Amsterdam were placed above them (fig. 36). In the middle of the room were Neo-Gothic wooden stands designed by Cuypers to take triptychs and loose altarpiece wings painted on both sides. The fact that all the museum's paintings were on display made for an odd mixture of important masterpieces jostling with pictures that were solely of documentary interest.

There can be historical and historico-cultural reasons for acquiring a painting, quite apart from its art-historical value. In 1889, for instance, the early 15th-century panel with *Eighteen scenes from the life of Christ* (fig. 23) was bought from Roermond Minster, and in 1884 the museum was given the *Memorial tablet for the Lords of Montfoort* (fig. 22), which was painted around 1380. Of the latter it was said that 'notwithstanding its poor condition, the scene is valuable for its historical significance'.

Victor de Stuers was instrumental in giving the Rijksmuseum a role as a storage depot for movable ecclesiastical and regional art, which is how the monumental ceiling decoration from the churches in Alkmaar and Warmenhuizen came to the museum. In 1894, the 'Teekenschool' (a building beside the museum) displayed not only the Warmenhuizen paintings (fig. 37) but also Barend van Orley's cartoons for the stained-glass window he designed for the Church of St Bavo in Haarlem, which the churchwardens had loaned to the state.

The decision whether or not to buy a painting was closely bound up with new art-historical ideas in the late 19th century. Art history had acquired a strong documentary slant at the time, and the

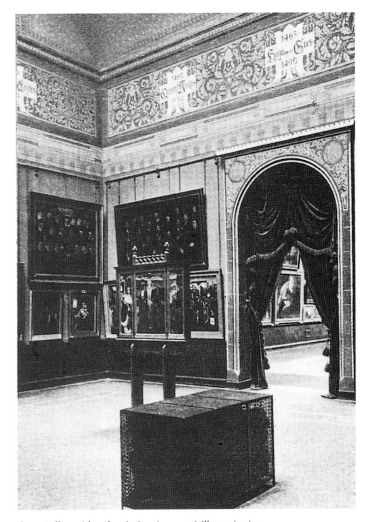

fig. 35 Gallery with early paintings (room 228), illustration in *In en om het Rijksmuseum*, 1909. Photograph: Rijksmuseum

resulting archival research revealed many new facts about painters and the production of art. The preference was to obtain dated and signed works by painters who had often been unknown until then, thus laying the foundations for that artist's oeuvre.

It was the recognition of the monogram and house mark of the early 16th-century Amsterdam painter Jacob Cornelisz van Oostsanen that led to the acquisition in 1879 of *Saul and the witch of Endor* [42] at an auction in Valenciennes, which was followed eight years later by the purchase of the same artist's *Self-portrait* [50].

In order to supplement the *Holy Kinship* [13], which had been entered the collection as a Van Eyck in 1808 but was reassigned to Geertgen tot Sint Jans in 1883, the museum acquired *The martyrdom of St Lucy* [15] as a Geertgen in 1897, and in 1904, on rather more persuasive grounds, his *Adoration of the magi* [12]. Another important late 15th-century work that entered the Rijksmuseum in 1907 was a painting by the Master of the Spes Nostra [18]. A second notable accession was the polyptych with *The seven works of mercy* by the

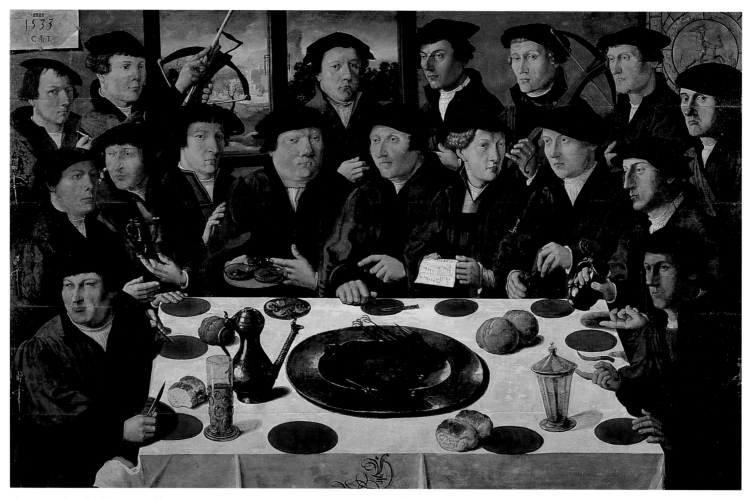

fig. 36 Cornelis Anthonisz, *Banquet of the copper coin*, 1533; oil on panel, 130 × 206.5 cm. Amsterdam, Amsterdams Historisch Museum (inv. no. A7279)

Master of Alkmaar [19], which was bought directly from Alkmaar's Church of St Lawrence in 1918 (where it had hung since it was made) for the record sum of 50,000 guilders.

The convincing reattribution of the *Portrait of Floris van Egmond* (fig. 45a) to Jan Gossaert in 1885 left the museum without a painting by Lucas van Leyden. It was believed in 1897 that the gap had been filled when the museum obtained *The church sermon* (fig. 45b) [49], which bears the monogram L and was regarded as a masterpiece by Lucas until shortly before the Second World War. A panel with *Christ taking leave of his mother* [43] purchased in Paris in 1897 was recognised as a work by the Leiden master, Cornelis Engebrachtsz. In 1906, a second panel from that *Altarpiece of the Virgin* was bought from the same dealer: *Christ in the house of Martha and Mary* [43a]. The collection was further enlarged with paintings by Jan Mostaert, Jan van Scorel, Maarten van Heemskerck and Pieter Aertsen.

Anyone visiting the Rijksmuseum around 1920 would have found a fairly representative sample of early northern Netherlandish painting. Its counterpart from the southern Netherlands was a far less balanced group. The only major Flemish

fig. 37 Workshop of Jacob Cornelisz van Oostsanen, vault painting with the Last Judgement, c. 1530. Warmenhuizen, Ursulakerk (these vault paintings were displayed in the Rijksmuseum's 'Teekenschool' between 1890 and 1963). Photograph: Rijksmuseum

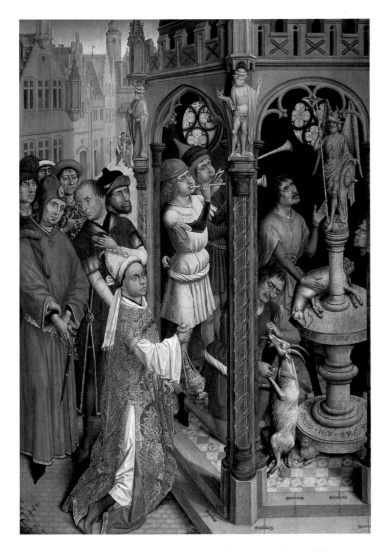

fig. 38 Anonymous Brussels master, *St Augustine sacrificing to a Manichaean idol*, c. 1480; oil on panel, 97 × 69 cm. Amsterdam, Rijksmuseum (inv. no. SK-A-2057); on loan to the Mauritshuis, The Hague, since 1948 (cat. no. 844)

collections at prices rarely exceeding more than a few thousand guilders, with the single exception of the Alkmaar polyptych.

The constant addition of new acquisitions must have made the galleries look very cluttered and uneven. This came to an end when Frederik Schmidt-Degener took over as the Rijksmuseum's director in 1922.

THE RIJKSMUSEUM UNDER SCHMIDT-DEGENER

Even before he was appointed, Schmidt-Degener had announced that he wanted what he called a 'museum of masterpieces' ('toppenmuseum') in which the very finest works from national and municipal collections would provide a survey of the development of western art from Egyptian times to the present day. The 'museum of masterpieces' never materialised, although Schmidt-Degener certainly pursued a distinctly international purchasing policy and a selective presentation focusing on the aesthetic experience of a work of art. The museum was totally rearranged, with the paintings being displayed in a more spacious and evocative way, and with art being divorced from history for the first time (fig. 39).

The rearrangement of the top floor of the museum (fig. 39b), where 'the art of the 15th, 16th and 17th centuries' was displayed, was accompanied by a new chronological hang starting in the eastern cabinets adjoining the main hall, which has been retained to this day. In the main hall, a plaster cast of the *Well of Moses* by the carver Claus Sluter from the Chartreuse of Champmol (fig. 40) marked the beginning of the realistic tradition in Netherlandish art. The cabinets were hung with 'The primitives', northern and southern Netherlandish painters of the 15th and early 16th centuries, and fastened to the windows were Netherlandish stained-glass roundels from the same period. The following galleries traced the further development of painting in the Netherlands: the beginning of specialisation in portrait, landscape and genre, and the Mannerists. In his illustrated *Guide*, Schmidt-Degener commented: 'the northern and southern Netherlandish panels have been integrated, since the ties between Holland and Flanders were still so close in the 16th century that it is difficult to distinguish between their modes of expression'.

Schmidt-Degener also made no distinction between north and south in his acquisitions policy. He was unsuccessful in his attempt to get a *Crucifixion* by Jan van Eyck from the Hermitage, but he did manage to lay his hands on two panels by Gerard David, a *View in a forest* (fig. 41a) painted on the outside shutters of a *Nativity* triptych (fig. 41b), which he presented as 'the earliest instance of autonomous landscape art'. The desire to have something by Hieronymus Bosch led to *The arrest of Christ* (fig. 42) entering the collection in 1931, which soon proved to be a copy. One major acquisition from the Hermitage was of two companion portraits by Antonis Mor [71].

primitives were Gossaert's portrait of Floris of Egmond (fig. 45a) and a *Virgin and Child* by Quinten Massys (fig. 26). In 1902, the museum bought a 15th-century Flemish work by the so-called Master of the Legend of St Barbara which was thought to depict *St Augustine sacrificing to a Manichaean idol* (fig. 38). Sixteenth-century Flemish landscape painting, which had long been represented by Paulus Bril and Jan Brueghel the Elder, was supplemented in 1882 with a circular panel of *Paradise* [76], which was acquired as a Jan Brueghel but is now given to Herri met de Bles. Joachim Beuckelaer's *Well-stocked kitchen, with Jesus in the house of Martha and Mary*, a large panel of 1566 [82], demonstrated the growing interest in the genre depictions in 16th-century religious scenes.

Flemish primitives, which even then were expensive and scarce, were never added, probably because of the prohibitive cost. Many of the early northern Netherlandish paintings came from Dutch

figs. 39a-b Plans of the ground and first floors of the Rijksmuseum, in *De Gids*, 1928. Photograph: Rijksmuseum

The collector I. de Bruijn, acting on Schmidt-Degener's advice, bought paintings by Quinten Massys, Adriaen Isenbrant [36] and Cornelis Ketel, which were all bequeathed to the museum in 1958.

It was under Schmidt-Degener that, on 1 July 1927, the Netherlands Museum of History and Art was split into the Rijksmuseum of Sculpture and Decorative Arts and the Netherlands Museum of History. The latter took shape between 1931 and 1937 on the ground floor of the east wing. Among the purchases made for it were the anonymous panels with *Scenes from the life of St Elizabeth of Hungary and of the St Elizabeth's Day floods (fig. 21)*. Sculpture and the applied arts were housed on the ground floor of the west wing and the adjoining courtyard. The 'Gothic gallery' beside the west entrance (now the museum restaurant) was filled with predominantly medieval sculpture. It opened with early fragments like the Egmond tympanum (fig. 6), which was followed by the bronze statues from the tomb of Isabella of Bourbon [3] and 'the small oak groups' [8], including those by Adriaen van Wesel, which were nameless at the time [6]. The gallery also contained sculpture from the transitional period linking the middle ages with the Renaissance, and also had lavish display of decorative objects from the late middle ages and the early Renaissance—furniture, copper artefacts, embroidered textiles, tapestries and so on. In addition to the chiefly Netherlandish works there were also French objects, which were to a certain extent integrated. The museum's slim budget meant that there was little if any room to expand these collections. Acting in concert with the collector and benefactor I. de Bruijn, the museum tried to buy an alabaster mourner (fig. 43) by the workshop of Claus Sluter that had come from a Burgundian tomb, but failed.

fig. 40 The main hall with a plaster cast of Claus Sluter's *Well of Moses*, c. 1930. Photograph: Rijksmuseum

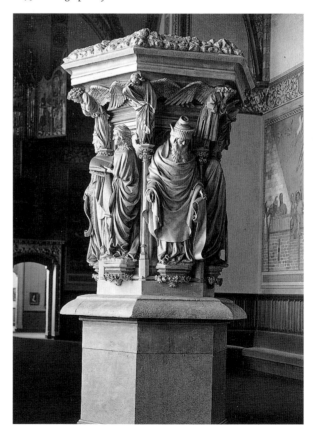

THE RIJKSMUSEUM AFTER THE SECOND WORLD WAR

When the Paintings Department was rearranged after the Second World War, the emphasis in the eastern cabinets fell entirely on the northern Netherlandish School. In 1948, the Rijksmuseum entered onto long-term loans with the Mauritshuis in The Hague, with the latter receiving Flemish and German paintings in exchange for French, Italian and northern Netherlandish works. The pictures by Gerard David (fig. 41a), Jan Gossaert (fig. 45a), Quinten Massys (fig. 26) and other Flemings moved to The Hague, while the early *Portrait of Lysbeth van Duvenvoorde* [2] and Jacob Cornelisz van Oostsanen's *Salome* went on show in Amsterdam. The group of early northern Netherlandish paintings was fairly systematically expanded with purchases and gifts. The most important works bought were *The Tree of Jesse* [14], portraits by Jan Mostaert [20], Jan van Scorel, Dirck Jacobsz and Maarten van Heemskerck [52], a triptych by Jacob Cornelisz van Haarlem [33], and Lucas van Leyden's triptych with *The dance around the golden calf* (fig. 45d) [47].

The Sculpture and Decorative Arts Department was raised to an international level after the war with the transfer to the museum of the Dr F. Mannheimer's exceptional collection of decorative objects

fig. 41a Gerard David, *View in a forest*, c. 1505-1515. Backs of the wings of a triptych with *The Nativity* (fig. 41b); oil on panel, 90 × 30.5 cm. Amsterdam, Rijksmuseum (inv. no. SK-A-3134); on loan to the Mauritshuis, The Hague, since 1948 (cat. no. 843)

fig. 41b Gerard David, *Triptych with the Nativity*, c. 1505-1515; panel transferred to canvas, central panel 90.3 × 71.1 cm, wings 90.2 × 31.4 cm. New York, The Metropolitan Museum of Art, The Jules Bache Collection, 1949 (inv. no. 49.7.20a-c). Photograph © 1998 The Metropolitan Museum of Art

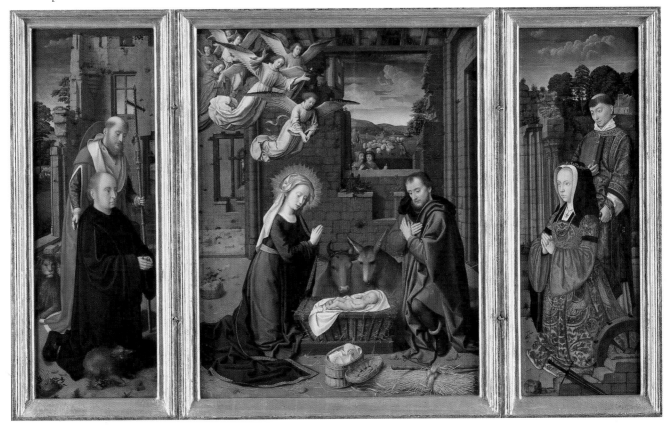

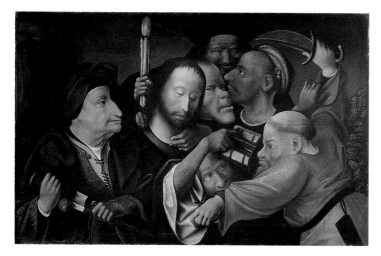

fig. 42 Copy after Hieronymus Bosch, *The arrest of Christ*, c. 1550; oil on panel, 51 x 81.5 cm. Amsterdam, Rijksmuseum (inv. no. SK-A-3113)

fig. 43 Workshop of Claus Sluter, *Three mourners*, from the tomb of Philip of Burgundy in Dijon, c. 1400; alabaster, h 41.8, 41.9 and 41.3 cm. Cleveland, The Cleveland Museum of Art (inv. no. 40.128, 58.66-67)

and statues. These additions also made it possible to display the Dutch applied arts and sculpture in an international context. The department was moved to the western galleries leading off the main hall, mirroring the Paintings Department in the east wing. French and German sculpture was intermingled with the Netherlandish works, with no distinction being made between the northern and southern Netherlands. The collection of late medieval and Renaissance sculpture grew apace in the first few decades after the war [4, 7, 11, 26-28, 30-32], and the late medieval and Renaissance decorative arts were reinforced, notably with tapestries

fig. 44 Post-war arrangement of the northern Netherlandish cabinets (room 201), c. 1960. Photograph: Rijksmuseum

a

c

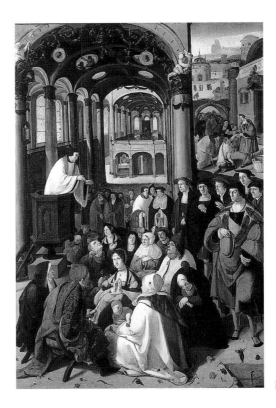

b

figs. 45a-d Lucas van Leyden in the Rijksmuseum

a Between 1800 and 1885 as Lucas van Leyden: Jan Gossaert van Mabuse, *Portrait of Floris van Egmond*, c. 1520; oil on panel, 39 × 29.5 cm. Amsterdam, Rijksmuseum (inv. no. SK-A-217); on loan to the Mauritshuis, The Hague, since 1948 (cat. no. 841)

b Between 1897 and 1940 as Lucas van Leyden: Master of the Church Sermon (Aertgen van Leyden?), *Church sermon*, c. 1530 [49]

c Between 1949 and 1980 as Lucas van Leyden: copy after Lucas van Leyden, *Virgin and Child*, c. 1530; oil on panel, 35 × 27.5 cm. Amsterdam, Rijksmuseum (inv. no. S-A-3739)

d Described by Van Mander in 1604 and rediscovered in 1952: Lucas van Leyden, *Triptych with the dance around the golden calf*, c. 1530 [47]

d

[39, 40, 58], which began to play an important part in the post-war arrangement of the galleries.

There were very few specialist curators working in the Rijksmuseum before the war, but their numbers grew steadily thereafter, and they contributed greatly to scholarly knowledge about the collections. This resulted not only in the publication of catalogues on various parts of the museum's holdings, but above all in exhibitions with detailed catalogues. Those shows, which were often prompted by changes in art-historical thinking, led in turn to new accessions.

The reappraisal of 16th-century 'Mannerism' was put firmly in an international context in the 1955 exhibition, *The triumph of Mannerism*, which smoothed the way for the purchase of paintings by Cornelis van Haarlem, Abraham Bloemaert [96] and Bartholomeus Spranger [91].

Medieval art in the northern Netherlands in 1958 was a survey of early Netherlandish art up to around 1530, with Geertgen tot Sint Jans, Hieronymus Bosch and Lucas van Leyden as the key figures. It was on this occasion that critics first raised objections about the separation of the art of the northern and southern Netherlands, on the grounds that the two countries were still a single political entity until late in the 16th century.

Oddly enough, those objections were not raised about the major exhibition of *Art before the Iconoclasm* of 1976, a presentation of northern Netherlandish art between roughly 1525 and 1580, but they did resurface at the 1993-1994 show, *Dawn of the Golden Age*, which covered the period 1580-1625, when, ironically, the northern and southern provinces had indeed been separated.

Smaller exhibitions that were also important for the study of early Netherlandish art were *Princely portraits* (1972), *The graphic art of Lucas van Leyden* (1978) and *Adriaen van Wesel: an Utrecht sculptor of the late middle ages* (1980).

The scarcity of early art, and the high prices it commands, has restricted the number of purchases in the past 30 years. There were, however, some major acquisitions, among them the sculpted group of *The meeting of the magi* by Adriaen van Wesel [6c] in 1977, the triptych by Jacob Cornelisz van Oostsanen [33] in 1975, Jan Vermeyen's *Marriage at Cana* [55] in 1982, a drawing of the *Resurrection* by Lucas van Leyden [46] in 1982, and the *Interior of a Gothic church* [10] by Master W with the Key in 1986. A recent addition was a large *Mount Calvary* of c. 1525 by an artist of the Leiden School [41].

Although southern Netherlandish art never entirely disappeared from the Rijksmuseum, with works by Jan Vermeyen [55], Joachim Beuckelaer [82], Antonis Mor [71], Jan Brueghel and Joos de Momper being on permanent display, the 16th-century section was reinforced in 1997 with the return of several loans from the Mauritshuis. Works by Flemish masters like Jan Provoost, Adriaen Isenbrant [36], Quinten Massys, Herri met de Bles [76] and the Braunschweig Monogrammist [79] were reinstated. In 1999, the Mauritshuis gave an *Allegorical scene* [57] by Jan Sanders van Hemessen on long-term loan that illustrates something of the influence of Italian art on later 16th-century Dutch painting. It is unlikely now that the Rijksmuseum will ever acquire major 15th-century Flemish primitives. They can be seen in modest numbers in the Mauritshuis and the Museum Boijmans Van Beuningen, but for a thorough presentation one has to go to large museums abroad.

FURTHER READING

On early Netherlandish painting in the Rijksmuseum, Filedt Kok 1998; on the Rijksmuseum's collecting policy up until 1896, Bergvelt 1998; on the history of the Paintings Department, cat. Amsterdam 1976, pp. 10-47 and cat. Amsterdam 1992, pp. 20-21. On the Royal Antiquarian Society, Heijbroek 1995; on Pit, Heijbroek 1985; on Schmidt-Degener, Luijten 1984.
For the exhibitions of 1958, 1986 and 1993-1994, exhib. cats. 1958, 1986 and 1993-94.

Netherlandish art in the Rijksmuseum 1400–1600
WORKS OF ART

I The late middle ages, c 1400-1515

THE FORMATION OF THE LOW COUNTRIES,
1400-1515

In the late middle ages, the inhabitants of the
Scheldt, Maas and Rhine delta began taking greater
control of the water management in their region,
in which the monastic orders played an important
role. Although there was still a risk of floods if a
dike along the great rivers gave way *(fig. 21)* or a
storm tide surged inland, there was intensive
farming and stock breeding, and a steady growth
in trade and shipping along the rivers.

The Low Countries, the area now occupied by
the Benelux nations and part of northern France,
developed into the most powerful economic region
in western Europe in the late middle ages *(fig. 46)*.
The agrarian sector, fishing and shipping
predominated in the north, with the towns along
the river IJssel being the economic powerhouse due
to their connections with the Hanseatic League.
The emphasis in the south was on trade and
industry, and here the hubs were Brabant and
Flanders, with their thriving urban communities of
Ghent, Bruges, Courtrai, Louvain, Brussels and
Antwerp. The political importance of the region
grew as the economy improved. The Low Countries
was made up of several duchies and counties, and
a large number of smaller feudal units that owed
their allegiance either to the German emperor or to
the French king. It was a highly urbanised territory,
and the civic authorities jostled for precedence
with the princes and nobles. In their struggle with
the king of France, the Burgundian dukes Philip the
Bold (1342-1404) and Philip the Good (1396-1467)
gradually expanded their lands in northern France
through marriage, inheritance and outright
conquest.

The power of the dukes of Burgundy was
extended in the course of the 15th century with the
acquisition of the counties of Namur (1421), Hainault
(1425-1428), Holland and Zeeland (1425-1428), and
the duchies of Brabant and Limburg (1404-1406),
Luxembourg (1451) and Gelderland (1473). When the
duchy of Burgundy reverted to the French crown
after the death of Charles the Bold (1433-1477), the
Burgundians moved their court to Brussels. The key
positions at court were held by nobles as members
of the ducal council and as governors and
stadholders, but as time passed technocrats and
jurists increasingly took over the role of the nobility

fig. 46 Map of the Low Countries around 1450. Drawing: Guus Hoekstra

in the duke's advisory bodies. The duke himself
relied for his income on the States-General, which
represented the estates of the various regions. The
rich cities were in a powerful position, for in order
to raise extraordinary 'benevolences' (taxes), the
ruler had to summon a meeting of the States-
General to seek its approval of the new levies.

In 1477, there was a crisis brought about by this
centralist policy and the heavy burden of taxation

resulting from successive wars, notably under
Charles the Bold. An uprising led by the Flemish
towns and later supported by Holland and Zeeland
forced Mary of Burgundy (1457-1482), Charles's
daughter and successor, to make several
concessions that gave the regions more autonomy.
Mary's marriage in 1477 to Maximilian I of
Habsburg (1459-1519), the future Holy Roman
Emperor *(fig. 47)*, brought the Burgundian

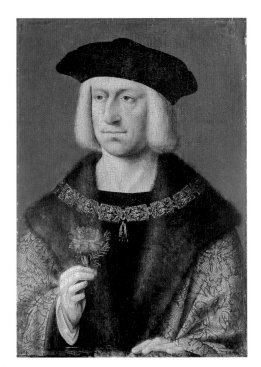

fig. 47 School of Joos van Cleve, *Portrait of Maximilian I*, c. 1510; oil on panel, 34.5 x 24 cm. Amsterdam, Rijksmuseum (inv. no. NG-SK-A-3293

Netherlands within the sphere of influence of the Habsburgs. Gelderland, with French backing, was the only part of the realm to resist assimilation, but it too succumbed in 1543. Despite the constant threat of war with France, and the fact that the towns of Holland became embroiled in a fierce and ultimately successful war with the Hanseatic League on the North Sea, there was relative peace under Maximilian's son Philip the Handsome (1478-1506) *(fig. 48)*, who became King Philip I of Castile in 1504, and it continued under his sister, regent Margaret of Austria (1480-1530), bringing some degree of economic recovery.

The Low Countries' position at a crossroads of trade routes, with the north-south axis running from the Baltic to the Mediterranean and the Americas, and the west-east axis extending from England to Germany and central Europe, gave it an extensive network of international contacts. Foreigners from all over Europe settled in the Netherlands, where they set up as merchants. There was a great demand for urban labour, which was met at the expense of the rural population. Most towns had fewer than 10,000 inhabitants, but half the population of the county of Holland were urbanised at the beginning of the 16th century. Cities like Brussels, Ghent and Antwerp had far more inhabitants. In addition to a large group of urban poor, there was a prosperous

middle class, with above it a group of rich or very rich merchants who surrounded themselves with luxury goods that had formerly been beyond the reach of all save princes and the nobility. The Catholic church pervaded everyday life, and was closely integrated with both state and society. Along with the court and the towns, the church and the monasteries had an important influence on cultural life, especially in the less densely populated north.

LATE-MEDIEVAL ART IN THE LOW COUNTRIES
The establishment of the ducal court in Brussels, the political power of the southern Netherlands, and above all the thriving economies of the large cities of Ghent, Bruges, Brussels, Louvain and, later in the century, Antwerp, resulted in an unparalleled flowering of art, the decorative arts and music in Flanders and Brabant. There was a vast increase in the output of tapestries, paintings, sculpture, furniture, textiles, jewelry and stained glass, all of which improved in quality and refinement.

In painting, the 15th century in Flanders was the age of the so-called Flemish primitives. Whether Jan van Eyck (c. 1390-1441) really did discover the technique of painting in oils is still under discussion, but what is unquestioned is that he and his contemporaries refined the technique to the point that they were able to achieve an

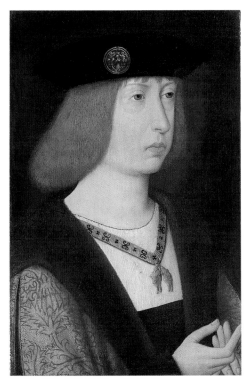

fig. 48 Master of the Legend of Mary Magdalen, *Portrait of Philip the Handsome*, c. 1500; oil on panel, 32 x 21 cm. Amsterdam, Rijksmuseum (inv. no. NG-SK-A-2854)

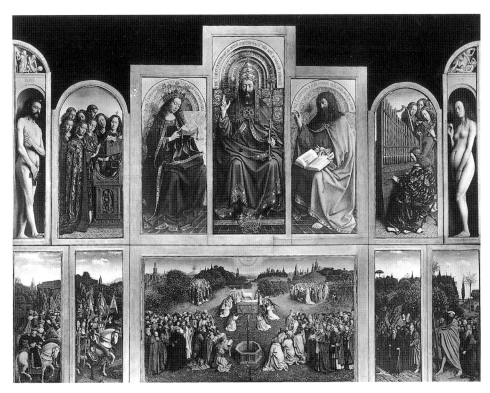

fig. 49 Jan van Eyck, *Altarpiece with the adoration of the Lamb*, 1432; oil on panel, inside when opened approx. 375 x 520 cm. Ghent, Sint-Baafskathedraal

incomparable degree of detail in the representation of reality. This new realism was of decisive importance for the burgeoning art of the Netherlands. The sculptor Claus Sluter (1360-1406), who came from the north, displays a remarkable realism in his handling of figures, particularly in the *Well of Moses (fig. 75)* commissioned by the Burgundian dukes in Dijon.

No paintings by Jan van Eyck have survived from the years 1422-1424, when he was employed at the court of John of Bavaria, Count of Holland. After he settled in Bruges, he became the court painter and confidant of Philip the Good, Duke of Burgundy, but that did not prevent him accepting commissions from other patrons. *The adoration of the Lamb* of 1432 *(fig. 49)*, his largest and most celebrated work, was ordered by the Ghent patrician Jodocus Vijdt. Everything in this altarpiece, right down to the tiniest details, is depicted with consummate skill in the imitation of materials, with the handling of light greatly enhancing the spatial illusion. Realism is also a characteristic of the later Flemish primitives, although few attained Van Eyck's painterly refinement. That realism, though, can be deceptive, for in some cases it turns out that the objects have a symbolic meaning.

Rogier van der Weyden (c. 1399-1464) used the naturalistic approach as a vehicle for conveying emotional expression in depictions of Christ's Passion *(fig. 50)*. Van der Weyden was probably trained by Robert Campin in Tournai. He moved to Brussels around 1435, where he became the city's official painter and established a large workshop with a copious output ranging from small portraits and devotional scenes to large altarpieces for both the local and international markets.

Among the next generation of Flemish primitives were Dirc Bouts (c. 1415-1475) from Haarlem, who worked mainly in Louvain, and Petrus Christus (c. 1420-1475/76), who was active in Bruges from 1444 until his death. Another artist working there from 1465 onwards was Hans Memlinc (c. 1433-1494), who trained in the Rhineland region and possibly in the studio of Rogier van der Weyden as well, as did Gerard David (c. 1460-1523), who came from Oudewater near Gouda. Their work lacks Rogier's emotive power, being more restrained and devout. Memlinc's portraits are unrivalled, while Gerard David's talent lay chiefly in the depiction of landscape.

The leading Flemish painter in the second half of the 15th century, however, was Hugo van der Goes (c. 1440-1482), who settled in Ghent as a master in 1467 and died insane in the Roo priory

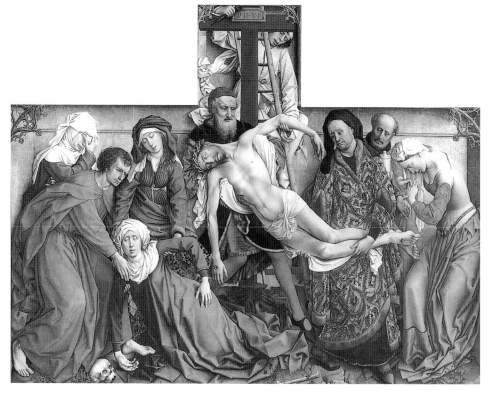

fig. 50 Rogier van der Weyden, *The Deposition from the Cross*, c. 1435; oil on panel, 220 x 262 cm. Madrid, Museo del Prado (inv. no. 2825)

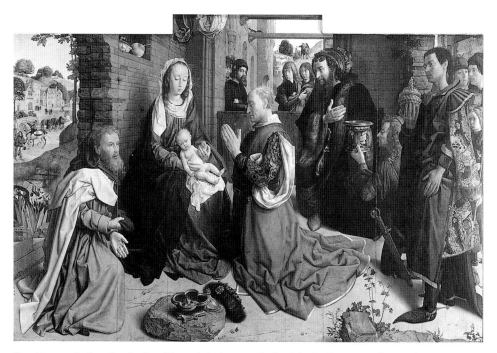

fig. 51 Hugo van der Goes, *The adoration of the magi*, also known as *The Monforte altarpiece*, c. 1470; oil on panel, 147 x 242 cm. Berlin, Staatliche Museen zu Berlin, Gemäldegalerie (cat. no. 1718). Photograph: Jörg P. Anders

fig. 52 Hieronymus Bosch, *Triptych with the temptation of St Anthony*, c. 1500; oil on panel, central panel 139 x 113 cm, wings 131 x 53 cm. Lisbon, Museu Nacional de Arte Antiga

near Brussels. The monumental figures in his *Monforte altarpiece (fig. 51)* have highly individualised features. The fall of light and warm tonality give the figures an almost tangible physical presence, and invested the picture space with a marked sense of recession into depth. It is a work that was imitated time and again in the northern Netherlands *[12]*.

Very different in both style and subject matter are the paintings of Hieronymus Bosch (c. 1450-1516), who lived in Den Bosch. His hellish scenes and portrayals of satanic temptations sprang from a boundless imagination, and were already much sought after in the 16th century *(fig. 52)*.

Little has survived of the art produced at the court of the counts of Holland *[2]*. The first great flowering of painting in the northern Netherlands is to be found in illuminated manuscripts, many of which were made in Utrecht. It was not until the late 15th century that there was a modest development of panel painting in the smaller towns of the north.

Karel van Mander, who wrote the first history of Netherlandish art in his *Schilder-boeck* of 1604, regarded Albert Ouwater as the founder of the

Haarlem school. Only one of his paintings has survived, a *Raising of Lazarus* that is dated around 1460. His pupil, Geertgen tot Sint Jans (c. 1467-c. 1495), owes his name to the Haarlem Knights Hospitallers, or Knights of St John (Jan, in Dutch), who housed and employed him. The foundations for the reconstruction of his oeuvre are the *Lamentation (fig. 53)* and the *Burning of the bones of St John the Baptist*, which together must have formed the right wing of the high altarpiece in Haarlem's Church of St John that the artist executed for the knights in or shortly after 1484. Geertgen was the equal of his Flemish contemporaries in technical mastery. The distinctive features are the bold local colours, the simplified geometrical forms, the oval faces, and the care lavished on the landscape. It is difficult to say whether he painted all 15 works currently attributed to him, or whether they originated in his shop or immediate circle. That also applies to the four paintings in the Rijksmuseum that have been attached his name in the past hundred years *[12-14]*. One obvious influence in his work is that of Hugo van der Goes, who also left his mark on another northern painter, the Master of the Virgo inter Virgines (the Virgin among virgins), so called

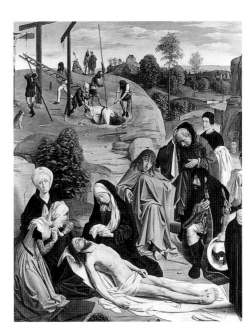

fig. 53 Geertgen tot Sint Jans, *The Lamentation of Christ*, after 1484; oil on panel, 172 x 139 cm. Vienna, Kunsthistorisches Museum (cat. no. 644)

after the painting in the Rijksmuseum [16]. He was active in Delft or Gouda (or both) between 1470 and 1500, and must have had help from a number of assistants who had mastered his expressive style.

Other northern Netherlandish masters of the late 15th and early 16th centuries are also known by acquired names, among them the Master of Delft (active c. 1500-1520), the Master of the Spes Nostra [18] and the Master of Alkmaar (active c. 1490-1520) [19].

As Frits Scholten explains in his essay about the world of the late-medieval artist (pp. 233-52), almost every town had at least one silversmith and a cabinetmaker, and generally there was a wood-carver and a painter's workshop as well. Local silversmiths are among the earliest northern artists whose names and works are known to us [24]. In some towns, too, there was a concentration of certain specialist craft products, such as those producing wooden statuettes, alabaster and brass in Mechelen, small pipe-clay figures in Utrecht, illuminated manuscripts in Bruges and Utrecht, and tapestries in Brussels, Oudenaarde and Tournai. Brussels was the main centre for retables in the 15th century, but from 1500 it was surpassed by Antwerp, where large carved altarpieces were turned out almost on a production line basis. Many had painted shutters, and were exported throughout Europe.

Sculpture was at least as important as painting in the late-medieval Low Countries. It is known that the pieces modelled by Jean Delemer of Tournai (active c. 1425-1460) were painted by Robert Campin. Burgundian tombs were the fruit of a collaboration between Delemer, the painter Rogier van der Weyden and the bronze-founder Jacob de Gerines. It is widely believed that the statuettes of 1476 from the tomb of Isabella of Bourbon [3], which are among the most delicately worked examples of 15th-century bronze sculpture, are based on models by Delemer. Just as those statuettes are fragments of a tomb that no longer exists, so the majority of the sculpted groups from this period were once part of a larger whole, for very few sculpted altarpieces have survived intact. In the main, only individual figures [5] or groups [4, 6] have come down to us, and in many cases their polychrome decoration has been removed with lye to expose the wood [6, 8]. Much of the output came from the Lower Rhine border region between Zwolle and Kalkar [7], and in Brabant [5, 27].

Another important centre was Utrecht [6, 25]. It was the home of Adriaen van Wesel (c. 1420-1500), the first northern wood-carver known by name for whom an oeuvre can be reconstructed. In the period 1475-1477 he was working on the great *Altar of the Virgin* for the Cathedral of St John in Den Bosch, several fragments of which have survived [6].

A branch of art that made its appearance around now was printmaking, which facilitated the widespread dissemination of examples from which artists could draw inspiration. It had its first flowering in the second half of the 15th century, chiefly in Germany. Around 1500 there were several Netherlandish engravers who are now known by acquired names. Master FVB, whose prints are closely related to the work of Rogier van der Weyden [9], and Master W with the Key [10] were both active in Bruges, while Zwolle had its Master IAM [17].

FURTHER READING
Post 1954; exhib. cat. Amsterdam 1958; Friedländer 1967-76; Châtelet 1980; exhib. cat. Ghent 1994; Ridderbos/Van Veen 1995; Huizinga 1997

Detail from [19] >

Elyas Scerpswert (active in Utrecht, second half 14th century)

1 Bust, reliquary of St Frederick, Utrecht, 1362

Parcel-gilt silver, h 45.2 cm, w 24 cm, ø 16.7 cm
From the Church of St Salvator (Old Minster), Utrecht; Old Catholic Congregation in Leiden, collection of Charles Stein, Paris; acquired in 1899 with the aid of the Vereniging Rembrandt and the Koninklijk Oudheidkundig Genootschap
inv. no. BK-NM-11450

The bust of St Frederick is the earliest surviving piece of Netherlandish precious metalwork from the Gothic period to bear a signature. It is on the retaining plate on the underside of the base: '+ano dni m° ccc° lxii° decan' + captm sti saluator tiecten/ me ex tuba ptut innovaca exhi + fi' fecerut p elya/ scerpswert aurifabru' (In the year of Our Lord 1362, the dean and chapter of St Salvator in Utrecht removed me from the tomb, which was being refurbished, and had me made by Elyas Scerpswert, goldsmith) [1a].

In addition to recording the name of the artist, the inscription contains valuable information on the date, donors and function of the bust. The word 'me' refers to the relic for which the reliquary was made: part of the skull of Bishop Frederick of Utrecht, who was murdered in 838. His tomb in St Salvator's was being refurbished, and a leading goldsmith, Elyas Scerpswert, was commissioned to make a reliquary. It is known as a head or bust reliquary, in allusion to the relic it contains. Reliquaries in the form of three-dimensional parts of the body like head, hands or feet had been made since the 9th century. From the 12th century, silver reliquary busts were produced throughout much of Europe, reaching a peak in the 14th and 15th centuries. The fact that very little free-standing sculpture has survived from this period makes Scerpswert's bust all the more valuable.

It has a several remarkable stylistic features. In the first place there is the architectonic, linear nature of the mitre, with its Gothic tracery. The archaic-looking birds and fabulous animals on the chasuble and collar are from a different artistic tradition, and it has been suggested that these motifs may have been derived from fragments of fabric found when the saint's tomb was opened. On stylistic grounds, however, it is more likely that Scerpswert was inspired by the decoration on early 14th-century fabrics. In any event, there was a deliberate attempt to make the bust look old-fashioned, probably to give at an air of authenticity.

The expressive power of the bust comes from the decidedly realistic appearance of the saint's face. The artist gave it strong features, and even the stubble of the beard was engraved in the skin with great feeling for detail. The individualised look is reinforced by the contrasting effect of the stiffly modelled locks of hair framing the face. It is this realism that makes the bust so innovative, placing Scerpswert in the vanguard of the artists who were breaking free of the formal and stereotype portrayal of saints that had been current up until then.

LITERATURE
Albers 1893; cat. Amsterdam 1952a, no. 7; Schrade 1957, pp. 33-64; Beltjes 1981, pp. 382-389; Van den Bergh-Hoogterp 1990, vol. 2, pp. 462-493, 594-595

1a Retaining plate on the underside of the base.

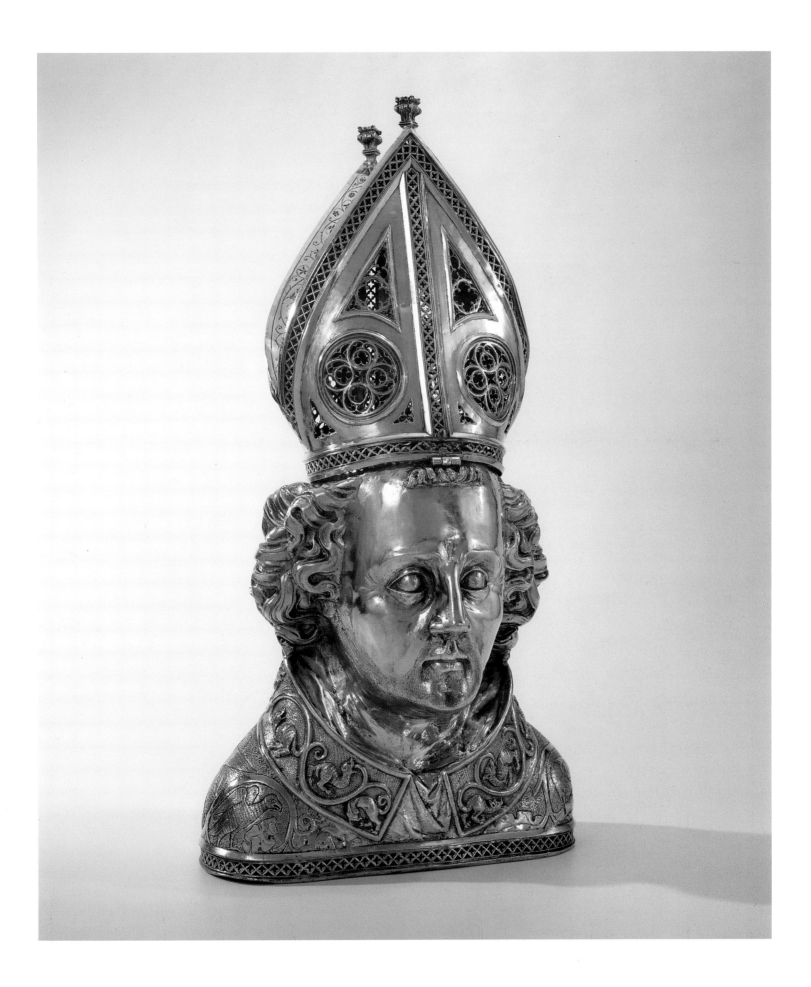

Northern Netherlandish School, c. 1430

2 Portrait of Lysbeth van Duvenvoorde

Oil on vellum, 32.5 × 20.5 cm
On loan from the Mauritshuis, The Hague, since 1959, which purchased it from a private
Dutch collection in 1941
inv. no. SK-C-145

This portrait of a woman is one of the earliest surviving paintings executed in the county of Holland. Pasted onto the back of the panel is an inscription giving unusually detailed information about the sitter: 'Afbeeltsel van Juffer Lysbeth van Duvenvoorde, Heer Dircks dochter. Sij troude den 19. Meert anno 1430 aen Symon van Adrichem, Ridder, Heer Floris soon, en stierf op ons Heeren Hemelvaerts Avond anno 1472 en is begraven in de Beverwijck int Reguliersconvent voor het H. Cruijs Autaer dat hij hadde doen maken' (The likeness of Lady Lysbeth van Duvenvoorde, daughter of Master Dircks. On 19 March 1430 she married Symon van Adrichem, knight, son of Master Floris, and died on the evening of the Ascension of Our Lord 1472 and is buried in Beverwijk, in the Convent of the Regulars, before the altar of the Holy Cross that he had ordered to be erected there).

The painting originally had a companion in the portrait of Lysbeth's husband, Symon van Adrichem, which unfortunately vanished from sight in the 19th century. Lysbeth is clad in the Franco-Burgundian fashion of the day, wearing a loose gown with wide sleeves known as a houppelande, and a gold belt studded with sapphires with four chains hanging from it. Over her pinned-up braids she has a flat chaperon with a long liripipe trailing down over the shoulder. She holds a scroll with a lengthy text: 'mi verdriet lange te hopen, wie is hi die sijn hert hout open' (Long have I yearned for he who opens up his heart). It is known that the portrait of Symon van Adrichem displayed the following

inscription: 'mi banget seret, wi is hi, die mi met minne eeret' (I have been afeared, who it is that would honour me with love). A great deal is known about the circumstances in which the couple lived, for Symon was Bailiff and Dikereeve of Rhineland, an important post in the gift of the counts of Holland. The chief importance of this picture, though, is that it is one of the very earliest individual portraits in European painting.

Lysbeth is occasionally mentioned in the history of portraiture, but usually only in passing, for her picture does not fit within the early tradition of painted portraits, which are almost always heads and busts, and very rarely full-length standing figures. The latter are found in illuminated manuscripts, though, where married couples were depicted full-length from an early date. The fact that this portrait is on vellum indicates that the artist came from the tradition of book illumination, which had deep roots in these regions.

The portrait is also remarkable for the prominence given to the scroll with its very intimate text. Inscriptions relating to courtly love are found in tapestries but not in individual portraits. Johan Huizinga wrote in his *Waning of the middle ages* that the presence of this text demonstrates 'the inferiority of pictorial as compared with literary expression.' But what art form did have the means for expressing such sentiments? This combination of text and portrait makes one realise the difference in potential between word and image. In Lysbeth's portrait, the addition of the word gives the image an emotional dimension,

turning the scene into a vehicle for personal feeling.

LITERATURE
Exhib. cat. Amsterdam 1958, no. 3; Van Os 1979, p. 136; Châtelet 1980, p. 201, no. 36; Campbell 1990, p. 61; Huizinga 1997, p. 342

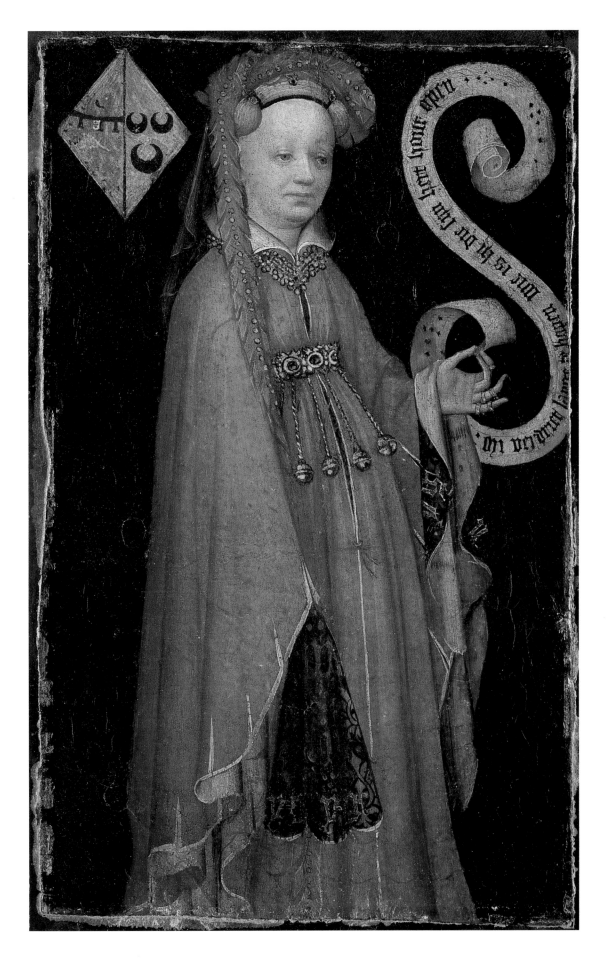

Jean Delemer (active in Tournai and Brussels c. 1420-c. 1460)

3 Two statues from the tomb of Isabella of Bourbon, 1476
Albrecht of Bavaria (1336-1404) and a female figure with a V-shaped head-dress

Bronze with a black lacquer patina, h 55.5 cm and 58 cm
From the tomb of Isabella of Bourbon in the former Abbey of St Michael in Antwerp.
Owned by the City of Amsterdam since 1691, exhibited first in the Civic Hall and from
1806 in the Cabinet of Curios; on permanent loan since 1887
inv. nos. BK-Am-33

There was an extraordinary, almost mystical reverence for bronze in the middle ages. It was initially associated with the might of Rome, thanks to the descriptions left by Pliny and other classical authors, and even more so to the bronze equestrian statue of Emperor Marcus Aurelius, which was one of the most visible remnants of Rome's glory in the middle ages. Later, bronze embodied more generalised concepts like durability, political power and age, although the echoes of the Roman empire never entirely died away. It is hardly surprising, then, that such a 'noble' metal was used for formal, often royal art.

It was such a ceremonial and courtly context that gave rise to this series of ten small bronze statues, two of which are illustrated here. They come from the funeral monument of Isabella of Bourbon, wife of Duke Charles the Bold of Burgundy (1433-1477). Her tomb, which was erected in the abbey church of St Michael near Antwerp in 1476, was robbed of most of its decoration in the 16th or 17th century. Originally the tomb was surrounded by 24 bronze statuettes of noblemen and women standing in niches. The bronze effigy of Isabella herself [3a] was later moved to the Cathedral of Our Lady in Antwerp, where it remains to this day. Nothing more of the tomb furnishings survives, with the exception of the ten statues in the Rijksmuseum.

The small bronzes were an essential part of the dynastic iconography of Isabella's tomb. They symbolised a cortège of the deceased's forebears and relatives, and thus in a sense depicted her noble descent and her position amidst the nobility of her day. Such a series of mourning family members and forebears, often called *pleurants* (weepers), had become a stock element in the traditional decoration of the tombs of the Burgundian counts. One could even call it an early form of political propaganda for the House of Burgundy. The *pleurant* tradition was started by the Haarlem sculptor Claus Sluter when he incorporated a funeral procession of 40 mourning figures dressed in long robes in the tomb of Charles the Bold in Dijon. The display of dynastic grief reached a peak in the mausoleum for the Habsburg Emperor Maximilian I (1459-1519) in Innsbruck, who was related to the House of Burgundy through his marriage to the daughter of Charles the Bold. There, lifesize bronze forebears stand around the tomb in the mortuary church.

Isabella's mausoleum is based on two almost identical Burgundian tombs that were commissioned by Philip the Good for Lodewijk van Mâle at Lille (1455) and for Johanna of Brabant in Brussels (1458). Those tombs, which no longer exist, were the work of a trio of artists: the sculptor Jean Delemer, the painter Rogier van der Weyden and the bronze-founder Jacob van Gerines. Remarkably, both tombs had identical ensembles of bronze *pleurants*, and some of the 24 statues around Isabella's tomb are copies of them in reverse. It is therefore assumed that the models for the Amsterdam series were also supplied by Jean Delemer or his workshop, and the old-fashioned garb of the ten *pleurants* does indeed indicate that they are based on models from the mid-15th century.

LITERATURE
Cat. Amsterdam 1973, no. 10; Gramaccini 1987; Roberts 1989; exhib. cat. Ghent 1994, pp. 138-141; Wiggers 1995

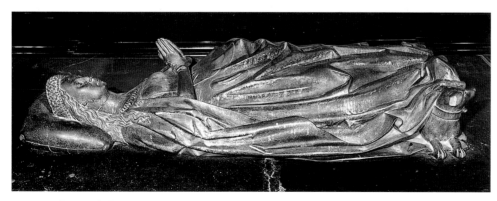

3a Bronze effigy of Isabella of Bourbon, 1476. Antwerp, Cathedral of Our Lady

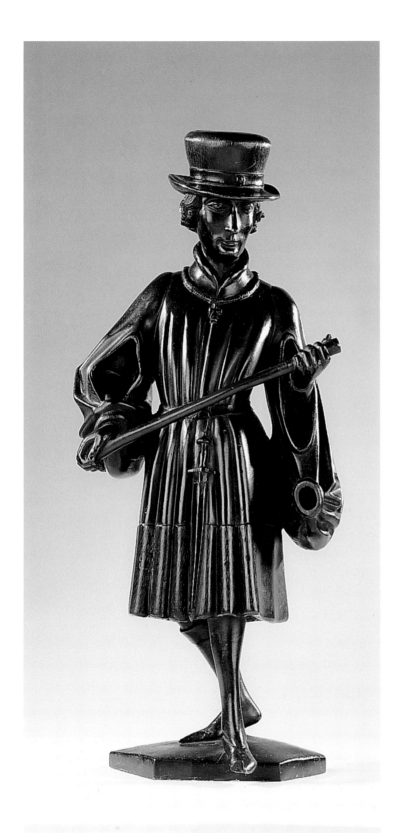

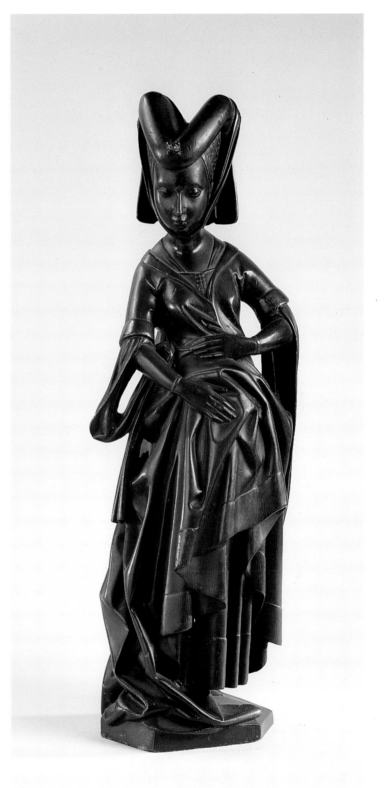

Southern Netherlands or Cologne, c. 1460

4 The Harrowing of Hell

Oak with original polychrome decoration, h 48.5 cm (group), 97.8 cm (case)
From a Passion retable; the group was bought in 1962, the case in 1964
inv. nos. BK-1962-33 (group), BK-1964-2 (case

Christ's descent into Limbo occupied a very special place in the many mystery plays that were performed in the middle ages. Apocryphal Bible stories relate how Christ entered the underground Limbo to free those who had lived according to the spirit of his teaching but who had not recognised him as the Redeemer.

The Harrowing of Hell, as this event was also called, was performed as a spectacular piece of theatre—with high drama, a great deal of action and numerous props—had Christ commanding Satan to open the gates of Hell in a stentorian voice. The gates were portrayed on stage as the mouth of a huge monster, which in some cases could be opened and closed mechanically. With the aid of smoke and fire, the audience was treated to a display of the horrors of the devil's kingdom.

The carver of this *Harrowing of Hell* in its original altar-case probably came from the southern Netherlands. He did not draw his inspiration from those public entertainments, but chose a moment that was less theatrical but theologically more important, namely the Redemption. Christ is helping the souls of the Old Covenant, who are stained with Original Sin, clamber from the mouth of Hell. They are led by Adam, with Eve in the flames behind him and three patriarchs. Christ stands in a relaxed and elegant pose with both feet on the ripped-off door of Hell, which has crushed the reptilian Satan. The Redeemer is assisted by two angels. The visual effect of the group is excellent, thanks to the preservation of the original polychrome decoration.

The Harrowing of Hell had a permanent place in the Passion cycle from the 11th century on. This group, too, comes from a large Gothic, Passion altarpiece, from which two others have survived, with their cases: horsemen flanking a Calvary scene [4a-b]. The cases were hung like doors on hinges attached to the large, central retable case, and could be opened and closed. The altarpiece was only opened on special occasions, unfolding the entire story of the Passion before the eyes of the congregation.

The sharply increased interest in the horrors of Hell in the 15th century, coupled with a more general fascination in the hereafter, was due in part to the growth in devotion among lay people. It was a development fostered by numerous writers who described 'the unspeakable pains of Hell', such as Dirc van Delf in his *Tafel van den kersten ghelove* of c. 1400, contributed to this development. Another influential work was the *Visio Tungdali* and its many versions, the vision of the knight Tundal, who was led past the terrors of Hell by an angel. Moralistic descriptions of this kind were reflected in the visual arts, and became increasingly horrific. Although the redemption of souls from Limbo is a triumphant concept, symbolising as it does Christ's victory over death and Satan, the scene of the gaping maw of Hell gives the living an immediate reminder of the dangers of a sinful life. Such a glimpse into Hell encouraged both repentance and compassion for those among the dead who had not attained heavenly bliss and awaited redemption in Limbo. The living were urged to intercede with prayers for those poor souls.

LITERATURE
Bauer 1948; cat. Amsterdam 1973, no. 8; Esser 1991; Davidson/Seiler 1992; exhib. cat. Utrecht 1994; exhib. cat. Zürich 1994

4a Group of six horsemen riding to the right in a landscape, from a Calvary group; oak, h 53 cm. Amsterdam, Rijksmuseum (inv. no. BK-1964-2a)

4b Group of five horsemen riding to the left, from a Calvary group; oak, h 57 cm. Amsterdam, Rijksmuseum (inv. no. BK-1964-2b)

Master of Koudewater (probably active in Den Bosch c. 1460-1480)

5 St Barbara and St Catherine of Alexandria, c. 1460-1470

Walnut with original polychrome decoration, h 92 cm and 94 cm
From the Mariënwater convent in Koudewater, near Rosmalen; bought from
the from the Bridgettine convent at Uden in 1875
inv. nos.: BK-NM-1195 and BK-NM-1196

'This book belongs to the Convent of St Mariënwater near Den Bosch'. This 15th-century annotation is found in an illuminated manuscript describing the life of St Barbara. The manuscript was written in the scriptorium of the Bridgettine convent of Mariënwater around 1480, and it is clear from this statement of ownership that it was intended for use within the convent walls. Its pendant, a *vita* of St Catherine of Alexandria, has also been preserved. Both testify to the special interest that the Mariënwater conventuals had in these two female saints. The veneration was also reflected in two walnut statues of Barbara and Catherine, which come from the same convent and were made around the same time. They are so closely related that they appear to have been conceived as pendants. That is by no means impossible, for the two saints were often depicted together. They symbolised the active and contemplative life respectively, which in a way sums up the essence of a Bridgettine convent, for the order set great store by both study and manual work.

Mariënwater was founded in 1434 in Koudewater, near Rosmalen, as a double monastery that followed the rule of St Bridget of Sweden. In 1713 it moved to Uden, where it still exists under the name Maria Refugie Abbey. The convent's rich furnishings, which had survived the Iconoclasm unleashed on Den Bosch on 22 August 1566, were also moved, with the result that in the 19th century the abbey still had more than 40 statues from the original, late-medieval inventory of Mariënwater. In 1875, 28 of them, including Sts Barbara and Catherine, were sold to the Nederlandsch Museum voor Geschiedenis en Kunst, which moved into galleries in the Rijksmuseum in 1885. The well-documented provenance of the two works makes them valuable guides in the indistinct terrain of late-medieval Netherlandish sculpture.

The Master of Koudewater's bold style gives his work a special place within the 15th-century tradition. All his works, without exception, are marked by a remarkably elegant stateliness. The straight, vertical forms reflect the shape of the original tree-trunks from which the saints were carved. The master rarely allowed gestures to stray outside that enclosed framework. The verticality of the statues is convincingly reinforced by the stylisation of the dress, particularly in the tight folds at the waist, and in the elongated faces. With this radical formalisation, the Master of Koudewater created statues whose transfixing and serene radiance would have had an immediate appeal for the convent residents.

The fact that Sts Barbara and Catherine are so remarkably well preserved, with large areas of their original polychrome decoration still present, is undoubtedly due to their almost unbroken existence in a single convent. The conservative ethos of the Bridgettines, who shunned all forms of luxury, made it possible for these late-medieval statues to be cosseted until well into the 19th century, as were the convent's late-Gothic manuscripts.

LITERATURE
Exhib. cat. Den Bosch 1971, pp. 17-26; cat. Amsterdam 1973, pp. 86-95, nos. 56-57; exhib. cat. Uden 1986; exhib. cat. Den Bosch 1990, nos. 96-100

6 Adriaen van Wesel (? c. 1420-Utrecht c. 1499)

6a The Visitation, 1475-1477

Oak, polychrome decoration leached off, h 51.5 cm
Fragment from the altar of the Virgin of the Confraternity of Our Lady in Den Bosch;
purchased in 1899. inv. no. BK-NM-11394

6b Joseph with musician angels, 1475-1477

Oak, polychrome decoration leached off, h 44.5 cm
Fragment from the altar of the Virgin of the Confraternity of Our Lady in Den Bosch;
acquired in 1901 from Baron Van den Bogaerde of Heeswijkfrom a merchant in Vught,
Joseph with musician angels was acquired from the collection of Baron Van den Bogaerde of
Heeswijk at the sale of his collection in Amsterdam in 1901. inv. no. BK-NM-11647

Very few northern Netherlandish altarpieces have survived intact. Most were destroyed during the Iconoclasm of 1566, and the remainder were removed after the Reformation, there was no longer being a place for them after the churches had been Protestantised. In the ensuing decades they were dismantled and the parts put into storage or disposed of. As time passed, many of them became dispersed, but occasionally it is possible to reunite these *membra disjecta*.

The history of the altar of the Virgin that the Utrecht wood-carver Adriaen van Wesel made for the Confraternity of Our Lady in

Den Bosch is typical of this process. The retable was commissioned in 1475 to replace an earlier one that had been destroyed by fire. The new altarpiece was to be installed in the confraternity's chapel in St John's Cathedral in Den Bosch. The brothers approached Van Wesel, who was one of the leading Netherlandish wood-carvers of his day, and came to an agreement with him that the work would be done within two years. The financial accounts confirm that the artist indeed delivered it in 1477, but unpainted, since the confraternity did not have the funds for this expensive, colourful form of decoration. It was not until 1508-1510 that the wooden statuary groups were finally polychromed, after the altarpiece had been fitted with two wings painted by Hieronymus Bosch.

The cathedral was not spared by the Iconoclasm of 1566, but thanks to the presence of mind of the one of the confraternity members, the altar of the Virgin was saved. For six days he had soldiers guard the chapel from the fury of the mob. The altarpiece was then dismembered and removed to safety until peace had returned to Den Bosch. It was reassembled in the chapel in 1567, and

6a Adriaen van Wesel, *The vision of Emperor Augustus: Augustus and the Tiburtine Sibyl*; oak with traces of the original polychrome decoration, 48.2 × 34.5 cm. Den Bosch, Confraternity of Our Lady (inv. no. B 8)

probably remained there until 1629, when Den Bosch was captured by the Protestant forces under Stadholder Frederik Hendrik. It is not clear where Van Wesel's altarpiece was stored after that. It was probably sold off in parts by the confraternity, for in 1896 the brothers had only two remaining groups with their original cases [6a]. Adriaen van Wesel was later rediscovered by art historians, and today key parts of the retable have been traced, giving us an insight into its artistic and iconographic riches.

It can be deduced from the 13 statues and groups that have so far been associated with Van Wesel and his *Altar of the Virgin* that the central theme was Mary's role in Christ's Incarnation. Those 13 fragments have been used to make a rough reconstruction of the form, size and iconography of the retable [6b]. The central case of the altarpiece stands almost 21/2 metres high, and has shorter sides. It was flanked by large, hinged cases with which the retable could be closed. On the back of

6b Reconstruction of Adriaen van Wesel's Altar of the Virgin

1. Kleine zijvleugels 3. Kleine zijluiken
2. Grote zijvleugels 4. Grote zijluiken

6c Adriaen van Wesel, The meeting of the magi; oak, 76.5 × 91 cm. Amsterdam, Rijksmuseum (inv. no. BK-1977-134)

6d Adriaen van Wesel, The death of the Virgin; oak, 74 × 54 cm. Amsterdam, Rijksmuseum (inv. no. BK-NM-11859)

those movable sides were the painted wings by Hieronymus Bosch. The upper part of the central section could be closed off with two smaller cases, which still survive, complete with the eyes of their hinges. When opened up, the retable was no less than 7 metres across.

In the centre was one of the crucial moments in the Christian story: the Nativity in the stable with the adoration of the Virgin and the magi. It was here that the group of *Joseph with musician angels* was located. Above, in the background of the main scene as it were, was *The meeting of the magi* [6c]. In the shorter, flanking cases were scenes from the life of the Virgin in separate compartments. The scale of this cycle of the Virgin is unknown, but it certainly included the fragments with the Annunciation, the Visitation and the Death of the Virgin [6d]. The two small hinged cases at the top, which are still with the confraternity, contain a scene of John the Evangelist on Patmos and of the Emperor Augustus with the Tiburtine Sibyl [6a]. Both groups are related to a vision of the Virgin, which is why St John and Augustus are gazing upward, for in the original

arrangement they were looking up at a statue of the Virgin that stood at the top of the retable.

When the retable was displayed in its full glory on high feast days, the viewer was presented with a three-dimensional narrative of the Virgin's key role as the mother of Christ in the story of Salvation.

LITERATURE
Cat. Amsterdam 1973, nos. 16 a and c; exhib. cat. Amsterdam 1980, esp. nos. 7 and 8

Master Arnt (Beeldesnider) of Kalkar
(active in Kalkar and Zwolle c. 1460-1492)

7 The Lamentation of Christ with kneeling donor, c. 1480

Oak with traces of the original polychrome decoration, h 54 cm
From a small wayside chapel near Boekoel (Limburg); bought in 1956 with aid
from the Commissie voor Fotoverkoop
inv. no. BK-1956-31

In 1958, four sculptures by an unknown wood-carver from the Lower Rhine region were grouped together under the *ad hoc* name 'Master of the Kalkar Altar of St George'. The principal work, from which the master took his name, is the altar of St George in the Church of St Nicholas in Kalkar. Clustered around it are a small altarpiece with the *Lamentation of Christ* [7a], an *Entombment*, and this *Lamentation*. All four have very obvious similarities in style that include drapery folds rich in contrasts, an almost graphic attention to detail (especially in the attire and vegetation), distinctive facial expressions, and emotive gestures. Several of the facial types are also closely related.

A few years later it proved possible to link this quartet with two documented works in the church at Kalkar: parts of the high altarpiece in St Nicholas's, and a lifesize *Christ* in the tomb. Archival documents reveal that those two works were delivered by a wood-carver called Master Arnt, whose activity in Kalkar is first recorded in 1460. Art-historical research has since established that Master Arnt was one of the most important and original Lower Rhine sculptors from before 1500, and that he has an impressive oeuvre of more than 20 works to which a magnificent polychromed relief of the Magi was recently added.

Arnt van Kalkar is an example of a master who developed a personal style for a local market. Unlike the large Brussels and Antwerp sculpture workshops, where altarpieces were made on a production line basis, Master Arnt probably worked primarily on commission. Nevertheless, he too repeated certain visual formulae, as shown by comparison of the Amsterdam *Lamentation* with the small altarpiece of the same subject [7a]. The compositional parallels are greater than the differences, although the small altarpiece is much richer in detail. For example, Mary Magdalen with her partly opened jar of

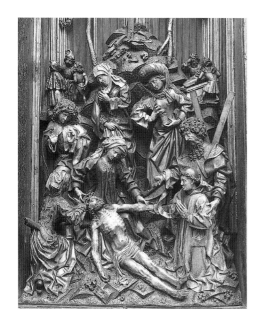

7a Domestic altarpiece with the Lamentation of Christ; oak, 97.5 x 45 cm. Paris, Musée de Cluny

ointment in the left foreground has the same pose and dress in both works, as does the woman with a jar of ointment in the right background.

The close relationship between these two Lamentation scenes is not necessarily due solely to laziness on Master Arnt's part, for both altarpieces were commissioned by Carthusian monks. They feature prominently in the compositions, praying beside Christ's body and accompanied by their respective patron saints. This shared Carthusian milieu leads one to suspect that Master Arnt repeated an existing Carthusian *Lamentation* at the donor's express request. It is not known, however, which of the works is the first, nor for which Carthusian monastery or monasteries they were made.

LITERATURE
Leeuwenberg/Gorissen 1958; Gorissen 1964; Meurer 1970; cat. Amsterdam 1973, no. 107; Hilger 1990, pp. 58-94; De Werd 1993

Master of Joachim and Anne (active c. 1460-1480)

8 *The meeting of Joachim and Anne, c. 1470*

Oak with traces of polychrome decoration, h 46 cm
Purchased in 1873 from the collection of David van der Kellen Jr
inv. no. BK-NM-88

The concentrated action and composition of this extremely intimate group tends to conceal the fact that it is just a fragment from a large sculpted ensemble. It may come from an altar retable illustrating the life of the Virgin. The scene shows the Virgin's parents, Joachim and Anne, meeting by Jerusalem's Golden Gate. In the middle ages, that meeting was regarded as the moment of Anne's (immaculate) conception, the instant when she received the fruit of Mary in her womb.

A fragment with the *Birth of the Virgin*, which is stylistically very close to this *Meeting of Joachim and Anne*, probably comes from the same retable [8a]. There is also a large, standing *Virgin and Child* [8b] by the same artist, but here the connection with the retable is more tenuous.

The maker of these three works with their highly personal style was named after the Amsterdam group, and is known as the Master of Joachim and Anne. Since the publication of the group in 1865, this anonymous wood-carver has come to be seen as one of the most important and typical representatives of the late medieval Holland or Utrecht style. The author of that publication pointed out the relationship between these restrained carvings and the work of the painter Dirc Bouts, who originally came from Haarlem. However, art historians are still in the dark as to the precise origins of the Master of Joachim and Anne.

8a Master of Joachim and Anne, *The birth of the Virgin*; oak, h 46,5 cm. Berlin, Staatliche Museen zu Berlin (inv. no. 8333)

8b Master of Joachim and Anne, *Virgin and Child*; oak, h 105 cm. Private collection

The complex case of the Master of Joachim and Anne demonstrates that an attribution made solely on stylistic grounds is generally an inadequate basis for a geographical localisation. The affinities between the master's work and southern Netherlandish sculpture, such as the small bronze statues from the tomb of Isabella of Bourbon (c. 1470) in Antwerp [3] may indicate that he came from Brabant. That is supported by the Brabant provenance of the above-mentioned *Virgin and Child*.

Localisation has, if possible, been complicated even further since a connection was made between the three sculptures by the Master of Joachim and Anne and the figurative carving on the choir-stalls in Ulm. The origins of this important work are well-documented in the archives. It was executed between 1469 and 1474, supposedly by the *Schreiner* Jörg Syrlin, whose name appears four times on the stalls. However, it is believed that Syrlin did not actually carry out the work himself but hired another wood-carver to do so. One name that was put forward was Michel Erhart (active between 1469 and 1522), but the anonymous carver is now identified with the Master of Joachim and Anne on the evidence of the striking similarities in style and facial types. This would mean that the master worked for some time in Germany, perhaps as an itinerant artist.

LITERATURE
Vogelsang 1906; cat. Amsterdam 1973, pp. 74-77, no. 43;
Schneckenburger-Broschek 1986

Master FVB (active in the southern Netherlands c. 1475-1500)

9 The Annunciation, c. 1480

Engraving, 20.4 × 16.1 cm; monogrammed FVB at lower centre
Purchased in 1985 with the aid of the F.G. Waller-Fonds and the Vereniging Rembrandt
inv. no. RP-P-1985-329

The artist who signed his prints with the monogram FVB is one of the first artistic personalities in Dutch printmaking with a clearly recognisable, individual style. A total of 59 engravings have been attributed to him (religious scenes, a few ornament prints and two quite remarkable genre scenes), and they demonstrate that he kept abreast of the latest artistic developments of his day. For example, he was familiar with the prints of Martin Schongauer (Colmar 1445/50-1491), the leading engraver of the period, and made copies of several of them. He also knew the paintings of Dirc Bouts, Hans Memlinc and Rogier van der Weyden.

It is noteworthy how closely Master FVB was able to approach the painted work of these artists in his engravings, not only in his depiction of figures, facial types and draperies but also in the rendering of the space in which the actions take place. This *Annunciation*, in particular, looks like a translation into print of a painting by Rogier van der Weyden [9a]. In early printmaking, the background is usually treated very cursorily, and the care taken here over the imitation of textures and the fall of light, on the canopied bed and beamed ceiling for instance, is exceptional. Another reason for believing that the engraving reproduces a painting is the reversed positions of the figures. By tradition, the Virgin was always shown on the right in Annunciation scenes, while the angel Gabriel entered with his message from the left.

The question of whether the print is after a painting is important because it is often asserted that the reproduction of works of art in print only began in the 16th century. There is a growing body of evidence suggesting that the duplication of existing works of art was one of the most important functions of graphic art from the very outset. On closer examination it turns out that the overwhelming majority of the 600 prints produced by FVB's contemporary Israhel van Meckenem (1440/50-1503), who worked in Bocholt, are reproductions of works by other artists.

Van Meckenem was one of the first professional print publishers whose name is known to us, and it is not inconceivable that he employed engravers to produce them. He certainly bought up copperplates by other engravers to which he added his own monogram, which served as a kind of trademark. At least one of those plates came from Master FVB, which is a plank in the theory that the latter's monogram should be read as 'Franz von Bocholt'. That, though, seems a little too simplistic, and although it is understandable that the name 'Frans van Brugge' has been put forward, that too appears to be no more than wishful thinking. Nevertheless, it very much appears that the artist was to be found near the location where the masterpieces of the Flemish Primitives were made.

LITERATURE
Lehrs 1908-34, vol. 7, pp. 102-164; exhib. cat. Amsterdam 1985, pp. 99-100, no. 8

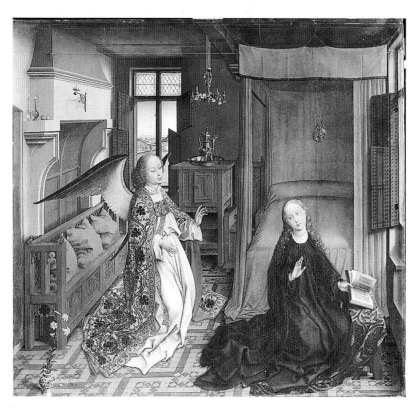

9a Rogier van der Weyden, *The Annunciation*, c. 1435-1450; oil on panel, 86 × 93 cm.
Paris, Musée du Louvre (inv. no. 1982)

Master W with the Key (active in Bruges c. 1465-1490)

10 *Interior of a Gothic church, c. 1490*

Engraving, 16.4 × 13.3 cm
Acquired in 1985 with the aid of the Rijksmuseum-Stichting and the F.G. Waller-Fonds
inv. no. RP-P-1986-42

It is assumed that the artist, whose monogram of a W and an A with a key or cross appears on the second state of this print, was active in Bruges during the reign of Charles the Bold, Duke of Burgundy (1467-1477). He was more widely known for his depictions of ships, the earliest to survive from the history of printmaking [10a]. Several of his engravings are connected with Charles's marriage on

10a Master W with the Key, *Ship*, c. 1465-1470; engraving, 16.5 × 13.4 cm. Private collection

3 July 1468 to Margaret of York, who was the sister of the English king, Edward IV. They are believed to be models for objects used in the wedding festivities.

A banquet was held on the first day of the celebrations, and that evening roast game was brought in on 30 large models of carracks which are described in detail in the chronicles. It took 48 workmen to build them, and it is possible that they used the master's prints as their guides. These may later have served as souvenirs of the occasion.

Most of the master's 81 prints were intended as models for other artists. He supplied designs for coats of arms and decorative objects like monstrances, a cruciform staff, an incense burner and a beaker. There are lavishly decorated canopies, windows, a fountain and ornamental motifs with foliage. One print shows a Gothic structure with a flying buttress. There are also examples of retable cases and a design for a monumental altarpiece with several registers and no fewer than eight empty niches for holding sculptures. It is a type that is found mainly in Bruges.

Just as the ship prints were wrongly taken to be portraits of real vessels, so it would be incorrect to think that this *Interior of a Gothic church* and related prints are records of existing churches that prefigure the work of Pieter Saenredam. They are architectural evocations which a cabinet-maker, sculptor, painter or goldsmith could use when he needed a space to be peopled with figures. He could replace the very slender columns in the print with pendants to prevent the figures getting lost in a forest of pillars. There are surviving retable cases and epitaphs that are set within late-Gothic ornaments of the kind seen here.

The subjects of the prints by Master W with the Key, and the close attention to decorative details, have resulted in his identity being sought among the ranks of goldsmiths. An attempt has been made to identify him with the goldsmith Willen Vanden Cruce (or: a Cruce), who is listed in the burgesses' book of the Bruges artists' guild in 1480. One benefit of that identification is that the name would explain the cross incorporated in the monogram, but unfortunately there are no surviving objects from Vanden Cruce's hand that could be compared with the prints.

LITERATURE
Lehrs 1908-34, vol. 7, pp. 1-101; Filedt Kok 1989; Wegener Sleeswijk 1994

Northern France/Southern Netherlands, last quarter 15th century

11 Head of John the Baptist

Alabaster, h 26.7 cm
From the Ruth Blumka Collection, New York; acquired in 1998 with the aid of the Rijksmuseum-Fonds
inv. no. BK-1998-1

The gospel of St Matthew relates the story of Salome's seductive dance before King Herod. Enamoured of his stepdaughter, the king promises in return to grant Salome her utmost desire. Upon her mother's instigation, Salome requests the head of John the Baptist presented on a plate, or charger (Matthew 14:6-8). In the middle

ages, sculpted heads of John the Baptist resting on a charger were most commonly found on the church altars of northern Europe. Said to possess miraculous qualities for the treatment of headaches and other ailments, St John's heads were venerated by many Christian believers as an important object of religious devotion.

This alabaster head of the Baptist belongs to this significant, if lesser known, tradition in late medieval imagery. Extant versions of John's head, commonly referred to as *Johannesschüsseln*, are often accompanied by a separate charger made of alabaster, wood, or even Spanish majolica. The St John's head featured here possesses no charger, though such a piece must once have existed.

As a relatively soft stone, alabaster requires a sculptural technique which differs from that of harder materials like marble. Sculpting in alabaster is in some respects more closely related to wood-working. The head of John the Baptist illustrates alabaster's exceptional suitability for carving subtle details and surface gradations that one normally associates with sculpture in ivory or wood. With a propensity for nuance, the sunken cheeks, sagging jaw and open mouth (the tip of the tongue only slightly revealed) contrast naturally with the wrought expression of the raised brow and forehead. This emotionally penetrating, realistic depiction of the human head is further enhanced by the flesh-like quality of the stone and the sensitive modelling of its surface. The sculptor's respect for the sedimentary structure of the raw block of alabaster is apparent when viewing the head in profile. The stone's natural striation is used to essentially determine the diagonal axis of the work as a whole. The sculptor's primary attention, however, focuses on the frontal view. While the sharply defined curls of the hair and beard outline the face, details on the reverse side remain cursory. One can here readily identify the kinds of tools implemented by the sculptor. The rather rough, broad furrows indicate the use of a toothed chisel. In France, tools of this kind were reserved for sculpting soft stone materials like alabaster.

Stylistically, the Baptist's head displays a marked affinity with works attributed to a sculptor based in northern France or the southern Netherlands: the Master of Rimini. The artist's name is derived from an alabaster *Crucifixion* group of c. 1430, originally found in a church in Rimini, Italy, but currently preserved in the Liebieghaus in Frankfurt. The style of the Master of Rimini, discernible in the pipe-shaped folds of the drapery and the intense facial expressions of his figures, would have a significant bearing on north-western European sculpture from the middle of the 15th century onward. Observing the highly distinctive facial features in the head of John the Baptist, as well as the character-istically refined hair and beard, a stylistic approach reminiscent of the Rimini Master becomes evident. The sculptor of the St John's head may therefore be sought within the bounds of this tradition, though active some 50 years later than his predecessor.

In the second quarter of the 15th century, numerous sources cite alabaster production originating in the region of Tournai and Lille. Between the rivers Seine and Rhine, a flourishing alabaster industry must once have existed, its influence extending into Germany in the latter part of the century. Much of this local alabaster production was ultimately destined for export abroad. The exceptional nature and superb quality of the St John's head, however, reveal this work to be a singular commission, most likely produced in a leading, seminal workshop. Considering the geographic background of this sculpture—echoing traces of the Master of Rimini—and acknowledging a prevailing regard for alabaster among the Burgundian nobility, a direct or indirect affiliation with the ducal court becomes conceivable

12a Infrared reflectogram of a detail in Geertgen tot Sint Jans's *Adoration of the magi*

Geertgen tot Sint Jans (Leiden ? 1460/65-Haarlem 1488/93)

12 Adoration of the magi, c. 1480

Oil on panel, 90 × 70 cm
Purchased in 1904 at the sale of the collection of W. Hekking Jr in Amsterdam
inv. no. SK-A-2150

No fewer than four of the 15 works associated with Geertgen tot Sint Jans are of the three kings. Each one is an interpretation of the central panel of the so-called *Monforte altarpiece* that Hugo van der Goes painted between 1467 and 1475 for the convent church of that name in Bruges *(fig. 51)*. The adoration of the three kings was a very popular subject with private patrons, eager as they were to join those three august men in adoring the Christ Child. The three worshippers described in the Bible were not kings but Magi. It was only in the middle ages that they began appearing in the guise of kings representing three different ages of man and three continents. The message of this gospel story, then, is that all the mighty of the earth, no matter what their age, nor whether they hail from Europe, Asia or Africa, worship the Christ Child in Bethlehem.

Geertgen reversed Van der Goes's composition, bringing the kings on from the left and not the right, but he followed his model closely in the characterisation of the main actors. This further highlights the difference in artistic temperament between the two painters. The poses and detail of the figures in the *Monforte altarpiece* gives them a decidedly individualised look, but in Geertgen's painting each figure, each face, is only described cursorily. Gestures are frozen. The Virgin's face is modelled as a sculptural, egg-shaped component with a minimum of physiognomic detail. Her naked child is certainly a three-dimensional presence in the picture space, but it remains a charming little doll which is only set in motion by the Virgin. Some of

the details, like the kings' attire, are fleshed out however, and particular care was taken over their headdress and gifts.

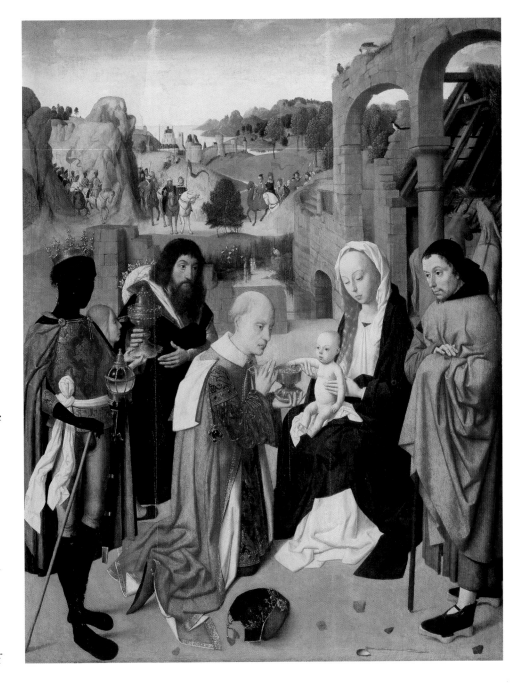

The artist was no longer tied to the Van der Goes model in the middleground—the landscape with cavalcades of horsemen. Each king's retinue is carefully composed and detailed so as to make it clear that they really do come from different parts of the world. The chalk underdrawing, which was applied to the white gypsum ground to prepare the painting and can be revealed with the aid of infrared reflectography, shows that the artist worked far more freely

in these passages than in the foreground figures. In order to emphasise the exotic nature of the scene, a horse that was sketched into the procession on the right in the underdrawing was turned into a camel during the painting stage [12a].

In this and other paintings associated with Geertgen tot Sint Jans, the primitive, the uninhibited, the intimacy and the moving profundity have been praised as being 'related to the nature of the Dutch'. Those who take this view regard Geertgen as the founder of the great tradition of Dutch art. Such interpretations based on 'the innate nature of a people' are risky. Here one need only say that this is the work of a rather clumsy follower of Van der Goes who even today charms the viewer with his poetic timorousness.

LITERATURE

Van Schendel 1957b; exhib. cat. Amsterdam 1958, no. 16; Châtelet 1980, p. 126, no. 86; Koch 1985; Van Asperen de Boer 1988; Ridderbos 1991, pp. 46-56 and pp. 177-178

Geertgen tot Sint Jans (Leiden ? 1460/65-Haarlem 1488/93)

13 The Holy Kinship, c. 1490

Oil on panel, 137.5 × 105 cm
Acquired for the Nationale Konst-Gallerij in 1808 as the work of Hubert and Jan van Eyck from the collection of G. van der Pot van Groeneveld, Rotterdam; exhibited under their names until 1858, then as by an anonymous artist, and since 1885 as the work of Geertgen inv. no. SK-A-500

The Holy Kinship, a large clan of men, women and children who are all related Christ, has been gathered together in a church [13a]. At centre left is the Virgin with the Christ Child. Behind them stands Joseph with a lily, the symbol of the virgin birth. Seated in front of the Virgin is her mother, Anne, accompanied by her husband Joachim. There was an intense veneration of Anne in the 15th-century Netherlands. An extensive family tree was developed in apocryphal stories to stress Jesus's descent in the female line. Anne supposedly married no fewer than three times, and from each marriage she had a daughter called Mary. Mary Cleophas and Mary Salome are shown on the right—one seated, the other standing. All their six sons, seen here as children, went on to become Christ's apostles.

The most prominent mother is Elizabeth with her son John, who would later baptise Christ in the Jordan. She sits by the edge of the picture on the right and is sumptuously dressed. In St Luke's gospel (1:36), Elizabeth is called Mary's cousin, but rarely does she occupy such a conspicuous position in a depiction of the Holy Kinship. It is even more unusual to see this extended family in an ecclesiastical setting; usually it was placed against a more or less neutral background. The prominence given to the Baptist and his mother has rightly been associated with Geertgen's chief patrons: the Knights Hospitallers. The way in which the infant John stretches out his hand

13a Geertgen tot Sint Jans, The Holy Kinship, c. 1490. The painting before its recent restoration (1985-2000) with old overpaints. Because the restoration of this badly damaged painting is not yet complete, only the central section is reproduced in colour here.

13b Siena, c. 1250, The Virgin and Child and Elizabeth with the infant Baptist. Detail of an antependium with the Baptist enthroned and scenes from his life; tempera on panel, 92 × 107.5 cm. Siena, Pinacoteca Nazionale.

towards Christ is an enlivening touch, and is the key to the meaning of this unique Kinship. The most widely read version of the scriptures in the late middle ages was the *Meditationes vitae Christi*, which relates that even as a small child John knew that his playfellow was someone special. A 13th-century scene in a series devoted to the Baptist's life can be regarded as the iconographic core of this painting [13b]. What the infant Baptist is doing is no more than he was later to do when he met Jesus:

he identifies him as the Saviour with the words: *Ecce Agnus Dei* (Behold the Lamb of God). This prophecy of John's later became a focal point of the liturgy of the Mass.

That is why this Holy Kinship is shown in a church with an altar, and why the interior is filled from front to back with Eucharistic symbolism. In the immediate foreground is a basket of apples. Eve had made the apple the fruit of sin, but thanks to Mary, and to her mother Anne, apples had once again become the fruit of grace.

The three little boys seated on the ground in the middle of the church can be identified from their attributes as James the Greater, John the Evangelist and Simon. They are pouring wine into a chalice from a tiny barrel. On the altar is a sculpted group of Abraham's sacrifice of Isaac, which at that time was the commonest Old Testament prefiguration of Christ's sacrificial death on the Cross. On the choir screen at the back are reliefs with the Fall of Man and the Expulsion from Paradise. It is against this backdrop of the first man and first woman who ate from the apple of sin that the bread of Salvation will shortly be eaten. The apostles serves as the acolytes at the Mass. In so far as they can be identified, the relief scenes on the capitals of the columns also allude to sacrifice, Salvation and veneration.

LITERATURE

Snijder 1957; Masseron 1957, pp. 61-73; exhib. cat. Amsterdam 1958, no. 15; Châtelet 1980, pp. 122-124, no. 81; Esser 1986, no. A1

Jan Mostaert (Haarlem c. 1474-1555/56) or circle of Geertgen tot Sint Jans

14 Tree of Jesse, c. 1500

Oil on panel, 88.5 × 59.5 cm
From the collections of Kvocinsky (Saint Petersburg), Demidoff (Saint Petersburg),
F. Meazza (Milan), Count G. Stroganoff (Rome) and C. von Pannwitz (Heemstede)
acquired in 1956 with the aid of the Vereniging Rembrandt
inv. no. SK-A-3901

The colourful bustle of this *Tree of Jesse* sets it apart from other early Netherlandish paintings. The subject is taken from the prophecies in Isaiah 11: 'And there shall come forth a rod out of the stem of Jesse, and a branch shall grow out of his roots: And the spirit of the Lord shall rest upon him, the spirit of wisdom and understanding, the spirit of counsel and might, the spirit of knowledge and fear of the Lord'. Jesse was the father of David. As he lies asleep on the grass, a heavily laden tree springs from his loins. It is clear from the above quotation that it was not Isaiah who was responsible for the people sitting and standing on the tree. It was Matthew, who at the beginning of his gospel traced Christ's descent from David and listed all the kings of Israel as the Messiah's forebears. The prophet's tree is thus also the evangelist's genealogical tree.

David, the first descendant, is playing his harp for the elderly, morose King Saul. If one then follows the tree upwards, delighting in the jaunty, fashionably dressed men, a king seen from the back suddenly reveals the significance of this particular tree. On the first branch, after King Solomon—the second king in the line of descent—comes King Joram with a crown on his head and a sash around his shoulders, both made of rose-buds. This Tree of Jesse is accordingly placed within the context of the rosary, the systematic cycle of prayers and meditation in honour of the Virgin. She herself is depicted at the very top of the tree with the infant Christ on her lap—the fruit of her womb. In this male-dominated world it is a queen who reigns supreme.

The Mariological interpretation of the Tree of Jesse was already 1,000 years old by Geertgen's day. When St Jerome translated the Bible into Latin in the 5th century and used the Latin word *virga* for the rod or twig mentioned in Isaiah, he added *virga est virgo* (the twig is the virgin). Fulbert of Chartres wrote a liturgical antiphon around the year 1000 for the feast of the Birth of the Virgin. The choir sings: 'The Tree of Jesse brought forth a twig, and that twig a flower'. Response: 'And upon that flower rests God's blessing'. Choir: 'The virgin and mother is the twig, the flower her son'. The Tree of Jesse thus became the tree of Mary. The first Netherlandish confraternity of the rosary was founded in Haarlem in 1478. This and three other paintings from Geertgen's shop are explicitly connected with the veneration of the Virgin through the rosary.

To return to earth. Compared to all other scenes of the Tree of Jesse, this one is exceptional not only for its colourfulness but also for the setting. Jesse is sleeping in a walled courtyard with the outlines of a monastery church in the background. At one stage the low brick wall on the left extended even further forward to a gate that gave access to the 'garden close-locked', a symbol of the monastic world [14a]. When the picture was restored in 1932 it was discovered that the wall and gate had been painted over a kneeling nun who had a rosary around her right arm. Her white habit may indicate that she belonged to the Whiteladies Convent (of Cistercian nuns) in Haarlem. The quiet, inward-looking pose of prayer gives the entire scene its true, personal meaning. The nun has been allowed to enter the paradisal garden. The life of prayer that belongs to this sequestered world is directed towards imitation of the Virgin. Like her queen, the nun wishes to give birth to Christ, not as the fruit of her womb but in her heart. Trees in medieval art often symbolise inner growth, especially in monastic literature. The colourful tree is thus the manifestation of the nun's devotion.

To the right of the tree stands a distinguished looking man, whose face, unlike the others, is highly individualised. The pronounced chin alone shows that this is a portrait. His bonnet and heavy, ermine-

14a Detail of the lower left corner, before the removal of the overpaint in 1932

lined cloak suggest that he was the rector of an ecclesiastical or charitable institution. He is looking up from his book, in which the writing is all in capitals, and it can be seen that he is holding the book upside-down, inviting the viewer to read it. Perhaps the rector was reading Isaiah's prophecy. He has fixed his gaze on the praying nun, and was probably her spiritual adviser. Reading the book over his shoulder is a peacock—a bird that had belonged in paradisal gardens since time immemorial, where it stood for heavenly bliss. This painting is thus a rare document of inner growth, and of the underlying hope of Salvation.

There is no agreement on the attribution of this painting, which in the past has been ascribed to both Jan Mostaert (Haarlem c. 1474-Haarlem 1555/56) and his teacher, Geertgen tot Sint Jans. However, there is little doubt that it was painted in Haarlem in Geertgen's immediate circle.

LITERATURE

Snijder 1957; Van Schendel 1957a; exhib. cat. Amsterdam 1958, no. 24; Châtelet 1980, pp. 127-130, no. 93; Ridderbos 1984; Roth-Bodjazhier 1985, pp. 48-49

Master of the Figdor Deposition (active in Amsterdam or Haarlem c. 1500)

15 The martyrdom of St Lucy, c. 1500

Oil on panel, 132.5 × 101.5 cm
This panel and the *Deposition* [15a] originally formed one wing of an altarpiece; the two sides were separated in the 19th century; the *Deposition* was lost in Berlin in 1945. The Rijksmuseum's panel passed through various collections, including that of F. Lippmann, Vienna, and was acquired in 1897 with the aid of the Vereniging Rembrandt
inv. no. SK-A-1688

The life of the holy virgin Lucy is a story of indomitability inspired by faith in Christ. Lucy gives all her earthly goods to the poor of Syracuse, her birthplace, because she has a treasure in Heaven. This unworldly behaviour infuriates the consul, Paschasius, and he resolves to teach her the facts of life. He orders her to be taken off to a brothel, but her faith makes her literally im-movable, and not even a crowd of soldiers and teams of oxen can shift her from the spot. The consul then has her thrown into a fire, where boiling oil is poured over her. A soldier tries to thrust a sword through her neck. Lucy eventually dies, but not before a priest has given her the last rites. The Roman senate orders that Paschasius be beheaded for abuse of power.

The key moments in the story are all gathered together in this painting. In the left background we see the two abortive attempts to carry Lucy off to the brothel. In the foreground the saint is being burned on the pyre, with several executioners bringing more wood and using a bellows to make the heat fiercer, while a soldier runs his sword through her neck. In the right middleground Lucy is being anointed in the sacrament for the dying. In the far right background, Paschasius is beheaded after being accused of corruption.

The artist depicted the martyrdom in strict accordance with the story related by Jacob de Voragine in his *Legenda aurea*, a compilation of saints' lives. Although the most important passages from the story have been brought together in a single scene, the narrative is not complete, for originally the panel was part of a larger ensemble, probably a triptych. When the painting emerged from obscurity in the 19th century, it had a *Deposition from the Cross* on the back. The panel was then split by sawing it crosswise down its length to create two thin panels that could be displayed separately. The *Deposition* entered the Figdor Collection in Vienna before passing to the Staatliche Museen in Berlin, where it was lost during the Second World War [15a].

The anonymous artist was christened with two *ad hoc* names: 'Master of the Figdor Deposition', and 'Master of the Legend of St Lucy'. The latter is not very serviceable, having already been assigned to

15a Master of the Figdor Deposition, *Deposition from the Cross*; oil on panel, 131 × 102 cm. Berlin, Staatliche Museen, lost in 1944/45

another painter who was working in Bruges in the same period. Although the Figdor Collection was dispersed long ago, and the *Deposition* no longer exists, that invented name is the better of the two, since it avoids all confusion. There are only a few paintings apart from the sawn panels that are clearly the work of this master.

It is more fruitful to examine the position of these two paintings amidst the work of contemporary artists. The master is closely related to both Geertgen tot Sint Jans [12, 13] and Jacob Cornelisz van Oostsanen [33]. He is midway between the two, so it is tempting to hypothesise that he was taught by the first and was the teacher of the second. One could even speculate that the Master of the Figdor Deposition was the young Jacob Cornelisz.

LITERATURE
Exhib. cat. Amsterdam 1958, no. 32; Châtelet 1980, pp. 138-139, no. 106

Master of the Virgo inter Virgines (active in Delft c. 1470-1500)

16 Virgin and Child with Sts Catherine, Cecilia, Barbara and Ursula, c. 1490

Oil on panel, 123 × 102 cm
This painting, the provenance of which is unknown, was one of the first works to enter the museum's collection, and was displayed as a work by Hubert and Jan van Eyck from 1809 to 1858
inv. no. SK-A-501

A scene like this could only have been painted for a nunnery. The Virgin is seated among four female martyrs. Their saintly lives made them the examples for, and often the name-givers of, gentlewomen who chose a life of chastity and took refuge from the world in the kind of 'garden close-locked', seen in the *Tree of Jesse* [14]. The painter very subtly included the saints' attributes as ornaments on chains around their necks. On the left is Catherine with the wheel on which she was tortured. Cecilia, behind her, has her organ. Barbara her tower, and Ursula is adorned with the arrow that pierced her heart.

Scenes of the Virgin and Child with saints are frequently found in Flemish art towards the end of the 15th century. This Delft master must have taken one such work as his model, although he depicted the subject in such an individual way that one can speak of a personal interpretation. His figures appear weightless, and consist mainly of nervously falling draperies. The faces are large and sharply drawn, and almost all are in profile. Despite the recurrent facial types, the figures have great intensity. Their lively outlines accentuate the void in which they find themselves, between symbolic and real space: the garden is situated in the inner courtyard of a building resembling a convent. On the right, in the courtyard itself, stands St Margaret with her attribute of the dragon, together with another, unidentifiable woman. On the left stand an old man and a youth, who likewise cannot be placed.

The emotional focus of the scene is the infant Jesus, who is reaching out towards Catherine. Of all the female saints it was she who came closest to him. His appearance to her in visions was so realistic that on one occasion she actually embraced him. He also became betrothed to her, which is why the Christ Child often presents Catherine with a ring in scenes of this kind. Here the artist opted for a more dynamic relationship between the two, giving Catherine a more general significance as the saint who was visited by Christ. Her life symbolises the desire of all nuns: to meet their Lord through Catherine.

A number of late 15th-century works were grouped around this picture at the beginning of the 20th century, and the artist was christened the Master of the Virgo inter Virgines after this painting of the Virgin among the virgins. Because it turned out that at least one of those paintings was made in Delft, it is assumed that the master worked there. That is also likely for other reasons. Since the paintings attributed to him vary widely in quality but are stylistically very close, it is believed that he headed a workshop with several assistants.

LITERATURE
Braunfels 1956; exhib. cat. Amsterdam 1958, no. 54; Châtelet 1980, pp. 146-55 and no. 125

Master IAM of Zwolle (active in Zwolle c. 1470-1500)

17 The lactation of St Bernard, c. 1480-1485

Engraving, 32 × 24.1 cm
Acquired in 1807 by King Louis Napoleon for the Koninklijke Bibliotheek with the collection of Pieter Cornelis, Baron van Leyden, and transferred to Amsterdam in 1816
inv. no. RP-P-OB-1093

There are only two known impressions of this print. Comparison with the other one reveals that the Amsterdam sheet lacks a strip some 2 centimetres wide on the right, and that narrow strips were trimmed off the top and bottom as well, removing the word 'zwoll' at the top, which the artist quite frequently engraved in the plate to identify the town where he worked. In addition to the monogram IAM or IA, some of the prints have a depiction of a small drill, from which it might be deduced that the artist was a goldsmith.

In the very early days, prints were mainly made by gold and silversmiths, largely because of the similarities in technique. It was only later that painters began exploring the new medium. What is even more interesting is that the monogram IAM can be associated with the name of a painter, Johannes van den Mynnesten, who is documented in Zwolle from 1462 to 1504. This would be an early example of a painter taking an interest in graphic art, but it is also possible that he merely designed the scenes that a goldsmith then cut in the copper.

The print depicts a strange event from the legend of the life of Bernard of Clairvaux (1090-1153), founder of the Cistercian order, namely the *lactatio* or miracle of the milk. Bernard needed God to reveal himself to him, and prayed to the Virgin: *Monstra te esse matrem* (Show thyself to be a mother). The Virgin promptly appeared to Bernard, and gave her mother's milk to him instead of to the Christ Child. In the print Bernard is struck by a well-aimed jet as the Virgin utters the words *Ecce Berde* (Behold, Bernard), which are written beside her.

This event was depicted several times in the middle ages, but almost invariably as a vision, with the Virgin appearing in the sky surrounded by rays of light or clouds, as if she has descended from a higher plane. The Zwolle master situated the story in a church populated with figures in contemporary dress, and depicted it as if the saint is kneeling in front of a miracle-working statue. The monk on the left is an eyewitness to the miracle. It is unclear whether the mouth of the little dog on the left has fallen open in amazement or whether it is barking at all the excitement. What the dog does do is confirm that this is no vision that is unseen by others.

However much the artist may have wrestled with the perspective and with the depiction of the space, it is the realism of the scene that heightens its impact. It may be an unlikely story, but it is told in a very direct way. It demonstrates that the Virgin is the mother of mankind, not of Christ alone, and that she wishes to nourish all the faithful.

The subject is an example of the mystical experience of monastics, and was extremely popular in the visual arts. Bernard of Clairvaux played an important part in his writings by laying so much stress on experiencing the proximity of Christ. Central to this was the physicality of that experience, which led to widespread depictions of Bernard embracing Christ after the Crucifixion.

LITERATURE
Lehrs 1908-34, vol. 7, pp. 165-218; Tiburtius Hümpfer 1927; Filedt Kok 1990; exhib. cat. Amsterdam 1994, pp. 52-53, 178

Master of the Spes Nostra (active in Delft or Gouda around 1500)

18 Four canons with Sts Augustine and Jerome by an open grave, with the Visitation, c. 1500

Oil on panel, 88 × 104.5 cm
Acquired in 1907 with the aid of the Vereniging Rembrandt
inv. no. SK-A-2312

This 15th-century painting confronts the viewer with death. In the foreground is an open coffin with a skeleton inside. The dead person addresses the beholder: *sum quod eris quod es ipse fui pro me precor ora* (I am what thou wilt be, what thou art I have been, I beg thee, pray for me). In a museum, such a confrontation is little more than a macabre experience, but at one time this meeting with death was intended to be edifying, since an awareness of the transitoriness of human life was a pre-condition for every desire for God's grace.

Some saints never ceased pointing it out: in order to be saved one had to ponder on one's mortality. The most important of them was the 4th-century father of the church, St Jerome, who is seen in the painting as a cardinal. To the left of him is his faithful companion, a lion, which is portrayed as a delightful little beast holding out a paw to have it shaken. On the right of the grave is the bishop and church father Augustine, whose attribute is a heart, denoting the emotional intensity of his devotion. He is gazing fixedly at St Jerome in allusion to a popular tale that he had seen him in a vision.

The text quoted above commands us to pray, and the four ecclesiastics are setting the example. They can be recognised from their attire as canons regular. They are staring straight ahead as they pray. It is their presence, above all, that gives the picture its introvert mood. Are they the ones who, as the text on the coffin-lid has it, *requiescant in pace*, are resting in peace?

Confrontation with death was designed to make one think about one's sinfulness and about the worthlessness of the world.

That is what is depicted in the foreground. The scene in the middleground is one of hope. Seated on a bench in a garden are the Virgin and Elizabeth, the elderly mother of John the Baptist. They are enacting the event known from St Luke's gospel as the Visitation. Elizabeth respectfully observes that Mary is pregnant. She calls out: 'Blessed art thou among women, and blessed is the fruit of thy womb'. Countless believers have recited those words ever since. Mary replies with the *Magnificat*, the song of praise that opens with the words: 'My soul doth magnify the Lord'.

For a better understanding of the connection between this scene and the one in the foreground one has to look further than just the first sentence of Mary's reply in the *Magnificat*. She goes on to say that she has become God's handmaiden, and announces that her pregnancy is the physical proof of his grace towards mankind. Mary praises God, who 'hath scattered the proud in the imagination of their hearts. He hath put down the mighty from their seats, and exalted them of low degree'. That is why the viewer must first humble himself in the face of death. Only then can he be raised up.

This spiritual, visual narrative of 'he who humbles himself shall be exalted' is taking place in remarkably naturalistic surroundings. The artist undoubtedly intended to depict a cloister-garth, with the church on the left and the refectory on the right. That is the third level in the painting. The garth is populated with angels, and the monastery is presented as a heavenly place where peacocks symbolise eternal life [*see 14*]. The small child may be

Jesus himself, who in a spiritual sense has been conceived within the monastery walls as the fruit of devotion. The female figures represent the souls of the blessed who are allowed to linger in this heavenly place. It is possible that these are the buildings of the real-life monastery of Mariënpoel near Leiden. The topographical precision subtly brings together inner and outward reality.

LITERATURE
Cat. Amsterdam 1976, p. 637; H. Schulte Nordholt 1963, who believes that the painting came from the Heilige Maria monastery in Monte Sion near Delft, and Bangs 1979, pp. 23-24, who thinks that it is an epitaph for the four rectors of Mariënpoel near Leiden

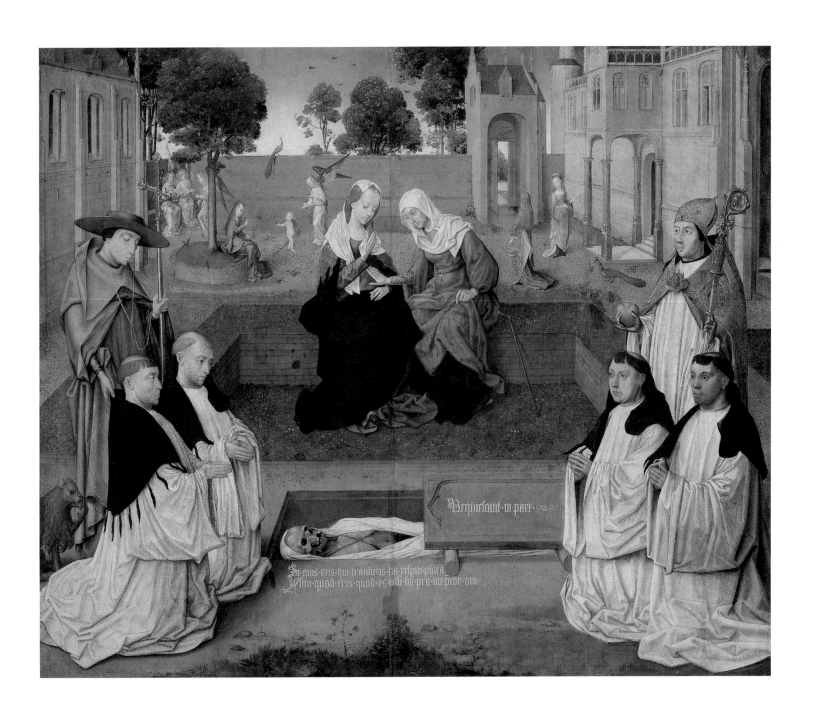

Master of Alkmaar (active c. 1500)

19 The seven works of mercy, 1504

Oil on panel, outer panels, 101 × 54 cm, the others 101 × 55.5 cm; dated on the frame:
'Gheschildert Anno 1504', and on the second panel: 'Ano MCCCCC en IIII
Possibly made for Hospital of the Holy Ghost in Alkmaar, which was closed in 1575.
In 1582 the polyptych was hanging in the Church of St Lawrence in Alkmaar;
purchased from the church council in 1918 with the aid of the Vereniging Rembrandt
inv. no. SK-A 2815

"Be charitable to the poor/ God shall once again have mercy on you' is the meaning of the inscription on the first of the *Seven works of mercy* that was painted by an anonymous artist now known as the Master of Alkmaar. The other scenes also have inscriptions proclaiming the great rewards waiting in Heaven for those who give to the poor: 'thou shalt be rewarded one-thousandfold'.

This seven-panelled work is a programmatic and crystal-clear illustration of Matthew 25:31-46, which details how one is judged by one's deeds on the Last Day, for 'inasmuch as ye have done it unto one of the least of these my brethren, ye have done it unto me'. This explains why Christ appears among the needy in all six scenes (even looking out at the viewer in the first one), while in the seventh, the burying of the dead, he is depicted in the sky on the Last Day. The Master of Alkmaar's Christ is mild and brotherly, which is how he was envisaged by the members of the Modern Devotion movement.

The Seven Works of Mercy formed a popular subject for artists in the late middle ages, and sometimes gave rise to remarkably realistic depictions of everyday activities. The Master of Alkmaar's version is an example of this, which is why some art historians have called him a forerunner of Pieter Bruegel. He was, nevertheless, an artist with glaring shortcomings. The backgrounds to his scenes look like cardboard cut-outs, and the anatomy of some of the figures leaves much to be desired. The benefactor giving drink to the thirsty is on the point of popping his shoulder out of joint as he fills the cups of the people queuing at his door. Many of the figures are in improbably rigid poses,

but what the master does have in common with Bruegel is his meticulous portrayal of the infirm and disabled.

Depictions of the Seven Works of Mercy are repeatedly documented in hospitals In the 16th century, which gave rise to the suggestion that the Master of Alkmaar's painting was made for the Holy Ghost Hospital in his native city. That is certainly not improbable, and if true it might have been commissioned by one of the hospital governors, who may be portrayed on the right of the scene with the tending of the sick. We even know the name of one of those who was in office in 1504: Jacob Dircksz. It is not clear whether the painting was installed in the Church of St Lawrence immediately upon completion, or first hung for a while in the hospital. The Holy Ghost Hospital was closed in 1575, and the work is mentioned as being in the church in 1582, where it may have served as a 'begging piece', with a collection box beside it.

The painting was severely vandalised during the Iconoclasm *(see pp. 16-17)*. It was hacked at with a metal object, and in some areas the paint was scraped off. When it was last restored (1971-1975) it was decided to leave some areas of damage visible rather than paint them in. As a result, the work provides a striking reminder of a tumultuous period of religious disturbance and image-breaking.

LITERATURE
Halm 1921-22; De Bruyn Kops 1975; Knevel 1996

Jan Mostaert (Haarlem c. 1475-Haarlem 1555/56)

20 *Portrait of a woman, c. 1520-1525*

Oil on panel, 64 × 49.5 cm
Purchased in 1952
inv. no. SK-A-3843

Little is known about this portrait of a woman set against the backdrop of a landscape with the story of St Hubert out hunting. Although unsigned, it is generally believed to have been painted by the Haarlem artist Jan Mostaert around 1520. The woman's identity is a complete mystery, but it is tempting to speculate.

The fur, brocade and gold necklace are clear evidence that she was a member of the moneyed classes, while the ring that she is twisting around her finger probably indicates that this is a marriage portrait.

One possible clue to her identity is the depiction of the legend of St Hubert in the background. While out on the chase the saint came across an unusual stag, and after pursuing it discovered that it had a crucifix between its antlers. This brought about his conversion to Christianity and the dedication of his life to pious works.

The woman undoubtedly had a particular devotion to St Hubert, but that is of no help in identifying her, for Mostaert made several paintings with St Hubert in the background. Haarlem, though, did have a confraternity of St Hubert, the patron saint of hunting, in the 16th century. Numerous noblemen (hunting was the preserve of the nobility) from the surrounding district of Kennemerland would have been members. This woman almost certainly belonged to that circle, although actual membership of the brotherhood would have been closed to her.

What remains is an attractive portrait of a woman painted by a good artist who lacked both the robust precision of a Hans Holbein and the forceful realism of a Jacob Cornelisz van Oostsanen or a Maarten van Heemskerck. Mostaert did not have the courage to allow his sitter's head cut the horizon of a landscape, so he carefully constructed a mountain around it. The landscape is not that of Kennemerland, nor of the Ardennes, to which Hubert retreated after his conversion. It is an imaginary stretch of country tailor-made for a saint whose life largely belongs to the realm of fantasy.

LITERATURE
Exhib. cat. Amsterdam 1958, no. 86; Friedländer 1967-76, vol. 10, p. 124, no. 42

Jan Geldofs Hoghenzoon (attributed to)

21 Monstrance, Breda, c. 1520

Parcel-gilt silver and glass (renewed), h. 63.6 cm, ø foot 19 cm
Acquired in 1981
inv. no. BK-1981-2

Although Breda did not have an independent guild of gold and silversmiths until 1552, quite a large number of Gothic metalsmithing work has come down to us from the city. They are mostly religious objects, for which Breda had become a production centre back in the 15th century. The Breda style was at first heavily influenced by that of the Rhineland, but at the end of the 15th century it became more and more autonomous. This is particularly evident in a very homogeneous series of early 16th-century monstrances that includes this one in the Rijksmuseum.

The introduction of monstrances at the beginning of the 14th century was closely associated with the growing desire on the part of the faithful to be allowed to see the host. A special feast day was created to honour the Blessed Sacrament, and in order to make it more popular Pope John XXII decreed around 1317 that the host was to be carried visibly in procession through the streets and squares on that day. What was needed was a vessel that would enclose and protect the host without concealing it. This initiated the custom of displaying it behind glass or rock-crystal set in an ornate metal frame. The distinctive, towered shape of this particular monstrance echoes Gothic architecture, which is marked by a pronounced verticality.

The monstrance in the Rijksmuseum is one of a group of eight bearing the maker's mark 'G', which is attributed to Jan Geldofs Hoghenzoon. Other monstrances from his productive workshop are preserved in a number of museums and churches. This one follows the usual pattern of a tower-

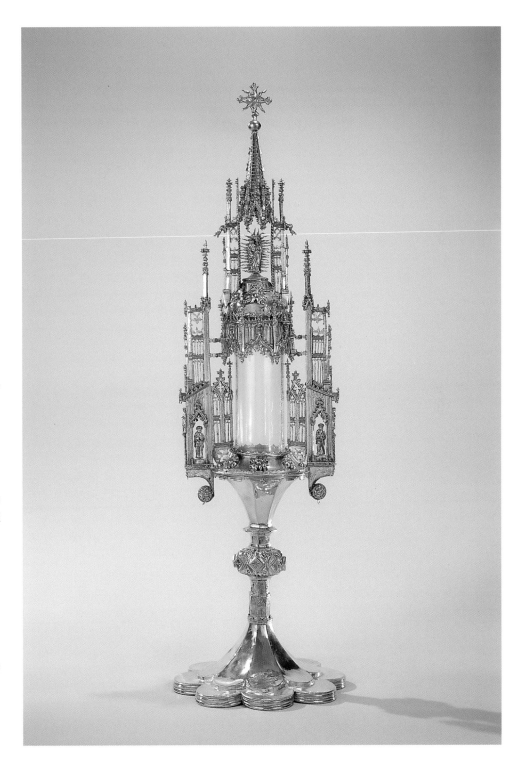

like structure framing a tall glass cylinder and standing on a lobate foot. The most distinctive feature of the Breda type is the rather severe, slender architecture of the superstructure containing the expositorium. It is composed of elements derived from Gothic architecture: (parcel-gilt) columns, shafts, lancet arches, tracery and gargoyles in the form of monsters, and a steeple crowned with a gilt motif of rays. Under two arches flanking the cylinder are the figures of Sts Peter and Paul. Standing on the right side of the monstrance is John the Baptist, and on the left side a female saint. The cylinder is topped with a hexagonal canopy decorated with parcel-gilt, screwed-on flowers, on top of which the Virgin and Child stand in a mandorla.

The superstructure was made from small parts that were produced in series. The figures of the Virgin and saints were also often made from the same models, leading to a certain lack of refinement in the work as a whole. One part that was not mass-produced is the foot, which could have six or eight lobes, and sometimes an openwork ring or star-shaped domed support. Although this part does break the rigid formula to some extent, its compact, closed design is at odds with the openness of the superstructure.

LITERATURE
Vermeulen 1924; Knippenberg 1970; Van Molle 1971

Northern Netherlands, c. 1520-1530

22 Dresser

Oak, h 147 cm, w 103.5 cm, d 74.5 cm
From the Paling and Van Foreest almshouse in Alkmaar; acquired in 1862 by the Koninklijk Oudheidkundig Genootschap; on loan to the Rijksmuseum since 1885
inv. no. BK-KOG-656

Most of the wooden chattels in a medieval household consisted of plain trestle tables and chairs. The main way of making furniture look grand and imposing was to upholster it with costly materials, or drape it with textiles or tapestries, which could be extremely fine and expensive.

As an exception to the general rule, the one item of furniture that was often the most ornate was the dresser. That is hardly surprising, since it was often used to store costly vessels: objects made of silver and gold, or of pewter and copper. During a reception or a meal they would be taken out and displayed on top. The dresser, in other words, was a conspicuous way of advertising its owner's wealth, be it a private individual or an official body, which made it a prestige object in its own right. Dressers (*tresooren*) are often mentioned in the earliest descriptions (c. 1500) of the masterpieces required of aspiring cabinetmakers in the various northern Netherlandish towns. which date from around 1500. Those pieces mark the period when separate guilds were formed for carpenters and cabinetmakers, and one can justly say that the dresser was present at the birth of the art of Dutch cabinetmaking.

The precise meaning of the descriptions of the dressers to be made as masterpieces is not always apparent to the modern reader. What is clear, though, is that figurative, sculptural decoration is never mentioned. Cabinetmakers were not allowed to do that kind of work. That right was reserved for sculptors or wood-carvers, and before a piece of furniture decorated with figures could be made, the cabinet-maker and the wood-carver had to come to an agreement defining the terms of their collaboration.

This dresser is thus a remarkable specimen, if only for the figurative carving of the lions on the feet and the angel bearing an escutcheon. Both the cabinet-maker and the wood-carver delivered work of the highest quality. Unlike earlier, more primitive cabinets, none of the metal fittings can be seen from the outside: 'the doors with blind fittings, so that the ironwork cannot be seen', as the Deventer guild charter of 1566 put it. What is exceptional about this dresser is that it is decorated on all four sides, which means that it was intended to stand in the middle of a room. All these factors indicate that it was a specific commission, which is confirmed by the carving on the doors. The specific combination of symbols: fleur-de-lys, imperial crown, flint and steel, and what appears to be a flame below a royal crown, can only refer to Charles V (1500-1558), Duke of Burgundy, King of Spain and, from 1520, Holy Roman Emperor. The symbol of a flint and steel pierced with two arrows beneath the imperial crown is an allusion to an archers' guild. Given the provenance from an Alkmaar almshouse it is likely that the dresser was made for one of the city's civic guards in the days of Emperor Charles V.

Both the form and decoration of the piece are firmly in the tradition of the 15th-century Gothic. The guild organisation, with its thorough training and stringent

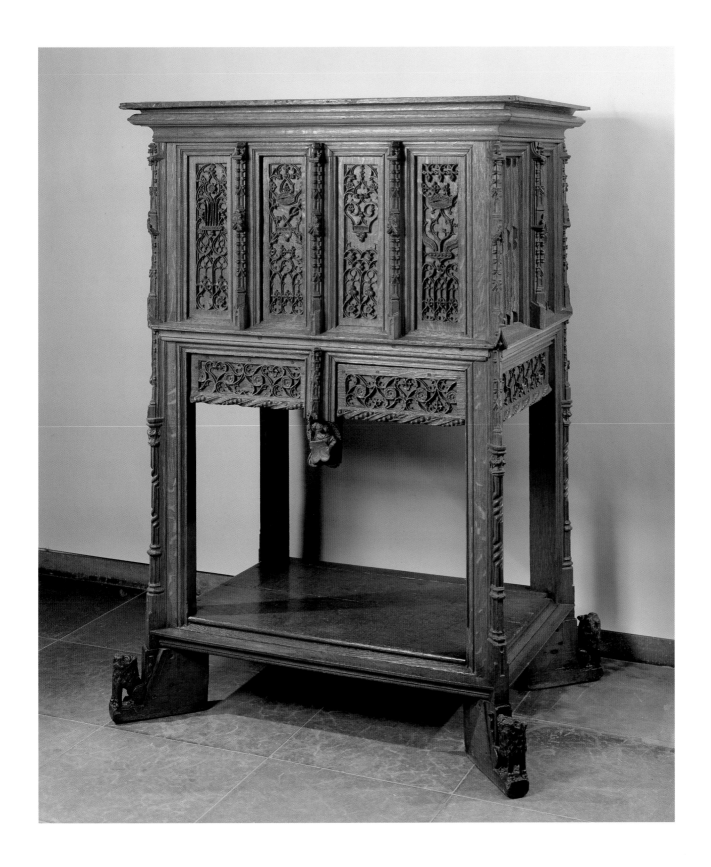

quality control, fostered a powerful
conservatism among cabinetmakers, with
the types of furniture and modes of deco-
ration changing but slowly.

LITERATURE

Lunsingh Scheurleer 1948; cat. Amsterdam 1952b, no. 87;
Dubbe 1980, pp. 31-33; Heijbroek 1995, p. 13

Northern Netherlands, first quarter 16th century

23 Ceremonial chain of the Calivermen's Guild

Parcel-gilt silver, l 80 cm
Commissioned by the Calivermen's Guild of Amsterdam; on loan from the City of Amsterdam since 1885
inv. no. BK-AM-10

Most of the secular silver objects that have survived from the 15th and 16th centuries come from the guilds. Chief among that early ceremonial silver are the badges of office of the deans and officials—the guild chains and associated insignia.

This chain was worn by the 'king' of the Calivermen's Guild, one of Amsterdam's civic guards. The links of the chain are in the form of claws, alluding to the term for the guardsmen: 'klauweniers'. As part of their practice of arms, they held regular shooting contests, the most colourful of which was the annual popinjay shoot, which had been one of the guild's most characteristic activities since the middle ages. The best marksman was awarded a silver popinjay hanging from a silver chain. He could wear it for a year and bore the title 'king of the guild', and it was he who

23a Manner of Dirck Jacobsz, *Sixteen guardsmen, Squad B of the Calivermen's Civic Guard, Amsterdam* (detail), 1556; oil on panel, 125 × 184 cm. Amsterdam, Amsterdams Historisch Museum

was the guild's official representative for that year. If a person won the popinjay several years in a row he was dubbed 'emperor'—a title that was sometimes held for life. It was customary for a new king or emperor to donate a small plate or shield for the chain bearing his engraved or embossed name and coat of arms or a depiction of his profession. The two shields on this chain commemorate two of the 17th-century kings of the guild: Jacob Dirckz (1638) and Pieter van Dyck (1663).

Objects like the civic guard chain and the associated rituals and customs had a binding effect on society. In this case they served to cement solidarity within the guild, which had quite a powerful social influence that occasionally led to a clash with the authorities. In 1569, for instance, the civic guard guild was disbanded by regent Margaret of Parma because it had refused to swear the oath of allegiance to her and had not sided with Spain in the Dutch Revolt. The guardsman were forbidden to hold meetings or bear arms. On the insistence of the Duke of Alva they even had to surrender their old letters and charters to the burgomasters, as well as all their money and valuables, including the silverware. The guild officials tried in vain to persuade the burgomasters not to carry out the order, and on 5 January 1569 they handed over their valuables, but only after a detailed inventory had been made. The earliest mention of 'the king's collar', as the guard chain was called, is found in that 'Inventory of the letters, silverware and jewels which the officials of the Calivermen's Hall have surrendered into

the hands of the Lords Burgomasters, as well as the receipt dated 5 January 1569 from the aforementioned Lords Burgomasters'. It is clear from this that the guild chain was not just a status symbol but had become an attribute of power as well.

In a painting of 1566 [23a], the chain is seen around the neck of the king at lower centre. He holds a second insignia of office, the king's sceptre, which like the 'collar' is decorated with a silver popinjay.

The Amsterdam guild was rehabilitated in 1578 when the Catholic city authorities came to an agreement with those rebelling against Spanish rule. In the course of the 17th century the guild developed into a sort of elite social club. Its silver, however, was cherished as a relic of more martial days.

LITERATURE
Van der Kellen 1856-62, pl. 15; Sterck 1900; cat. Amsterdam 1952a, no. 26; exhib. cat. Amsterdam 1964; Knevel 1994; Jensen Adams 1995

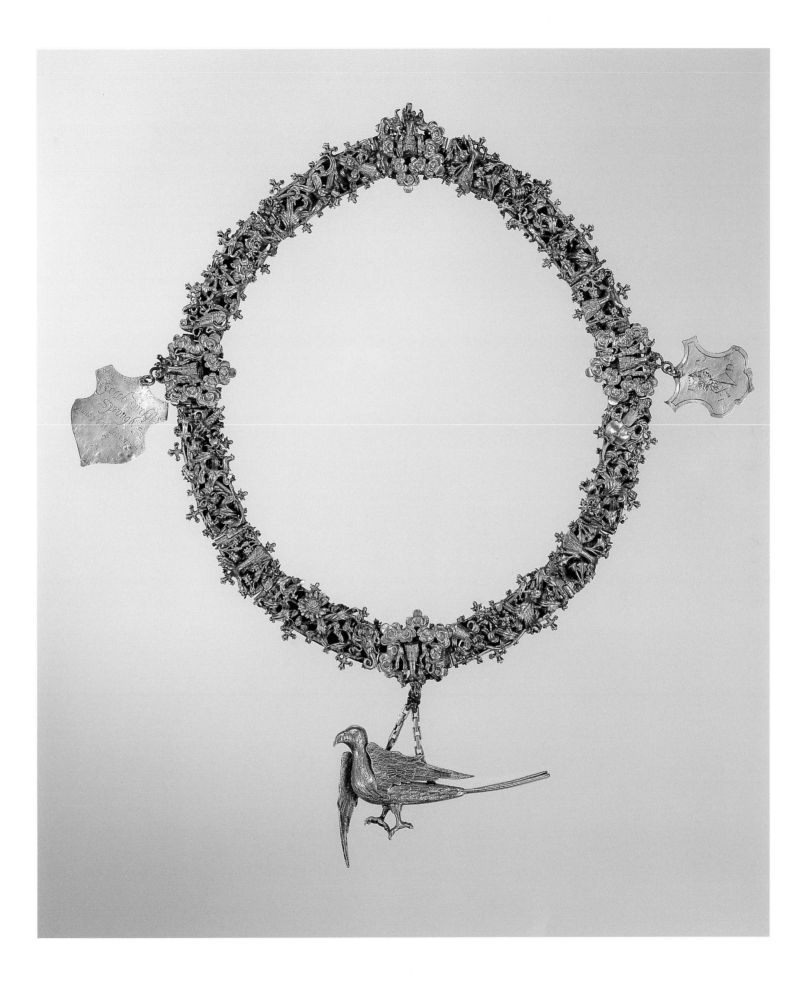

Johannes Vuystinck (active in Utrecht c. 1503-1523)

24 Ceremonial staff, Utrecht, 1518

Parcel-gilt silver, h 115 cm
Made for the chapter of the Old Minster in Utrecht; in the Koninklijk Kabinet voor
Zeldzaamheden in The Hague from 1822; in the Rijksmuseum since 1885
inv. no. BK-NM-633

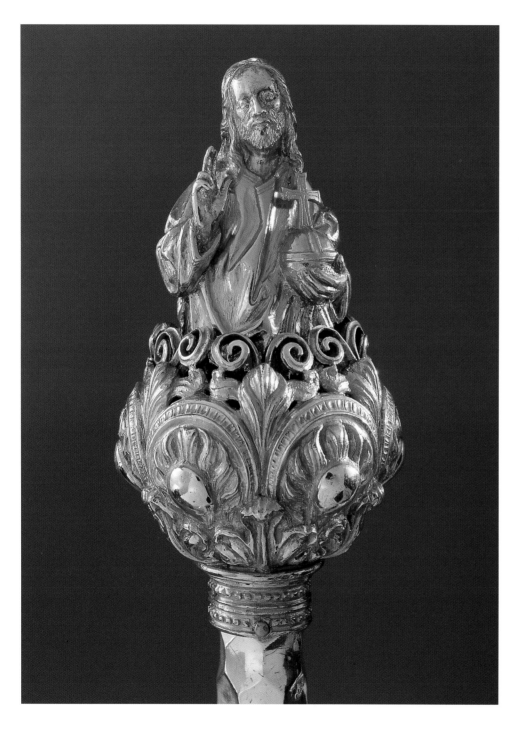

Thanks to a recent study, this ceremonial staff from Utrecht is one of the few well-documented silver objects from the period of the Netherlandish Gothic. All of its hallmarks have now been identified: the city mark of Utrecht, the date letter for 1518, which appears in the earliest alphabet used by the Utrecht silversmiths' guild, and, most crucial of all, the maker's mark of a stonemason's hammer in a shield. The latter was linked to the goldsmith Johannes Vuystinck by the discovery of an invoice for the staff which mentions his name. The invoice was from the clerk of the works of the chapterhouse of Utrecht's Old Minster, from which it emerges that in 1518 he had paid the goldsmith Johannes Vuystinck and had signed a contract with him for the delivery of a silver staff for the church bailiffs, 'weighing three marks and one lead of silver, at 32 Dutch stuivers an ounce'. The fact that this comes to approximately 750 grams removed all remaining doubts that this was a reference to the staff in the Rijksmuseum, which weighs 715 grams.

What is so important about the discovery of the invoice is that a name can now be attached to a maker's mark, which is very rare for the early 16th century. Moreover, Johannes Vuystinck was not some obscure goldsmith, but the founding father of a large family of gold and silver-smiths active in Utrecht and The Hague up to the end of the 17th century.

The bailiff or bailiffs of Utrecht Old Minster for whom the staff was made originally had the right to administer justice in the areas inside and outside the city that fell under the church's authority. Later they also collected rents. The staff can be regarded as the rod of the bailiff's office, which he bore at the head of the procession of prelates on solemn ecclesiastical occasions. The bailiff's position may be reflected in the cast sculpture of Christ as Salvator Mundi at the top of the staff, which can be interpreted as the prototype of the ruler, the prince. In this way reference was made in the ecclesiastical courts to the one in whose name the bailiff acted.

This type of staff, with a capital topped with a cast, three-dimensional figure, had a secular origin. Such objects were found in the 15th century, mainly in German-speaking regions, where they served as university sceptres. Such a secular design was evidently considered suitable in ecclesiastical circles to express the bailiff's semi-secular function.

LITERATURE
Brom 1901; Eelkman Rooda-Hoogterp 1983; cat. Amsterdam 1952a, no. 29; exhib. cat. Amsterdam 1958, no. 390 (as Amsterdam, c. 1530); Vorbrodt/Vorbrodt 1971, vol. 1; Van den Bergh-Hoogterp 1990, vol. 2, pp. 565-75, 619

Master of the Utrecht Stone Female Head
(active in Utrecht c. 1490-c. 1530)

25 Bellows with the Flight into Egypt, c. 1510

Oak with traces of polychrome decoration, leather and copper, h 62 cm
Acquired in 1873 from the collection of David van der Kellen Jr, Amsterdam
inv. no. BK-NM-66

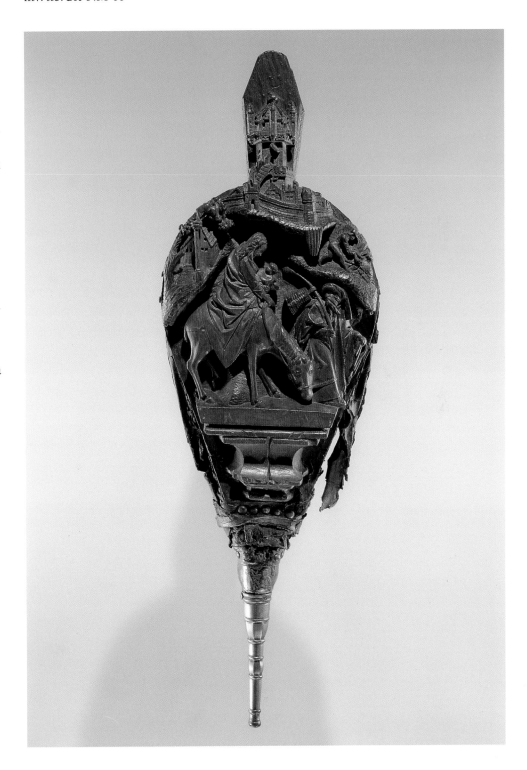

25a Master of Catharine of Cleves, *The Holy Family at supper*. Miniature in the Book of Hours of Catherine of Cleves, fol. 151. New York, Pierpont Morgan Library (inv. no. M 917)

During the six winter months, domestic life centred largely around the hearth, for it provided heat and light, and was where the cooking was done [25a]. The larger town houses often had more than one chimney as well as a stove—a small room near the hearth that was kept well-heated and was where people preferred to sit during cold spells.

One can imagine this bellows hanging beside a large sandstone chimney-breast in a grand Utrecht mansion. It is a luxury item not intended for daily use, and indeed the carving on the front panel displays very few traces of wear. The relief with the Flight into Egypt by Joseph, Mary and the infant Jesus is almost as new.

The anonymous Utrecht carver with the impossible *ad hoc* name Master of the Utrecht Stone Female Head, to whom this bellows is attributed, developed an elegant way of depicting the scene within the shape of the object. He also added a number of secondary scenes which, in medieval minds, were indissolubly bound up with the Bible story. The main one of Joseph and Mary with the child on the ass is situated in a landscape with a medieval town on the horizon which is probably meant to represent Bethlehem, from which the Holy Family had just fled. In the right middle-ground is a farmer reaping corn, and on the left a farmhouse with an idol tumbling off a pillar.

Compressing so many key details into such a small space is a skill displayed by carvers of large, multi-figured, sculpted retables, so it is no surprise that this master won his spurs in this sphere, for there are several retables in Norway that are attributed to him. His choice of the Flight into Egypt to adorn this secular, domestic object may be associated with the fact that in the late middle ages the Holy Family had become the paradigm for family life. One does, however, find other religious subjects depicted around the hearth, particularly in the decoration of sandstone mantel friezes that were a Utrecht speciality around 1500. They were often less specific scenes, such as the Virgin and Child, or appropriate patron saints [25b].

Two other carved bellows are attributed to this artist, one with the same subject but now combined with the Amsterdam coat of arms (Metropolitan Museum, New York), and the other with a bust of the Virgin and Child (Museum für Kunstgewerbe, Hamburg). One can perhaps draw the tentative conclusion from the fact that one and the same artist made three such rare objects that carving bellows was one of his specialities. The bellows reminds us that medieval wood-carvers did not only produce religious art. Most of these objects no longer exist, being used until they broke or thrown out because they were no longer in fashion.

LITERATURE
Leeuwenberg 1959, pp. 79-102; Halsema-Kubes 1968; cat. Amsterdam 1973, no. 37; exhib. cat. Zwolle 1980, pp. 51-55; Defoer 1994

25b Utrecht, c. 1510-1520, Mantel frieze with the Virgin and Child and two heraldic supporters; sandstone, 46 × 127 cm. Amsterdam, Rijksmuseum (inv. no. BK-NM-11962)

Mechelen, c. 1525

26 Antler woman (Leuchterweibchen)

walnut with some original polychrome decoration, antler, h 56 cm
Purchased in 1969
inv. no. BK-1969-1

The Germans use the words *Leuchterweibchen* of *Lüsterweibchen* to describe a very odd combination of an antler with a small sculpted figure suspended from chains or wires. The name is a little misleading, for not all the figures are women, nor are all *Leuchterweibchen* associated with light. The primary function of this one is as a heraldic supporter, for she holds a coat of arms bearing a rearing goat. One looks in vain for anywhere suitable to put candles.

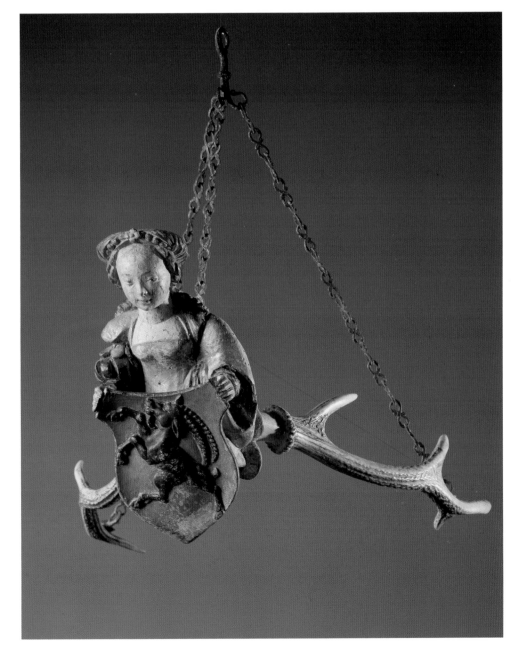

The history of this remarkable type of object is still far from clear. It was not restricted to Germany, as is so often assumed. Important specimens of antler chandeliers are also found in the southern Netherlands, which is the probable place of origin of this particular *Leuchterweibchen*, for the sculptural style is typical of Mechelen. The woman, wearing Renaissance garb with sleeves puffed out by the elbow and a turban, has the distinctively doll-like face of many statuettes of female saints produced in the town.

Little is known about the origin and significance of *Leuchterweibchen*. Early illustrations and archival documents confirm the presence of antler chandeliers in the Netherlands. A Bruges miniature shows a finished *Leuchterweibchen* lying on the counter of the workshop of the mythological sculptor Pygmalion [26a]. Such chandeliers are regularly listed in 15th-century inventories, such as the 'hanging hartshorn chandelabre' that was to be seen in the house of Derick van Ghoir of Deventer in 1494.

It turns out from the examples of antler chandeliers still *in situ*, in contemporary depictions or recorded in the archives, that they all had a secular use. There is just a single mention, from Germany, of one hanging in a church. Many of them probably had a ceremonial function, for they were found remarkably frequently in town halls. The 15th-century specimen in that of Diest played a part in an important political ritual—the transfer of the keys to the archive cabinet by the outgoing city authorities to their successors. The

26a Willem van Vreelant, The workshop of the sculptor Pygmalion. Miniature from Epitre d'Othea de la prudence, chef des royes, Bruges, c. 1460. Erlangen, University Library (Ms. 2361, fol. 34v)

presence of antler chandeliers in a 1559 drawing of Lady Justice by Bruegel, as well as in a sketch of an execution by Willem Buytewech of c. 1600, suggests that there was a connection with the administration of justice. Their frequent combination with heraldic devices, as in the Rijksmuseum, also points to an official use.

Perhaps the origins of the antler chandelier should be sought in the age of chivalry. Lordship of a manor had always brought with it the right to the chase, and what better way to publicising that privilege than by hanging up an antler as a hunting trophy in combination with one's coat of arms? Since the knight also had administrative and judicial powers, the association with the dispensation of justice is not strange. Like so many other knightly ideals and symbols, the *Leuchterweibchen* ultimately entered the late-medieval, urban culture as a way of proclaiming one's status.

LITERATURE
Leeuwenberg 1978; exhib. cat. Brussels 1991, pp. 308-309

Southern Netherlands, c. 1520

27 Crowning element of a wall tabernacle

Limestone with original polychrome decoration, h 51.7 cm
From the collection of Prince Karel of Belgium; purchased in 1985
inv. no. BK-1985-41

A monumental, sculpted retable is still high on the Rijksmuseum's shopping list, but since 1985 it has been able to display one of more modest dimensions, and one of exceptional quality and workmanship at that. It is a unique, late-Gothic relief of polychromed limestone, little more than 50 cm high, and given its size it could have been made for the purposes of private devotion. Small it may be, but within its confines it contains all the essential features of the large altarpieces made in the same period.

It consists of three compartments with round-headed arches, as so often found in altarpieces and votive reliefs from the early 16th century. The arches are filled with delicate Gothic tracery. The figures standing in the niches are the Virgin with the Child on her arm flanked by St Benedict of Nursia (dressed in black) and a figure who is probably identifiable as St Bernard of Clairvaux—the founders, respectively, of the Benedictines and the Cistercians, two related monastic orders. From left to right in the lower register, which would be called a predella on a large altarpiece, are the half-length figures of Sts Peter, John the Baptist and Paul. Finally, beneath the corbel on which the Virgin is standing is an Old Testament prophet holding a scroll as a symbol of his prophecy.

There are a few unusual aspects of this clear-cut iconography. In the first place there is an explicit reference to the sacrament of the Eucharist, for the Christ Child is holding a chalice and a host. The combination of Christ, the Virgin, the Eucharist and St Bernard of Clairvaux is

evidence of a connection with the theological tenets of the Cistercians. The veneration of the Eucharist was actually one of the principal features of Netherlandish Cistercian piety in the 15th century. Given this Eucharistic iconography and the presence of St Benedict, who established the monastic rule observed by both the Benedictines and the Cistercians, this is a typically Cistercian object.

The size of the relief might suggest that it was portable, but for the fact that the material is limestone. It was probably let into a wall, and might have been a votive stone or epitaph, partly because of the shape of the relief, but the iconography contains not a single reference to a donor, nor to death. It appears equally unsuited as an *Andachtsbild* for private devotion, for the scene contains little that would stimulate private prayer. Its most likely function was as the crowning element of a wall tabernacle, a space let into the wall of a church near an altar where the consecrated hosts were kept after Mass had been celebrated. That would accord not only with the Eucharistic message of this exceptional object, but also with its shape and size.

LITERATURE
Van Molle 1959; Browe 1967; Van Herwaarden 1982; Haarsma 1989

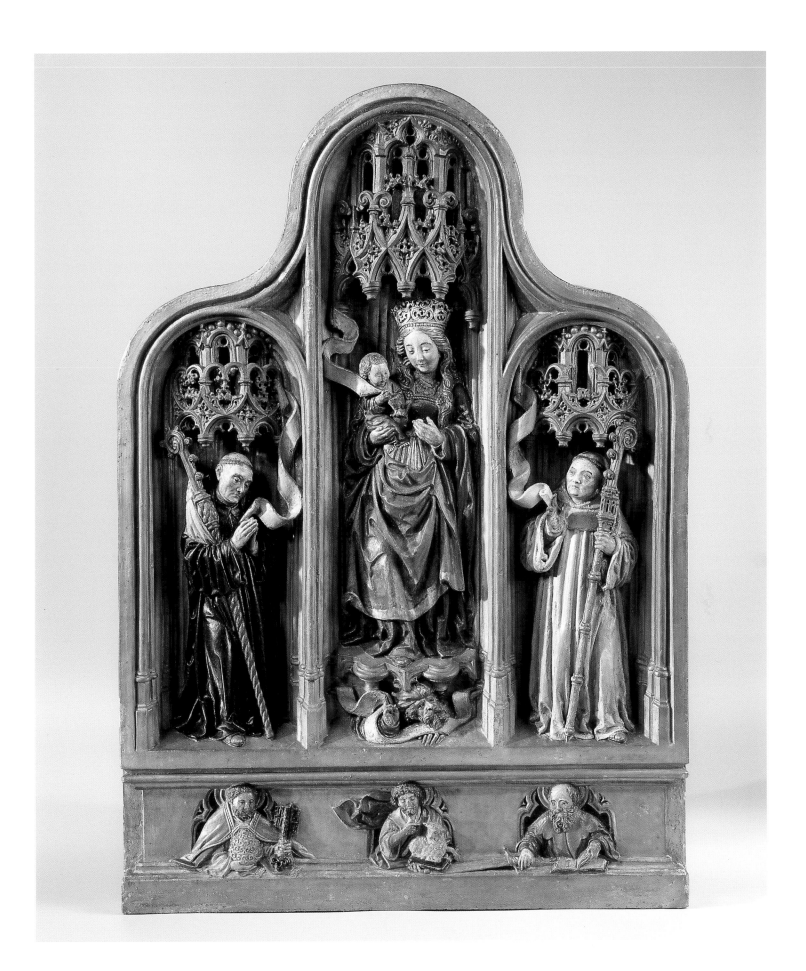

Holland or Brabant, c. 1515

28 The Flight into Egypt

Oak, h 42 cm
From collection of Baron Cassel, Brussels; purchased in 1955
inv. no. BK-1955-18

In this concise and expressively sculpted fragment of the Flight into Egypt, which must at one time have been part of a large retable with scenes from the life of Christ or with the Seven Sorrows of the Virgin, Joseph walks proudly in front while looking back at Mary and Jesus on the ass. From being the passive old man in the background of Nativity scenes he has moved centre stage.

Despite the immediacy and appeal of the scene, the Flight was not intended for private devotion, and anyway it was part of a much larger ensemble. Nevertheless, the medieval viewer could easily empathise with the plight of the Holy Family upon seeing this intimate, almost idyllic scene, in which one is barely aware of the many tribulations that dogged Joseph and his family. The 16th-century believer, though, familiar with all sorts of unpleasant details of the story of the Flight from carols, Christmas plays or apocryphal narratives, would have been well able to conjure up the dark side of the story. In 1400, for

instance, Dirc van Delf gave a graphic description in his *Tafel van den kersten ghelove* of the hardships on the journey through the desert to Egypt. 'The sun shone, and there was not a tree to be seen, there was parched sand and no well, the day's journey was long and there was no inn. Their drink went stale, their bread hardened, they had no food. The old man was thirsty, the young Virgin hungry, the small child tired, the she-ass sluggish.' Moreover, a long journey on foot with all its attendant dangers was an everyday experience for medieval people, and they would have been able to identify with Joseph, whom the carver accordingly depicted as a contemporary traveller with his possessions carried over his shoulder in a case on a forked stick.

There is little that can be said for certain about the origins of this group of figures. Certain similarities to a woodcut dated 1511 by Jacob Cornelisz van Oostsanen led to the assumption that it was made in the county of Holland around 1515. However, the lack of properly documented works from Holland makes this localisation rather unreliable. An alabaster *Flight into Egypt* that recently emerged on the art market is related to the oak group right down to the details [28a]. Comparison of the two reveals that the alabaster is probably a 19th-century copy of the group in the Rijksmuseum.

There are two points about the alabaster that broaden our knowledge of the oak version, Since alabaster was rarely worked in the northern Netherlands, the copy must come from Belgium, France or Germany. The Rijksmuseum group is from a Brussels collection, so perhaps an origin

in the southern Netherlands should not be ruled out. Stylistic parallels with sculptures from Louvain point in the same direction. Secondly, the stone group has an intact background, and given the care the copyist took to reproduce the Rijksmuseum figures one can take it that this is a fairly accurate representation of the setting in the original oak version.

LITERATURE
Mak 1958, pp. 251-276; cat. Amsterdam 1973, no. 51; Kammel 1994

28a Southern Netherlands, 19th century, *The Flight into Egypt*; alabaster with polychrome decoration, 34 × 45 cm. Whereabouts unknown

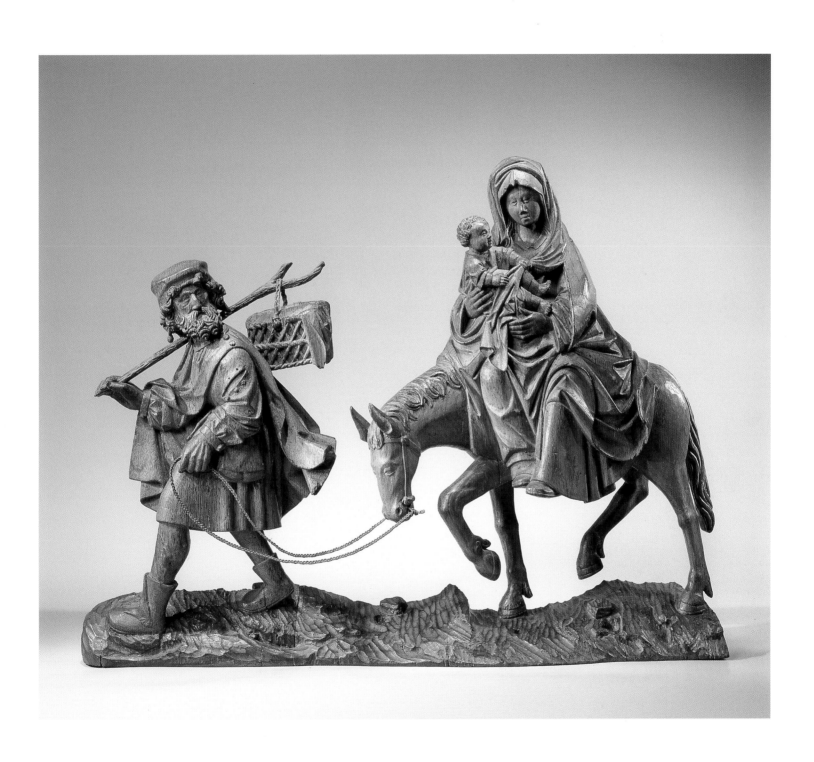

Master of Elsloo (active c. 1510-c. 1530)

29 *St Anne with the Virgin and Child, c. 1520*

Oak, the polychrome decoration removed, h 82.5 cm
Purchased from the collection of C. Guillon, Roermond, in 1874
inv. no. BK-NM-1278

In the late middle ages there was a great flowering of devotion to St Anne, the mother of Mary and grandmother of Christ. She was invoked in all sorts of short prayers, played a part in stories of miracles, had treatises devoted to her, and repeatedly appeared in works of art. One particularly

29a Circle of the Master of Koudewater, *St Anne with the Virgin and Child*, c. 1490-1500; oak, h 67 cm. Amsterdam, Rijksmuseum (inv. no. BK-NM-2537)

popular theme was St Anne with the Virgin and Child: grandmother Anne, mother Mary and the child Jesus united in a single composition. This visual type formed a condensed embodiment, as it were, of Jesus's descent in the female line, and is an implicit depiction of the theology of Mary's Immaculate Conception. St Anne was portrayed as an oversized seated figure with a slightly smaller Mary beside her or on her arm or lap, with Jesus as an infant in his mother's arms [29a].

In this version, which is attributed to the Master of Elsloo, that formalistically theological and unnatural composition has made way for a more realistic presentation. Mary and St Anne are standing side by side, more or less as equals, and turn slightly towards each other. By using the playful infant as the link between the two, the carver turned a stiff trio into an intimate family scene. Such a light-hearted device is encountered quite often in late 15th-century Netherlandish sculpture, by such artists as the Master of Joachim and Anne [8] and in other works by the Master of Elsloo. In his *St Anne with the Virgin and Child* in Maaseik, the infant Jesus in the Virgin's arms is eating grapes and actually creasing the pages of the open book on his grand-mother's lap. It is possible that the Rijks-museum's St Anne also held out a bunch of grapes to the Christ Child in her right hand (which has broken off) as a symbol of his later suffering. Such a display of everyday domesticity was closely connected with the late-medieval devotion to St Anne, in which associations with family life played a great part.

Why did St Anne, of whom there is not a single mention in the Bible, become such a popular saint in the 15th and 16th-century Netherlands? Her existence had long been known from several of the apocryphal gospels, among them the Protevangelium of James, the Pseudo-Gospel of Matthew, and the Gospel of the Birth of the Virgin. The latter was included in full in Jacob de Voragine's *Legenda aurea*, a collection of legends that was widely read in the late middle ages. The interest in St Anne was fanned by the theological hair-splitting between Dominicans and Franciscans, who quibbled over the question of whether Mary had been purified from original sin from the moment of her own birth ('immaculation') or only after conceiving Christ ('sanctification'). Her descent obviously played an important part in the debate, with the result that the spotlight suddenly fell on St Anne, the chaste matriarch.

Moreover, in the eyes of many late-medieval believers, St Anne's maternal and grandmaternal role made her the embodiment of several virtues relating to marriage and family life, particularly in the towns. She personified devoted mother-hood, the wisdom that came with her age, and chastity as a widow. She could thus evolve into a cherished example of motherhood. In the 15th century, St Anne became in a sense the 'Grand Mother' of late-medieval family life.

LITERATURE

Cat. Amsterdam 1973, no. 122; exhib. cat. Horst 1974; Brandenbarg 1990; exhib. cat. Uden 1992; exhib. cat. Sint-Truiden 1996, nos. 52-55

II The Renaissance, c 1515–1565

THE SEVENTEEN UNITED PROVINCES OF THE
NETHERLANDS, 1515-1565

Charles V, who was born in Ghent (1500-1559), became the ruler of the Habsburg Netherlands in 1515 *(fig. 55)*. The following year he inherited the Spanish crown, and in 1519 the Austrian Succession States and the imperial crown of Germany. Invested with such myriad power, he delegated the government of the Netherlands to regents. The first governor-general was his aunt, Margaret of Austria (1480-1530), who turned her court at Mechelen into a meeting-place for humanists and artists. In 1531 she was succeeded by Charles's sister, Mary of Hungary (1505-1558), who ruled from Brussels *(fig. 56)*. Stadholders, most of whom came from the southern nobility, governed the regions. Charles pursued the Burgundians' earlier attempts to centralise the realm and professionalise the bureaucracy at the expense of the nobles. It was under his rule, which was in fact exercised by Mary of Hungary, that the 17 provinces were unified. Between 1524 and 1543 he incorporated the territories of Friesland, Utrecht and the Oversticht, Groningen, Drenthe and finally Gelderland. In 1548 they all became an integral part of the German empire as the Burgundian *Kreis*.

The devastating war against Gelderland shattered the prosperity of the northern territories, but Brabant and Flanders flourished. Now that the Western Scheldt had replaced the river's eastern arm as the access route to the North Sea, Antwerp swiftly evolved into the mercantile metropolis and financial hub of western Europe. With its Iberian connection, it imported spices, silver and luxury goods from the Americas and Asia and sold them on to the nations of central Europe. An idea of the level of prosperity can be gained from the group portrait of the De Moucheron family *(fig. 57)*. Pierre de Moucheron (1508-1567), the son of a Norman noble, became a burgess of Middelburg in 1530 and built up a thriving trading company. In 1545, he moved his business to Antwerp.

In the north, Amsterdam had gradually acquired the monopoly of grain imports from the lands around the Baltic. The economic strength of the Low Countries provided an important source of taxation for Charles V, who was desperate for money to finance the debts run up during his costly wars. The worldwide network of contacts built up

fig. 54 Map of the Low Countries around 1530. Drawing: Guus Hoekstra

in the Low Countries created a climate of tolerance and curiosity about the unknown among broad sectors of the population, especially the rich merchants.

Charles V's reign was marked by the rise of humanism and reform movements in both Germany and the Low Countries. Humanism, which was closely related to the Renaissance and had one of its foremost advocates in Erasmus of Rotterdam,

had a major influence on intellectual circles in the Netherlands *(fig. 58)*. The many printers and publishers in the region ensured that this view of life and society was propagated throughout the Low Countries in the second half of the 16th century, especially among wealthy burghers, artists, merchants, scientists and military officers, who all put its principles into practice in their daily lives.

Of all the reform movements, Calvinism was the one that attracted fanatical and widespread support, especially in the south. Repression and persecution was fiercely resisted in the towns, but many people nevertheless fled to England and Germany. When he abdicated in 1555 *(fig. 59)*, Charles V's empire was divided between his brother Ferdinand, who became German emperor, and his son Philip II, King of Spain and Lord of the Netherlands. The young ruler left the Low Countries in 1559 and appointed his half-sister, Margaret of Parma (1512-1586), regent in his stead.

THE RENAISSANCE IN NETHERLANDISH ART
The influence of the Italian Renaissance began to make itself felt in the Low Countries in the early decades of the 16th century, and brought about a change in figurative vocabulary and ornamentation. The choice of subject also altered under the influence of humanism, with the emphasis in religious art shifting from devotional aspects to biblical stories. Nevertheless, altarpieces and works for private devotion continued to form a sizable part of artistic production until the Iconoclasm of 1566. Output was highly localised, with Antwerp playing a key role as the largest city in the Netherlands.

Mechelen was an important centre for sculpture. Works for private devotion were made there on a production line basis, and it was one of the first cities in the north to absorb the influence of the Renaissance. This was a direct result of Margaret of

fig. 55 Circle of Jan Cornelisz Vermeyen, *Portrait of Charles V,* c. 1550; oil on panel, ø 17.5 cm. Amsterdam, Rijksmuseum (inv. no. SK-A-979)

fig. 56 Netherlandish School (?), *Portrait of Mary of Hungary,* c. 1550; oil on panel, ø 9 cm. Amsterdam, Rijksmuseum (inv. no. SK-A-4463)

fig. 57 Cornelis de Zeeuw (attributed to), *Pierre de Moucheron with his wife Isabeau de Berbier and their eighteen children, their son-in-law Allard de la Dale, and their first grandchild,* 1563; oil on panel, 108 x 247 cm. Amsterdam, Rijksmuseum (inv. no. SK-A-1537)

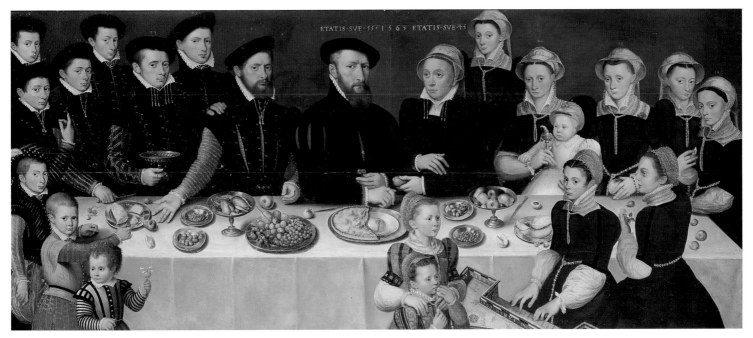

fig. 58 Albert Jansz Vinckenbrinck, *Statue of Desiderius Erasmus*,
c. 1650; oak, h 60 cm. Amsterdam, Rijksmuseum
(inv. no. BK-NG-NM-9281)

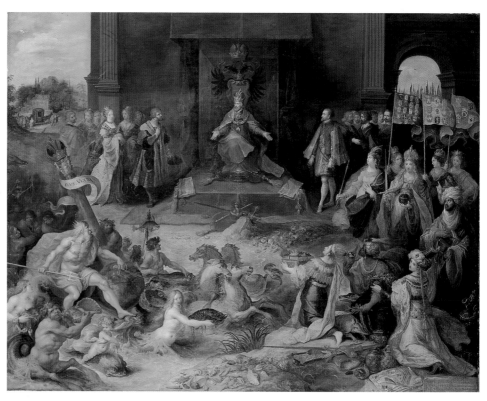

fig. 59 Frans Francken II, *Allegory of the abdication of Emperor Charles V at Brussels on 25 October 1555*,
c. 1620; oil on panel, 134 x 172 cm. Amsterdam, Rijksmuseum
(inv. no. SK-A-112)

Austria's decision to set up her court there in 1507. It attracted a number of foreign artists who sculpted in alabaster in the modern Italian manner, among them Conrad Meidt and Jean Mone. Their presence in the city acted as a spur to local carvers, who adopted the new formal vocabulary and material *[67]*.

Princely patrons were also responsible for the upsurge in tapestry weaving, one of the costliest forms of art *[39, 40, 58]*. In Brussels, the workshops of Pieter van Aelst, Willem de Kempenaer, Willem de Pannemaker and others made tapestries of wool, silk, and gold and silver thread after cartoons by artists like Bernard van Orley, Pieter Coecke van Aelst, Michel Cocxie and Jan Vermeyen.

Antwerp took a leading role as the home of painting and sculpture. Until 1585, it also had a virtual monopoly of printmaking and book production. In the second half of the century, Antwerp print publishers like Hieronymus Cock, Gerard de Jode and Philips Galle built up immense stocklists of prints after designs by contemporary artists, both Italian and Netherlandish.

The manufacture of luxury goods, blown glass *[64]* and majolica *[65]* was imported from Italy, with Italians being lured to the city to impart their

knowledge to local artists.

Antwerp also played an important part in the production of stained glass. Thanks to works that have been preserved in France and England it is possible to get some idea of the creations of famous glass designers like Arnold van Nijmegen, who was in Antwerp from 1513 to 1538, and Dirck Jacobsz Vellert, who was active there between 1511 and 1547. There is a more plentiful surviving stock of the glass panels produced during this period in Antwerp and elsewhere *[37, 38, 60]*.

The vast output of sculpted retables in Antwerp has already been mentioned. The workshops of so-called Antwerp Mannerists concentrated on the large-scale production of paintings.

One artist who played a key part in bringing the Renaissance style to the Netherlands was Jan Gossaert van Mabuse, who was born around 1478 and travelled to Italy in 1509 with Philip of Burgundy, later to be Prince-Bishop of Utrecht. The trip brought Gossaert face to face with the art of classical antiquity, and he was the first to include lifesize nudes in his paintings *(fig. 60)*. He was active in Antwerp, Utrecht and Middelburg as Philip's court painter *[35]*. Other prominent painters from Antwerp were Quinten Massys (1466-1530)

(fig. 26) and Joos van Cleve (c. 1490-1540). Joachim Patinir (c. 1475-1524) was the first painter to specialise in landscape, and his lead was followed by Herri met de Bles (c. 1510-1550) *[76]*. The great workshops in Antwerp were now those of Frans Floris (1520-1570), Jan Sanders van Hemessen (c. 1500-1565) *[57]* and Pieter Aertsen (1509-1575) *[81]*, who returned to his native Amsterdam in the 1550s. With their cornucopian displays of food, he and his pupil Joachim de Beuckelaer took an important step on the path towards the still life *pur sang [82]*.

In Bruges it was Jan Provoost (c. 1465-1529) and Adriaen Isenbrant (ca 1490-1551) *[36]* who preserved the Gerard David tradition until well into the 16th century. One large studio in Brussels was run by Barend van Orley (1492-1542), court artist to Margaret of Austria and Mary of Hungary, and it was continued by his pupil Pieter Coecke van Aelst (1502-1550). Both were also leading tapestry designers. Jan Vermeyen of Haarlem (1500-1559) was another who was in Margaret of Austria's service, and in 1534 he accompanied Emperor Charles V on his Tunis expedition *[55, 56]*. Pieter Bruegel the Elder, who made such a vital contribution to genre and landscape painting, was also active in Brussels *[77]*.

Even though workshops were now smaller and their output more limited, there was at least one painter or shop in almost every northern town. Jan Mostaert of Haarlem (c. 1475-1554) continued painting in the late-Gothic mode until well into the 16th century [20]. Another rather conservative shop was run by Jacob Cornelisz van Oostsanen (c. 1472-1533) in Amsterdam [33, 42, 50], and then by his son Dirck Jacobsz (c. 1497-1567).

The Leiden school entered onto a fruitful period at the beginning of the 16th century with painters like Cornelis Engebrechtsz [43] and his pupils—among them Lucas van Leyden, who built up an international reputation as printmaker and painter [44-47]. It is known that his imposing altarpiece of *The Last Judgement* in the Lakenhal Museum in Leiden was painted in 1526-1527 for the wealthy timber merchant Claes Dircksz van Swieten *(fig. 61)*. The influence of the Italian Renaissance is evident in the large, daring nudes dominating the scene with their animated gestures and poses.

Jan van Scorel (1495-1562), who trained in the studio of Jacob Cornelisz van Oostsanen, was in Italy from 1520 to 1524. He brought the Italian Renaissance style back with him when he returned to Utrecht, where he was made a canon in 1524 and headed what must have been quite a sizable

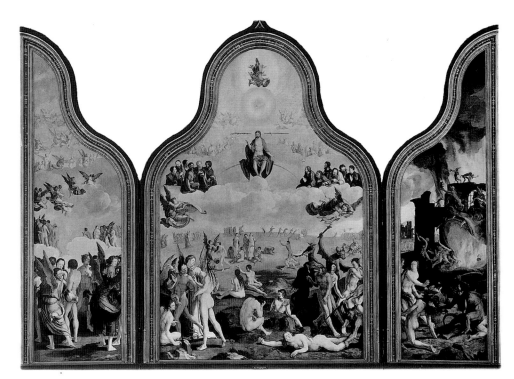

fig. 61 Lucas van Leyden, *Triptych with the Last Judgement*, 1526-1527; oil on panel, central panel 269.5 x 185 cm, wings 265 x 76 cm. Leiden, Stedelijk Museum de Lakenhal (inv. no. 244)

workshop [51, 53]. Large altarpieces were executed for churches in Utrecht and Delft under Scorel's supervision, and even for Marchiennes Abbey near Douai in northern France. His pupil Maarten van Heemskerck (1498-1574) spent the period 1532-1536 in Italy, and returned to Haarlem with sketchbooks filled with drawings after the antique, which he used extensively in his work thereafter. In addition to being a skilful portraitist [52] and painter of monumental altarpieces and mythological scenes, he designed hundreds of prints [73]. Another Utrecht artist and pupil of Jan van Scorel was the celebrated portrait painter Antonis Mor van Dashorst (c. 1517-c. 1575), who worked at many European courts [71].

One of the most ambitious artistic under-takings in the second half of the 16th century was the programme of stained glass-windows for the Church of St John in Gouda that was carried out between 1555 and 1603, among others by the brothers Wouter and Dirck Crabeth [59].

FURTHER READING
Post 1954; Friedländer 1967-76; exhib. cat. Amsterdam 1986; Kloek *et al.* 1986; Vos/Leeman 1986; Israel 1995

fig. 60 Jan Gossaert van Mabuse, *Neptune and Amphitrite*, 1516; oil on panel, 188 x 124 cm. Berlin, Staatliche Museen zu Berlin, Gemäldegalerie Preussischer Kulturbesitz (cat. no. 648)

Mechelen, c. 1525

30 St Sebastian

Walnut with original polychrome decoration, h 121 cm (with console)
From the Onze Lieve Vrouwen Gasthuis in Mechelen; purchased by the
Commissie voor Fotoverkoop in 1971
inv. no. BK-1971-50

The sculptor has not portrayed the saint in his usual, tormented pose. High realism has made way for a certain Mannerist tendency expressed in the elegant curve of the body and Sebastian's cherubic, resigned countenance. Here one detects the traces of a new artistic approach inspired by Italian models. Mechelen was one of the first northern centres of art to absorb the influence of the Italian Renaissance. The city owed its role as trailblazer to the fact that it had been the capital of the Netherlands since 1507, the year in which Margaret of Austria, regent of the Netherlands, set up her court in Mechelen. It attracted several leading artists who worked in the modern, Italian manner. The carver of *St Sebastian* had sampled the influence of this court art, and embodied some of its features in this statue.

Sebastian lived during the reign of Emperor Diocletian, a fanatical persecutor of Christians. He was an officer in the imperial guard until he was unmasked as a Christian and condemned to death. Riddled with arrows in the amphitheatre, he survived thanks to the ministrations of a Christian woman. Sebastian made no secret of his faith, and was again arrested and this time clubbed to death.

His great popularity as a saint (he has been venerated since the 4th century) reached a pitch in the middle ages. Like St Roch, he was regarded as a protector against the plague—an arrow being the symbol of that epidemic disease. Sebastian's martyrdom also presented artists with a welcome opportunity to depict the male nude, which often resulted in sensual and rather unrealistic images, as is the case here.

The presence of a civic coats of arms consisting of three bars branded into the wood firmly identifies this as a product of Mechelen [30a], and a very unusual one at that. Most of the local statues in the 16th century were small (no more a few decimetres high): Virgins, infant Christs and saints made for private devotion. Given its size, *St Sebastian* must have had a public function. Exceptionally, it has proved possible to establish its original provenance. It is a seamless match with a series of four other male saints that also bear the Mechelen stamp and stand on similar consoles: Sts Anthony, Christopher, Roch and Adrian [30b]. What unites these five saints is their role as protectors of the sick. In 1857/58 they were installed in Mechelen's newly finished Onze Lieve Vrouwen Hospital, which was originally a medieval convent. It seems likely that St Sebastian and the four others were originally made for an infirmary.

LITERATURE
Halsema-Kubes 1971; cat. Amsterdam 1973, no. 172

30a Detail of the revers: the brand with the three bars of the Mechelen coat of arms

30b Mechelen, c. 1525, *St Anthony*; walnut with polychrome decoration, h 73 cm. Mechelen, Museum van de Commissie voor Openbare Onderstand

Hendrick Douwerman (c. 1480-1543/44)

31 St Ursula, Lower Rhine (Cleves), c. 1520

Oak, the polychrome decoration leached off, h 93 cm
From the collection of Sir Arthur Conan Doyle; purchased upon the retirement of
Dr A. van Schendel as Director of the Rijksmuseum in 1975
inv. no. BK-1975-70

It was not until the 19th century that the riches of Kalkar Church were rediscovered. Art-loving tourists and scholars were particularly intrigued by the work of the wood-carver Hendrick Douwerman, and were fascinated by the well-nigh impossible technical mastery that Douwerman displayed in his masterpiece, the *Seven Sorrows* altarpiece executed in 1518-1522. Although he worked with tough, unyielding oak, he achieved spatial effects that really can only be created in limewood and other softer kinds of wood.

Douwerman's *Saint Ursula* in the Rijks-

31b Hendrick Douwerman, *The Tree of Jesse*. Predella of the *Seven Sorrows altarpiece*, 1522. Kalkar, Church of St Nicholas

31a Hendrick Douwerman, *Virgin and Child*, c. 1510; oak, h 120 cm. Amsterdam, Rijksmuseum (inv. no. BK-Br-543c)

museum is stylistically close to the Kalkar altarpiece, so must be dated around 1520. The saint is standing on a base covered with vegetation and is reading from what is known as a satchel book. She originally held an arrow in her right hand as the attribute of her martyrdom. Seven small female companions are clustered around Ursula's feet and in the folds of her garment. These fashionably dressed miniature maidens are a few of the 11,000 virgins with whom Ursula, the daughter of an English king, went on a pilgrimage to Rome. On their return journey they were all slaughtered by the Huns near Cologne. The citizens buried Ursula and her companions and founded a church in their honour.

Despite the care with which Douwerman carved his statues, he was often undiscriminating in his choice of wood. That applies to this *St Ursula*, which has some very obvious pegs and inserts, and even more so to another of his statues in

the Rijksmuseum, a *Virgin and Child* [31a]. By contrast, the wood of his Kalkar altarpiece, which was never polychromed, was very carefully selected and carved [31b]. Douwerman probably reserved the best wood for works that were not going to be polychromed, and was less concerned about those that were. This indicates that he ran an economical shop, which was essential for a prolific artist who had to contend with fierce competition. It can be deduced from this that *St Ursula* was also given a colourful finish, which was probably leached off in the 19th century to conform to contemporary taste.

The decision whether or not to paint statues was a very pertinent one in Douwerman's day. There was a growing appreciation of monochrome, unpainted wood in the late 15th century. This altered taste was not due solely to the question of expense. Although polychromy was extremely costly, often more so than the

actual work of carving, patrons also had
aesthetic reasons for leaving the wood
unpainted, since it allowed the form to
speak for itself. Douwerman found a very
subtle compromise in the Kalkar *Seven
Sorrows altarpiece*. Only the three crucified
bodies of Christ and the thieves in the lofty
Cavalry scene have been given flesh tones,
and Christ hangs on a golden Cross. This
scene, which is the centrepiece of the altar,
thus stands out amidst the unpainted
riches of the other carvings.

LITERATURE
Halsema-Kubes 1975; Hilger 1990; exhib. cat. Aachen 1996,
no. 24

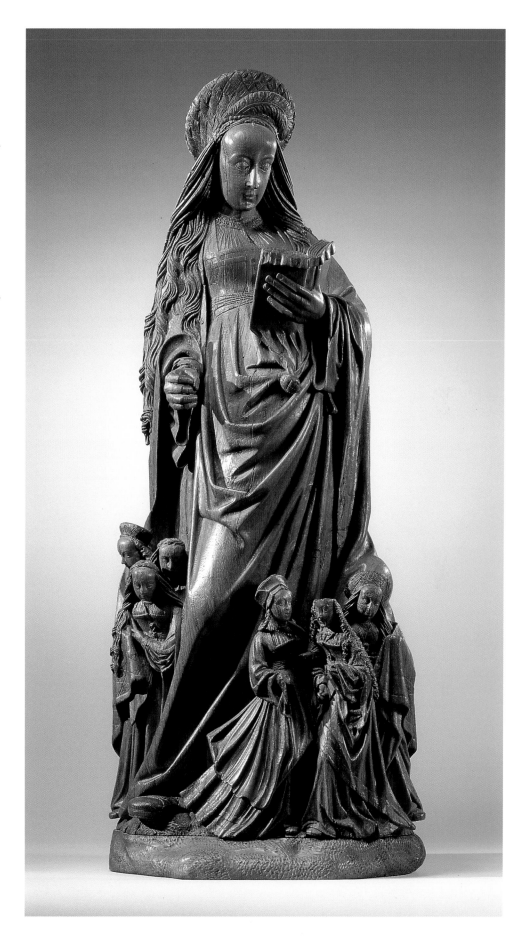

Adam Dircksz (active in the southern Nederlands around 1500) (attributed to)

32 Prayer-nut with the Carrying of the Cross and the Crucifixion on the inside, c. 1500

Boxwood, ø 4.6 cm
Made for Evert Jansz van Bleiswijk (1460-1531) of Delft; purchased in 1981 from the heirs of the
writer Marcellus Emants
inv. no. BK-1981-1

Lay piety became increasingly intense at the end of the middle ages. This is apparent not only from all sorts of written sources, such as prayer-books and devotional tracts, but also from the output of small-scale religious art. In order to satisfy the growing market of lay spirituality, artists produced a variety of devotional artefacts in the form of small, often portable objects that would assist in prayer and meditation. Outstanding Netherlandish examples of this form of devotional art are the micro-carving in boxwood of miniature altarpieces [32a], tabernacles, memento mori in the form of skulls and coffins, knife handles, and above all rosary beads and

prayer-nuts. The latter are small wooden spheres (not nuts at all) consisting of two hinged halves that can be opened and closed.

The outside of the Amsterdam rosary bead is decorated with delicate Gothic tracery, and the nut opens to display two minuscule Passion reliefs: the Carrying of the Cross and the Crucifixion. The reliefs were made from separate pieces of wood which were then fixed inside the hollow hemispheres of the nut with tiny nails, a small space being left between the inner wall of the nut and the relief. Originally the nut would have had an eye mounted on the top. The Rijksmuseum specimen is

exceptional in that it still has its copper case and velvet pouch [32b].

These little objects command respect for their tiny size and the wealth of minutely carved details, and they would have been treasured both for their artistic virtuosity and their cachet as luxury items. Possession of one was the privilege of rulers, noblemen and rich burghers.

It is still not known precisely where in the southern Netherlands this 'carving by the millimetre' was carried out, nor in how many workshops. One prayer-nut is signed DAM THEODRICI ME FECIT, so the maker's Dutch name would have been Adam Dircksz.

32a Flanders, c. 1520, Miniature altarpiece with The Virgin and Child; boxwood, h 15 cm. Amsterdam, Rijksmuseum (inv. no. BK-Br-946-H)

32b The prayer-nut closed, with its velvet pouch and copper case. Amsterdam, Rijksmuseum (inv. no. Bk-1981-1)

The Amsterdam nut is closely related to
that signed work. The size, images and
lettering are virtually identical, so Dircksz
can also be regarded as the maker of the
Amsterdam piece. Interestingly, too, the
name of its first owner is known. On the
outside is the inscription 'eewert ian z'
va(n) bleiswick' and two coats of arms—a
combination that identifies him as Evert
Jansz van Bleiswijk, a Delft patrician. The
coats of arms are his own and that of his
wife, Erkenraad van Groenewegen.

LITERATURE
Leeuwenberg 1968; cat. Amsterdam 1973, no. 131; Marks
1977; Mesenzeva 1978; Falkenburg 1994

Jacob Cornelisz van Oostsanen (Oostzaan ? c. 1472-Amsterdam 1533)

33 Triptych with the adoration of the magi, donors, and Sts Jerome and Catherine; Sts Christopher and Anthony on the reverse, 1517

Oil on panel, 83 × 56 cm (central section) and 83 × 25 cm (wings)
From the collection of King Willem II; on loan from Mr and Mrs J. William Middendorff II, Washington, from 1973; acquired in 1978 with the aid of the Vereniging Rembrandt and the Prins Bernhard Fonds
inv. no. SK-A-4706

Viewers of Jacob Cornelisz van Oostsanen's *Adoration of the magi* in the Rijksmuseum are both missing and gaining something compared to the faithful of Van Oostsanen's day. In its original position in the church, it was closed for most of the year, and all that could be seen were the two grisailles of Sts Christopher and Anthony [33a] on the backs of the shutters. They are hidden from sight in the present, open arrangement. Back in the 16th century, the triptych was only exhibited on major feast days (and certainly on 6 January, the feast of the Epiphany), briefly revealing the painting in all its glory.

This is a private memorial, a painted *in memoriam* for the donors—in this case a distinguished couple with a large clutch of children. Several of the latter have identical faces, so it is likely that they died very young. The triptych was probably returned to the family when the churches were Protestantised in the 1570s, but since it is not badly damaged it may have been taken to a place of safety by the donor's descendants before the Iconoclasm broke out. Later, when it was evidently felt necessary to stress the noble descent of all branches of the family, the coats of arms

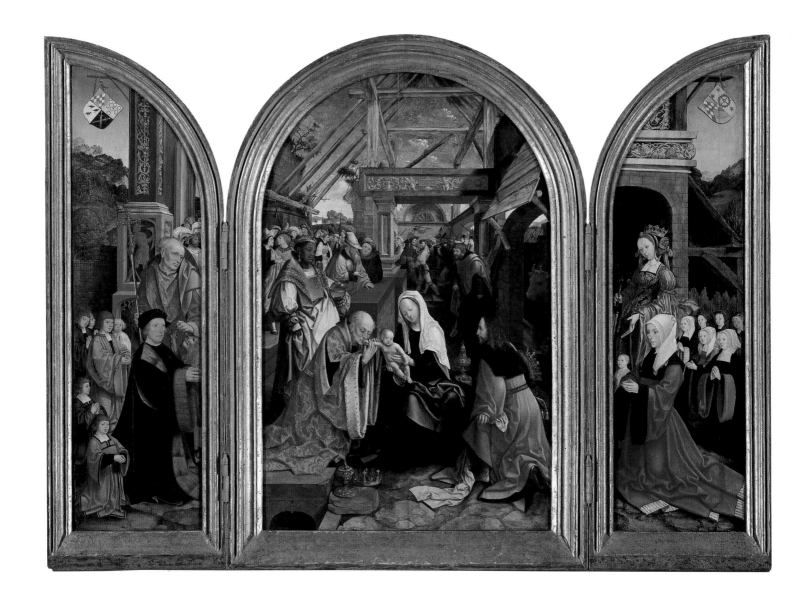

were altered, making it impossible to identify precisely who the donor was. Because Jacob Cornelisz's clientele came almost exclusively from Amsterdam, he would undoubtedly have been a respected burgher of that city. The splendid, fur-lined gown (known as a *tabbaard*) that he is wearing makes it clear that he belonged to the highest civic circles. He can perhaps be identified as the apothecary Claes Bouwensz, who had numerous children and was also one of the forefathers of the family bearing the principal coat of arms.

Jacob Cornelisz made nifty use of an invention he had come up with a decade previously. The Virgin seen from the front is presenting the Child to one of the Magi on the left in such a way that he can kiss its hand. The artist had employed that motif in a woodcut in a series illustrating the life of the Virgin [33a]. Those woodcuts served as models for other artists—possibly embroiderers, sculptors or decorative painters. In this case, though, he re-used his own compositional device. Sixteenth-century viewers very probably did not spot the repetition, but even if they did it would not have affected their appreciation of the work. The originality of a composition was not yet considered very important, and was certainly less highly prized than the wealth of colour and delicate finish.

LITERATURE
Friedländer 1967-76, vol. 12, no. 239; exhib. cat. Amsterdam 1958, no. 107; Kloek 1989; Dudok van Heel 1996

33a Jacob Cornelisz van Oostsanen, *Christ taking leave of his mother*, c. 1507; woodcut (St. 28) from a series illustrating the life of the Virgin, c. 20 × 12 cm. Amsterdam, Rijksmuseum (inv. no. RP-P-1927-306)

Amsterdam or Leiden, c. 1525

34 Hood of a cope embroidered with the Debate of St Catherine of Alexandria

Linen, embroidered with gold thread, silk and pearls in long and short stitch with laid and couched work, 53 × 49 cm
Acquired in 1921 from the Old Catholic Church of St John the Baptist in Gouda
inv. no. BK-NM-12713

This shield-shaped piece of embroidery once adorned the back of a cope or pluvial, an overgarment worn by priests at non-Eucharistic functions like Vespers. In its earliest form it was a Roman rain-cloak with cowl, the shape of which is echoed by the hood.

Embroidery on church vestments usually took the form of a narrative in medieval times. This particular scene depicts an event from the life of St Catherine of Alexandria. Under the watchful eye of Emperor Maxentius she is summing up the arguments for her belief in Christ, counting them off on her fingers in accordance with the rules of classical rhetoric. Her audience of philosophers from Alexandria whom the emperor had summoned to put Catherine's faith to the test, are gesturing animatedly. The debate is taking place in a palace chamber dominated by Maxentius's throne. The scene is closed off at the top by a late-Gothic arcade. At the lower edge, fore-shortened benches on the left and right and the Bible in the middle lead the eye to the centre of the scene.

Certain pictorial features, the manner of execution and the provenance suggest that both the subject and embroidery of the hood can be attributed to a workshop in the northern Netherlands, probably in the county of Holland. It is difficult to identify the town, because several of them had leading embroidery workshops. Both Amsterdam and Leiden have been suggested. The expressiveness of the scene displays an affinity with the work of Jacob Cornelisz van Oostsanen, who was active in Amsterdam [33], but attention has also been drawn to the stylistic similarities to the print oeuvre of Lucas van Leyden. Jacob Cornelisz seems to be the most likely contender, though, because he is regarded as the designer of several other embroidered vestments that are clearly related to this one.

LITERATURE
Steinbart 1921; exhib. cat. Amsterdam 1986, no. 26; exhib. cat. Utrecht 1987, no. 38; Van Eck 1994, p. 42

Jan Gossaert van Mabuse (Maubeuge ? c. 1478-Middelburg 1536)

35 The Virgin and Child with saints, c. 1511

Black chalk, 42.5 × 31 cm ; annotated at lower left: P. Aelst (pen in brown)
From the collection of P. Baderou, Paris; purchased in 1949
inv. no. RP-T-1949-488

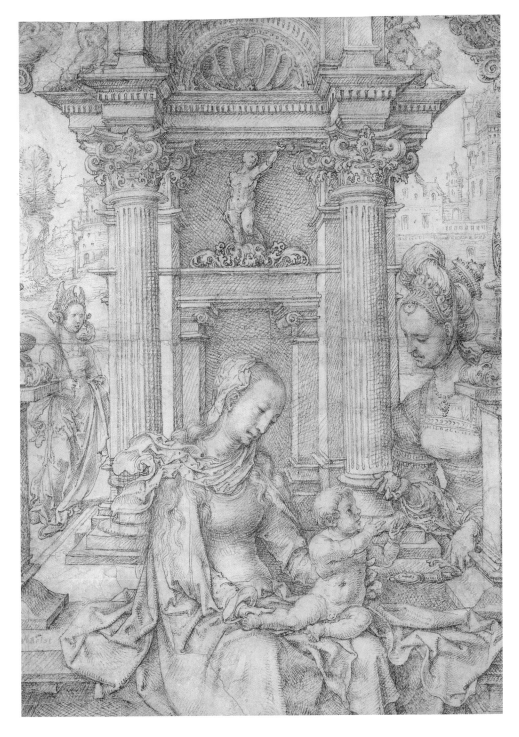

Karel van Mander stressed the innovative nature of Jan Gossaert's art as follows: 'He visited Italy and other countries and was at least one of the first to have brought the correct manner of composing and making pictures full of nudes and all kinds of allegories from Italy to Flanders, which things were not so common in our country before his time'.

Gossaert did indeed paint mythological scenes with large nude figures which must have regarded as outrageously 'modern' at the time (fig. 60). That, though, is just one aspect of his oeuvre. When the subject demanded it—chiefly in religious scenes—he was perfectly capable of employing a far more conventional idiom, quoting freely from the work of great 15th-century masters like Jan van Eyck, Rogier van der Weyden and Hugo van der Goes.

Gossaert's drawings also fall into 'Gothic' and 'Renaissance' groups. This *Virgin and Child with saints*—St Barbara on the left and probably St Catherine of Alexandria on the right—clearly belongs to the first category. The fact that this is not the work of a 15th-century artist can only be deduced from the ornamentation of the structure behind the Virgin, which has obvious Renaissance features. The drawing is usually dated around 1511, a few years after Gossaert's return from Italy.

A common element in Gossaert's work is the lack of depth, which gives the impression that the figures are herded uncomfortably close together in a cramped space. Also typical of Gossaert is the size of the hands, which are far too small in relation to the heads.

The *Virgin and Child with saints* is one of two chalk drawings that are attributed to Gossaert. The modelling of the figures in the Rijksmuseum sheet is suggested with a dense network of short cross-hatchings—a method that is also found in a number of Gossaert's pen drawings. It seems that he felt rather ill at ease with chalk and was experimenting with the technique that was

familiar to him from his pen drawings.

The drawing has probably been trimmed on all sides, for the chalk lines extend right up to the edge of the sheet. It is impossible to say for certain what the original function of this drawing might have been. There are *pentimenti* here and there, areas where the artist corrected his initial version, so the drawing was more probably a design for a painting than a drawn copy of a finished one. It is possible that this large, carefully detailed design was meant to be submitted for a patron's approval.

LITERATURE

Boon 1953, pp. 65-71, exhib. cat. Rotterdam/Bruges 1965, no. 49, cat. Amsterdam 1978, no. 285

Adriaen Isenbrant (active in Bruges c. 1510; died 1551) (attributed to)

36 Virgin and Child

Oil on panel, 61 × 41.5 cm
From the collection of Thomas Baring, Earl of Northbrook; bequeathed by Mr and Mrs I. de Bruijn-van der Leeuw, Muri, 1960
inv. no. SK-A-4045

This *Virgin and Child* has long been given to Adriaen Isenbrant, a painter from Bruges, although serious doubts are now being cast on that attribution. Isenbrant was certainly a pupil of Gerard David, but nothing at all is known about how he painted. The picture was definitely executed in Bruges by a master who relied heavily on Gerard David for his figures, whether he was Isenbrant or another of David's pupils. He also took great care over the ornamentation, which is of a type used around 1520.

The Virgin is seated rather casually on a bench and holds the Christ Child on her right arm. She has placed its cheek against her own, and it is stroking her chin. The artist undoubtedly borrowed this cheek-to-cheek motif from Gerard David, although it had actually been introduced back in 1450 by Rogier van der Weyden, who in turn took it from an early Italian model. The drapery folds are rather harsh; long folds break, as it were, and then crease in an orderly way. In this, too, the master was closely following the earlier Flemish painters. Mary is wearing a magnificent green gown and is seated in architectural surroundings painted in different shades of grey, which makes her the focus of attention. The ornamentation serves merely to provide a sumptuous and worthy throne for the Saviour's mother.

The artist was more interested in the details of the architecture than in its basic forms. There is a triangular niche in the wall behind the Virgin decorated with cornices, pilasters and circular openings let into the walls. These elements are surrounded by lavish ornamentation in the form of foliate motifs, horns and rams' heads. This decoration includes geometrical shapes reflecting the renewed interest in classical design.

Renaissance ornaments were chiefly used in Flanders within the formal language of the Late Gothic. That elegant style was enriched around 1500 with a variety of curling foliate motifs, S-shaped ornaments and delicate tracery patterns. These were supplemented with Renaissance forms like pediments and columns with classical capitals, although these did not dictate the principal form of the architecture. The transition from the Gothic to its exuberantly ornamented form known as the Flamboyant Gothic, and then to the architecture of the Renaissance took place more gradually in the Netherlands than in Italy, and contained several transitional phases that are not usually distinguished in overviews of the main architectural styles.

LITERATURE

Friedländer 1967-76, vol. 11, pp. 47-58, no. 173; Wilson 1995; exhib. cat. Bruges 1998, no. 48

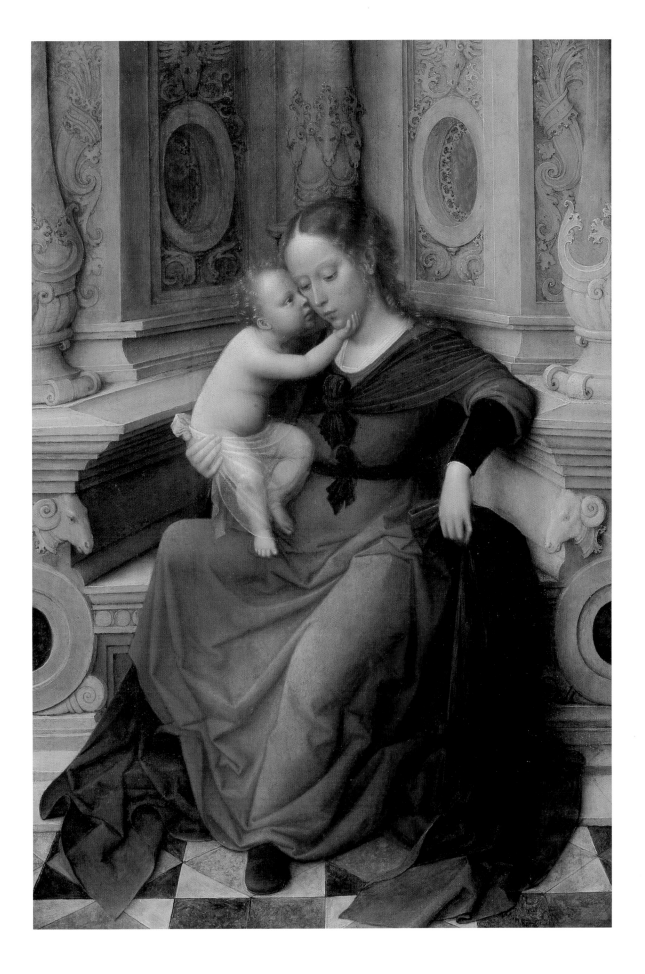

Dirck Jacobsz Vellert (Amsterdam c. 1480/85-Antwerp 1547)

37 The triumph of Faith, 1517

Pane of clear, lightly tinted glass, painted in grisaille, ø 22.2 cm
Acquired in 1966
inv. no. BK-1966-58

Dirck Vellert, who was born in Amsterdam and became a member of the Antwerp Guild of St Luke in 1511, was one of the foremost designers and painters of stained glass. Almost all of his monumental work has been lost. The only surviving ensemble is the series of windows that he designed in 1517 for King's College Chapel, Cambridge.

Those windows, the pane in Amsterdam and the Triumph of Time [37a] are Vellert's earliest dated works. The series to which both the individual panes belonged, probably consisting of six in all, was based on the famous poem I Trionfi by Francesco Petrarca (1304-1374) describing the six triumphs of Love, Chastity, Death, Fame, Time and Faith in that order, with each successive concept vanquishing the previous one. The series was depicted on other stained-glass panes [60] and on tapestries [39].

The Amsterdam pane is painted with a fine brush in grisaille-like tones ranging from pale grey to dark brown. It and the Triumph of Time are the only panes by Vellert that contain no silver stain yellow. There is a very sparing use of the burin, chiefly in the angel's hair and wings. The painterly style is achieved by the refined combination of these techniques and the marked tonal contrasts between the dark and light passages.

A triumphal car rides past a mountainous landscape with a town in the background. Seated on the car is Faith, symbolised by the Holy Trinity. It is preceded by the attributes of the four evangelists —Matthew's angel, Mark's lion, Luke's bull and John's eagle, jointly representing the New Testament. The three-wheeled car, the Trinity, is drawn by the apostle Bartholomew,, recognisable from his knife, and St Paul (largely hidden by the angel), who holds up a book in his right hand. The angel is pointing out the way to the saints, prelates and ordinary citizens crowding behind the car.

Vellert based his scenes of the triumphs on 15th-century Italian engravings of the same subjects. The glass panes have a pseudo-classical look, with the Triumph of Time echoing prints after Mantegna.

The intended location of this series of panes is not known, but they may have been made for the home of someone who was interested in humanism. It is known, for instance, that panes depicting the triumphs were part of the decoration of the dining-room of the scholar Jerome van Buysleden in Mechelen.

LITERATURE
Exhib. cat. Haarlem 1986, pp. 36-66; Konowitz 1987, pp. 22-23; Wayment 1988, p. 90, no. 40; Konowitz 1992; exhib. cat. Antwerp 1993, no. 50a; exhib. cat. New York 1995, no. 68; Konowitz 1995, p. 142; Ritsema van Eck 1999, pp. 44-47 and p. 103, no. 17

37a Dirck Vellert, The triumph of Time, c. 1517; glass roundel, ø 20 cm. Brussels, Koninklijk Museum van Kunst en Geschiedenis (inv. no. 5956)

Dirck Jacobsz Vellert (Amsterdam c. 1480/85-Antwerp 1547)

38 The judgement of Cambyses, 1542

Pane of clear, lightly tinted glass, painted in grisaille and silver stain yellow, ø 27.9 cm
Acquired in 1931
inv. no. BK-14517

This, Vellert's last dated pane of glass, is painted in medium to dark-brown grisaille combined with silver stain yellow in tones from golden yellow to a deep, reddish yellow. It is interesting to see how Vellert had matured as an artist since his Triumph of Faith of 1517 [37]. That crowded composition has made way for a well-ordered mise en scène in which the figures have been placed in the picture space in an entirely credible way.

The Judgement of Cambyses was frequently depicted in 15th and 16th-century Netherlandish art as an exhortation to pursue justice and virtue. The story was first recorded by Herodotus in the 5th century BC, with a second version following later from the pen of Valerius Maximus. A 14th-century variant of the latter account was included in the Gesta Romanorum. The story takes place in the 6th century BC, and relates how the corrupt judge Sisamnes, who had been taking bribes, was ordered to be flayed alive by King Cambyses of Persia.

The glass pane brings together three episodes in the story. On the left is Sisamnes bowing his head before Cambyses, who is standing in the centre in front of a pillar with a sceptre, pointed hat and ermine shoulder cape, or tippet. In the foreground, two executioners are carrying out the gruesome flaying of the naked, highly foreshortened Sisamnes. Seated on the judgement seat in the left background is Otanes, Sisamnes' son and successor. Hanging above him as a warning for all to see is his father's skin, to which Cambyses is gesturing imperiously. Outside the window the public looks one in interest

and revulsion. The axe leaning against the righthand pillar symbolises justice.

Many public rooms in town halls were decorated with paintings and tapestries depicting the Judgement of Cambyses. In 1498, for instance, Gerard David painted a diptych of the subject for the magistrates' chamber in Bruges Town Hall (it is now in the Groeningemuseum, Bruges). Certain details identify the written version of the story from which it was taken.

Vellert based this pane on the later account in the Gesta Romanorum, which states that Cambyses ordered Sisamnes' skin to be hung above Otanes' seat.

LITERATURE
Wayment 1972, pp. 19, 70; Konowitz 1987, p. 11; exhib. cat. New York 1995, no. 80; Ritsema van Eck 1999, pp. 54-57, no. 20

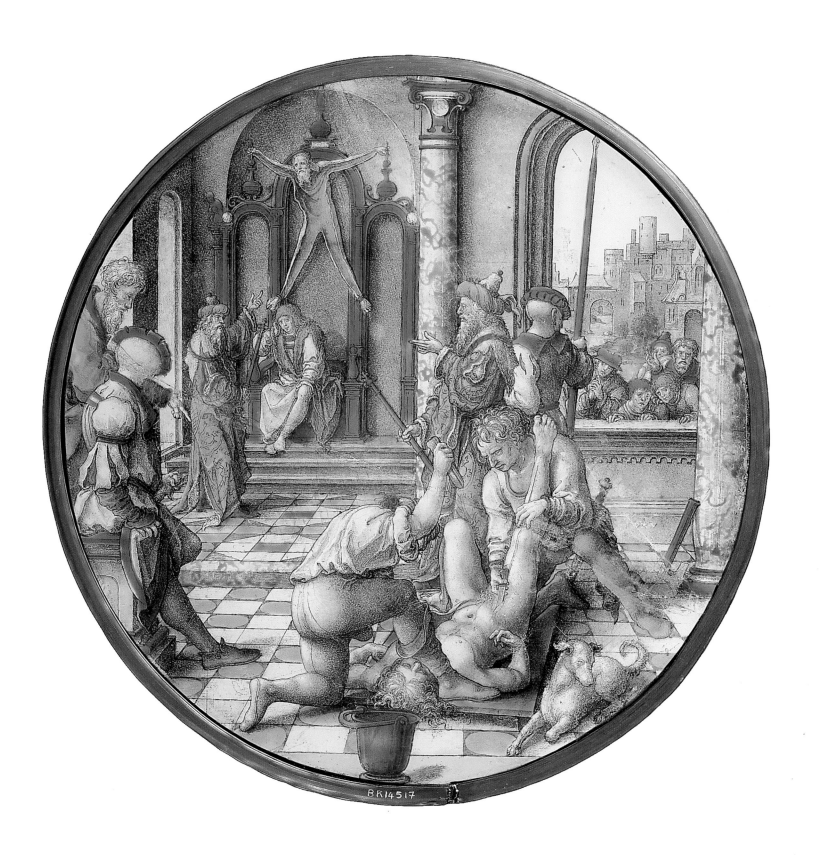

Brussels (?), c. 1510-1520

39 *Tapestry with the Triumph of Fame over Death*

Silk and wool on a woollen warp, 445 × 800 cm
Acquired with the aid of the Vereniging Rembrandt and with contributions from
the Nationale Vereniging Caritas and the Jubileumfonds upon the retirement of
Jhr D.C. Röell as Director of the Rijksmuseum in 1959
inv. no. BK-1959-98

Like the small pane of stained glass by
Dirck Vellert [37], this *Triumph of Fame* is
from a series of six based on Petrarch's
Trionfi, which served as a source of
inspiration for many artists. The theme
held a particular appeal for rulers and
scholars. There are surviving tapestry from
series of the triumphs that once belonged
to cardinals Wolsey in London and Erard de
la Marck in Liège, King Henry VIII and
Emperor Charles V.

Triumphal scenes were often arranged
in the form of processions of a theatrical
nature. The composition in each tapestry in
this series consists of two triumphal cars
bearing the *dramatis personae*. The names of
the 'participants' are often woven in.

Oxen have been yoked to the car on the
left of the tapestry, while its counterpart on
the right is drawn by elephants, the
attributes of Fame. The actions on the
lefthand car refer to the triumph preceding
that of Fame over Death—Death's victory
over Chastity. The latter lies on the car,
towered over by Atropos, the Fate respons-
ible for cutting the thread of life. Her
triumph is not total, however, for Fame,
the main subject of this tapestry, fells her
with a trumpet-blast. Fame also stands on
the other car, with the vanquished Fate
seated in front of her. Among the crowd
pressing around the cars are several
identifiable groups: heroes and rulers from
classical antiquity and the middle ages,
among them Alexander the Great, Julius
Caesar and Charlemagne. Some are
clambering out of their graves, others are
on horseback. The bearded figure of Julius

Caesar, seated on a dark horse beside
Fame's car, contains a contemporary
reference, for his coat of mail is decorated
with the double-headed eagle of the
Habsburgs, and may be an allusion to
Emperor Maximilian. Caesar, the female
rider behind him and several other figures
could also refer to the Nine Heroes and

Heroines, who were much in vogue in the 16th century.

Fame's procession with her entourage, which appears to include portraits of contemporary people, was probably also associated with the 'Joyous Entries' of Burgundian dukes into the towns of Flanders.

LITERATURE

Cat. London 1980, pp. 35-39; Delmarcel 1989

Studio of Pieter van Edingen, known as Van Aelst (active in Brussels 1495-1531)

40 Tapestry with the Washing of the Disciples' Feet

Gold thread, silk and wool on a woollen warp, 300 × 315 cm
Acquired in 1958 with the aid of the Jubileumfonds
inv. no. BK-1959-63

This undated tapestry is from a series illustrating the Passion story, and consisted of four pieces until the 19th century. One of them, the *Crucifixion* (Madrid, Prado), has the date 1507 woven into it, which probably refers not to the year of weaving but to the completion of the design. The reason for this is that there are three weavings, or editions, of this Passion series, all of them woven after that putative design of 1507. One tapestry (also Prado, Madrid) has Gothic pilasters just inside the inner border, and is accordingly regarded as the first edition, executed in or shortly after 1507. Those pilasters were replaced with Renaissance ones in two slightly later versions. They also feature in the Rijksmuseum tapestry, which means that it is one of the latter. It is believed that the two later editions were executed after 1511, since they contain elements derived from Dürer's print series of that year: *The large Passion* and the *Life of the Virgin*.

There are more clues for dating the later editions, and thus for the *Washing of the disciples' feet* in the Rijksmuseum. In one of the tapestries there is a male figure which may have been the model for the same figure in a tapestry of Mount Calvary that was delivered to Margaret of Austria in 1520. The second and third editions are accordingly datable between 1511 and 1520. Cardinal Bernardo Cles, Bishop of Trento in north Italy, bought one of the two later series for his palace, where it remains to this day.

The *Crucifixion* not only informs us about the year of the design but also the name of the weaver: Pieter van Edingen, known as Van Aelst, one of the most famous and outstanding tapestry weavers and dealers in Brussels at the beginning of the 16th century.

The lower half of the Rijksmuseum tapestry depicts the Washing of the Disciples' Feet (John 13:1-20). Knotted like an apron around Christ's waist is the cloth with which he will dry his disciples' feet. He is gesturing towards Peter, while a youth with a basin stands between them. The apostles are seated in a semicircle on a bench, the back of which separates the bottom scene from those above. The three scenes in the upper part of the tapestry depict the events that unfolded in the Garden of Gethsemane, the kiss of Judas, and Christ before the high priest Caiaphas.

The materials used, including the abundance of gold thread and the amount of detail, point to a wealthy patron from the immediate circle of the King of Spain, probably Margaret of Austria, regent of the Netherlands during the minority of Charles V.

LITERATURE
Göbel 1923, pp. 302-308; Schneebalg-Perelman 1969; exhib. cat. Brussels 1976, p. 71; cat. Madrid 1986, I, pp. 27-29 and p. 34; Castelnuovo 1990, esp. pp. 19-33, pp. 85-97 and pp. 144-165; exhib. cat. Amsterdam 1993, pp. 45-53

Leiden School, c. 1520

41 Mount Calvary

Oil on panel, 172.5 × 119 cm
Acquired with the aid of the Vereniging Rembrandt, the Rijksmuseum-Fonds, the Stichting het VSB-fonds and the Rijksmuseum-Stichting upon the retirement of Prof. H.W. van Os as Director-General of the Rijksmuseum in 1996
inv. no. SK-A-4921

This complex work, which consists of seven Passion scenes on ascending levels, gave the believer the opportunity to experience the Passion along with Christ. The enormous number of scenes of the Road to Calvary that have survived from the years around 1500 merits the question why this sort of image of affliction, pain and cruelty was depicted so often. It is certainly raised by this particular painting of the preparations for the Crucifixion, which are not even mentioned in the gospels. There are two key concepts that will help answer the question: the *imitatio Christi* and *compassio*.

In the 15th century, the *imitatio Christi*, the imitation of Christ, had become the central theme of spiritual life. For the medieval believer, as follower of Christ, it was utterly unbearable that the evangelists had nothing to say about what happened between Christ's arrival at Golgotha and his crucifixion there. This proved to be gaping chasm blocking the follower's path. Illustrations of the preparations on Golgotha began appearing in prayer-books in order to fill that emotional void.

The second key concept is *compassio*, 'com-passion'. This is the most important instrument with which the follower could bridge the gap in time and space separating him or her from Christ. It is a different emotion from what we today mean by compassion and sympathy. Those are a feeling which have meaning in themselves, here and now, between individuals. The historical *compassio* is not an end in itself but a way of accompanying Christ on the road to eternal salvation. Contemporary devotional literature presented the act of beholding as a precondition for *compassio*. Without it, the inner process that leads to Jesus cannot even begin.

This painting enables the viewer to experience what happened between Jerusalem and Golgotha in a series of episodes. The figures brawling in the left foreground are brutish dice-players. In the gospels, dicing for Christ's robe only took place after he was hanging on the Cross, but in the late middle ages this event was brought forward in time. In order to dramatise Christ's suffering even further, gospel exegetes introduced the words of Psalm 22:16-20: 'For dogs have compassed me: the assembly of the wicked have inclosed me: they pierced my hands and my feet. I may tell all my bones: they look and stare upon me. They part my garments among them, and cast lots upon my vesture'. One could hardly wish for a better appeal to partake in Christ's Passion: 'See, that's the kind of brute who crucified him'. Driven by animal passions they are not even capable of playing a decent game, but tumble over each other clutching the dice, fighting out of blind avarice. That is how they are depicted here. Facing all this aggression is Christ in all his nakedness.

Late-medieval narrators of the Passion story also seized on the chance to inject an extra disrobing of Christ on Golgotha. After the Flagellation and before the Carrying of the Cross, Christ had been dressed again, so his clothes would have to be removed before the actual Crucifixion. He then sat naked, waiting to be nailed to the Cross. In the middle of the picture we see the sorrow of those who love him: Mary his mother, John, who accompanied her, her sisters, also called Mary, and Mary Magdalen. They serve as the models for the viewer's 'compassion'. Mary's role at the foot of the Cross as described by the evangelists was far too limited for the purposes of medieval devotion. In accounts of the Passion, the Virgin eventually began turning up almost everywhere where compassion was required, including the preparations for the Crucifixion.

The painting is based on a famous drawing of 1505 by Albrecht Dürer which is now in the Uffizi in Florence. Around 1525, a version of that drawing was scaled up from 60 cm high to 170 cm and translated into paint, probably in the workshop of Cornelis Engebrechtsz. The result was a new, monumental painting in the idiom, palette and style typical of the Leiden School.

LITERATURE
Filedt Kok 1996a; Van Os 1996

Jacob Cornelisz van Oostsanen (Oostzaan ? c. 1472-Amsterdam 1533)

42 Saul and the witch of Endor, 1526

Oil on panel, 88.3 × 123 cm
Purchased in 1879
inv. no. SK-A-668

Seventeenth-century artists often made remarkable use of the contrast between foreground and background. A small image in the background provided the key to the meaning of the principal scene. Among those who employed this device were Pieter Aertsen and Joachim Beuckelaer [82]. An early example is found in this painting by Jacob Cornelisz van Oostsanen, *Saul and the witch of Endor*, in which several episodes from the biblical story are depicted in a simultaneous narrative, while the clue to the scene is hidden in the distance.

In order to unravel this puzzling picture one has to be familiar with the Old Testament story found in the first book of Samuel, especially chapters 28 and 31, which relates that Saul, the first king of the people of Israel, was counselled by the priest Samuel for many years. Eventually, though, Saul rejected him and began acting in defiance of God's commands, whereupon God charged Samuel with the task of finding a new king for Israel. The choice fell on David, but Saul refused to accept him. He was confronted with mounting difficulties, one of which was a disastrous

Cornelis Engebrechtsz (Leiden c. 1460/65-Leiden 1527)

43 Christ taking leave of his mother, c. 1515

Oil on panel, 55 × 43 cm
Acquired in 1897 with the aid of the Vereniging Rembrandt
inv. no. SK-A-1719

war with the Philistines. Just before the decisive battle, Saul decided to consult a fortune-teller to seek the advice of the dead Samuel.

On the far left, Saul and several of his men arrive to consult the witch, with the tents of Saul's army in the background. The sorceress, half-naked and seated in a magic circle, summons a witches' sabbath. This foreground scene does not come from the Bible, although the latter does refer to the witch's magical arts. Witches flying through the skies on a ram, like the one in the right background, were a symbol of the devil in the late middle ages, and it was with their help that the witch could harness secret forces. Through the gateway in the centre one sees Samuel emerging from his grave, rebuking Saul for disturbing the repose of the dead. In the distance is the real key to the meaning of the picture: the battle that Saul lost, after which he committed suicide by falling on his sword. Saul's godless desire to know the future, which led him to disturb the dead, proved fatal.

LITERATURE
Exhib. cat. Amsterdam 1986, no. 20

Cornelis Engebrechtsz headed a large painters' workshop in the first decades of the 16th century, and trained Lucas van Leyden, Aertgen van Leyden and his own three sons Pieter Cornelisz (Kunst), Cornelis Cornelisz (Kunst) and Lucas Cornelisz (Cock). He and his pupils and assistants produced altarpieces and numerous smaller works for private devotion. One of his chief patrons was the

43a Cornelis Engebrechtsz, *Christ in the house of Martha and Mary*, c. 1515; oil on panel, 55 × 44 cm. Amsterdam, Rijksmuseum (inv. no. SK-A-2232)

Augustinian nunnery of Mariënpoel just north of Leiden. Among the works he made for the convent church were altarpieces with the Lamentation (c. 1508) and the Crucifixion (c. 1517), which were described by Karel van Mander in 1604 and are now in Leiden's Museum de Lakenhal.

The Amsterdam painting undoubtedly comes from an altarpiece illustrating episodes from the life of the Virgin. It was recognised as Engebrechtsz's work in 1904, and shortly afterwards the Rijksmuseum was able to acquire a second, less well-preserved panel from the same altarpiece: *Christ in the house of Martha and Mary* [43a].

The events depicted in the two panels are not found in the Bible but in the popular late-medieval *Meditationes vitae Christi*. Both scenes precede the Arrest of Christ. In the conversation with his mother and Mary Magdalen [43a], Christ refused to abandon his planned visit to Jerusalem during the Jewish Passover, and foretold his impending death.

The second panel shows Christ taking leave of his mother, immediately before he and his disciples set off for Jerusalem.

Movingly he embraces the kneeling Virgin amidst the sorrowful Marys and the apostles. Some of the disciples are descending into a valley on the right, with the city gate and walls of Jerusalem in the distance.

The attribution of the panels to Cornelis Engebrechtsz, based partly on the correspondences in style, colouring and manner of execution with the *Crucifixion* triptych in Leiden, was recently confirmed by an examination of the two underdrawings using infrared reflectography. This revealed that both had been prepared with a detailed underdrawing with the brush in black in the same style as Engebrechtsz's two triptychs in Leiden. The figures and the landscape in *Christ taking leave of his mother* were prepared with bold outlines and long parallel hatchings. Changes were made in the group of disciples behind Christ and the Virgin. The drawing of the hands and the way in which the landscape was laid down with rapid strokes of the brush are characteristic of Engebrechtsz [43b].

This painting is a fine example of the artist's more mature work. The poses and gestures in the figure group highlight the emotional nature of the leave-taking. The landscape and city in the background are painted in a surprisingly lively way. The steely, blue-white shapes of the mountains and rock formations contrast with the warm, bright colouring of the figures in the foreground. The attention paid to ornamental details, which was relatively slight by the standards of the day, and the broad manner of painting, which fades to the sketchy in the background, are typical of the work of Engebrechtsz and of the Leiden painters he trained.

LITERATURE
Exhib. cat. Amsterdam 1958, nos. 116-117; Gibson 1977, pp. 107-109; Bangs 1979, esp. pp. 1-16; Van Asperen de Boer/Wheelock 1973

43b Infrared reflectogram assembly of the group with the Virgin and Christ

Lucas van Leyden (Leiden c. 1489 or 1494-Leiden 1533)

44 *Susanna and the elders, c. 1508*

Engraving (B. 33), 19.7 × 14.4 cm
Acquired in 1807 by King Louis Napoleon for the Koninklijke Bibliotheek with the collection of Pieter Cornelis, Baron van Leyden, and transferred to Amsterdam in 1816
inv. no. RP-P-OB-1607

Lucas van Leyden was a child prodigy, and must have taught himself how to engrave in copper. He made his first engravings when he was 9 years old, and his earliest dated sheet, *Mohammed and the monk Sergius* of 1508, shows that he was already a fully-fledged artist, which is how Karel van Mander described him in his *Schilder-boeck* of 1604. Even if one moves his year of birth back from 1494 to 1489, as many scholars do, his early maturity is an unassailable fact. Although his first prints display a novice's shortcomings, his choice of subjects and way of depicting them is astonishing. Lucas was not influenced by the visual tradition, but took a strikingly original approach to the subjects of his early prints.

The same applies to this engraving of the story of Susanna and the elders. In the foreground, hidden behind a rocky outcrop and some trees, the elders spy on the bathing Susanna, who is a small figure in the distance. The apocryphal Bible story, which took place during the Babylonian exile of the Israelites, relates how two elders of the people who had been appointed judges lusted after the virtuous Susanna, the young wife of a wealthy Jew. They tried to seduce her while she was bathing in her garden, but she repulsed their advances. After threatening her they went to a judge and told him that they had discovered her committing adultery with a young man —an offence punishable by death. The young prophet Daniel finally proved her innocence by confronting the elders with their conflicting accounts of what had happened. The moral of the story is that Susanna's innocence and virtuousness triumphed over the villainy of the two elders.

Artists generally depicted the moment when the elders threaten the nude Susanna. In the print, Lucas chose the moment preceding that dramatic event. The focus is on the two evil-doers whose faces, gestures and poses betray their

44a Marcantonio Raimondi, *Lucretia*, c. 1511-1512; engraving (B. 192), 21.7 × 13.3 cm. Amsterdam, Rijksprentenkabinet

furtive and lustful intentions. Lucas accentuated their concealment behind the rock by placing the kneeling elder in deep shadow in the foreground. As in the Bible story, where the elders' iniquity is unmasked by the prophet Daniel, the evilness of the two men is emphasised by the contrast between their gross ugliness and Susanna's beauty and purity. The difference between the light and shade of the foreground figures and the tenuous background produces a convincing sense of depth.

Barely two years later, around 1510, the Italian engraver Marcantonio Raimondi used this landscape and its buildings in his print *Lucretia* [44a], the protagonist of which was engraved after a drawing by Raphael. A few years later, Lucas borrowed that figure in turn for his own engraving of Lucretia [44b], which illustrates just how important prints were for disseminating new images and ideas. It also shows that the engravings of Lucas van Leyden were widely known at a very early date.

LITERATURE
Van Mander 1604, fols. 211v-215r; Vos 1978, pp. 54-69; exhib. cat. Amsterdam 1978, p. 27; exhib. cat. Washington/ Boston 1983, no. 15

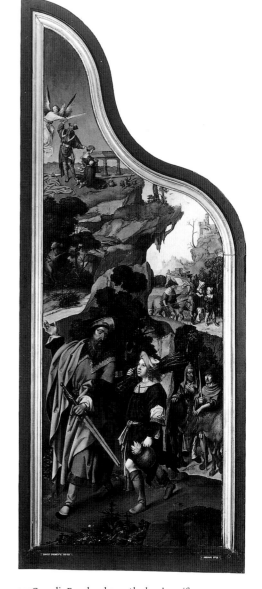

45a Cornelis Engebrechtsz , *Abraham's sacrifice*, c. 1515-1520, left wing of the *Crucifixion* triptych; oil on panel, 180 × 63.5 cm. Leiden, Stedelijk Museum de Lakenhal (inv. no. 93)

44b Lucas van Leyden, *Lucretia*, c. 1515; engraving (B. 134), 11.5 × 6.8 cm. Amsterdam, Rijksprentenkabinet

Lucas van Leyden (Leiden c. 1489 or 1494-Leiden 1533)

45 *Abraham and Isaac on their way to the place of sacrifice, c. 1517*

Woodcut (B. 3), 28.5 × 21.1 cm
Acquired in 1807 by King Louis Napoleon for the Koninklijke Bibliotheek with the
collection of Pieter Cornelis, Baron van Leyden, and transferred to Amsterdam in 1816
inv. no. RP-P-OB-1798

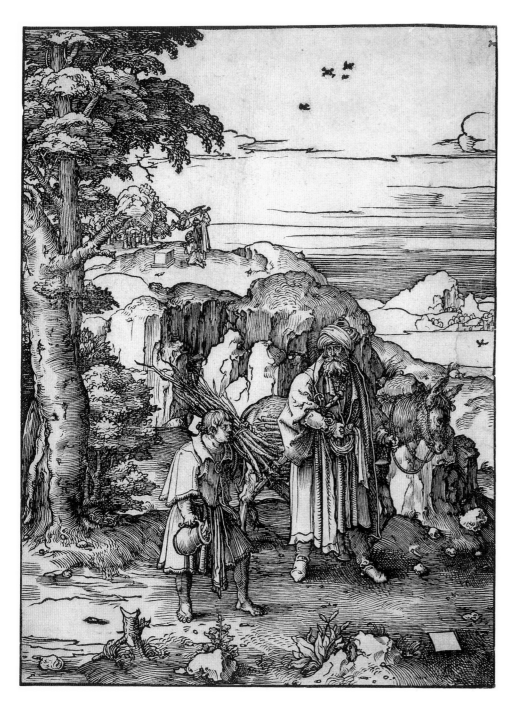

The woodcut was a popular technique in
the late middle ages for producing
illustrations in large editions. Only one or a
handful of impressions have survived of
these often coarsely cut and multi-
coloured, hand-painted woodcuts, despite
their wide circulation at the time. While
engravings were collected and lovingly
preserved by a more exclusive circle of art-
lovers, it is usually only by pure chance that
examples of the simple woodcut have come
down to us. It was raised to a higher plane
by Albrecht Dürer, who trained and
employed professional wood-cutters. They
refined the technique and turned the
woodcut into an artistic medium
comparable in quality to the engraving.

To a certain extent that is also true of the
small group of woodcuts that are convin-
cingly attributed to Lucas van Leyden,
although they were never as popular as his
engravings. It was only recently that their
great rarity made them his most sought-
after works. It is the drawing style alone
that reveals that Lucas was the maker of the
more than 20 woodcuts in his oeuvre, for
not one is signed. The impression repro-
duced here has a small, blank square where
one would expect to find his initial L, but it
remained empty.

Abraham and Isaac is among Lucas van
Leyden's most successful prints, thanks to
its clear visual structure and pictorial
richness—the delicate balance between line
and tone. The refined technique suggests
that Lucas cut his drawing in the wood
himself, for there were no wood-cutters in
Leiden who could match the skill of their
German colleagues.

The Old Testament story of Isaac
carrying the wood to the place of sacrifice
where, on God's orders, he is to be
sacrificed by his father Abraham, is seen as a
prefiguration of the Crucifixion of Christ,
the son who was offered up by God for the
salvation of mankind. That is how Lucas's
teacher, Cornelis Engebrechtsz, depicted
the event on the left inner wing of his large

Crucifixion altarpiece [45a]. As in the painting, the denouement of the story is shown on a rock in the background, where the sacrifice is halted at the last moment, just as Abraham has raised his sword above the kneeling Isaac. The focus, though, is on the journey of father and son: Abraham clad as an oriental with turban and large sword, and the young Isaac with a bundle of wood on his back and carrying a pot with glowing coals. The figures are set in a broad landscape that is convincingly built up in several planes and recedes into the distance, thus making clever use of the expressive potential of the woodcut technique.

LITERATURE
Exhib. cat. Amsterdam 1978, pp. 95-96; exhib. cat. Washington/Boston 1983, no. 69

Lucas van Leyden (Leiden c. 1489 or 1494-Leiden 1533)

46 *The Resurrection, c. 1529*

Black chalk, brush in grey and black, 25.2 × 20.1 cm
Acquired in 1982 from an old French collection with the aid of the Vereniging Rembrandt and the Rijksmuseum-Stichting
inv. no. RP-T-1982-75

At first sight this carefully executed drawing appears to lack the originality and spontaneity that are the hallmarks of Lucas's earlier work [44]. This is because Christ's Resurrection was one of the most popular subjects in the whole of Christian art, and this drawing closely follows the tradition [46a]. On closer examination, though, the style and execution turn out to be characteristic of Lucas's late work.

None of the gospels describe the Resurrection of Christ after his death on the Cross. Only the discovery of the open tomb is mentioned, and Matthew alone speaks of guards. Later church fathers relate how Christ rose from the tomb without breaking its seals. The Resurrection from the closed tomb was likened to Christ's birth from the virgin womb of Mary.

The risen Christ stands on the closed tomb holding a cruciform staff and banner in his left hand as a sign of his triumph over death. Five of the seven guards around the tomb have fallen asleep. One of the others looks up in amazement, while the seventh flees in panic on the right. Stylistically, Christ's body forms a contrast with the motley garb of the soldiers. The idealised rendering of the nude and the nervous folds and flare of the draperies are closely related to the engravings dated 1529 illustrating *The story of Adam and Eve*, which were influenced by the Italian engraver Marcantonio Raimondi. The sleeping and waking soldiers enabled Lucas to display his gifts as a narrator. The same motley-clad soldiers are also seen in the triptych with *The dance around the golden calf* from the same period [47]. On the right wing there is

46b After a design by Lucas van Leyden, *Samson and Delilah*, c. 1525; stained glass, 28 × 19.5 cm. Darmstadt, Hessisches Landesmuseum (inv. no. KG 70:3)

a similar fleeing figure, who was borrowed from Raimondi. Given the size and amount of detail. it is likely that the drawing was a design for a stained-glass window. A window with *Samson and Delilah* [46b], which is close in size, style and composition, must also have been made after a drawing of this kind.

LITERATURE
Kloek/Filedt Kok 1983; exhib. cat. Amsterdam 1986, no. 32

46a Albrecht Dürer, *The Resurrection*, 1512; engraving (B. 17), 11.9 × 7.5 cm. Amsterdam, Rijksprentenkabinet

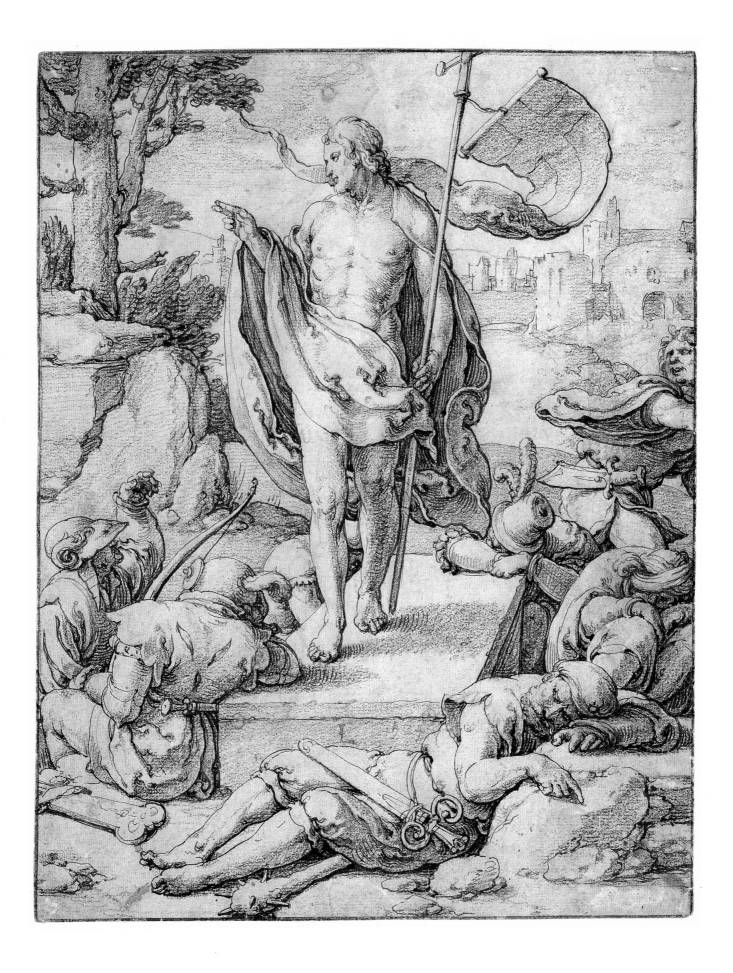

Lucas van Leyden (Leiden c. 1489 or 1494-Leiden 1533)

47 The dance around the golden calf, c. 1530

Oil on panel, 92.5 × 67 cm (central panel), 91 × 30 cm (wings)
Purchased in 1952
inv. no. SK-A-3841

The interlocking composition of this triptych shows the people of Israel disobeying God's commandment by setting up a golden calf in the desert of Sinai and giving themselves over to dissipation. According to the Bible, this took place after the long absence of their leader Moses, who was communing with God on Mount Sinai. When he returned after 40 days and 40 nights bearing the stone tables of the law on which God had written the Ten Commandments, he found the people dancing in a frenzy around the idolatrous image. Moses is depicted twice in the central panel. First he appears as a minuscule figure kneeling on a rocky

47b Infrared reflectogram assembly of the underdrawing of the group of figures dancing in the background.

47a Infrared reflectogram assembly of the underdrawing of a foreground figure.

overhang surrounded by black clouds, and then he is seen slightly lower down the mountain, this time accompanied by his servant, discovering the idolatry of the people and throwing down the stone tablets in fury (Exodus 32). Below that in the middle, still in the background, is a small orchestra on the left, elated couples dancing around the calf, and on the right a group among the trees engaged in a round dance. The festive Israelites are scattered across the foreground of all three panels. Van Mander described them as follows in his *Schilder-boeck* of 1604: 'At this banquet, one sees a very lively depiction of the sensual appearance of the people and the impure desires revealed in their eyes'.

The painting warns against unbelief, which leads to riotous and immoral behaviour, and exhorts the viewer to obey

God's commandments. This moral provides the excuse for the evident pleasure with which Lucas van Leyden depicted the biblical story.

The subject and the plain decoration of the backs of the wings with red imitation marble indicates that the triptych was intended for domestic use. Nothing is known about the patron, nor of the owner in whose house on Amsterdam's Kalverstraat Van Mander saw it. After being auctioned in Amsterdam in 1709 and later in Paris in 1870, the picture vanished from sight. It was rediscovered in Paris in 1952 and bought by the Rijksmuseum.

It is exceptionally well-preserved, and shows Lucas van Leyden at his very best as a painter. In style it ties in with his late work [see 46], so was probably painted around 1530.

Infrared reflectography reveals an underdrawing applied to the chalk ground with black chalk that cursorily indicates the forms and volumes [47a]. The small figures in the background, who are rendered extremely sketchily and in a limited range of colours in the paint layer, are defined with a few contour lines in the underdrawing [47b]. The manner of painting is far more detailed and draughtsmanlike in the foreground figures. The palette resembles Cornelis Engebrechtsz's, but with its forceful red, yellow, orange, pink and light blue tones is bolder and more transparent. The landscape in which the lively figures have been placed undergoes a convincing transition by way of the depth of the middleground with the dark green trees, to a light green and blue for the far-off mountains.

LITERATURE
Van Mander 1604, fol. 213v; Filedt Kok 1978, pp. 101-104; exhib. cat. Amsterdam 1986, no. 37; Smith 1992, pp. 37-44, 106-109

Leiden, c. 1525-1530

48 The ship of St Stonybroke, c. 1525-1530

Woodcut printed from eight blocks, 76.5 × 106.5 cm;
an address at lower right: Geprent tot amstelredam bij mij Doen Pietersoen in Englenburch
From a large album containing 16th-century German and Netherlandish woodcuts from the collection of the Duke of Saxe-Coburg-Gotha in Gotha, 85 of which were auctioned in Leipzig in 1932; 73 of them were acquired by the Rijksmuseum with the aid of the Vereniging Rembrandt
inv. no. RP-P-1932-119

The 1567 inventory of Breda Castle lists a tapestry from the collection of the Princes of Orange with an intriguing subject. It showed 'l'histoire de St Reynuut', the story of St Stonybroke, a mock saint who was the subject of several light-hearted texts in the 16th and 17th centuries but who rarely put in an appearance in the visual arts. St Stonybroke was the fictitious patron of all who had lost everything through drunkenness, excess or some other cause. The tapestry would not have been a depiction of the story of St Stonybroke in the strict sense, but rather a portrayal of the destitute seafarers of the kind shown in this magnificent woodcut, which can best be described as a 'paper tapestry'.

It used to be said that down-and-outs had stranded with St Stonybroke's 'lice-ridden ship'. That is precisely what is depicted here, which explains the prominence given to the ship. On the right, honour is being paid to the patron saint of drinkers, who is seated on a throne and is paying not the slightest attention to the kneeling pilgrims as he moodily discovers that his second jug of drink is empty. The text on the rhyme print consists of an ironic exhortation to people of all sorts, including painters and printers, to join the voyage of the ship called 'quaet regement' (bad conduct).

Immoderation is mocked in both word and image. Throughout the scene, people are gazing into tankards, and beggars receive a dash of wine instead of alms.

Couples are billing and cooing on the left in and around an inn cobbled together from poles and bits of canvas and with a pig in a cradle as its signboard. One of the women is relieving her partner of his purse.

The church also comes under fire. The concept of a pilgrimage is ridiculed, as is the church's swindling of the faithful by selling indulgences and trading in votive gifts. Wax heads and candles are being sold around the pavilion where the mock saint is holding court. The text is also addressed to

> Priests, mothers superior and friars,
> Abbots, monks, clerics and fathers in Christ,
> Sisters beguine and guzzling laity,
> Who have worn themselves out with drinking
> and dozing.

Drunken monks and nuns have also been included in the scene. The print is drenched in irony, and radiates the spirit of Erasmus's *Praise of folly*. It is debatable whether the standing man reading a book on the right is meant to be the famous Rotterdam humanist, as some have suggested. He looks more like a generalised commentator on the events taking place around him. The designer of the scene and the author of the text would anyway have sympathised with his ideas.

For a long time it was thought that the print was by Lucas van Leyden, but there are too many differences in style to support that attribution. The figure types and other stylistic features indicate that it is by a Leiden artist active around 1530.

The Amsterdam publisher Doen Pietersz, who also marketed many of Jacob Cornelisz van Oostsanen's woodcuts, must have thought that there was an international market for *The ship of St Stonybroke*, for he also published a French edition shortly after the Dutch one. The impressions would have been hung on the wall, and were certainly not preserved in albums by collectors on a large scale, for only two impressions have withstood the ravages of time.

LITERATURE
Exhib. cat. Amsterdam 1986, pp. 155-157, no. 40

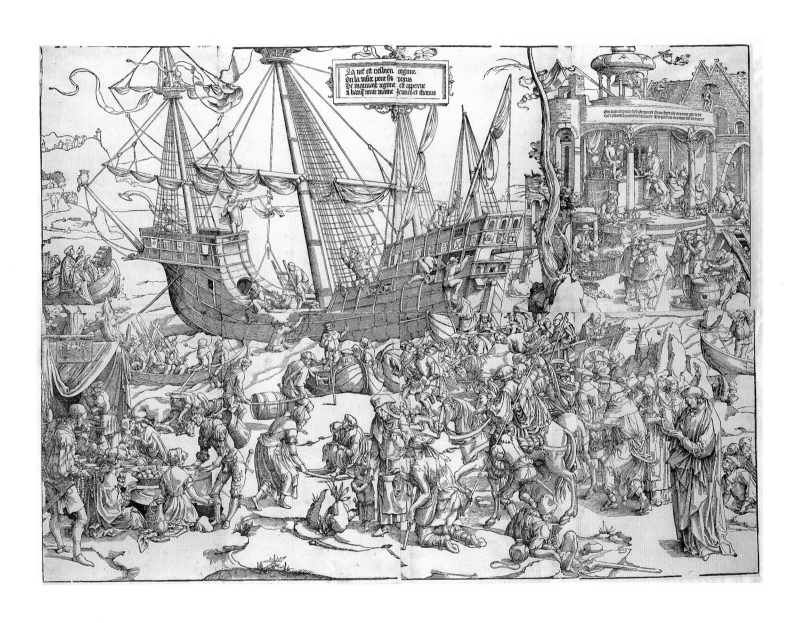

Master of the Church Sermon
also attributed to Aertgen van Leyden (Leiden 1498-Leiden 1564)

49 Church sermon, or The calling of St Anthony, c. 1530

Oil on panel, 132.7 × 96.3 cm
Purchased in 1897 with the aid of the Vereniging Rembrandt
inv. no. SK-A-1691

This painting was attributed to Lucas van Leyden until the 1930s; the monogrammed L in the foreground was a later addition. A comparison with other works by him, such as *The dance around the golden calf* [47], made it clear that the stylistic differences were too great to justify the attribution. What is particularly noteworthy, though, is the exceptionally high quality of the donors' portraits, which recall Lucas's portrait drawings of 1521. The other figures, especially those in the background, are characterised by loose brushwork and cool colours. Both those elements are found in a number of paintings from the same period, such as *The temptation of St Anthony* in Brussels [49a], which some suspect came from the same altarpiece. The two paintings, which

were formerly thought to be by Lucas van Leyden, are attributed in the recent art-historical literature to the Leiden master, Aertgen van Leyden, who enjoyed great fame in the 16th century. Van Mander states in his *Schilder-boeck* of 1604 that his painting style was 'somewhat shoddy and unpleasing', and that he was influenced successively by Cornelis Engebrechtsz, Jan van Scorel and Maarten van Heemskerck. Although this attribution to Aertgen is not accepted by everyone, there is much that suggests that the painting was executed in the city of Leiden around 1530.

Just as no convincing answer has yet been found for the attribution, so meaning of this unusual painting still defies interpretation. It shows a priest in his pulpit

addressing a crowd in and around a Renaissance church. The six standing men on the right, all of whom have distinctly individualised features, are probably the donors of the painting. The man in the front has a cross of St Anthony on his breast, as does the young man wearing the same garb in the right background, who is distributing bread to the poor and the lame. Wearing a cross of St Anthony or tau cross indicates that the person was a member of a St Anthony Brotherhood, but there is also a possibility that this is the saint himself.

If that were true it would mean that the scene could also be called *The calling of St Anthony*. After hearing a gospel reading about the rich young man (Matthew 19:21), Anthony, a rich orphan, converted to the Christian faith. He sold all he owned, distributed the proceeds among the poor, and spent the rest of his life as a hermit in the desert, where the devil put him sorely to the test.

However, it is also possible that this is a scene of the preaching of the Our Father, with the distribution of the bread and the altar prepared for the sacrament of the Eucharist alluding to the line in the Our Father: 'Give us this day our daily bread'.

Since the painting must have been made in Leiden, one can seek the donors of the *Church sermon* in the local Brotherhood of St Anthony or in the guild that ran St Anthony's Hospital just outside the city, which had its own altar in the Church of St Peter.

LITERATURE
Bruyn 1960; exhib. cat. Amsterdam 1986, pp. 153-166, no. 44; Scholten 1986

49a Master of the Church Sermon (Aertgen van Leyden?), *The temptation of St Anthony*, c. 1530; oil on panel, 66 × 71 cm. Brussels, Koninklijk Museum voor Schone Kunsten

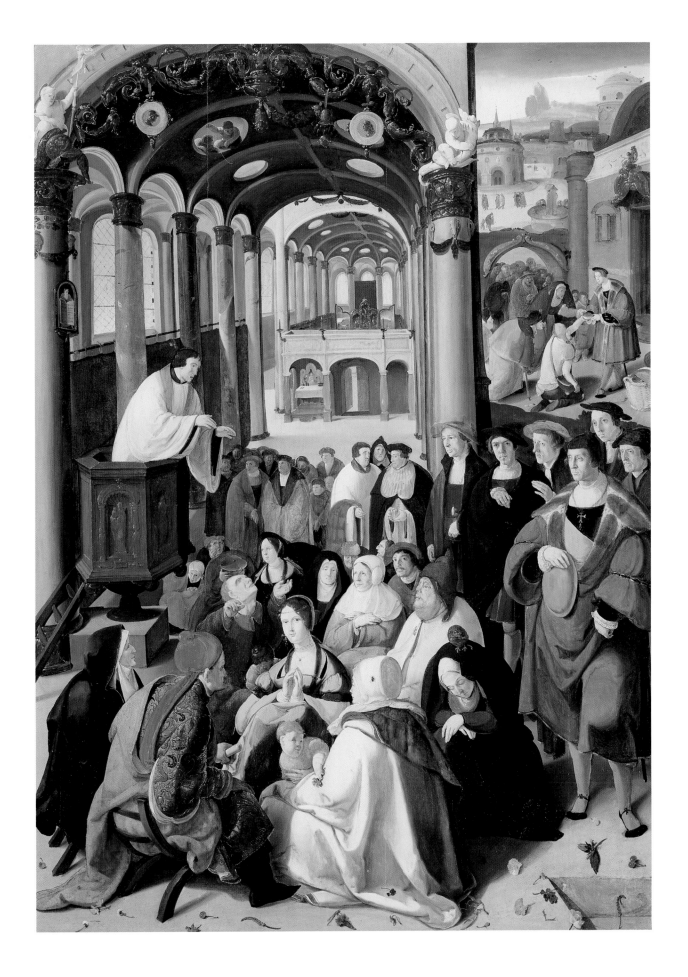

Jacob Cornelisz van Oostsanen (Oostzaan ? c. 1472-Amsterdam 1533)

50 Self-portrait, 1533 ?

Oil on panel, 37.9 × 29.5 cm; in the centre a trompe l'oeil note bearing the monogram IAM, the painter's house mark and the date 1533
Purchased in 1887
inv. no. SK-A-1405

Occasionally a painting contains extra information, about the scene itself, for example, or about the artist. This *Self-portrait* by the Amsterdam painter Jacob Cornelisz van Oostsanen tells us important facts about his life. The note with the date 1533 and the house mark between an I and an A appear to announce that Iacobus Amstelodamensis, or Jacob of Amsterdam, painted this portrait of himself in 1533. It is known from the archives that Jacob Cornelisz van Oostsanen, the person behind the name Jacob of Amsterdam, must have died before 18 October 1533, the date of a document stating that his wife was a widow. That and the date on the *Self-portrait* appear to be conclusive evidence that the artist did indeed die that year.

However, it has been suggested that he was dead by 1532, when one of his houses was sold. So 1533 or 1532—it is not known for sure. On top of that, there are doubts about when the *Self-portrait* was actually executed. It is very close in style to the paintings that Jacob Cornelisz made around 1525, and he is not known to have made any more after 1526. It is possible that the date was added later, in the year of his death, and that we are looking at a Van Oostsanen who is younger than he appeared in 1533.

There is another panel in which the same man is seated before an easel, painting the portrait of an older woman [50a]. It is by Dirck Jacobsz, the couple's son, who traced the head in the Rijksmuseum *Self-portrait* and used it for the man by the easel. He then added his mother's likeness, creating an anachronistic scene: a portrait of his father as he probably looked before 1533, and one of his mother as she appeared around 1550.

LITERATURE
Exhib. cat. Amsterdam 1986, nos. 73 and 74

50a Dirck Jacobsz, *Jacob Cornelisz painting his wife's portrait*, c. 1550; oil on panel, 62.1 × 49.4 cm. Toledo (Ohio), The Toledo Museum of Art (inv. no. 60.7)

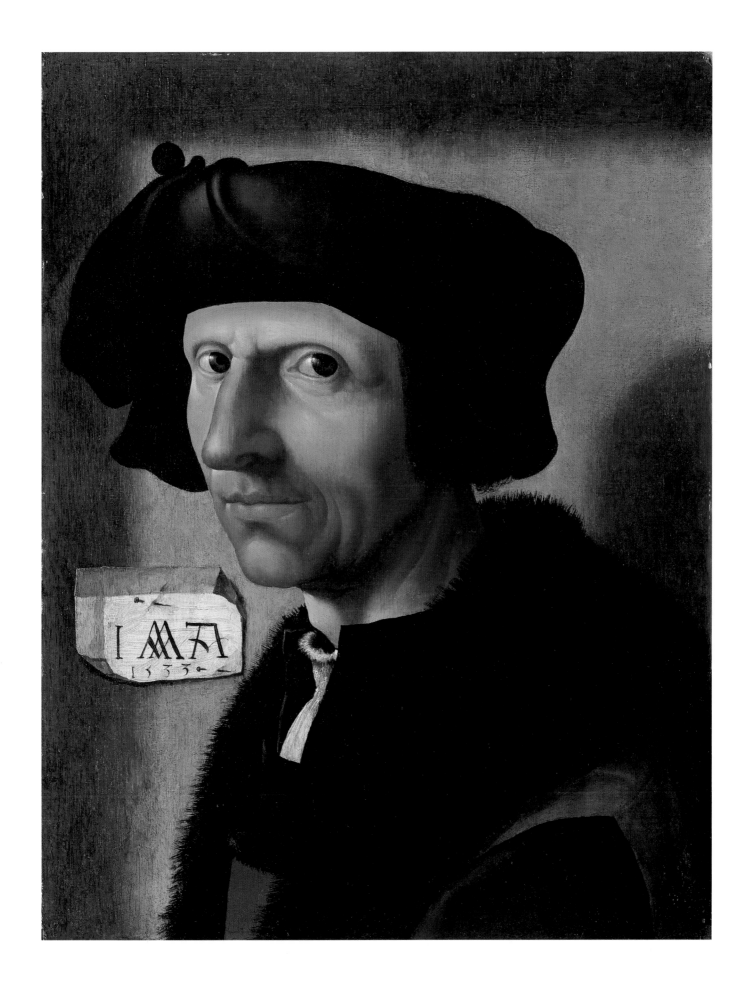

Jan van Scorel (Schoorl 1495–Utrecht 1562)

51 Mary Magdalen, c. 1530

Oil on panel, 67 × 76.5 cm
From the Commandery of St John, Haarlem; purchased from the
City of Haarlem in 1804 for the Nationale Konst-Gallerij
inv. no. SK-A-372

In 1519, after training with Jacob Cornelisz van Oostsanen and other masters, Jan van Scorel travelled to Nuremberg, Carinthia, Venice and Jerusalem. On returning from the Holy Land he visited Rome, where he was appointed keeper of the Vatican collections by Adrian VI, a Dutch pope who wore the tiara but briefly. Scorel was back in the Netherlands by 1524, entering the priesthood in Utrecht and setting up his own studio there. He later occupied an important ecclesiastical post as canon of St Mary's in Utrecht.

Jan van Scorel was the first Renaissance artist in the Netherlands, and must have wanted to pass on to others all that he learned on his travels. It was not for nothing that Karel van Mander called him 'the lantern-bearer and road-builder' of Dutch art. The influences he had been exposed to abroad were many and varied, and it took him some time to absorb them properly. For instance, he must have seen the work of Albrecht Dürer in Bavaria, but in Austria he painted a triptych that was still permeated with the spirit of Jacob Cornelisz. In Venice he saw paintings by contemporaries like Giorgione and the young Titian, and in Rome work by Raphael, Michelangelo, and Raphael's followers: Giulio Romano, Polidoro da Caravaggio and Baldassare Peruzzi. Scorel incorporated all those influences into his paintings, and he ran his Utrecht studio along the lines of Raphael's in Rome—the master making a design and a plan for the execution, and then leaving much of the work to assistants.

Scorel did not yet have any collaborators when he painted this *Mary Magdalen* in the late 1520s during a stay in Haarlem. What he did not paint was the top plank with the sky and branches, which is over 12 centimetres wide, nor the remainder of the sky on the original panel, which was completely overpainted when the plank was added in the second half of the 16th century. Originally, the Magdalen's head almost touched the upper rail of the frame.

She is depicted as a Venetian courtesan (Venice had a thing about blondes) seen through the eyes of a Netherlandish artist who had mastered the imitation of materials.

Netherlandish painters were famous in Venice for their landscapes, and Jan van Scorel was no exception. He placed the Magdalen and her hermitage in the mountains of southern France to which the converted prostitute supposedly retreated in later life. She is being borne up to Heaven near the overhanging rock. Here Jan van Scorel combined his love of nature with the chance to give his imagination free rein in the landscape.

LITERATURE
exhib. cat. Amsterdam 1986, no. 63

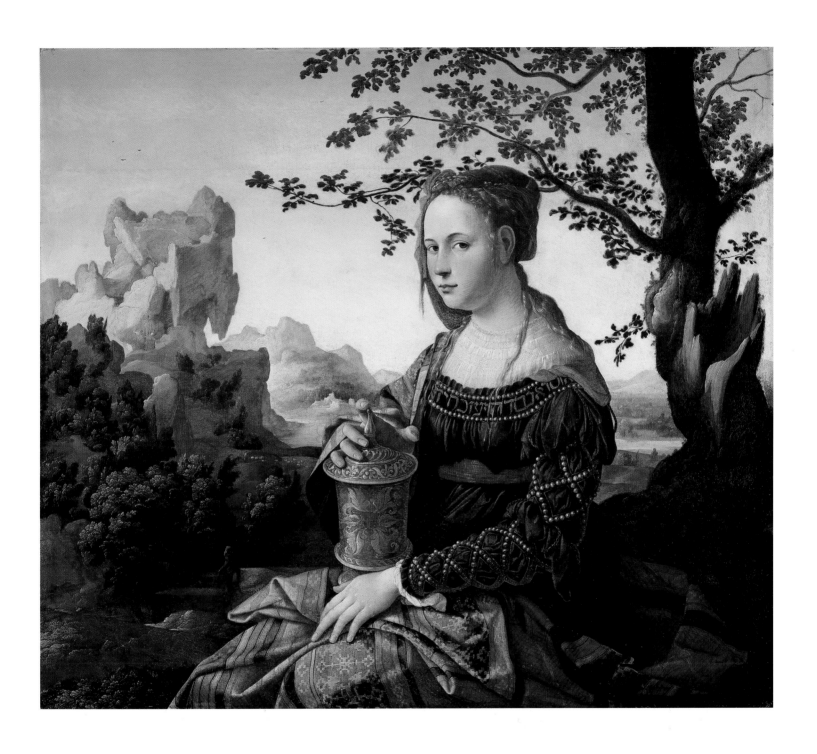

Maarten van Heemskerck (Heemskerk 1498-Haarlem 1574)

52 Portraits of a man and a woman, 1529

Oil on panel, with the original frames, each 86.3 × 66.4 cm
From the Schimmelpenninck van der Oye family, Huize de Poll near Voorst;
donated by D. and N. Katz, Dieren, 1948
inv. nos. SK-A-3518 and SK-A-3519

These two paintings are known as the
'Bicker portraits', but the traditional
identification of the couple as Pieter Bicker
and Anna Codde is incorrect. The
attribution of the two unsigned panels to
Jan van Scorel is also dubious, and almost
all the experts now agree that they were
painted by Maarten van Heemskerck. The
scroll at the bottom of the frame bears the
date '1529', and although the frame is a
17th-century addition, that date does agree
with the one in the man's cash-book. If the
attribution to Maarten van Heemskerck is
correct, they come from his successful early
period, before he travelled to Italy in 1532
to study the works of the classical masters.
It also means that the sitters were more
likely to have lived in Haarlem, Heems-
kerck's home town, than in Amsterdam,
the home of the powerful Bicker family.

These likenesses of seemingly wealthy
burghers illustrate the rise of the private
portrait. People who commissioned
portraits generally did so for a specific
reason. Many of those from the 15th and
16th centuries were painted to commem-
orate the dead [see also 18]. That is the case
with portraits in an ecclesiastical setting,
such as donors' likenesses on altarpieces or
those on private epitaphs, but it also
applies to people seen in their own homes.
Often there is more than one portrait of the
same individual, probably because several
heirs received or ordered a likeness to
preserve the memory of the deceased.

These two portraits are of a young and
hard-working couple, and were probably
painted to mark their betrothal. The man
would normally have been depicted to the

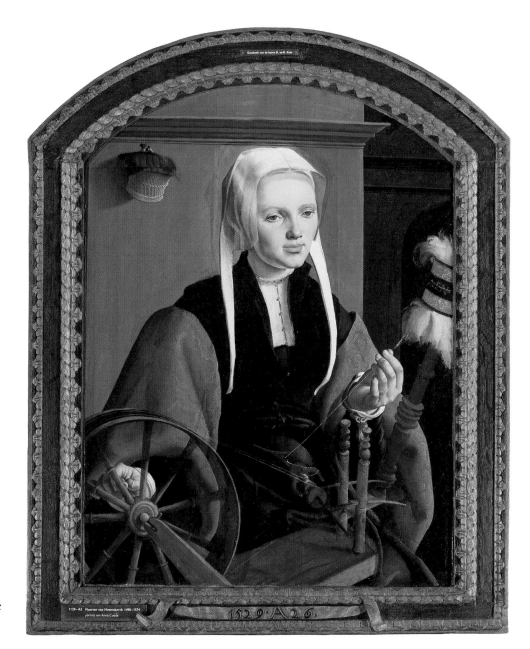

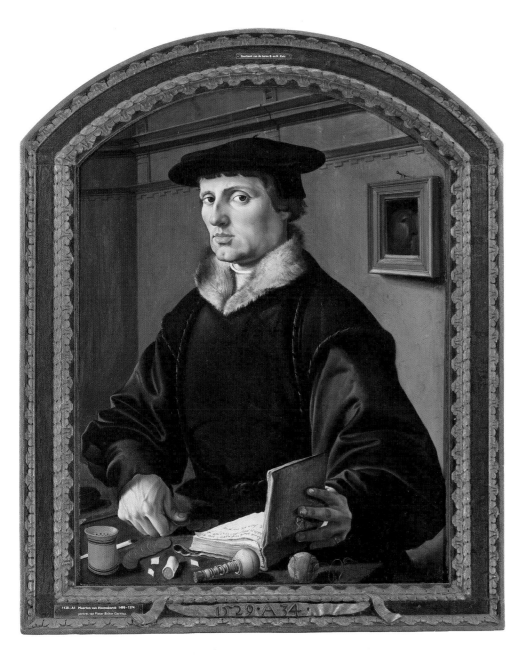

left of the woman, and the unusual arrangement of this couple probably means that they had already taken their marriage vows but were not yet officially wed. The coin in the man's right hand, the cashbook and other objects on the table make it clear that he was in business. The woman has one hand on the spinning-wheel, as befits a virtuous and industrious housewife. Interestingly, the beautifully painted wheel was added at a late stage, after the artist had finished the clothing. The composition was also altered around the woman's head, which was made a little smaller, presumably so that she would not appear to be larger than the man.

LITERATURE
Exhib. cat. Amsterdam 1986, no. 71

Master of the Good Samaritan (circle of Jan van Scorel)

53 The Good Samaritan, 1537

Oil on panel, 73 × 85 cm
Bequeathed in 1944 by Mrs J.H. Derkinderen-Besier, widow of the artist A. Derkinderen
inv. no. SK-A-3468

Jan van Scorel had several outstanding assistants, among them Antonis Mor van Dashort, who went on to become a celebrated portraitist [71], and an anonymous artist known as the Master of the Good Samaritan after this painting. His style is like Scorel's, but the finish is more arid. He made several repetitions of compositions by Scorel which must have been commissioned by his teacher. It is not known whether this particular one is his own invention or Scorel's, but it seems unlikely that the latter was involved in any way at all, for the uncaring Levite on the right has been turned into a monk with a tonsure. One would hardly expect such overt criticism from Jan van Scorel, a canon who had reason to be grateful to the Church of Rome.

The story of the Good Samaritan tending a robbed and wounded traveller, as seen in the foreground, is related in St Luke, chapter 10. It was one of the parables that Christ told his audience to teach them to walk daily with charity in their hearts. A merchant journeying from Jerusalem to Samaria was set upon by robbers, who left him stripped naked and badly hurt. A priest passed by a little later, decided not to get involved and took a wide berth around him. Then a Levite appeared on the scene, but he too ignored the man. A third passer-by, a man from Samaria (a city in Israel where no descendants of Jacob lived) stopped, put the man on his horse and took him to an inn in the city, leaving behind a sum of money so that the innkeeper could take care of him.

The Samaritan in the painting is about to put the wounded man on his horse and take him to a city with ruins, an obelisk and a pyramid—elements designed to show that this is a biblical narrative, even if the city does more like Rome than Jerusalem. At the same time, the artist tried to bring the story up to date by dressing the Levite as a monk. The emotional appeal to the viewer, though, comes from the sorely wounded body of the ambushed traveller lying in a pool of blood. The painting invites reflection, not so much on human woes as on the charitableness that one is expected to practise, in imitation of the Samaritan.

LITERATURE
exhib. cat. Amsterdam 1986, no. 116

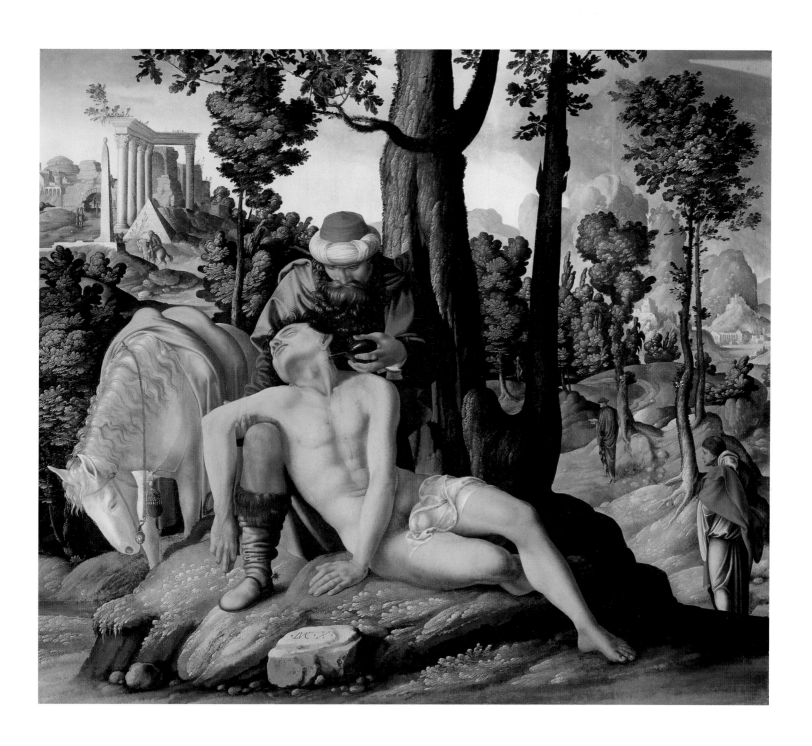

Jan Swart van Groningen (Groningen ? shortly before 1500-Antwerp ? c. 1560)

54 Woman lamenting by a burning city, c. 1550-1555

Pen in black, brush in brown, heightened with white bodycolour, 36 × 28.3 cm
Purchased in 1921
inv. no. RP-T-1921-483

Swart drew his *Woman lamenting* on paper that he coated with a blue-green preparatory layer, which provides the 'mid-tone'. Light passages are in white bodycolour and shadows are brushed in brown ink. The outlines were drawn with the pen in black ink. Chiaroscuro drawings of this kind were never as popular in the northern Netherlands as they were in Flanders and Germany. Maarten van Heemskerck occasionally used the technique in designs for engravings. It is hard to say whether Jan Swart used chiaroscuro often. Too little is known about his oeuvre, but he does seem to have employed it at different stages in his career.

The *Woman lamenting by a burning city* is certainly not the least puzzling of the many drawings attributed to Jan Swart, above all because of its unusual subject. It has been identified variously as an allegory of bad fortune, Lot's wife by the burning Sodom, and Cassandra bewailing the fall of Troy, but none of those titles is very satisfactory.

The scarcity of dated works makes it all but impossible to put a precise date on Swart's drawings. A series of ten scenes from the life of John the Baptist, which was etched in iron by Hans Liefrinck after designs by Jan Swart, does give something to go on. The fourth and fifth prints are dated 1553 and 1558 respectively. Features that they share with the Rijksmuseum drawing are the heavy, stiff contour lines and the dramatic contrasts between light and shade. The facial type of the *Woman lamenting*—triangular face, long, straight nose, heavily shadowed eyesockets and a small mouth with thick lips—is also frequently encountered in the print series. The background landscape bears a resemblance to that in the seventh in the series of iron etchings, *John pointing out Christ to his disciples*. All these factors lead to the conclusion that the *Woman lamenting* was also executed in the 1550s.

LITERATURE
Cat. Amsterdam 1978, no. 445; Kloek et al. 1986, p. 79; exhib. cat. Amsterdam 1986, no. 128

Jan Cornelisz Vermeyen (Beverwijk 1500-Brussels 1559)

55 The marriage at Cana, c. 1530

Oil on panel, 66 × 84.5 cm
Purchased in 1982
inv. no. SK-A-4820

Jan Vermeyen, who came from Beverwijk, was court painter to Margaret of Austria, Mary of Hungary and Emperor Charles V. He was a typical, versatile, Renaissance artist, being a painter, a war reporter during the emperor's campaigns in North Africa and Italy, a designer of tapestries and one of the first masters of the art of etching [56].

This painting, which was probably executed in Mechelen in the late 1520s, stands at the beginning of a long tradition of candlelit interiors. In fact, it precedes it by some considerable time, for it was not until around 1600 that Caravaggio ensured

55a Infrared reflectogram assembly of the underdrawing

According to a medieval legend, the young John married Mary Magdalen at Cana, and it is that wedding banquet that is depicted here. The scene illustrates several key moments in the story. The Virgin in the foreground is telling one of the servants that her son can resolve the wine shortage, while on the right Christ is telling her that she should not interfere, which explains his rhetorical gesture. At the same time, John realises that there is a higher ideal in life and that he must follow Christ. The contrast in the painting lies in John's choice between the simple music of the world and Christ's spiritual argument. The inclusion of the jars of water that would be turned into wine, which are usually a key element in scenes of the Marriage at Cana, would only have distracted the viewer from John's conversion.

This subject is taken not from the Bible but from tradition, that tissue of stories dreamed up by pious Bible exegetes in order to give an event greater unity. The one depicted here follows Ludolf of Saxony's interpretation of the circumstances surrounding the Marriage at Cana.

The picture, which is such an obvious product of the Renaissance in its originality of composition, thus gives shape to a late-medieval legend in a way intended to enrich the spiritual life of the likely patron, Margaret of Austria.

LITERATURE
Bruyn 1984; exhib. cat. Amsterdam 1986, pp. 201-206, no. 76

the genre's widespread popularity. The group seen in a sharp contrast of light and shade around a table in a totally dark room, and the backlit foreground figures, must have caused quite a stir when the painting was made. The remarkably free under-drawing [55a] shows just how openly the artist experimented to get the composition right. It can be assumed that Vermeyen's royal patrons greatly appreciated the originality of this work.

The subject of the picture has not always been interpreted as the Marriage at Cana. When it was bought it was assumed that it depicted the meal in the house of Martha and Mary (Luke 10), with the woman behind the table being the pious, contemplative Mary, and her counterpart in the foreground, who has placed her hand on a servant's shoulder, being the active, bustling Martha. That, however, does not explain the presence of the young man in the centre who is so emphatically poking the bird that has been served up. He is undoubtedly the young John the Evangelist. In addition, the foreground woman is identified by her blue gown and red cloak as Mary, the mother of Jesus.

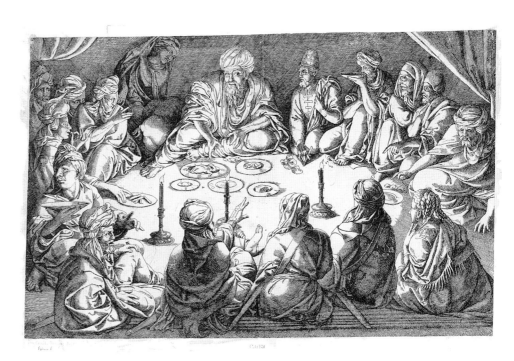

56a Jan Vermeyen, *Oriental meal*, c. 1545; engraving (H. 5), 33.8 × 53.6 cm. Paris, Bibliothèque Nationale de France (inv. no. C 10821)

Jan Cornelisz Vermeyen (Beverwijk 1500-Brussels 1559)

56 Seated oriental woman, 1545

Etching, 24.7 × 17.1 cm; at lower right the monogram and date: 15 IC 45
Acquired in 1964 with the aid of the F.G. Waller-Fonds
inv. no. RP-P-1964-218

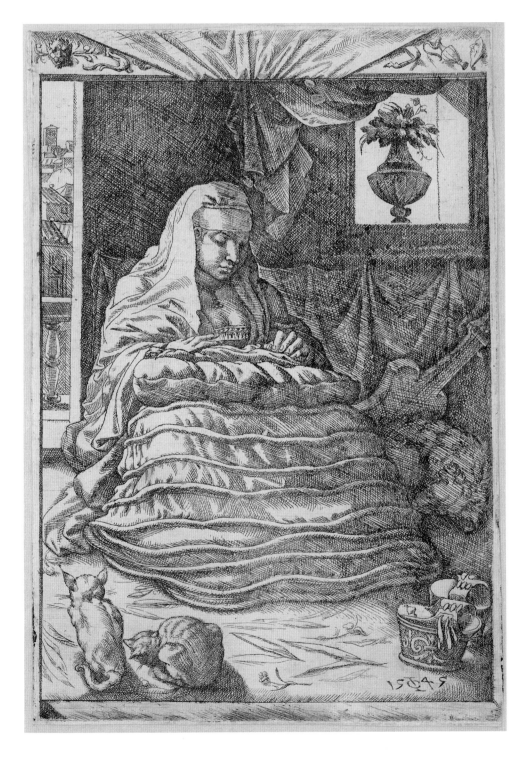

Jan Vermeyen was a well-travelled man for his day. Around 1534, for instance, he went to Spain, and from there he joined up with Emperor Charles V's army a year later as it sailed for North Africa and the Tunis campaign. There he made the drawings on which he based his cartoons for a series of monumental tapestries depicting the feats of arms in Tunis that were woven for Mary of Hungary in 1546-1547.

Vermeyen's travels had an impact on his art, as can be seen from his etchings of an oriental meal by candlelight [56a] and a *Spanish banquet*, which is actually an Iberian, costumed brothel scene. His love of exotic dress was noted by Karel van Mander, who had his information from the artist's daughter Maria. She told him that Vermeyen enjoyed dressing her up in oriental costume for the Brussels procession. He had also painted a portrait of her 'when she was still a child, clad very delicately in Turkish costume'. This particular aspect of Vermeyen's art must have caught the eye of his contemporaries, the more so in that he handled it so superbly.

Like the *Seated oriental woman*, the prints mentioned above date from 1545, the year in which a whole series of prints by Vermeyen flooded the market, as if he had suddenly been fired with enthusiasm for this relatively new technique. He employed it in a remarkably free and draughtsmanlike way, and did not imitate the more schematic engraving technique, as so many of his contemporaries did. He is consequently regarded as one of the first Netherlandish artists to exploit etching to the full. The lines are loosely scratched in different directions with the etching needle. The burin, the engraver's instrument, was used at most to strengthen a contour here and there.

Vermeyen's execution is extremely attractive. The borders at top and bottom create the impression that one is looking in from another room. At the top, beneath the

raised curtain, is a frame decorated with ornamental motifs. In a vista measuring just a couple of square centimetres the artist succeeded in suggesting that the scene is set in a sun-drenched Mediterranean city. His powers of observation are exceptional. Great care, of course, has been lavished on the platform shoes, but no less striking is the way in which the cats bask in the sun, as is their custom, while the dog seeks the shade. It is not clear precisely what the woman is doing on the cushion in her lap.

Vermeyen excelled in the treatment of light, both in his nocturnes and here in this southern impression. The backlit vase of flowers in the window and the fall of light on the woman's dress are far from commonplace. The fact that the etching was made years after Vermeyen's time in North Africa raises the question of whether he could summon up such lighting from memory, or whether he worked from a very detailed drawing made on the spot.

LITERATURE
Popham 1927; exhib. cat. Amsterdam 1986, pp. 201-207; Horn 1989; Hollstein 1949-, vol. 36, pp. 113-148

Jan Sanders van Hemessen
(Hemiksem near Antwerp c. 1500-Antwerp 1556/57)

57 *Allegorical scene, c. 1550*

Oil on panel, 159 × 189 cm
Acquired in 1984 by the Mauritshuis, The Hague, with the aid of the Vereniging Rembrandt and the Stichting Johan Maurits van Nassau; on loan to the Rijksmuseum since 1998inv. no. SK-C-1657

The fact that Giorgio Vasari, the Italian biographer of artists, was familiar with the work of Jan Sanders van Hemessen and called him one of the most famous painters from the Low Countries, suggests that the artist visited Italy, although the documentary sources are silent on that point. All that is known is that Van Hemessen was studying with someone called Hendrick van Cleve in Antwerp in 1519, and that he registered with the local guild as an independent master in 1524 and took on a pupil. The influence of Italian art on his work was so great that one can hardly doubt that he journeyed south, and it has been suggested that he was in northern Italy around 1530. It may have been there that he saw paintings by Moretto da Brescia, Romanino and Savoldo, from whom he borrowed his figure types. Van Hemessen's work is marked by such a bizarre form of Mannerism that it is also likely that he visited Fontainebleau in the 1540s when Rosso Fiorentino and Primaticcio were working on the decoration of the castle there for King François I. Van Hemessen became Antwerp's leading painter after the death of Quinten Massys in 1530. In 1548 he is recorded as the dean of the Guild of St Luke, and his last dated work was executed in 1556. Royal collectors vied for his paintings, which were spread all over Europe—from Prague to Vienna and from Munich to Stockholm.

Van Hemessen painted many a St Jerome in the Desert, altarpieces with biblical scenes, large genre pieces illustrating man's sinfulness, portraits and allegories. This

pastoral-like work is the most puzzling of the latter group, and the subject is distinctly odd. A woman seated in a landscape sprinkles milk from her breast over the *lira da braccio* of the man opposite her. In the background is a flock of sheep, with a shepherd writing or drawing on the ground with his staff.

The picture has been interpreted in several ways, among others as the musician's inspiration, as poetry and the poet, as an allegorical wedding portrait and as an allegory of marital harmony. The packing list made in 1676 when the painting (erroneously though to be by Floris) was sent from Antwerp to Vienna describes it as 'a naked woman and a man holding a viol and bow, being the concord of nature'. Clearly, then, it was regarded as a symbol of harmony in the 17th century, although one wonders whether that should be seen solely in the context of love between a man and a woman. The 'concord' could equally well refer to the relationship between art and nature in the sense of nature as the nurturer and inspiration of art. It is debatable whether the interpretation of the person who filled in the packing list automatically matched Van Hemessen's intentions almost a century and a half earlier.

Karel van Mander writes that Van Hemessen's 'working method was more approaching the ancients, somewhat different from the moderns. He painted large figures and was in some respects very neat and precise'. This ties in with the style of this meticulous work. The 'large figures'

in the foreground are indeed painted very precisely, almost harshly, while the landscape has been given a great deal of atmospheric haze. One can even see what Van Mander meant by the 'working manner [of] the ancients'. Van Hemessen endeavoured to give his figures a classical and timeless air, and in this he has succeeded magnificently.

LITERATURE
Winternitz 1967, pp. 47-48, 202-210; Wallen 1983; Broos 1987, pp. 194-202, no. 34

Brussels, after 1567
after a design by Michel Cocxie (Mechelen 1499-Mechelen 1592)
workshop of Willem de Pannemaker (active in Brussels 1535-1578)

58 Tapestry with *God the Father establishing his covenant with Noah*

Wool and silk on a woollen warp, 430 × 560 cm
Commissioned by Margaret of Parma, 1567; donated by the
Commissie voor Fotoverkoop in 1955
inv. no. BK-1955-99

This is one in a series of tapestries depicting the story of Noah, the first, eight-piece edition of which was made in Brussels shortly after 1548 for King Sigismund II Augustus Jagello of Poland. Today it is preserved in Wawel Castle in Cracow. The borders of the Polish tapestries are composed of grotesques. Philip II had the series rewoven between 1563 and 1565, this time with his own coat of arms and new borders containing scenes with animals. Three of that series of ten are still in the Spanish royal collection. The tapestry in the Rijksmuseum is from a third weaving that is closely related to the Spanish series. It was made a year after Philip's for the famous illegitimate daughter of Emperor Charles V, Margaret of Parma, who was regent of the Netherlands from 1559 to 1567. Her arms, Austria-Burgundy, are in

the top left and right corners.

Margaret loved tapestries, and in this particular case she gravely embarrassed Maximilian Morillon, vicar-general of the archdiocese of Mechelen and confidant of Cardinal Granvelle, Margaret's prime minister. In 1567, after he had returned to Spain, Margaret asked him to obtain the cartoons of Philip's Noah series for her, which Morillon refused to do. Changing tack, Margaret evidently managed to persuade the famous weaver Willem de Pannemaker (active 1535-1578), in whose workshop the cartoons were stored, to weave a new series. Shortly afterwards she returned to Italy, her husband's homeland, taking a large number of tapestries with her. Some of them ended up in the Bourbon palace in Caserta, near Naples, including the Noah series from which the Amsterdam tapestry comes.

The series remained extremely popular for a long time, and no fewer than 19 reweavings are known up until the end of the 17th century. Some are close to the original, others are freer interpretations. This tapestry depicts God's covenant with Noah (Genesis 9:8-17). God, seated on a rainbow, is blessing Noah, his wife and sons (on the right) and his sons' wives (left). The ark is at upper right. The animals in the broad border stand for the fowl, cattle and 'every creeping thing of the earth' that Noah was to take with him into the ark.

LITERATURE

Göbel 1923, p. 314; Piquard 1950; Szablowski 1972, pp. 116-157; cat. Madrid 1986, pp. 269-272; Meijer 1988; Forti Grazzini 1994, pp. 183-184

Dirck Pietersz Crabeth (active in Gouda c. 1540-1574)

59 Adam and Eve after the expulsion from Paradise

Pen in black and brown, brush in grey and red, 40.8 × 14.8 cm
Purchased in 1936
inv. no. RP-T-1936-6

The name of Dirck Crabeth will always be associated with the famous stained-glass windows in the Church of St John in Gouda. Although this drawing is quite clearly a design for a monumental window, it has nothing to do with Crabeth's work for Gouda; the tracery is totally different from that in the windows of St John's. The church for which the design was made has never been identified.

This is a fine example of a *vidimus* (literally: we have seen)—a fully detailed design that was submitted to patrons for their approval. Once they had accepted it, the next stage of the work could begin, making the cartoons—full-scale working drawings of the window. The contract between the patrons and the artist often stipulated that the cartoons would become the property of the church after the work was finished, so that they could be used as a guide in case the window had to be repaired after storm damage, some other calamity, or simple decay. Many of the cartoons for the Gouda windows have also survived.

Crabeth's *vidimus* depicts two key moments in the earliest history of mankind as recounted in the first chapters of the book of Genesis. When Adam and Eve ate the fruit from the tree of the knowledge of good and evil, God expelled them from the Garden of Eden and condemned Eve to painful childbearing and subjection to her husband, and Adam to toiling on the land until the end of his days. In the left foreground is Adam, digging the earth with his spade as Eve looks on, a distaff in her hand and her son Cain by her side. A little further off is Abel with a bird perched on

his finger. They are surrounded by a multitude of animals, all in pairs, in reference to what is seen in the background: Noah's ark bobbing on the waters of the Flood.

After a while, having observed human wickedness, God regretted creating man and decided to sweep all living creatures from the face of the earth. Only Noah, a righteous man, and his family would be spared. He entered into a covenant with Noah, charging him to build an ark and take into it his family and all the animals of the earth, the sky and the seas—two of each, male and female. It would then rain for 40 days and 40 nights, and all life on earth would be swallowed up. And so it

Detail

came to pass. When the inundation finally ended no creatures were left alive on the earth. The waters gradually receded, and after many months the earth reappeared. Noah, his family and the animals could leave the ark. After Noah had made a sacrifice, God uttered the same blessing he had bestowed on the first man and woman before the Flood. This, too, is incorporated in the drawing. God appears high in the heavens, and from his mouth come the words 'Crescite Fi[lii] multiplicamini', 'Be fruitful, and multiply'. Noah has become the new Adam.

LITERATURE
Van Regteren Altena 1938, pp. 109, 113-114; Van der Boom 1940, pp. 159-160; exhib. cat. Amsterdam 1978, no. 155

Workshop of Pieter Coecke van Aelst

60 *The triumph of Fame*

Pen in black and brown-grey, brush in grey, heightened with white bodycolour (partly oxidised), ø 28.4 cm
Purchased by the Rijksmuseum-Stichting in 1992
inv. no. RP-T-1992-3

This is the fourth in a series of six designs for stained-glass panes that dates from the 1640s. The scenes are based on Petrarch's *Trionfi*, a long allegorical poem that was widely read in 16th-century humanist circles [*see also 37 and 39*]. They are joined together like the links in a chain, which makes it difficult to understand a scene without knowing what happened in the previous one. The series begins with the triumph of Cupid, carnal desire, which is vanquished by Chastity in the next scene. Death triumphs over Chastity before in turn being destroyed by Fame, which can resonate long after a person's death. But Fame, too, is eclipsed by Time, that gnaws away relentlessly. Time, finally, is defeated by the power that nothing and no one can withstand: Faith.

Fame stands on a cart drawn by two lions and blows two trumpets, one for good

and one for ill repute. In front of her is a lectern with several books in which great deeds of the past are recorded. Thronging around the cart are classical heroes, only one of whom is identifiable by his attributes: Hercules in a lion's skin. The two men walking beside the cart on the far side are historiographers, engrossed in their work. Lying vanquished in the foreground are the Three Fates. In the preceding drawing they were still triumphant, riding on a car driven by Death.

Four of the six designs for this series are in Paris, one is in Vienna and one in Amsterdam. The latter was unknown until it surfaced on the art market in 1992. A considerable number of stained-glass panes made from these designs have survived, of which the Rijksmuseum has two: a *Triumph of Time* and a *Triumph of Faith*.

The name of the artist who made the drawings is not known. He was formerly believed to be Pieter Coecke van Aelst, but that theory has now been abandoned. The style of drawing, which is very incisive and immediately recognisable, is too far removed from that in Coecke's small drawn oeuvre. It is widely assumed that the drawings are the work of an artist who occupied an important position in Coecke's busy workshop, and he is accordingly known as Coecke's 'master assistant'. There are several other drawings and paintings that can be attributed to him.

LITERATURE
Bruyn 1987; exhib. cat. New York 1995, nos. 81-84

Arent Coster (active in Amsterdam between 1521 and 1563) (attributed to)

61 Drinking horn of the Calivermen's Civic Guard of Amsterdam, Amsterdam, 1547

Buffalo horn and silver, h 37.5 cm, w 61 cm
Made for the Amsterdam Calivermen's Guild in 1547; on loan from the
City of Amsterdam since 1885
inv. no. BK-Am-12

Govert Flinck included this drinking horn in a group portrait of the governors of the Calivermen's Civic Guard in 1642, almost a century after it was made. The painting captures the moment when the horn is handed to the four governors by the guild steward [61a]. Its prominence underlines the importance that the guild authorities attached to it. Communal drinking from the horn was an expression of the mutual ties between the governors. The painting originally hung in the great chamber of the Calivermen's Hall, close to another famous group portrait of the same year, Rembrandt's *Company of Captain Frans Banning Cocq and Lieutenant Willem van Ruytenburgh*, popularly known as *The nightwatch*.

The late-Gothic design of the silver mount for the buffalo horn looks a little old-fashioned for the mid-16th century. Rooted in a quatrefoil, domed foot, which is usually found in church plate, is a gnarled, naturalistic tree flanked by a dragon and a lion. The combination of these heraldic beasts is found in the coat of arms of the Van der Schelling family, members of which may have donated the horn to the guild. The canopy of the tree decorates the underside of the mount in which the horn is fastened. On either side of the openwork section of the mount is a bird's claw, the symbol of the Calivermen's Guard, set in an asymmetrical foliate scroll. The claws are linked by a horizontal double shield with the arms of Amsterdam, mounted on which is the lion of Holland.

Surprisingly, this part of the mount is not the same as that shown in Flinck's painting [61b]. There the coats of arms are different, lean against each other, and are topped with the imperial crown. The lion

61b Detail of fig. 61a

61a Govert Flinck, *Four governors of the Calivermen's Civic Guard with a servant*, 1642; oil on canvas, 203 × 278 cm. Amsterdam, Rijksmuseum (inv. no. SK-C-370); on loan from the City of Amsterdam

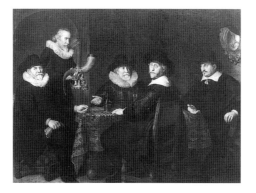

of Holland is missing, as are the scrolls on either side of the claws. The original decoration of the mount as reproduced in the painting is far more clear-cut and balanced than the present-day composition. The discrepancies are probably due to alterations made in the 19th century.

LITERATURE

Cat. Amsterdam 1952a, no. 35; exhib. cat. Amsterdam 1984-85, no. 6; exhib. cat. Amsterdam 1986, p. 388, fig. 267b; Knevel 1994

Jan Coster (active in Amsterdam between 1521 and 1563) (attributed to)

62 Messenger's badge, Amsterdam, 1548 ?

Silver, parcel-gilt and enamelled
mounted on a copper backplate, 18.4 × 15.5 cm
Made for the City of Amsterdam; on loan from the City of Amsterdam since 1885
inv. no. BK-Am-15

This badge was made for the City of Amsterdam as the insignia for the city messenger, and derived from a powerful medieval tradition of receptacles for carrying letters. Badges of this kind identified the city or corporation employing the messenger, and also afforded him some degree of protection. It was a sign of the city's authority. This specimen is one of three surviving, 16th-century messengers' insignia that are well-nigh identical. The other two are in the Amsterdams Historisch Museum.

The lavish design of this badge, which is

62a Cornelis Bos, Female herm in strapwork against a cartouche with satyrs and masks, 1546; engraving (S. 123), 24.3 × 17.9 cm. Amsterdam, Rijksprentenkabinet

remarkably advanced for 1548, reflects the civic pride of Amsterdam, which expanded rapidly in the course of the 16th century. The maker's ingenuity emerges mainly in the framing element. There was little he could do with the medallion itself, for it is completely filled with a depiction of the great seal of Amsterdam. Superimposed on the vessel known as a cog, the old symbol of the city, are the arms of Amsterdam surmounted by an imperial crown. The shield is supported by two Roman soldiers, the one on the left also holding the crowned, imperial coat of arms, while his counterpart has the crowned arms of the county of Holland. The three coats are enamelled in red and black.

The ornate frame, composed of six satyrs in scrollwork compartments, is an unusually bold interpretation of the southern Netherlandish Mannerism that evolved in Antwerp in the 1540s. That variant reached the north through prints by artists like Cornelis Floris and Cornelis Bos. Beginning in the early 1540s, they

produced numerous prints with out-landish inventions in which there are endless variations on the strapwork. One common motif in Bos's work are satyrs completely confined by strapwork [62a]. It was this element that Jan Coster incorporated in the frame of the medallion, although without imitating it slavishly. He did not portray his satyrs as secondary details, as they are in the print, but allowed them to dictate the form and outline of the frame. This invention gives the badge its force and originality, making it one of the most remarkable examples of Mannerism in northern Netherlandish silverwork.

LITERATURE
Schéle 1965, no. 123; Weber 1966; exhib. cat. Amsterdam 1984-85, no. 7; exhib. cat. Amsterdam 1986, no. 191

Adriaen de Groet (active in Den Bosch c. 1558)

63 Covered cup, Den Bosch 1561-1562

Gilt silver, h 27.2 cm, ø 10.6 cm
From the collections of Anthony Rothschild and Michael Noble; acquired in 1957
inv. no. BK-1957-36

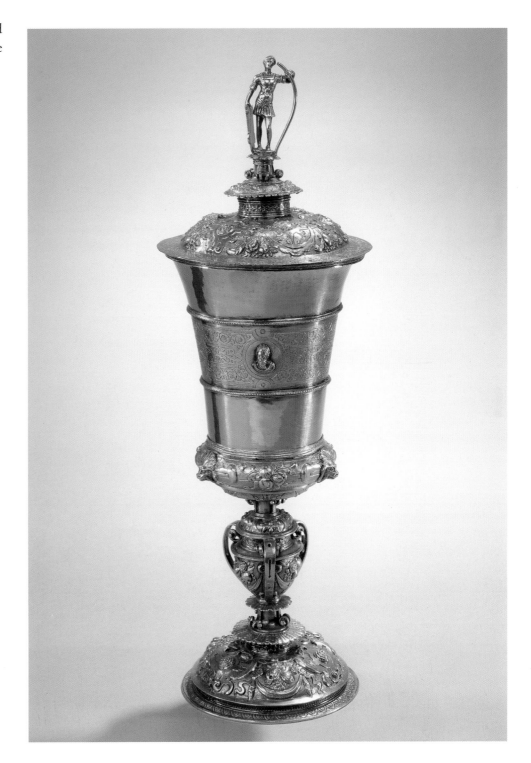

One outcome of the growing prosperity in the northern Netherlands in the 15th and 16th centuries was that the rising burgher class and civic institutions like town councils and guilds began proclaiming their status with silver showpieces. This cup is a fine example of this development, and was mainly intended for display. Only on exceptional occasions did people drink from it.

The Renaissance reached the Netherlands around 1520, but the new style only became popular in northern Netherlandish silver around 1550. Adriaen de Groet's silver-gilt covered cup, with its well-proportioned shape and extremely delicate decoration, is one of the finest of the rare showpieces made in the northern Netherlands in this period. It is executed in a purely Renaissance style; every trace of the Gothic has disappeared. Both the form and the range of decoration are derived from the vocabulary of classical antiquity. The cup stands out for its solid symmetry and a clearly defined structure of horizontal sections that harks back to Antwerp specimens from the 1530s and 40s. The pronounced verticality and the contrasts between smooth and decorated areas presage an even newer style.

The cup is decorated with various ornaments that recur in different combinations on each section. The domed foot is adorned with cartouches separated by repeating bunches of fruit and draperies, which reappear on the baluster-shaped stem. The convex base of the bowl once again has bunches of fruit, this time alternating with mascarons. The broad band around the middle of the smooth bowl is decorated with engraved moresques and three cast busts. The structure of the shallow-domed cover is very similar to that of the foot and is decorated with similar ornaments. In the middle is a plinth supporting a soldier in classical garb.

Adriaen de Groet used this showpiece to demonstrate his perfect mastery of the different smithing techniques of chasing, casting and engraving—such a display being considered very important in the 16th century. The ornamental friezes of small rosettes found in various places on the cup. They were made with punches, a typically 16th-century technique that was especially popular in Germany. De Groet drew on his great technical ability to achieve such delicacy in the small-scale decoration that the cup looks almost like a jewel.

LITERATURE
Frederiks 1961, vol. 4, pp. 22-23, no. 40; exhib. cat. Den Bosch 1985, no. 40; exhib. cat. Amsterdam 1986, no. 279

64a Two ciborium glasses, depicted in the *Catalogue Colinet*, c. 1550-1560, fol. 5. Corning, The Corning Museum of Art (Juliette K. and Leonard S. Rakow Research Library of the Corning Museum of Glass)

Netherlands, second half 16th century

64a *Goblet, blown à la façon de Venise*

Clear, grey-brown and opaque turquoise glass, gilding, h 20,5 cm, ø 11,5 cm
From the Koninklijk Kabinet van Zeldzaamheden, The Hague, 1875
inv. no. BK-NM-771

64b *Goblet, blown à la façon de Venise*

Clear, grey-brown and opaque turquoise glass, gilding, h 25.2 cm, ø 13.2 cm
Bequest of A.J. Enschedé, Haarlem, 1896
inv. no. BK-NM-10754-32

Little is known about the production of Netherlandish glassworks in the 16th century. There is a general overview, but the precise data that would provide an insight into the typology and use of certain kinds of drinking glass is lacking. One of the few aids is the *Catalogue Colinet*, an illustrated sales catalogue of the Colinet family glass-house at Momignies and Beauwelz in the province of Hainault (in modern-day Belgium). This manuscript [64a], which is probably a later transcription of an original written in the third quarter of the 16th century, gives a good idea of the production of a large glass-house that made not only the traditional green Waldglas but also glass *à la façon de Venise*. Listed under nos. 2 and 3 are two 'veeres cibores a panse pour vins ou bier' (ciborium glasses with round bowls, for wine or beer) [*cf. 64a*]. They could be supplied with or without a cover, and executed in clear or ice glass (*verre craquelé*). Glasses of that type were also manufactured in Italy. The draughtsman Giovanni Maggi depicted four variants in his *Bichierografia*, which was published in Florence in 1604 [*64b*].

The term ciborium, which is now applied only to an ecclesiastical vessel, is used here to describe the type. It is derived from the Greek *kiboorion*, and in antiquity and the middle ages it meant both a protective vessel and a goblet.

The other piece is a tall wine-glass of the type known as a half-high flute in the 16th century, with a hollow, mould-blown stem decorated with mascarons and lion's masks under a gadrooned collar. It was a popular

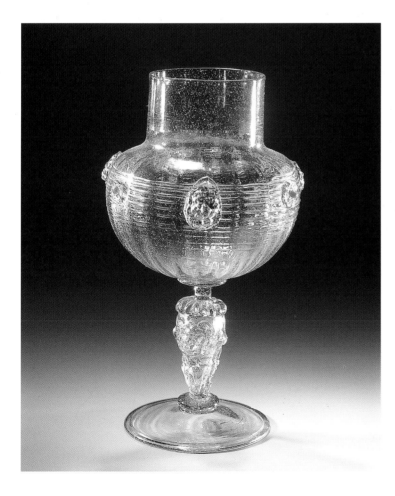

64b Ciborium glass with cover, depicted in Giovanni Maggi, *Bichierografia*, Florence, 1600-1604, fol. 21. Photograph: Rijksmuseum

type, both in Venetian glass and in glass blown *à la façon de Venise*.

It is difficult to distinguish a Venetian glass from one made in the Netherlands *à la façon de Venise*. Glass-blowers worked on an international scale, and were extremely mobile. The names of the same glass-blowers continually turn up in Venice, Antwerp, Amsterdam and other northern centres. Venice also had a thriving export industry, not only for glasses but for the raw materials for making glass.

Characteristic of the early production in the Netherlands, which was concentrated in Antwerp (1549), and later in Middelburg (1581) and Amsterdam (1597), are the grey-brown colour of the glass, which often contains many impurities, and the rather less delicately blown walls of the bowl.

LITERATURE

Liederwald 1964, p. 153; exhib. cat. Amsterdam 1986, nos. 293-294, cat. Amsterdam 1993, nos. 93 and 101

Jan Bogaert or Adriaen Jansz Bogaert (active in Antwerp)

65 Dish with the Conversion of Saul, 1550

Majolica, painted in blue, green, yellow, ochre and purple, in a brass frame, ø 39 cm
Acquired in 1990
inv. no. BK-1990-10

This impressive dish, which must originally have had a diameter of around 50 cm, is unique for 16th-century majolica north of the Alps. There is no such dish from Antwerp that compares with it, either in form or size. It originally had a flat rim, and bears a closer resemblance to several majolica plaques produced in Antwerp than to the dishes intended for the sideboards of the rich. This particular specimen can therefore be regarded as wall decoration, rather like a painting. The colour was applied in a medium that was not very common in Antwerp at the time: tin glaze on earthenware.

After approximately 150 years the rim had become so damaged (it had probably lost at least one large fragment) that it was decided to grind it down and put the dish in a brass frame. One remaining area of damage was covered with a small heart-shaped patch.

What remained was the central scene. Saul of Tarsus, the future apostle Paul, has been struck by lightning and lies on the ground beside his horse, which is being calmed by a servant. The other horsemen are scattering and riding off in two directions. Above the clouds is Jesus surrounded by angels. In the distance, tucked away in the landscape, is the city of Damascus that was Saul's destination.

65a Venice, second quarter of the 16th century, *The conversion of Saul*; woodcut, 77.5 x 103.5 cm.
Boston, Museum of Fine Arts (inv. no. 52.1089.a/b)

The scene of Saul is based on a woodcut in the style of Titian that was made by an anonymous Venetian artist in the second quarter of the 16th century [65a]. The background, mountains and buildings, however, appear to have been taken from a tile picture of the same subject that is dated 1547 [65b] and probably came from the shop of Franchois Frans, a second-generation majolica-maker (now in the Museum Het Vleeshuis, Antwerp). The size of this tableau, which is 11 tiles across (approx. 140 cm), gave the painter far more room than was available on the dish. A special, reduced design had to be made for the latter, with the woodcut serving as the guide.

Pieces that are dated or monogrammed, or both, are rare in Antwerp majolica. They are usually ambitious in their design and are of a very high quality. This dish must have been a technical and artistic challenge for both the potter and the painter, and the result was regarded as a *pièce de résistance*, so it was only logical to sign and date it. The monogram J.A.B. with house mark could be that of Jan Bogaert. Pieces marked in this way are attributed to the 'Den Salm' works run by Franchois Frans, although there is no convincing evidence that they were not made by the Bogaert family. Their name, after all, is the closest match with the monogram.

LITERATURE
Dumortier 1986, pp. 6 and 27; exhib. cat. Antwerp 1993, no. 102

65b Workshop of Franchois Frans, *The conversion of Saul*, 1547, tile tableau, 96.5 × 193.5 cm. Antwerp, Museum Het Vleeshuis

Reijnier van Jaersvelt (active in Antwerp between 1528 and 1576)

66 Covered goblet, 1546-1547

Gilt silver, pearls and glass, h 27.1 cm, ø 11,7 cm
From the collection of King Willem II, Paleis het Loo; donated to the Koninklijk Oudheidkundig Genootschap (KOG) in 1885 by King Willem III; on loan to the Rijksmuseum since 1885
inv. no. KOG-2465

This goblet represents a type that was used throughout Europe in the 16th century, only a few examples of which have survived. In 1533-1540, Hans Holbein the Younger designed a similar object of rock-crystal set in enamelled gold for King Henry VIII of England. A very similar specimen made entirely of silver is the so-called Boleyn Cup in the Church of St John the Baptist in Cirencester, England. Similar goblets were also found in the northern Netherlands, as evidenced by the 1571 inventory of Toutenburg House near Vollenhove, which lists 'A tall crystal glass with a gilt foot and gilt cover'.

The goblet, which consists of a glass bowl and a silver-gilt foot and cover, was probably made in its entirety in Antwerp.

The fittings bear the maker's mark of the Antwerp goldsmith Reijnier van Jaersvelt. The glass could be Venetian, but is more likely to have been blown in Antwerp by the Italian Michiel Cornachini, who set up a glass-house there in 1541. The goblet has a funnel-shaped bowl decorated with vertical ribs above a steep, composite foot. The moulded, convex cover is topped with a stem collared with a fleuron with foliate ornaments and scrolls set with pearls. Seated on top of the stem is a boar. The decorative elements of the mount are an early example of Mannerism: the strapwork with lion's masks on the foot, the satyr's heads on the knot and the crowning element of the flower-basket on the cover. Chased on top of the cover is a continuous

scene of figures derived from classical antiquity enacting the Triumph of Faith. The inside of the cover is decorated with a circular scene of numerous animals in Paradise. Projecting from the centre is the body of a unicorn that can be seen through the glass when the cover is in place [66a]. This is what makes the goblet unique, for there is no other known specimen with a figure protruding from the inside of the cover. The concave termination of the animal's horn may explain this puzzling addition, for the opening very possibly contained a piece of narwhal tooth. It was believed that this material, which came from a marine animal found in Greenland, belonged to the unicorn, the paradisal animal to which people attributed magical powers. When the glass was filled, that part of the supposed unicorn would have been below the surface of the liquid, thereby infusing it with the animal's magical powers. The inclusion of a piece of foreign material placed the goblet in the tradition of the late-Renaissance *Kunst- und Wunderkammer*. Such collections, where were put together by rulers or high dignitaries, housed both works of art and natural history specimens. Collections of this kind combined ornately decorated objects in precious metals with products of nature, like the well-known glasses set in coconut and nautilus shells. It is to that genre that Van Jaersvelt's rare goblet belongs.

LITERATURE
Van Hasselt 1896, p. 92; cat. Amsterdam 1952a, no. 34; Hayward 1976, p. 395; exhib. cat. Antwerp 1988-89, no. 24; exhib. cat. Amsterdam 1992, pp. 169-191; Ter Molen 1995, pp. 111-112

66a Interior of the cover

Mechelen, c. 1550

67 Domestic altarpiece

Alabaster and oak, gilt and painted, h 122 cm, w 81 cm
Probably from the Commandery of St John in Harderwijk; on loan since 1953
from T.H. de Meester, The Hague, and his heirs
inv. no. BK-Br-515

The foundations of the Mechelen alabaster industry were laid by a small group of artists, some of them foreign, who worked at the beginning of the 16th century for the court of Margaret of Austria in the new Renaissance style that had been imported from Italy. The best-known among them were Conrad Meidt and Jean Mone. Their presence in Mechelen stimulated local carvers to work in alabaster using this new vocabulary of forms.

The main products of these so-called 'carvers of minor works' were small tableaus with mythological and biblical subjects that were made in almost endless series until well into the first half of the 17th century. These little alabaster paintings, ranging in size from 10 to 12 centimetres, were set in frames with pressed papier-maché borders [67a]. Gilders then enlivened the scenes and frames with gold highlights. Many of these objects have the monograms and house marks of their makers—testimony to the rivalry between them and also a guarantee of quality.

Alongside this rather coarse, series production, Mechelen also supplied domestic altarpieces in which reliefs of various sizes were set in richly ornamented wooden frames. There are two in the Rijksmuseum. This, the most important of them, and also one of the finest examples of the Mechelen carvers, very probably belonged to the Commandery of the Knights of St John at Sint Jansdal near Harderwijk. It was excavated there in the 18th century, packed in a chest and in remarkably good condition. The altarpiece was probably hidden in 1566, only a few years after it was made, to save it from the fury of the Protestant iconoclasts.

One iconographic detail in the top relief makes it clear that this is no mass-produced work but the result of a special commission. Here the Virgin is depicted in the company of John the Baptist, the patron saint of the Knights of St John. Although domestic altarpieces could be supplied from stock, the high standard of these reliefs demonstrate that this is not a mass-produced piece.

The relief in the centre illustrates Christ's Last Supper with his disciples—a theme that appears on many Mechelen altars, and one that was particularly fitting for an altarpiece due to its Eucharistic associations. The bottom register is filled with a long relief illustrating an Old Testament typology of the Eucharist, namely the Meeting of Abraham and Melchizedek (with the bread and wine). The antique style of this relief, with horsemen in classical garb, is particularly reminiscent of Roman sculpture, and would undoubtedly have appealed to the style-conscious patrons of the altarpiece. That applied equally to the frame, which consists of a classical column order and a fantastical combination of strapwork and scrollwork, festoons, griffins, mascarons and putti in the wings and crowning elements. These motifs come directly from the repertoire of the Antwerp artist Cornelis Floris, whose model prints were highly prized and widely disseminated.

LITERATURE
Jansen 1964; exhib. cat. Trier 1967, no. 60; cat. Amsterdam 1973, no. 176; Wustrack 1982

67a Mechelen, c. 1600, *Africa*; alabaster with traces of gilding, 10 × 12.5 cm.
Amsterdam, Rijksmuseum (inv. no. KOG-1255)

Amsterdam, c. 1560-1570

68 Two corbels

Oak, h 89 cm, w 30 cm, d 25 cm
From the demolished house at No. 3, Hasselaarssteeg, Amsterdam; purchased in 1911
inv. no. BK-Bfr-284 a, b

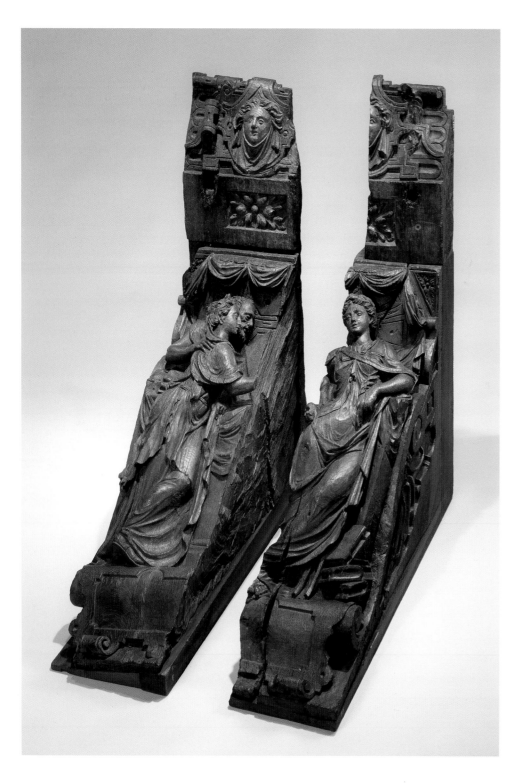

The use of Renaissance forms in architecture was not restricted to the exterior decoration of buildings. The timber frame, which was the commonest method of domestic construction up until the middle of the 17th century, also changed in response to the new style, and some of its decorations were of extremely high quality. That could be seen in the interiors of the grander 16th-century houses in the decoration of the corbels and brackets that supported the beams where they met the vertical wallposts.

The main change in the shape of the corbel took place around the middle of the 16th century. The medieval type, a separate, diagonal support beam with very little in the way of decoration, evolved into a triangular block with a curved front—the swan-neck corbel. The new enclosed type provided more room for decorative elements, and wood-carvers seized on the opportunities it presented them. The embellishments were often based on ornament prints and model books that propagated the Renaissance style. The work of the Antwerp designers Cornelis Floris, Cornelis Bos and Hans Vredeman de Vries were particularly popular in the Netherlands [see also 62].

The influence of Vredeman de Vries is apparent in these two corbels from an Amsterdam house that once stood at No. 3, Hasselaarssteeg. Similar but not identical corbel shapes can be found in his book on columns, *Corinthia composita* of 1565. The principal scene on the Amsterdam pieces consists of a single figure or a couple in classical dress standing beneath a balda-chin. Their meaning is not clear, but perhaps they are Christian or classical personifications of virtues. The woman with a pile of books beside her might be *Sapientia* (Wisdom). Since these two corbels are probably all that remains of a larger array, one suspects that the decoration consisted of a unified iconographic

programme adorning a room used on formal occasions.

It is not known who commissioned the corbels. There was a brewery at No. 3, Hasselaarssteeg in the 16th century. The owner in 1643 was Willem Jansz Brouwer, and 14 years later the house was in the hands of his son-in-law Andries Boelen Hollesloot. The latter, whose family had already gained considerable political power in the first half of the 16th century, belonged to Amsterdam's regent class, with Andries Boelen himself being appointed sheriff in 1572. In 1587 the brewery was owned by Pieter Dircksz Hasselaar, who was certainly well-off and owned many of the other buildings in the same street. The brewery traded under the name 'De Witte Arent' (The White Eagle). Either Hollesloot or Hasselaar could have commissioned the corbels, for as sheriff and property owner they would have had the means to order such lavish carvings.

LITERATURE
Cat. Amsterdam 1952b, no. 20; exhib. cat. Amsterdam 1986, no. 271; Dudok van Heel 1986

Northern Netherlands, c. 1550-1600

69 Armchair

Oak, inlaid with rosewood and walnut, h 115 cm, w 57.5 cm, d 44.5 cm
From Nieuw-Teylingen House near Voorschoten; in the Nationale Konst-Gallerij, The Hague, around 1800, as the chair of Jacoba of Bavaria
inv. no. BK-NM-1009

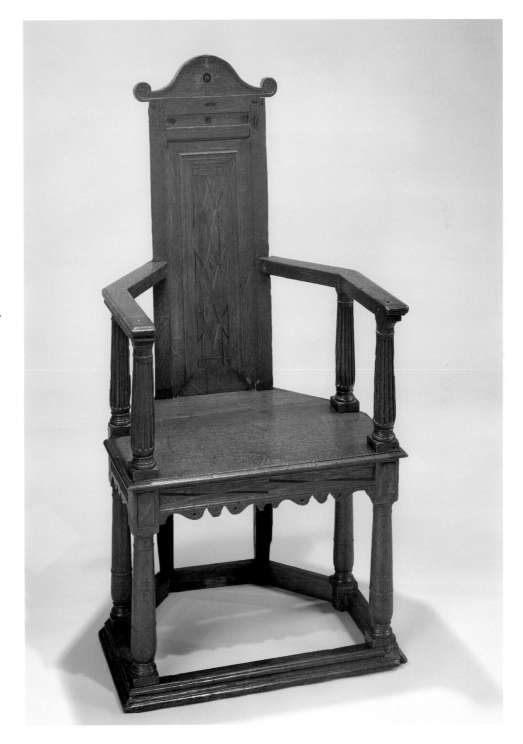

Northern Netherlands furniture very much had a style of its own in the 17th century, but that was less marked in the 16th century, in so far as we can make out from this distance in time. The major centres of furniture-making lay beyond the borders of the northern Netherlands, and domestic production reflected influences that came from a variety of sources.

This type of armchair, with its high back, the seat widening towards the front, and the legs, connected by rails, extending up to support the arms, was derived from French models. This example was clearly not made in France, given the use of oak, the rather heavy colonnettes supporting the seat and arms, the moulded panel in the back, and the unusual crowning element, as well as some rather unattractive features like the shaved capitals of the arm supports. It looks Netherlandish in its solidity, with the pronounced horizontals somewhat vitiating the tall, elegant model. The main indication of a Netherlandish origin, however, is that the chair was already at Nieuw-Teylingen House near Voorschoten in 1746. By then it had acquired the legend that it had once belonged to Jacoba of Bavaria, Countess of Holland and Zeeland, who lived at Teylingen Castle at the end of her life. The date of the chair rules that out completely.

Painted portraits of Jacoba and her last husband, Frank van Borselen, were also kept at Nieuw-Teylingen. Around 1800, they and the chair were acquired by the Nationale Konst-Gallerij, the forerunner of the Rijksmuseum. It was housed in Huis ten Bosch when it first opened its doors to the public in that year. The armchair was prominently displayed in the palace's former White Dining-Room, where it was flanked by two 'Jacoba jugs', and with the two portraits hanging above it. Like Dirck de Graeff's chair [70], it was preserved thanks to a historical association—one that was certainly false in this case.

The chair, imitating the French style and skilfully made, would undoubtedly have appeared elegant and costly in the 16th-century Netherlands. Its foreign, almost courtly nature, is reinforced by its inlaid decoration, which follows the example of the finest French pieces. It was a technique that was still in its infancy in the Netherlands, although in Italy and Germany it had already reached great heights.

LITERATURE
Lunsingh Scheurleer 1946, p. 52; cat. Amsterdam 1952b, no. 183; Van Thiel 1981, pp. 213 and 218, no. 217; exhib. cat. Amsterdam 1986, no. 274

Northern Netherlands, c. 1560-1580

70 Armchair

Oak, h 163.5 cm, w 88 cm, d 55 cm
On loan from the De Graeff family to the Koninklijk Oudheidkundig Genootschap
from 1873; on loan to the Rijksmuseum since 1885
inv. no. BK-KOG-1777

Wooden furniture has a relatively low intrinsic value. Once it goes out of fashion there is little reason to hold on to it, especially when it is not lavishly decorated. It is often thrown out or literally used up. If 16th-century items of furniture are consequently rare, rarer still are those whose early provenance is known, and with it an indication of the place of manufacture. Most of them come from institutions, which are usually not so susceptible to the whims of fashion as private individuals are [see 22], or were cherished because they were associated with a particular person or event, which made them secular relics, in a way [see 69]. That is the case with this armchair. Attached to the back is a copper plate with the words 'In dese Stoel heeft geseten Willem de eerste Prince van Orangien, wanneer hij A° 1578. ten huyse van mijn Over groot Vader, de Burgermeester, Dirk Jansz de Graeff, Wonende alsdoen in de Keijser op het water, Gelogeert was' (Willem the First, Prince of Orange, sat in this chair in 1578 when he stayed with my great-grandfather, Burgomaster Dirk Jansz de Graeff, who then lived in a house called 'De Keijzer' by the water). The connection had evidently been handed down from one generation of the De Graeffs to the next, and the chair was reverentially preserved in the family for that reason.

Prince Willem I (William the Silent) visited Amsterdam not in 1578 but 1580, when he was indeed the guest of Burgomaster Dirck Jansz de Graeff in 'De Keizer' on Warmoesstraat, opposite Papenbrugsteeg. He was obviously given the best chair in the house, and it is very possible that it was indeed this imposing specimen, which has undoubtedly always been a single and remarkably distinguished piece. The plate with the inscription may have been added by De Graeff's great-grandson Cornelis, who bought Ilpendam House, where the chair was to be found in the early 19th century. Generally, stories of

this kind should be viewed with great scepticism, but in this case it seems not unlikely that the legend is true.

If so, this hooded chair is a unique example of an item of formal furniture from the estate of a late 16th-century Amsterdam burgomaster. It is a meticulous and beautiful piece of work. The type, which offered good protection from draughts, is from all ages, but the workmanship and above all the carved decoration indicate that this one was made in the 16th century. The satyrs and the scrollwork with the angel's head that adorn the pediment are motifs that were widely applied in northern Netherlandish decorative arts from the middle of the century on. Dirck de Graeff returned to Amsterdam shortly before the Alteration of 1578 (the replacement of Catholics with Protestants in civic bodies), after having lived elsewhere for many years. It is possible that he bought a new chair for his eminent visitor, but equally conceivable that it had been in his possession for some time.

LITERATURE

Breen 1924, pp. 71-72; cat. Amsterdam 1952b, no. 185; exhib. cat. Amsterdam 1986, no. 273

Antonis Mor van Dashorst (Utrecht c. 1516/19-Antwerp c. 1575)

71 Portraits of Sir Thomas Gresham and his wife Anne Fernely, c. 1560-1565

Oil on panel, 90 × 75.5 cm; panel transferred to canvas, 88 × 75.5 cm
From the collections of Ann Compton, Countess of Northampton (1792), and the Hermitage, St Petersburg; acquired in 1931 with the aid of the Vereniging Rembrandt
inv. nos. SK-A-3118 and SK-A-3119

Antonis Mor van Dashorst was a pupil of Jan van Scorel in his birthplace of Utrecht. His earliest dated work, a double portrait of 1544, fits in seamlessly with the style and approach displayed in Scorel's portraits of the period. It was as a portraitist that Mor made his name—not in Utrecht, although he always kept up in touch with his friends there, but in Antwerp, where he was registered as a master in the Guild of St Luke in 1547. His talent was soon spotted by one of the most powerful people at the

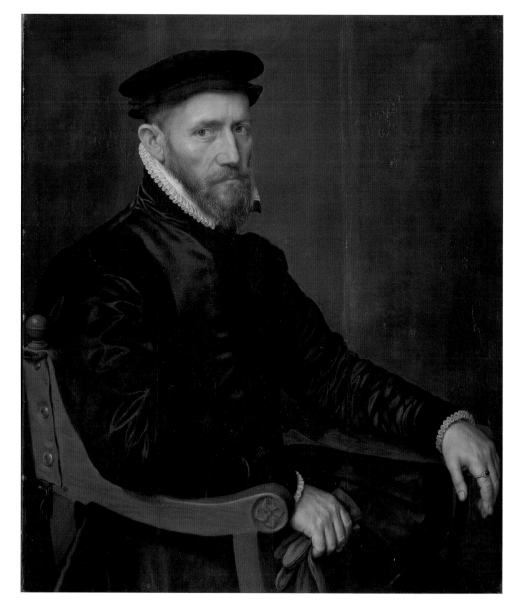

Habsburg court in Brussels: Antoine Perrenot de Granvelle, Bishop of Arras and later cardinal. His portrait of 1549 and that of the Duke of Alva of the same year demonstrate how rapidly Mor matured as an artist. He soon abandoned Scorel's rather angular and stiff manner for a far more sculptural and stately form of depiction. The dignified reserve of his models reflects the influence of the formal state portrait that Titian had developed shortly before in Venice. This gave rise to the theory that Mor met the Italian master in 1548 when he reputedly accompanied Granvelle to the Imperial Diet in Augsburg, where Titian was employed painting the portraits of Emperor Charles V and his entourage. It is more likely, though, that Mor discovered Titian's achievements in the Brussels palace of regent Mary of Hungary, who had dozens of the Venetian's paintings.

The combination of a keenly observed sitter, great plasticity, a meticulous manner and the formal presentation derived from Titian made Antonis Mor the ideal painter for the Habsburg court. His work for Granvelle must have caught the eye of Prince Philip, later King Philip II of Spain, and his family, for in subsequent years he was employed by them in Spain, Portugal, Italy and England, where he painted numerous princes and princesses and their courtiers. Those portraits in turn exerted a powerful influence on the genre of official portraiture in the second half of the 16th century, particularly in Spain, where Mor's pupil, Alonso Sánchez Coello, became court painter.

In addition to portraying the imperial family and high nobles, Mor also painted members of the prosperous burgher class. It is known, for instance, that in October 1564 he made the portraits of several merchants in Antwerp, and that may be when Sir Thomas Gresham (1519-1579) and his wife Anne Fernely (d. 1596) sat to him. Gresham was the leading English merchant in Antwerp, the financial agent of the English crown in the Low Countries, and the founder of the Royal Exchange and Gresham College in London. Here he is seated in an armchair with his head turned three-quarters to the right. His wife is in a similar pose but turned three-quarters to the left. Their poses and bearing are far less reserved than one is accustomed to in such an august couple. The texture of their clothing is reproduced brilliantly. Sir Thomas has his wife on his left, putting him in the hierarchically superior position that was employed in donors' portraits on the wings of 15th-century triptychs and remained *de rigueur* until well into the 19th century. This placement also explains why the light comes from the left, for it falls squarely on the woman's face, allowing her to look her best.

LITERATURE

exhib. cat. London 1995-96, no. 18

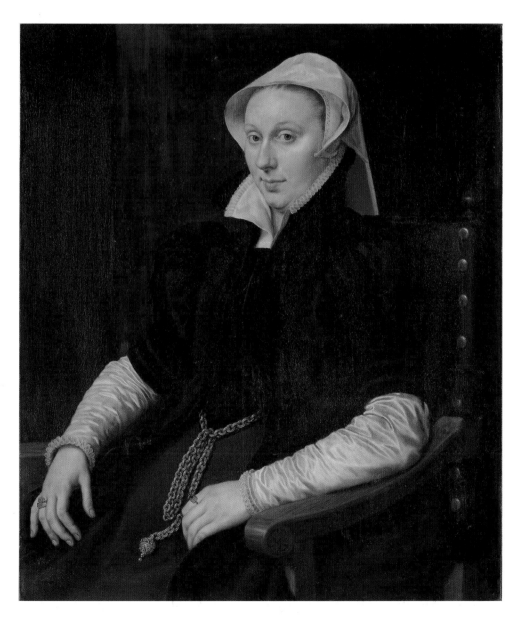

Cornelis Anthonisz (Amsterdam c. 1499-Amsterdam 1553)

72 Saint Crosspatch, c. 1550

Woodcut, hand-coloured, 22.9 × 20.2 cm; text in letterpress, 36.5 × 28.4 cm
published by Jan Ewoutsz, Amsterdam; monogrammed at lower left: CAT
From a large album containing 16th-century German and Netherlandish
woodcuts from the collection of the Duke of Saxe-Coburg-Gotha in Gotha;
acquired in 1932 with the aid of the Vereniging Rembrandt
inv. no. RP-P-1932-126

72a Albrecht Dürer, *The Flight into Egypt*, c. 1503;
woodcut from the series *The life of the Virgin* (B. 89),
30.1 × 20.9 cm. Amsterdam, Rijksmuseum,
Rijksprentenkabinet (inv. no. RP-P-OB-1418)

Prints had many functions from their very inception. They ensured the spread of artistic ideas and models, were used for devotional purposes, enjoyed for their sheer visual pleasure, recorded historic events, and served as maps. In addition, they could make a moral point, when they might be combined with a text. The scene could be allegorical, pure propaganda, satirical or parodic, like this hand-coloured woodcut after a design by the Amsterdam artist Cornelis Anthonisz.

The long text spread over three columns makes it a rhyme print, and its size was ideal for decorating a wall. At lower right it has the publisher's address, as if it were a book. We read that Jan Ewoutsz, 'carver', printed and published the scene himself, and he probably cut it as well. The print could be bought from Ewoutsz's shop, 'Inden vergulde Passer' (In the Gilt Compass) in Amsterdam's Kerkstraat, but it was undoubtedly available from other print and book sellers as well. The distribution network for books and graphic art evolved very rapidly.

It is a parody in word and image, a parody of a devotional print in which a saint is depicted along with the prayers addressed to him or her. The woman riding on the ass with a halo around her head is a mock saint, not a real one. She is called St Crosspatch, and was widely venerated, or so we are told in the legend above the scene. In the 16th century, the word 'aelwaer' (the 'saint's' Dutch name) had several meanings, ranging from rash and foolish to grouchy

and slanderous. It was used of someone who was stupid enough to condemn everything out of hand, and was a dull-witted scold into the bargain.

Crosspatch's animal attributes fit her to a T. Pigs were regarded as greedy and lazy, cats as demonic and sly (and were associated particularly with marital discord). The foolish Crosspatch is compared in the poem to a magpie, a notorious chatterbox,

> He never lets up
> Even when he's utterly wrong, his tongue chatters on
> So he must be an unpleasant natterer
> Who always wants to win, and never lose.

The ass, of course, was associated with stubbornness, and 'Riding the ass' meant losing one's temper.

It is no coincidence that St Crosspatch is a woman, for bickering and indiscretion had long been seen as a female preserve. The scene also contains an ironic reference to the Virgin Mary which would have been spotted by viewers who knew their Bible well. She, too, is seated on an ass in depictions of the Flight into Egypt, and Cornelis Anthonisz copied this particular animal very faithfully from Albrecht Dürer's woodcut from the *Life of the Virgin* [72a]. Mary, who epitomised female virtue, has here been transformed into her opposite.

The poem, too, is filled with humorous sallies, particularly in the roll-call of Crosspatch's acolytes: drunkards and their ranting wives, prostitutes, gamblers,

musicians and artists, lawyers, foreigners from far and wide, and rhetoricians too—the group to which the anonymous author of the poem probably belonged. The woodcut itself is also mentioned: St Crosspatch had an especially devoted following in Amsterdam, 'her likeness is lovingly printed there'.

LITERATURE
De Jong 1975-76; exhib. cat. Amsterdam 1986, no. 155; Armstrong 1990, pp. 37-44

Elck dient sinte aelwaer met grooter begheert die van veel menschen wordt gheeert.

Heestelick waerlick coemt al ghelijcke
om te versoecken dese groote santinne
een patroenerse van arm ende rijcke
edel onedel / twaert tot uwer gewinne
Sinte aelwaer heeft verstaet wel den sinne
dus brengt haer wt minne / v offerhande
want si heeft gheregeert van swerelts beghinne
oost west suyt noorden in allen landen
daer der twe vergadert zijn / opent v verstanden
daer is si int middel / soot heeft ghebleken
wilt haer verlichten v licht laet branden
ende wilt haer dach daghelic een kaers ontsteken
op dat ghi by haer moecht worden gheleken
kwodit v gheraden ter goeder trouwen
haer gracie en sal v niet ontbreken
wilt se doch met ooghen aenschouwen
waer dat ghi zijt voor ende na
lof grote santinne aelwaria.

Op een eezel is si gheseten
die niet haest wt sinen tret en gaet
so ist oock mede so elck mach weten
met alwaerts kinderen dit wel verstaet
sy willen doch recht hebben tsi goet of quaet
niemant en wilt verloren gheuen
sy en vraghender niet na wat hindert of baet
al sorden si altijt onrustelick leuen
dese waerde grote santinne voorschreuen
onder den eenen arm heeft si een vercken
ende in dander hant een kat op ghehecuen
twelck is tot alwaers verstercken
een vercken moet gnorten in allen percken
twelck alle onrust heeft te beduyen
door tollen der katten so machmen bemercken
onuredelicheyt van daelwatighe luyden
waerich haer noorden of suyden
ick moet haer aenroepen vroech ende spa
lof grote santinne aelwaria.

Op sinte aelwaers hooft een voghelken sit
een aecrter gheheeten die altijt schatert
so is een alwaerich mensch die nemmermeer swicht
die zijn kinnbacken nemmerme er goet en snatert
heeft hi recht onrecht zijn tonghe die clatert
met luttel bescheps ramp heb zijn kiesen
dus moetet wel wesen een onghewalicke pratert
en altijt winnen wil ende niet verliesen
onder duysent walen ende vriesen
daer is sinte aelwaer wel bekent
ick weetse die met aelwaers horen so sterck bliesen
dat si daer door int eynde werden ghescheindt
maer Tamstelredame der stede present
daer is sinte aelwaer hooch op gheresen
haer figure wort ter door liefde gheprent
sy wort vanden menighen int herte ghepresen
dunct v met dat ick die waerheyt ra
lof grote santinne aelwaria.

Sinte aelwaer begint tonse huyse heel te bollen
sprach daer een man van vremde faetsoen
alsmen hem des auents drocken thuys siet comen
soe stoot hy teghen den drompel zijn schoen
maer sanderendaechs smorgens vroech voorde noene
dan hoortmen sinte aelwaer thooft op steken
dan swicht hi ende en is niet so coene
dat hi niet een woort wederom en darct spreken
al slumerende ouerdenct hi zijne ghebreken
hoe dat hi zijn ghestelicke schult niet can betaien
daerom moet hi een gordijn spreken
met tgeloof van dien is verde te halen
Sinte aelwaers gheest sietmen oock dickmael dalen
daer si met die cannekens doppen ende clincken
thiet ende wijn en laten si oock niet verscalen
tot dat v mijn heer van valckestcyn singhen
al dese religie van sinte aelwaers dinghen
moet ick verconndighen waer ick sit of sta
lof groote santinne aelwaria

Te boideus hout sinte aelwaerdick haer starie
daer die behulpelicke vroukens vander gilde wont
su sterkens vroerhens sentse oock haer gracie
lollaertkens bagninkens so si han befonen
dit volck en aelwaert niet om malcander te hoonen
maer elck wilt liefste kint ghcacht zijn
schickent so si moghen om hem selue te vscoonen
op liso moghen vanden pater bedacht zijn
sinte aelwaer toont oock haer moghende cracht zijn
op dobbelaers kuysers ende sanghers mede
dat die hoofde staen en rokt tmoet oec ghesacht zijn
verkeerders tittackers zijnte oock haer seden
rtorijckers muysikers clappen seer met reden

Organisten herpenisten alle konstenaers tsamen
hoe dat si verheffen zijn in dorpen in steden
Van sinte aelwaers gracie twelck si haer namen
maer al dese and moeten haer tot dancbaer zij tsamē
Van sinte aelwaers gracie buyten haer sca
Lof groote santinne aelwaria

Den abt va grimberghe mz mijn heer ba kijspoeck
Die sachmen verheffen ende canonizeeren
Met doctor muylaert hoet in gheuif cloeck
Sinte aelwaria niet om vol te eeren
Dock ghinghen een costelick gilt ordineeren
Op dat die relequie nyet en soude verwalen
Om een comiers guldeis dit goette ontbeeren
Comt noormans denen duysten ende walen
Dese gracie moechdi altsamen berwerten
Met sanch salmense eerlick te kercken halen
Al die ghene die in dit ghilde sullen sterten
Een eewighe memorie moecht ghi w seluet ermen
U kinto kinderen die sullent ghenieten
Sinte aelwaers gheest salder oock om stetten
Wit den dou haere gracie sal sise beghieten
Haer te bewijsen laet v niet verdrieten
Godt weet dat ichse niet en versma
Lof grote santinne aelwaria

Prince.

Prince naeken des volcx zijn quaet om sommen
Ende by na onmoghelick als ment wel besiet
Ofter yemant waer bergheten te nomen
Aduocaet procurues wi biddē v en wilts v belegē ns
Of wiet mach zijn pieter of griet
Van sinte aelwaers ghilde vaet dit bediet
So mochdi gheacht zijn als haer gerechte dienaers
Ghi en dorster niet om te roemen of te colen varen
Haer milde gracie is v altoos by
Sy en wilse door niemant ter werlt sparen
Hoe groot hoe machtich hoe riche dat hy sy
Dus wil ick gaen slupten met herten bly
Sinte aelwaers legghende seer soet om hooren
Want luttel yemant isser ter werelt wy
Van wat staten dat si zijn gheboren
Ofter yemant waer die haer gracie hadde verloren
Wen soude se weer crijghen waert datmer om ba
Lof grote santinne aelwaria

Gheprent tot Aemstelredā / aen de oude
side in die kerckstraet / By mi Jan
Ewoutzoon Figuersnijder inde
vergulden Passer.

Maarten van Heemskerck (Heemskerk 1498-Haarlem 1574)

73 *The unhappy lot of the rich, 1560*

Pen in brown, outlines indented for transfer, 16.1 × 23.2 cm
Acquired in 1910 with the aid of the Vereniging Rembrandt
inv. no. RP-T-1910-9

'He was a very good designer, yes: a man who, in a manner of speaking, filled the world with his inventions', Karel van Mander wrote about Maarten van Heemskerck, and he went on: 'there would be no end to it if one wanted to relate how many of his prints have already been published'. The number of prints after designs by Heemskerck is indeed impressive: around 600 in all. Many of them form 'instructive series' that encouraged the viewer to examine his or her conduct. Heemskerck's philosophy is permeated with the ideas of Erasmus and Coornhert, and time and again he proclaims his conviction that man can ensure the salvation of his soul by striving to do good.

This particular drawing was also a design for a print [73a], the fifth in a series of six that was engraved by Philips Galle in 1563. Originally it had no title. That was only added in the third, 17th-century edition, when it was called *Divitum miseria*, or the unhappy lot of the rich. The six prints are composed in such a way that when placed side by side they can be read as a running frieze consisting of a long procession of allegorical and historical figures, supplemented with references to the Bible and classical mythology. The first scene is a literal depiction of two of Christ's pronouncements: that the gate and the way to eternal life are narrow, and that a rich man will never enter the kingdom of God. The last print points the moral that earthly riches are of no avail when death draws near. Between the very similar beginning and end, the viewer is taught that there are two ways of acquiring wealth—the honest and the dishonest—and is introduced to

notorious rich men of the past. The fourth and fifth prints form a single unit illustrating the dangers and consequences of wealth. Seated on a triumphal car is *Regina Pecunia* (Queen Money). It is drawn by the personifications of Danger and Fear, and beside it is Robbery, Following behind are Folly, The Whole Populace, Envy and Theft. Then come the personifications seen in the Amsterdam drawing: *Honor* (on the right), *Splendor* and the large figure of *Fama*. In the background are the *Parasiti*, the scroungers and spongers who worm their way into the good graces of the rich in order to further themselves. Honour is

fleeting, vanishing as swiftly as the smoke from the fire-pot and fuse that are *Honor's* traditional attributes. In the print after this drawing, the fuse is replaced with a bunch of flowers, which soon wither. Fame flies before one knows it, which is why *Fama* has wings. Her robe is strewn with eyes, for fame is no more than an outer sham.

LITERATURE
Cat. Amsterdam 1978, no. 310; exhib. cat. Haarlem 1986, pp. 26-35

73a Philips Galle after Maarten van Heemskerck, *The unhappy lot of the rich*, the fifth print in a series of six, 1563; engraving (NH 480), 17.2 × 23.2 cm. Amsterdam, Rijksprentenkabinet

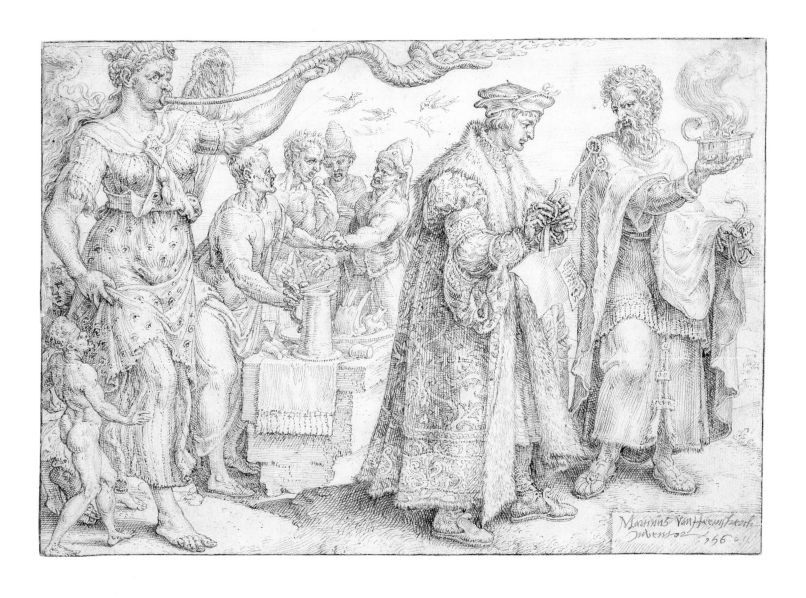

Southern Netherlands, c. 1530–1531

74 *Two of twelve fragments of a table-cloth with the arms of Egmond-De Lannoy and scenes from the story of Susanna*

White linen damask in seven-shaft satin weave, each fragment approx. 125 × approx. 125 cm
From the Linen Room of Noordeinde Palace, The Hague; on loan from the Stichting Historische Verzamelingen van het Huis Oranje Nassau since 1975
inv. no. BK-BR-786

The guests of the Egmond-De Lannoys, seated at a table covered with this magnificent cloth, were admitted to a world of courtly love and restrained sensuality in which lust is vanquished by piety and decorum.

It is only in raking light that the white linen reveals its secrets. In the corners are the impaled arms of Egmond-Buren-IJsselstein and De Lannoy, for it was commissioned by Maximilian van Egmond, Count of Buren, and Françoise de Lannoy.

The table-cloth, which was originally almost 10 metres long, was probably first used when the couple married in 1531. Their daughter Anna became the first wife of William the Silent, which explains why the cloth passed to the House of Orange-Nassau. It survived intact until the 20th century, when it was cut up to make table-napkins.

Originally, there were six, roughly square panels woven into the centre of the cloth with a background of grotesques. The panels showed episodes from the story of the chaste Susanna as related in the apocryphal book of Daniel [see 44].

A small signboard inscribed SUSANNA

in the first scene removes any doubts about which story is depicted. It hangs in a tree, beneath which Susanna, flanked by two maidservants, is bathing her feet in a small pond. The essence of the tale, the two lecherous old men, was unfortunately cut off this fragment. The six scenes are admonitory and moralistic. They hold up the chaste, pious Susanna as an example, and warn that indecency and lying will be punished. That the story is directed primarily at the newly wed Françoise is clear from the depiction of the subject during the Renaissance on Italian bridal chests.

The broad border originally had scenes of young women being proffered flowers and gathering them in their laps, alternating with groups of musicians, with a flute-player dressed as a soldier. Musicians in the corners play a fiddle, a drum and a flute. The entire cloth would have evoked an idyllic world where people whiled away the days with delightful pastimes. It would be going too far to associate the drummer and flautist with the licentious mob that followed in the train of late-medieval mercenary armies, as depicted in prints, or to see the monkeys and squirrels in the trees and the little rabbits as allusions to the sensual pleasures to be enjoyed in a garden of love

surrounded by an artfully woven wicker fence. There is, however, a contrast between the high moral tone in the central scenes and the idyllic diversions in the border.

LITERATURE
Van IJsselstein 1962, pp. 41, 90-91; exhib. cat. Amsterdam 1986, no. 92; Hartkamp-Jonxis 1997, pp. 300-305

Workshop of Willem Andriesz de Raet (active in Leiden c. 1541-1574)

75 Tapestry with *The meeting between Abraham and Melchizedek, c. 1550-1570*

Wool and silk on a linen warp, 170 × 665 cm
Probably purchased in 1873 by the Koninklijk Oudheidkundig Genootschap, Amsterdam (in two pieces); on loan to the Rijksmuseum since 1885
inv. no. KOG-1A

This tapestry was woven in Leiden shortly before the Iconoclasm, in a period when tapestry-making in the northern Netherlands had not yet reached the heights it attained a few decades later, when numerous southern Netherlandish artists, entrepreneurs and craftsmen settled in the north. The maker of this piece, the Flemish weaver Willem Andriesz de Raet, emigrated around 1540 from Brussels to Leiden, where he was active until 1573/74. De Raet worked in Holland with designers like Dirck Pietersz Crabeth on tapestries for the town hall of Gouda, and possibly with Maarten van Heemskerck on a series for the Old Church in Amsterdam. The scene in this work, *The meeting between Abraham and Melchizedek*, is largely borrowed from a tapestry in a series illustrating the story of Abraham that was designed by Barend van Orley in c. 1535. The composition, though, displays little of Van Orley's refinement. De Raet seems to have found it difficult to spread the main and secondary characters harmoniously over the surface, and he also ran into problems with their size, probably because of the frieze within which the scene had to be arranged.

The story (Genesis 14:18-20) revolves around the two figures immediately to the left of centre. Melchizedek, the priest-king of Salem, is offering bread and wine to the patriarch Abraham, the progenitor of the Israelites, on the latter's return from the battle in which he rescued his nephew Lot from the hands of hostile tribes. The offering of wine is depicted not only in the form of a tall amphora standing between Abraham and Melchizedek, but also by the servant holding a large jug behind the king.

In addition to this frieze, De Raet made two tapestries with a similar horizontal format showing *Elijah and the angel* and *The last supper* [75a]. The theme they share is that of the Eucharist, both Old Testament themes presaging the Last Supper.

The two tapestries were apparently delivered to the Church of St Peter in

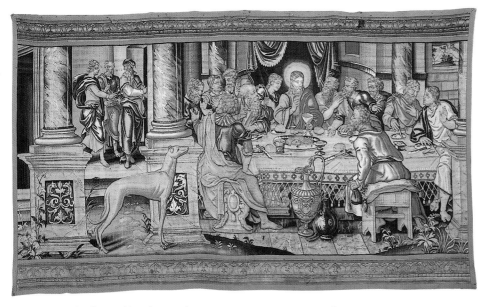

75a Workshop of Willem Andriesz de Raet, *The Last Supper*, c. 1550-1570; tapestry, 180 × 313.5 cm.
Whereabouts unknown

Leiden, and are usually taken to be hangings for the tops of the long choir-stalls. The one with the Last Supper probably hung between the other two, and may have served as the antependium for the altar. Such an arrangement of tapestries need not have been permanent. Works of art were taken out of storage on feast days and temporarily installed in the church, so it is conceivable that the three tapestries in St Peter's were hung up when the veneration of the Eucharist was at its most intense, during Passiontide, the week before Easter.

LITERATURE
Mulder 1903; Van IJsselstein 1936; exhib. cat. Amsterdam 1986, nos. 259-260; Bangs 1986

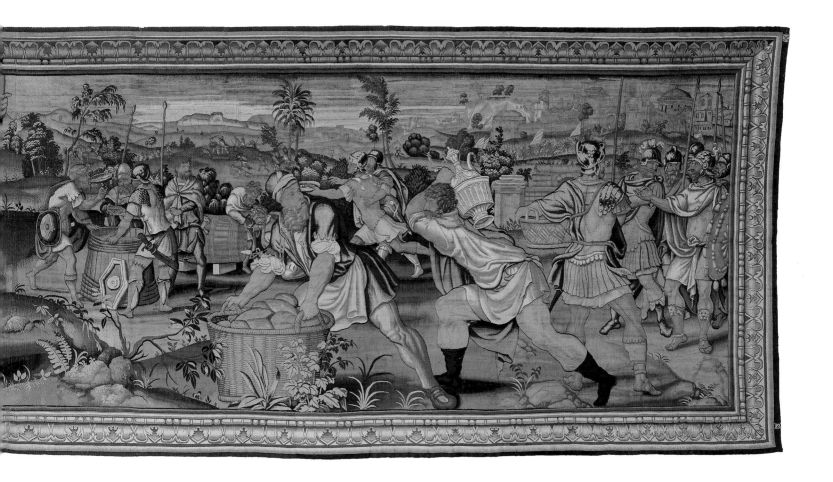

Herri met de Bles (Bouvignes-les-Dinant c. 1485/90-Ferrara ? after 1550)

76 Paradise

Oil on panel, ø 47 cm
Purchased in 1882
inv. no. SK-A-780

Herri met de Bles depicted the entire world as created by God in this small roundel. In a ring around the earth is the sky with birds, sun, moon and stars. Beyond that is the void outside the earth: chaos. On the earth itself are forests, mountains and seas, and also the Garden of Eden with the story of the Fall of Man (Genesis 1). The fountain in the middle of the picture is the source of the four rivers that watered Paradise (Genesis 2:10), the well of living waters (Song of Solomon 4:15), and the river of the water of life that flowed from God's throne in the hereafter (Revelation 22:1).

The story of the Fall of Man begins at lower left with God creating Eve from one of Adam's ribs. Behind this he is commanding the first human couple not to eat the fruit of the tree of the knowledge of good and evil. The snake is offering that fruit to Adam and Eve in the right foreground, and beyond an angel drives them from Paradise. This small painting thus includes not only the entire world but also the full story of the disobedience of the first humans.

Herri met de Bles based his depiction on the opening page of the bible translated by Luther and decorated with woodcuts by Lucas Cranach [76a]. Several of the small scenes, such as the creation of Eve and the expulsion from Paradise, were also taken from Cranach's Bible illustrations.

The little roundel stands out for the depiction of the landscape. Herri met de Bles worked as a true miniaturist by including flowers, plants and animals in the microcosm of this painting. The world of Paradise is closed off at the back by a mountainous landscape which contains a field where corn is being reaped.

Like Joachim Patinir, his fellow citizen in Antwerp, Herri met de Bles is regarded as one of the founders of landscape painting, along with his fellow citizen Joachim Patinir. The origin of the painted landscape lies not so much in the desire of artists to communicate the visual delights of beautiful countryside as in the wish to encapsulate within a single painting the entire world in all its guises, beauties and dangers. In that way the world is likened to the landscape of life through which man must find his way as a pilgrim in search of salvation. The safe road can only be found with God's help. The questing pilgrim is nowhere to be seen in the painting, but outside Paradise lies the world that Adam and Eve were the first to experience in all its harshness. Their descendants must also rediscover God.

LITERATURE
Broos 1988, pp. 60-61; Falkenburg 1988

76a Lucas Cranach, Opening page with the Creation for the Bible translated by Martin Luther, 1512

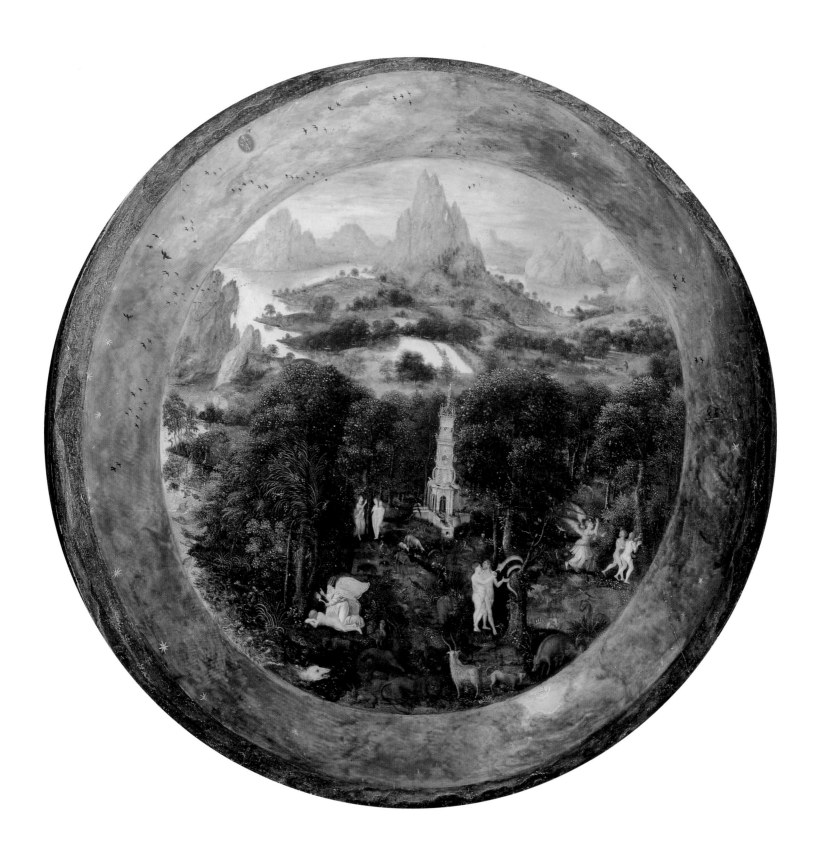

Pieter Bruegel the Elder (Bruegel c. 1525-Brussels 1569)

77 The hare hunt, 1560

Etching and engraving, 22.3 × 29.1 cm
Probably from the collection of Pieter Cornelis, Baron van Leyden
inv. no. RP-P-OB-2141

The overwhelming majesty of the Alps, which Pieter Bruegel saw on his journey to Italy between 1552 and 1555, awakened the landscape artist in him. 'On his travels he drew many views from life, so that it is said that when he was in the Alps he swallowed all those mountains and rocks which, upon returning home, he spat out again onto canvases and panels', as Karel van Mander put it in his biography of the artist.

Hieronymus Cock published 12 large prints after landscape drawings by Bruegel almost immediately upon the latter's return to Antwerp. The main theme of some of them appears to be the grandeur of nature, even though they are populated with small figures which gave rise to marginal titles (in Latin) like 'Soldiers resting', 'The road to Emmaus', or 'The dishonest bird-catcher'. The young brothers Lucas and Baptista van Doetecum, assistants in Cock's studio, were responsible for translating Bruegel's drawings into prints, and did so convincingly. That being said, they are mere workmanlike translations of another artist's drawings which lack the designer's personal touch and supple, varied handling of line.

Only once did Bruegel take up the etching needle himself, for this *Hare hunt*, and the differences are considerable. The print looks far freer. The lines head off in every direction, short dashes alternative with long strokes, the white of the paper has an evocative power, and there is great atmospheric effect. Shapes are created not just by contours but by reserves. This is clearly the work of someone who etched as if he was drawing, and it is regrettable that

Bruegel never returned to the technique. Perhaps his working method was unsuitable for large editions. This is quite a rare print. There are around 20 known impressions, some of which have a grey tone and lack contrast.

Almost all of the prints for which Bruegel made designs were published before 1560, and one gets the idea that only once did he have the desire to explore the potential of etching. He worked from a drawing showing the scene in reverse. That sheet, which is done with the pen, is different from and much freer in design than those he made for professional engravers, which are worked out down to the finest detail. When etching himself he required just a broad outline.

The margin of the print is blank, which has prompted speculation as to what title it might have been given. A Latin proverb found in Erasmus's writings has been proposed, which translates as 'He who hunts two hares will catch none'. The hunter with the crossbow, and his dog, have concealed themselves behind some bushes. He has two hares in his sights and will have to choose between them. The archer, in turn, is being stalked by the man on the right, which might be interpreted as the hunter hunted. That would certainly be typical of Bruegel's wit.

LITERATURE
Lebeer 1969, no. 62; Fehl 1970; exhib. cat. Berlin 1975, no. 75; White 1979; Mielke 1996, no. 53

Lucas van Valckenborch (Louvain 1535?-Frankfurt am Main 1597)

78 Mountainous landscape, 1582

Oil on panel, 25 × 35.5 cm
Purchased in 1892
inv. no. SK-A-1559

Lucas van Valckenborch monogrammed this small landscape with the letters LVV and dated it 1582. Although there can be no doubt about either the autograph nature of the work or the date, it should be added that the artist had conceived of the composition some years earlier, for there is a version in the Prado in Madrid with the date 1580.

Van Valckenborch spent several years depicting rivers flowing through craggy landscapes in which figures are working a mine. The workmen are seen with a spade, a sieve or a wheelbarrow, and the deep shaft is fenced off. Small factory buildings and watermills in other paintings indicate that the ores were extracted on site. Van Valckenborch was continuing a tradition of landscapes with mining activity and the extraction of ores. The genre evolved in Antwerp in the circle around Joachim Patinir and Herri met de Bles, and was further developed by Lucas van Gassel. Even as late as 1610, Roelant Saverij was practising it successfully at the court of Emperor Rudolf II.

The two founders, Joachim Patinir and Herri met de Bles [76], both came from the region around the river Meuse near Dinant, where copper was mined in the 16th century. It is often said of these two artists that they did not so much work from real landscapes as construct them in their studios using a piece of rock as the model. Van Valckenborch's *Mountainous landscape* might have been painted using that method, but it has been rightly suggested that he was depicting the actual landscape near Huy in works of this kind—a landscape that was altered considerably down the centuries by mining activities. All the same, his pictures cannot be considered true topographical records, for they are too generalised and often contain a castle, invariably with a gate cut out of the rock. Nevertheless, Van Valckenborch did draw his inspiration from the countryside around Huy. He was a true specialist, developing a motif which he then re-worked, repeated and explored in variants, thus exploiting his talents to the full.

That Lucas van Valckenborch did indeed take an interest in topography is demonstrated by a painting of 1593 [78a], in which the artist is seated with a sketchbook on his lap, gazing out over a broad panorama containing the city of Linz. His interest in the real world was not limited to this one work, for he also made many topographical drawings.

LITERATURE
Stiennon 1954, pp. 14-17; Wied 1990, pp. 23, 28-30, no. 41

78a Lucas van Valckenborch, *View of Linz with the artist's self-portrait*, 1593; oil on panel, 23.5 × 36 cm.
Städelsches Kunstinstitut, Frankfurt am Main

Braunschweig Monogrammist
(active in the southern Netherlands, second quarter 16th century)

79 Ecce Homo, c. 1545

Oil on panel, 55 × 89.5 cm
Purchased in 1893
inv. no. SK-A-1603

This *Ecce Homo* is by an artist given the *ad hoc* name of the Braunschweig Monogrammist after a painting signed with a large monogram in that city. Some scholars believe that it belongs to Jan van Amstel, a northern Netherlandish painter who worked in Antwerp.

The picture shows a crowd standing outside a large building, with workmen on scaffolding to the left of centre, and people fighting below them. In the background is a busy market. Several market traders can be made out in the crowd on the right. It is only after a second look that one notices the scene on the steps in front of the building—Pontius Pilate showing Christ to the people as the king of the Jews with the crown of thorns on his head and a reed sceptre in his hand.

The painter was undoubtedly influenced by Lucas van Leyden's famous engraving of the same scene [79a], from which he took the wildly waving arms and the idea of placing Pilate's palace parallel to the picture plane. Lucas indicated that the event had taken place in a foreign land, many years in the past. He imagined how people might have dressed in those days, and gave the buildings in his imaginary Jerusalem an old-fashioned look. The Braunschweig master retained the element of fantasy in the palace, which is oddly situated within the shell of a huge church that is still being built on the left, The people in the crowd, however, are dressed like the Antwerp contemporaries of the Braunschweig Monogrammist, giving the entire scene the lively look of a tumult and a marketplace in a Netherlandish city. The painter deliberately arranged the stalls and carts of the market traders in lines. Behind them is a harbour with sailing ships, and beneath the massive gate barrels are being taken to the docks on a sledge drawn by a team of horses.

The monogrammist set out to show contemporary viewers how they themselves could have been part of such a crowd, and how they too might have been indifferent to Christ's suffering, concerning themselves only with their daily business.

Paintings like this updated *Ecce Homo* played an important part in the development of a genre focused on daily life—the religious subject notwithstanding.

LITERATURE
Cat. The Hague 1993, no. 41; Becker 1994

79a Lucas van Leyden, *Ecce Homo*, 1510; engraving (B. 71), 28.7 × 45.2 cm. Amsterdam, Rijksprentenkabinet

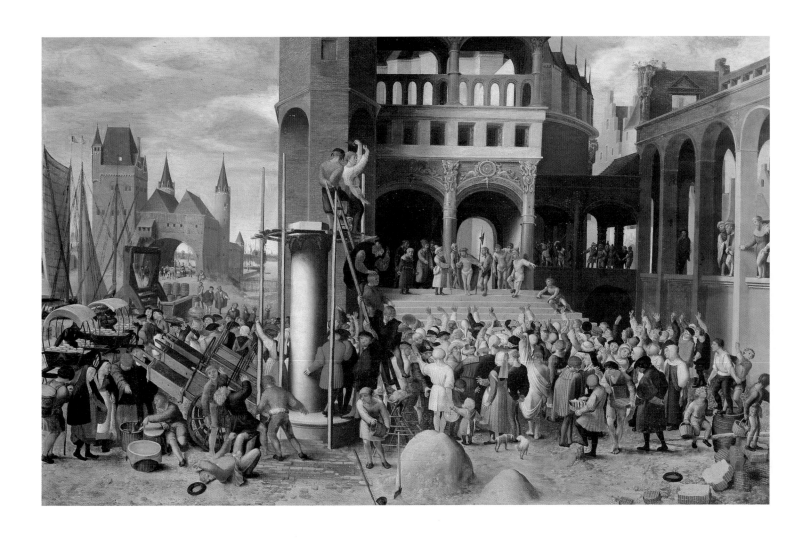

Pieter Aertsen (Amsterdam 1507/08-Amsterdam 1575)

80 The egg dance, 1552

Oil on panel, 84 × 172 cm
Purchased by King Willem I for the Rijks Museum in 1839
inv. no. SK-A-3

During his Antwerp period, Pieter Aertsen produced altarpieces and other religious paintings, as well as market scenes and interiors with all kinds of people making merry. His market and kitchen pieces contain an abundance of the fruits of the earth. Aertsen had great success with this genre, and Joachim Beuckelaer [82], his pupil and assistant, was to develop his ideas even further. Interiors with merry companies or drunken brawls became very popular in the 17th century, and the work of Pieter Aertsen was seen as the first step on that path. Although Aertsen was undeniably a great innovator, he was not the first to depict this kind of scene. There had already been prints of genre scenes, and small, painted 'brothels' as well.

Aertsen's pioneering role lay in his monumental handling of these subjects.

This picture shows a merry company at an egg dance. The object was to keep dancing while kicking the egg round in a circle without breaking it, and then cover it with a wooden bowl, again using only one's feet. It was a popular dance during the Shrovetide carnival, a period that was not only associated with partying and merriment, but above all with excess and sinful behaviour. In this picture, it is clear that immoderation is harmful. The young man seated at the table is singing the joys of strong drink while fondling the breast of the girl beside him. The dancing young peasant has left his sword and bonnet lying on the ground and is engrossed in the

dance. This is all taking place in a house of ill repute, which is identified as such by the pot of leeks in the window. We can take it that all this merriment sparked off by 'wine, women and song', can erupt into a fight at any moment, possibly between the two men vying for the girl's favours.

As so often in paintings by Pieter Aertsen and artists from his circle, the background supplies a commentary on the main action. Here it takes the form of the child in the doorway on the right, who is being ushered into this sinful world. His parents are showing him a world peopled by degenerates, one that he should both know about and be warned against.

LITERATURE
Bijl et al. 1989, pp. 197-202

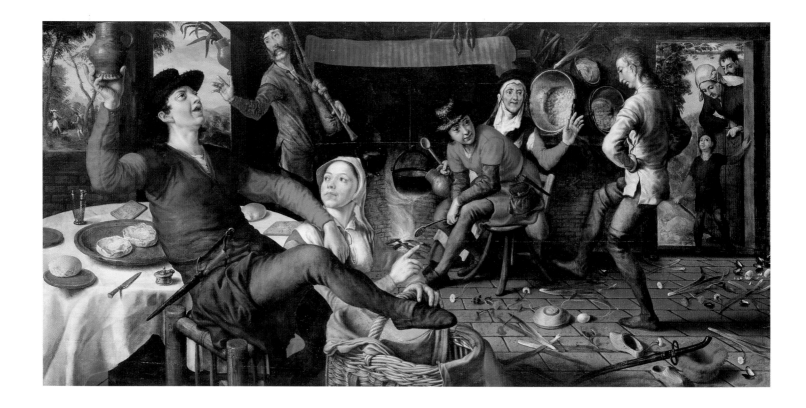

Pieter Aertsen (Amsterdam 1507/08-Amsterdam 1575)

81a Left wing of a triptych with the Adoration of the magi, with the Circumcision or the Presentation in the Temple on the reverse, c. 1560

Oil on panel, 190 × 72.5 cm
Probably from the New Church in Delft; on loan to the Rijksmuseum from 1885;
donated to the museum in 1900 by the heirs of Jonkheer J.P. Six
inv. no. SK-A-1909

81b Central panel of a triptych with the Adoration of the magi, c. 1560

Oil on panel 167.5 × 179 cm
From the Deutz Almshouse, Amsterdam; on loan from the Stichting Collectie
P. & N. de Boer since 1960
inv. no. SK-C-1458

Pieter Aertsen, who was born in Amsterdam and headed a successful workshop in Antwerp, returned to his native city around 1555. In a short space of time he had produced several major altarpieces, some of them for the city's Old and New churches. He also carried out important commissions for other towns in the northern Netherlands. Little remains of those monumental works, for many were destroyed in the Iconoclasm of 1566. Tradition has it that the only surviving fragment of Aertsen's *Adoration of the shepherds* for Amsterdam's New Church is the *Shepherd with a cow's head* [81a], which gives an idea of the huge size of the complete triptych.

Aertsen witnessed the fate of his works at first hand. Karel van Mander tells how he had to be restrained when he saw the image-breakers lay their hands on his art. They were utterly convinced of the rightness of their cause, for the second of the Ten Commandments forbids the making of any graven image or other likeness. The iconoclasts could not even be bribed, as a wealthy lady from Alkmaar discovered in Warmenhuizen when she offered the mob money for a *Calvary* by Pieter Aertsen that they had just dragged from a church.

The two panels discussed here had been

in the Rijksmuseum for some time before it was realised that they came from the same triptych. They had arrived in the museum by very different routes. The wing was from Delft, and the centre panel from the Deutz Almshouse in Amsterdam. However, Agneta Deutz (1633-1692), the founder of the almshouse, had lived in Delft for a while, and it is very possible that she had acquired her fragment there.

More important evidence that the two belong together came to light when they were being restored. It was discovered that the central panel had been sawn down along the right side and at top and bottom. The lower edge supplied a number of clues,

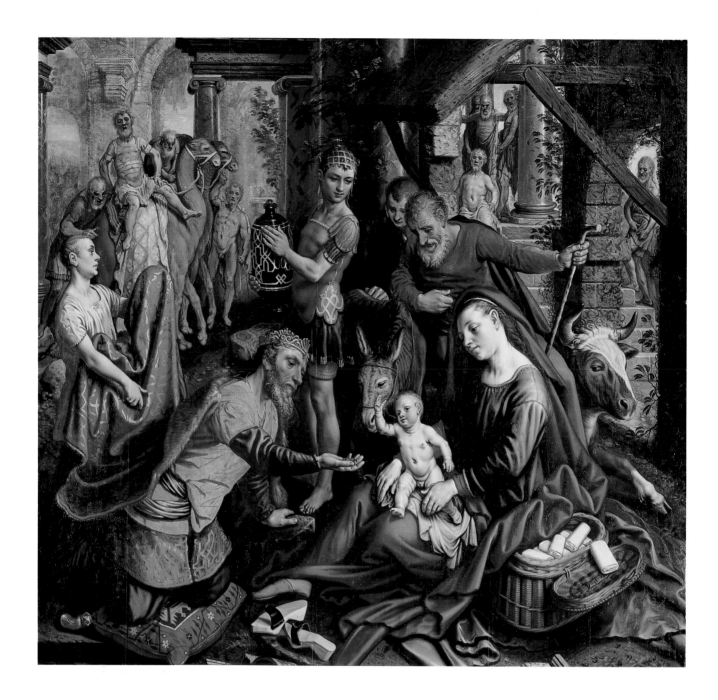

among them that the pieces of architecture are so fragmentary that there was probably more to be seen there originally. The figures are arranged in the form of a pyramid, so some of the composition must be lost on the right if the triangular shape was symmetrical. The painting was also squared with a grid of lines so that the design could be copied onto the panel. A narrow strip of the grid is visible on the left but is missing on the other three sides. Finally, it proved possible to make a reconstruction of these two parts of the triptych, with the step on which the central king is kneeling being aligned with the one beneath the black king on the wing. The result is that the centrepiece, which was once jokingly described as 'the adoration of one king', has been reunited with a wing to form the greater part of the triptych, but with only two kings. In the 17th century there was a panel by Pieter Aertsen in Antwerp with just a single king, which may have been the missing wing.

LITERATURE

Exhib. cat. Amsterdam 1986, nos. 230-231; Bijl et al. 1989, pp. 202-214

Joachim Beuckelaer (Antwerp c. 1530-Antwerp 1573)

82 The well-stocked kitchen, with Jesus in the house of Martha and Mary in the background, 1566

Oil on panel, 171 × 250 cm
Purchased in 1888
inv. no. SK-A-1451

81a Pieter Aertsen, *Fragment of an Adoration of the shepherds*;
oil on panel, 89.8 × 59.2 cm. Amsterdam, Amsterdams
Historisch Museum (inv. no. A 7255)

Joachim Beuckelaer assisted Pieter Aertsen in his Antwerp studio, and took it over when Aertsen returned to Amsterdam. He was a nephew of Aertsen's wife, and was the master's most important pupil. Beuckelaer followed in his teacher's footsteps by painting market scenes and opulent still lifes with a religious scene in the background. The fact that both artists depict the religious event as a small vignette at the back in no way implies that they wished to subordinate it to the still life or market scene. The biblical story is the key, as it were, to understanding the picture.

Although Joachim Beuckelaer used the same principles as Aertsen in his work, there are clear differences between them. The latter, for instance, was more inventive, but Beuckelaer was often more skilful in his execution of the still lifes. Many of

Aertsen's figures have an air of carefree jollity, while Beuckelaer's women, particularly in his best work, are touchingly melancholy.

In this well-stocked kitchen, in which the disciples Peter and John are keeping themselves busy (something that is not related in the Bible but was often depicted in the 16th century), the preparations for the meal are dominated by two superb, preoccupied cooks. Aertsen clearly delighted in audacious compositions, but Beuckelaer concentrated mainly on the convincing imitation of textures: textiles, vegetables, fruit, poultry and other foods. His perfectionism in this respect makes him, rather than Aertsen, the great forerunner of the 17th-century masters of still life, despite the fact that the latter was the originator of the genre.

In the background of this painting is the story of Christ in the house of Martha and Mary (Luke 10:38-42). Martha is busy ensuring that everything in the household runs smoothly, while Mary sits beside Jesus, listening to him. When Martha complained about her passive sister, Jesus told her that Mary had chosen the 'good part'. That is the moment depicted in the background. Martha and Mary are regarded as the embodiments of the active and contemplative life. The parity of those two approaches to life is not what the picture is about, as is clear from the surfeit in Martha's kitchen and the misbehaviour of Christ's disciples. Here Beuckelaer was not basing himself on the Bible but on a late-medieval legend. Jesus's commands to his disciples have to be taken literally. They were to live in accordance with his teachings and not yield to the temptations of earthly abundance. The contrast between foreground and background is thus essential for understanding the painting.

LITERATURE
Buijs 1989

Pieter Pietersz (Antwerp 1540/41-Amsterdam 1603)

83 Man and woman by a spinning-wheel, c. 1570

Oil on panel, 76 × 63.5 cm
Purchased in 1958 with the aid of the Jubileumfonds 1958
inv. no. SK-A-3962

The power of this painting lies in its simplicity. Pieter Pietersz was an artist who built on the work of his father, Pieter Aertsen, and like him he could lose himself in compositions of great complexity. Here, though, he has done precisely the opposite, using a simple but forceful palette and no histrionics at all to depict two people sitting close together before an open hearth. The original painting was a little larger, so the hearth would have been more clearly defined.

The young woman is seated in a chair beside a spinning-wheel, and holds a spindle in her left hand and a bobbin winder in her right. She is looking out at the viewer, displaying the attributes of her work. At first sight she seems to bear a resemblance to the woman spinning in Maarten van Heemskerck's portrait of a virtuous housewife [52]. However, the elegantly clad young man beside her is grasping a flagon, and is quite the opposite of a solid, upstanding husband. It seems that he is trying to distract the woman from her work with drink.

The virtuous, spinning housewife had in fact become a well-worn cliché by around 1570, and even in the previous century she was an object of ridicule. In France, for instance, there was a popular satire that was published in Dutch under the title Die evangelien vanden spinrocke (The gospels of the distaff), which was quite a daring book, considering that the praises of the industrious spinner had actually been sung in the Bible (Proverbs 31:13). In the 17th century, moreover, numerous ladies were depicted spinning in prints and paintings, seated by the wheel either as models of

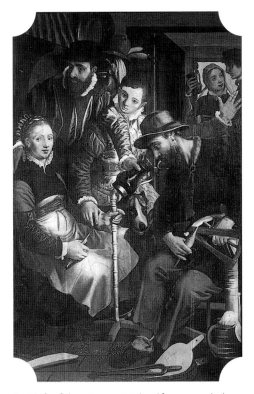

83a Circle of Pieter Aertsen, *Interior with a woman spinning and three suitors*, c. 1565; oil on panel, 163 × 106 cm. Whereabouts unknown

industry or with their hands in their laps as examples of idleness or gossip.

In other works from the circle around Pieter Aertsen one finds spinners who are also being tempted by men with drink. One painting [83a] shows a young woman beside her spinning-wheel surrounded by three men, who represent the three choices open to her. She can choose between spinning and drink, and between a young man, a greybeard and the gormless, good-natured soul who is helping her with her spinning. The latter is probably a proverbial type known as a *gortentelder*—a servile man always prepared to satisfy a bossy

woman's every whim. This particular woman, however, is firmly clasping the distaff, which is inscribed 'Jhesus'—quite clearly the right choice. In our painting, Pieter Pietersz presents a far more clear-cut contrast. The girl has to choose between the wheel and the flagon, between good and evil.

LITERATURE

Exhib. cat. Amsterdam 1986, no. 301; Pleij 1979, pp. 179-180; exhib. cat. Amsterdam 1997, p. 270

III After the Iconoclasm: the separation of north and south

ICONOCLASM AND REVOLT, 1565-1585

When Margaret of Parma became governor-general of the Netherlands she was confronted with growing unrest among large sectors of the population. The nobility, led by William of Orange (1533-1584), opposed the centralist reforms that Margaret wanted to introduce with the aid of a new body of government officials. Religious persecution forced many craftsmen and merchants to leave the country, disrupting social life and swelling the numbers of the poor. In 1566, price rises resulting from a reduction in grain imports from the Baltic states led to famine. The people of Flanders rose in revolt, spurred on by Calvinist preachers who held mass sermons outside the gates of the towns. The popular fury was mainly directed against the church, and hundreds of ecclesiastical buildings and monasteries were destroyed. The Iconoclasm spread rapidly to the northern provinces, but died out when the nobles, fearful of a popular insurrection, sided with Margaret of Parma.

In 1566, several nobles presented a petition urging that she treat the Protestants more leniently. A member of her court scornfully referred to the delegation as *gueux* (beggars), a name that the dissidents seized on and bore proudly throughout the ensuing struggles. The beggar's attributes of a cup and a satchel became the symbols of the Dutch Revolt *(figs. 62, 63)*.

William I, Prince of Orange and Stadholder of Holland and Zeeland *(fig. 64)*, emerged as the leader of the Revolt against King Philip II. His policy of religious toleration was backed by the majority of the people. The king declared him an outlaw in 1580, and he was murdered in Delft four years later.

King Philip believed that Margaret of Parma was not up to her task and replaced her with the Duke of Alva (1507-1582) *(fig. 65)*, who entered Brussels at the head of a Spanish army in 1567. Many fled, including William of Orange, and those who did not were either condemned to death or thrown into prison. Their property was also confiscated. Alva built citadels in Antwerp, Utrecht and elsewhere. William's incursions with mercenary armies from Germany, where the Protestant German princes sympathised with his cause, and from France, where a powerful Calvinist party under De Coligny lent support, were no match for the Spanish troops. Greater successes were scored by the Water Beggars stationed in English ports and at Emden in Germany, which they used as bases for harrying shipping. Their capture of Den Briel in 1572 precipitated a Calvinist takeover of almost every important town in the provinces of Holland and Zeeland, with the exception of Amsterdam. To everyone's surprise, Alkmaar (1573) and Leiden (1574) *(fig. 66)* managed to turn the tables on Spain by using their superior knowledge of the Dutch terrain and by flooding parts of the countryside. Mutiny in the Spanish army led to its withdrawal from Holland and Zeeland, allowing William to continue coordinating the Revolt from Delft. The main towns of Flanders and Brabant had taken up the cause, and in 1576 the provinces signed the Pacification of Ghent, the main object of which was to drive the Spanish out of the Netherlands. In 1578, Amsterdam finally came over to the Revolt.

The Pacification was short-lived, for in 1579 Artois and Hainault formed the Union of Arras and returned to Spanish rule. That same year, seven northern provinces and a large number of towns in Flanders and Brabant formed the Union of Utrecht in order to continue the Revolt *(fig. 67)*. A new

figs. 62a/b 'Beggars' medal' with cup and gourds, c. 1570; obverse: portrait of Philip II, reverse: two clasped hands within a beggar's satchel, silver, 5 x 2.5 cm. Amsterdam, Rijksmuseum (inv. no. NG-711a-b)

fig. 63 'Beggars' medal' in the shape of a half moon with eye, 1574; 3.5 x 3.1 cm. Amsterdam, Rijksmuseum (inv. no. NG-VG-1-407a)

fig. 64 Adriaen Thomas Key, *Portrait of William I, Prince of Orange*, c. 1568; oil on panel, 48 x 35 cm.
Amsterdam, Rijksmuseum (inv. no. SK-A-3148)

Spanish offensive under Alessandro Farnese, Duke of Parma (1542-1592), not only brought most of the southern towns, but also Maastricht and Den Bosch, back into the Spanish fold. The northern and eastern provinces were constant battlegrounds. Antwerp fell to the Spanish in 1585.

William of Orange had been murdered the previous year, removing the central leadership of the Revolt. Philip II had been repudiated by the States-General, but the search for a new ruler was unsuccessful. The French king refused, as did Queen Elizabeth I of England, although she did enter into a military agreement with the rebels, and in 1585 sent an expeditionary force commanded by the Earl of Leicester (1533-1588), who would also act as governor-general. When that, too, ended in failure, the States-General decided to take on those powers itself. And so, in 1588, the Republic of the Seven United Provinces came into being without any official proclamation.

Prince Maurits (1567-1625) had succeeded his father as stadholder of Holland and Zeeland, and William's nephew, Willem Lodewijk (1560-1620) was appointed stadholder of Friesland and Groningen. The future looked bleak for the fledgling republic in 1588. There was no political leadership, a towering mountain of debt, and the Spaniards occupied most of the provinces and were massed at the borders of Friesland, Holland and Zeeland.

Yet the tide turned. The Spanish Armada was resoundingly defeated in 1588, and when war

between France and Spain broke out again the following year, Parma was forced to break off his Netherlands campaign and head for the southern border. In the meantime, Maurits and Willem Lodewijk were hard at work reforming and professionalising the States army. They studied the classics in order to develop new battle and drill techniques, introduced uniform weaponry, trained the troops in the use of new weapons and siege methods, and for the first time paid proper attention to logistics. This made the army more than a match for the Spanish, as well as a model for the armies of other European powers. In 1600, it at last ventured outside the 'Garden of Holland' and defeated the Spanish at Nieuwpoort, Seven years later, the States fleet dared show itself off the coast of Spain for the first time, and in the ensuing battle Admiral Jacob van Heemskerck defeated the Spanish fleet at Gibraltar.

Even more important, though, was the economic recovery in Holland and Zeeland, which was given a powerful impulse by the many southern Netherlandish immigrants who fled their country after the fall of Antwerp in 1585. They had international trading contacts, capital and expertise, and were welcomed into the towns of Holland and Zeeland with open arms. This blend of money and knowledge combined with the maritime skills and labour potential of the Republic led to a massive increase in overseas trade and shipping. Antwerp's role as the link between the northern and southern Netherlands was usurped by port cities of the north, Amsterdam chief among them.

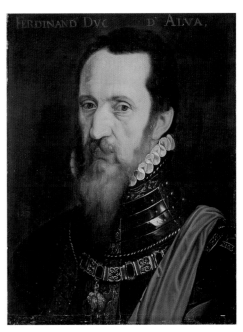

fig. 65 Copy after Willem Key, *Portrait of Ferdinand Alvarez de Toledo, Duke of Alva*; oil on panel, 49 x 38 cm.
Amsterdam, Rijksmuseum (inv. no. SK-A-18)

fig. 66 Otto van Veen, *The distribution of herring and white bread after the Water Beggars raise the siege of Leiden on 3 October 1574*, 1574; oil on panel, 40 x 59.5 cm.
Amsterdam, Rijksmuseum (inv. no. SK-A-3911)

The Revolt created a true war economy, with all sorts of products being manufactured and sold in large numbers. Almost every town had an acute shortage of housing and workshops. Major reconstruction projects swiftly altered the medieval look of the towns. New city districts, fortifications and harbours were built in rapid tempo. Many of the immigrants from the southern Netherlands were fervent Calvinists, which sharpened the religious divides in the north. Other religions continued to be tolerated, however, although the Catholics were banned from holding their services in public.

The southern immigrants brought not only expertise and capital, but also a rich cultural heritage. Cartographers, artists and printers settled mainly in Leiden, Haarlem and Amsterdam, and were to have a profound influence on the cultural life of the republic.

ART AFTER THE ICONOCLASM

As the towns embraced the new faith between 1573 and 1580, the churches in the north were stripped of their works of art and decoration, and no more altarpieces were made. The church was no longer the major patron. In the southern Netherlands, on the other hand, there was a restoration of the Catholic traditions. After a long period of stagnation during the Revolt, the production of art in the north recovered rapidly in the years leading up to 1600. Immigration from Antwerp to Amsterdam brought about a resurgence of trade, industry and art. Although contacts were maintained with the southern, 'Spanish' Netherlands, and many Flemish artists contributed to this, the revival of the visual arts in the north— the 'dawn of the Golden Age', as it is called, was an independent development.

Oddly enough, it took a while before the realism that is so typical of 17th-century Dutch art gained the ascendancy. At first, the late 16th-century artists employed an international style based on Italian art that had been exerting its influence even before the Iconoclasm. Because a number of Dutch artists had rounded off their studies in Italy, their work had a marked leaning towards the Italian style then in vogue. The Amsterdam painter Dirck Barendsz (1534-1592), who worked in Titian's studio in Venice between around 1555 and 1560, brought the Venetian palette and broad manner of execution back to the Netherlands [89]. Shortly after his return he applied that style in his Nativity triptych for the Church of St John in Gouda. Gouda embraced the Protestant faith in 1573, and it was removed from the church. It is doubtful whether the equally

fig. 67 Map of the Low Countries in 1579. Drawing: Guus Hoekstra

ambitious Assumption altarpiece of 1579 by Anthonie Blocklandt (1533/34-1584) (fig. 28) was ever installed in the Utrecht church for which it was destined. The idealised figures and the tonality in Blocklandt's work are fully in line with the style current in Florence and Rome at that time, which had its origin in the paintings of Parmigianino and was elaborated by such artists as Vasari and the Zuccaro brothers. During their time in Italy, Dutch artists like Anthonie Blocklandt, Hans Speckaert [90] and Bartholomeus Spranger (1546-1611) contributed to the further development of the style. In sculpture, it was mainly men from the Low Countries who gave direction to artistic developments in Florence: Willem van Tetrode of

Delft [88], Johan Gregor van der Schardt of Nijmegen [87], and above all Giambologna (1529-1608), who came from Douai and settled permanently in Florence to work for the Medici. As well as monumental statues of idealised nudes in stone and bronze, they made small cabinet sculptures that were much sought after by collectors. After an apprenticeship in Florence or Rome, their Dutch pupils Hubert Gerhardt (c. 1540-1622), Adriaen de Vries (1545-1626) [92] and Hans Mont (c. 1545-after 1585) helped spread this Mannerist court style throughout Europe, and were themselves often employed at court. This international style had its heyday in Prague between 1580 and 1610 at the court of Emperor

Rudolf II (1552-1612), who employed Dutch artists schooled in Italy like Adriaen de Vries and Bartholomeus Spranger.

The idealised figure style of Bartholomeus Spranger was the shining example for a trio of young artists who got to know each other in Haarlem in 1583: Cornelis Cornelisz van Haarlem, Karel van Mander and Hendrick Goltzius. They developed a decidedly individualistic style for painting mythological and biblical scenes that was as elegant as it was expressive. Cornelis Cornelisz, with his graceful nudes in gatherings of the Olympian gods *(fig. 24)*, was a direct follower of Spranger, although he used the nude in a great variety of poses and used foreshortening to express emotions in spectacular, dramatic compositions *[94]*. Several Utrecht artists also worked in this style, which is known as Dutch Mannerism, among them Joachim Wtewael (1566-1638) and Abraham Bloemaert (1566-1651) *[96]*.

Hendrick Goltzius and his pupils Jacques de Gheyn the Younger and Jan Muller *[92]* made a major contribution to the international dissemination of the new style with prints after the work of Prague artists like Spranger and De Vries, of such Dutch contemporaries as Cornelisz, Bloemaert and, above all, Goltzius's own designs *[93]*. They and their pupils also produced prints of mythological and biblical subjects, religious and profane allegories, and portraits of contemporary princes and scholars. As print publishers they built up their own stocklists and broke Antwerp's stranglehold on print publishing. Goltzius and De Gheyn even left their work as engravers and publishers to professionals in Amsterdam, Haarlem and The Hague. Immigrants from the southern Netherlands made vital contributions to the decorative arts, textiles, glass production and silversmithing in Amsterdam, Haarlem, Delft, The Hague and Leiden. The prosperous burgher elite in the cities became the patrons of a growing body of artists, launching the beginning of the great period in Dutch art: the Golden Age. Although Dutch Mannerism was a short-lived phenomenon (the intensely expressive style was abandoned as early as the 1590s), the history painting—both biblical and mythological—remained popular for decades. Individual portraits of men, women and children *[85]*, and the group scenes of civic guard companies *(fig. 36)*, had a long tradition in the 16th century that carried over into the next. The realistic themes of still lifes, landscapes, interiors and merry companies evolved into genres in their own right, and attracted a large clientele. One innovation in the late 16th century was the meticulous observation of nature exemplified by Jacques de Gheyn the Younger's drawn studies of animals *[99]*. All these developments illustrated in this final group of works foreshadow the achievements to come in the new century.

FURTHER READING
Exhib. cat. Amsterdam 1993-94; Falkenburg *et al.* (eds.) 1993; Israel 1995

Netherlands, c. 1580-1590

84 Dice glass, blown à la façon de Venise

Clear, colourless and white glass with diamond-point engraving and silver mount
with ivory die, h 17 cm, ø 5,2 cm
From the Guépin Collection, Bussum, and the Dutch Renaissance Art Collection,
Amsterdam; donated by Joost R. Ritman in 1995
inv. no. BK-1995-4

This glass belongs to the earliest group of Dutch glasses decorated with diamond-point engraving. The distinguishing features of this type are the rather ungainly shapes of the Roman letters and the clearly defined contours filled with finely drawn, parallel lines, which derive from Italian diamond-point engraving of the 16th century.

The first mention of engraving with a diamond was in 1534, when the Venetian *Podestà* (chief magistrate) granted a patent on the process to one Vincenzo di Angelo dal Gallo. Italian diamond-point engraving reached its peak in the second half of the century, and spread throughout Europe in the wake of glass production *à la façon de Venise*. There were engravers working in London, Catalonia, Germany, Bohemia, Austria (Hall, near Innsbruck) and the Netherlands. The technique did not catch on in the northern provinces until the end of the 16th century, when it was past its prime in Venice and the rest of Europe. Only a few pieces from the earliest group have survived. The Rijksmuseum has a second, but damaged dice glass engraved with the name LISBET HENDRICK and the date 1590.

Dice glasses without a foot but often with a silver mount were popular in the second half of the 16th century and throughout the 17th. There are several variants. The glass was used in a drinking game in which it had to be drained in one for the number of times shown on the dice. It was also known as a 'drink-up' (*drinkuit*) —a glass that had to be placed on the table upside-down, preferably empty.

Dicing was regarded as a scandalous activity in the 16th and 17th centuries, on a par with drinking and fornication. The blithe exhortation inscribed on the glass, BYBE CUM GAVDIO VINUM ECLESIASTES IX CAP (Drink thy wine with a merry heart; Ecclesiastes 9), could not be further removed from that puritanical attitude. The words come from the apocryphal book

Ecclesiasticus (The Wisdom of Jesus the Son of Sirach) 9:10, which reads: 'Forsake not an old friend; for the new is not comparable to him: a new friend is as new wine, when it is old, thou shalt drink it with pleasure'. The combination with the second inscription, ICK BRINGT U MIJN LIEF (I give you my love), suggests that the glass was engraved to seal a relationship between friends who saw nothing wrong in drinking and dicing.

LITERATURE
Exhib. cat. Amsterdam 1993-94, no. 116; cat. Amsterdam 1995, no. 1a

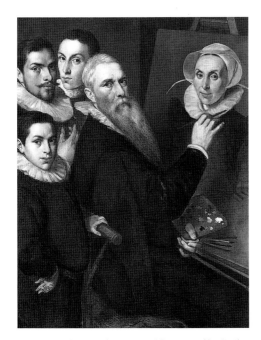

85a Jacob Willemsz Delff, *Portrait of the artist and his family*, c. 1590; oil on panel, 83.5 x 109 cm. Amsterdam, Rijksmuseum (inv. no. SK-A-1460)

Jacob Willemsz Delff I (Gouda 1540/45-Delft 1601)

85 *Portrait of a young boy, 1581*

Oil on panel, 61.5 × 47.5 cm
From the collection of Baron Van den Bogaerde, Heeswijk Castle;
purchased in 1900
inv. no. SK-A-1907

Jacob Delff portrayed most of his sitters down to the knees, as in this painting of 1581—a rare example of a child's portrait from the period. It is one of Delff's earliest surviving works, and the remarkably lively palette and amusing dog make it something of an exception within his oeuvre. The child is wearing a splendidly adorned black hat and holds a basket of fruit in one hand and in the other a large biscuit which the little dog is trying to get at. He is also in a dress, which was the standard clothing for all children below the age of four. The inscription at upper left states that the boy is two years old—although he looks considerably older—around seven or eight. This is because he fills a great deal of the picture surface and is so much larger than the dog. Delff combined a keen eye for detail with affection for the sitter in order to show what he was capable of: depicting a small boy as a child rather than as a miniature adult. Such spontaneity and naturalness is less evident in his other portraits. His adult models evidently wanted to commit their likenesses to posterity in a serious and dignified pose.

Jacob Willemsz Delff, who came from Gouda, probably studied with Anthonie Blocklandt in Delft, where the young artist was admitted to the Guild of St Luke in 1575 and acquired citizenship seven years later. He had three sons by his marriage to Maria Nagel, all of whom became artists: the still-life painter Cornelis, the portraitist Rochus and the engraver Willem. Delff immortalised his entire family grouped around his easel [85a]. Only a dozen of his paintings are known, all dating from the period 1580-1593. There is not a single portrait that can be safely attributed to him from then until his death in 1601.

All his works are portraits. In addition to single individuals, he painted group portraits, including one of the officers of a civic guard company, and a historicised portrait. He was the leading portraitist in Delft at the end of the 16th century. The simple and direct way in which he captured his sitters had a major influence on Michiel van Mierevelt, who was the most sought-after portrait painter of the following generation.

LITERATURE
Exhib. cat. Amsterdam 1993-94, pp. 25-26

204

Cornelis Ketel

86 Design for *The mirror of virtue*, c. 1595

Black chalk, pen in brown, brush in grey, heightened with white bodycolour, on blue paper; contours indented for transfer, 51.5 × 37.6 cm
Purchased in 1888
inv. no. RP-T-A-1423 (1888)

This is a design for an engraving executed by Jan Saenredam that bears the inscription *Naturae sequitur semina quisque suae*, literally: 'Each follows the seed of his nature'. Van Mander, who called the print the *Deught-spiegel* (Mirror of virtue), described it in his biography of Ketel as follows: 'An invention full of meaning denouncing the ingratitude of evil people who, although receiving the sun, repay that favour badly by biting, while gratitude, receiving the moon, forever bears and imprints it in her memory in order to repay it properly. Copious symbolic details accompany this, as can be seen in the print.' Van Mander described only the central group, consisting of *Beneficentia* (Kindness), flanked by Gratitude and Ingratitude. The principal theme is elaborated by the 'copious symbolic details', some of which can be understood only with the aid of the inscriptions on the engraving. Two snakes are locked in mortal combat around one of Ingratitude's legs. His other knee rests on a skull, and in front of him is a coffin, which is inscribed *Mors. Oblivio* in the print. The point that the allegory is making is that forgetting an act of kindness is no less terrible than death. The kneeling woman on the right is the antithesis of Ingratitude: she will never forget the kindness shown to her. Behind her is an obelisk inscribed *Aet*[erna] *M*[emoria] in the print, or 'In eternal memory'. The statue in the niche behind *Beneficentia* stands for the impartiality with which Kindness bestows her gifts. The lion, the dog nestled fearlessly against him, and the mouse gnawing through his fetters, can all be seen as her

attributes. The mouse is a reference to one of Aesop's fables about a lion that freed a mouse entangled in its mane. The mouse later repaid the favour when it freed the king of the beasts by chewing through the net in which it had been trapped. The dog likewise alludes to a classical story, which exists in several versions, about a lion that was eternally grateful to an insignificant creature for tending its wounds.

The scene is set in an architectural framework adorned with figures that embroider on the allegory. Those flanking the *aedicula* show why people have different natures. On the left is *Natura*, in the guise of the many-breasted Diana of Ephesus, giving birth to a child identified in the print as *Malignitas*, or Evil Nature. *Natura* is assisted in her travails by Saturn, who breathes his pestilent breath into the baby. On the right, Apollo helps at the birth of *Bona Indoles*, or Good Nature. The two mothers also adorn the top of the framework; the one on the left using a spoon to feed the bad child, which has the tail of a serpent, the one on the right suckling the good child. In the centre of the entablature is a winged heart. The wing on the side of the bad child's mother is a bat's, signifying the night, and in this context possibly also the dark side of human nature, while that on the good side is a dove's. The rectangular tablet below the image is inscribed in the engraving with a Latin poem signed by Petrus Hogerbeets. The oval below the tablet bears the dedication to Sion Luz from Jacques Razet, also of Amsterdam, the maecenas who commissioned the print.

LITERATURE
Van Mander 1604, fol. 277v; Reznicek 1961, vol. 1, p. 166, note 64; exhib. cat. Amsterdam 1978, no. 328; exhib. cat. Washington/New York 1986-87, no. 75; Heezen-Stoll 1987, p. 27 and fig. 3; exhib. cat. Amsterdam 1993-94, no. 40

Johan Gregor van der Schardt (Nijmegen 1530-Nuremberg in or after 1581)

87 *Sol, c. 1570*

Bronze with a brown patina, h 45.7 cm
Purchased in 1977
inv. no. BK-1977-24

It was in the 16th century that Netherlandish artists discovered the importance of Italy for rounding off their studies. Among those who made the journey south were a number of extremely talented sculptors: Giambologna from Douai, Hubert Gerhardt from Den Bosch, Elias de Witte from Amsterdam, Willem van Tetrode from Delft, Adriaen de Vries from The Hague, Hans Mont from Ghent and Johan Gregor van der Schardt from Nijmegen. Their subsequent careers display striking parallels.

After an apprenticeship in Florence or Rome, most of them found permanent employment abroad in the second half of the 16th century, mainly at royal courts in Italy and Germany. Many preferred working in bronze and specialised in small cabinet sculpture. By bringing the Florentine, Mannerist style to courts north of the Alps, they had a considerable influence on the development of 16th-century Netherlandish sculpture.

This standing man with a lion is attributed to Van der Schardt. The mask of rays that he is holding in front of his face identifies him as *Sol*, the sun. He is clasping a piece of hollow piping above his head with his left hand, and has a staff in his right hand.

This bronze was undoubtedly not a single piece, but must have formed part of a group with several other personifications of celestial bodies. There is a closely related bronze of a woman representing *Luna*, the moon, in

87a Johan Gregor van der Schardt, *Luna*; bronze, h 46 cm. Vienna, Kunsthistorisches Museum

87b Wenzel Jamnitzer, *Merkelsche Tafelaufsatz*, 1549; silver, h 100 cm. Amsterdam, Rijksmuseum (inv. no. BK-17040)

Vienna [87a], which is virtually identical in style and size and clearly by the same artist. Evidence that *Sol* and *Luna* once belonged to the same ensemble is provided by an odd feature they have in common—vestiges of a hollow pipe that was part of a metal conduit. The figures come from a large table fountain—a stack of statues and water basins that stood in the middle of an aristocratic or royal dining-table. During the meal, water spouted from the figures. During the meal, the figures spouted water, in *Sol*'s case from the lion's mouth and the pipe above his head.

It is not known who commissioned the table fountain, but it was probably someone at the court of the Habsburg emperor, Maximilian II. The latter himself ordered a very large table fountain from the Nuremberg silversmith Wenzel Jamnitzer in 1568. The only surviving figures from that ensemble are four silver-gilt bronzes representing the four seasons, which were supplied by Van der Schardt, who was working in Nuremberg at the time. All the other parts were made of silver and were melted down in the 18th century. Early descriptions show that the iconographic programme of the fountain illustrated the position of the House of Habsburg in the cosmos. One could well imagine *Sol* and *Luna* in a similar constellation with the five other planet-gods (Jupiter, Mars, Venus, Mercury and Saturn), the four seasons or the four elements—all glorifying the patron or owner of the fountain. A smaller table-piece by Wenzel Jamnitzer, the *Merkelsche Tafelaufsatz* of 1549 [87b], gives an idea of the elaborate nature of the large table fountain to which the Amsterdam figures must once have belonged

LITERATURE
Exhib. cat. Amsterdam 1986, pp. 461-464; Honnens de Lichtenberg 1991; exhib. cat. Berlin 1995, nos. 94-97

Willem Danielsz van Tetrode (Delft c. 1525-Delft before 1588)

88 Nude warrior, c. 1570

bronze with a dark lacquer patina, h 40 cm
Purchased in 1959
inv. no. BK-1959-3

Arnold Buchelius of Utrecht noted in his diary for 1598 that he had called on the painter and brewer Apert Francen in Delft, who had a large number of works by Van Tetrode in his bedchamber. The 1624 estate inventory of the Delft goldsmith Thomas Cruse also lists works by the sculptor. This hardly seems surprising since Van Tetrode

came from Delft himself, but in fact it is, for it provides evidence of the new enthusiasm on the part of private individuals for collecting sculpture. Van Tetrode made an important contribution to the trend. The innovative features of his work, and the fact that he did not remain in Delft for long, make it likely that his sculptures only circulated within a small group of artist-collectors. It was not until the 17th century that collecting bronzes became more widespread in the Netherlands.

Willem Danielsz van Tetrode may have been born in Delft, but he spent most of his life abroad. Between 1545 and 1551 he was in Florence, working in the studio of Benvenuto Cellini under his Italian name of Guglielmo Fiammingho. He then moved to Rome. During his Italian period he became familiar with forms of sculpture and patronage that were barely known in his native Holland. He worked for princes with a refined taste and a cultured interest in classical antiquity. The most important thing he learned in Italy was how to make bronze sculptures that went on to grace his patrons' art cabinets: small, portable statues, mainly of mythological subjects. In 1567, a year after the Iconoclasm, Van Tetrode returned to his birthplace, but left again in 1574.

This striding bronze man, a sort of classical swordsman in an attacking pose, is a typical example of this kind of cabinet sculpture. The lack of any attributes apart from the handle of a broken-off sword or dagger in his right hand makes it impossible to identify this warrior with any god or mythological hero. It is a study of the human form, which is shown in a fascinating and visually stimulating pose, so no secondary details were necessary. The subject is related to popular 16th-century print series of wrestlers and swordsmen, like those of 1562 after designs by Maarten van Heemskerck. The bronze has the same emphasis on nudity, stretched limbs and bushy hair. In addition to the two

88a Hendrick Goltzius, *Calphurnius*, from the series
Roman heroes, 1586; engraving (B. 103), 36.6 × 23.5 cm.
Amsterdam, Rijksprentenkabinet

mentions of Van Tetrode's bronzes in Delft,
there are indications that his small statues
(or models of them) were known in the
Haarlem studio of the painter and engraver
Hendrick Goltzius. Some of his prints
display surprising similarities to Van
Tetrode's figures. For instance, the Rijks-
museum's classical sword-fighter reappears
in an engraving by Goltzius in the guise of
the Roman hero Calphurnius [88a].

LITERATURE
Radcliffe 1985; Nijstad 1986; exhib. cat. Amsterdam 1986,
no. 360; Van Binnebeke 1993

Dirck Barendsz (Amsterdam 1534-Amsterdam 1592)

89 *The Last Supper*

Grisaille in oil on paper, 24.5 × 20.4 cm
Purchased in 1995 by the Rijksmuseum-Stichting
inv. no. RP-T-1995-8

Dirck Barendsz lived in Italy from 1555-
1562, and seems to have spent most of his
time in Venice, where, as Van Mander puts
it, 'the great Titian took him to his bosom'.
Indeed, Barendsz's Passion scenes with
their flickering, indefinable lighting that
gives the setting the stifling nature of a
nightmare, are not really conceivable with-
out the example of the late Titian or of
Tintoretto. It is more difficult to say
whether Barendsz was also influenced by
the Venetians in his choice of materials.
The oil sketch on paper certainly became
very popular in Venice, but that was later.
Domenico Tintoretto, the son of the great
Jacopo, preferred this kind of sketch when
preparing for a painting. During Dirck
Barendsz's time there, though, the
medium's heyday still lay in the future. It is
possible that Barendsz took his example
from someone nearer to home, such as
Anthonie Blocklandt, who made at least
four grisailles in oils of the evangelists,
which Philips Galle turned into prints.

This oil sketch was once part of a series
of 40 depicting the story of Christ's Passion.
The series remained intact until the middle
of the 19th century, but the individual
sheets then vanished from sight and have
only been tracked down in the past two
decades.

The series is first described in the
Abecedario, the collection of art-historical
notes made by the famous 18th-century
collector Pierre-Jean Mariette. He reported
that several of the oil sketches had been
translated into prints by Jan Sadeler I.
Mariette examined the sketches on two
occasions. The second time he noticed that
they bore not only Dirck Barendsz's name

but that of Sadeler as well. The editors of
Mariette's *Abecedario* reported in 1851 that
they had recently seen the series when it
was offered for sale to the Louvre. The
transaction fell through, and for more than
125 years nobody knew where the sketches
were. It was not until 1978 that an article
appeared in which seven of them were
discussed. Many of the others have since
been located, and at the moment the
whereabouts of 26 are known. A French
collector of the 18th or early 19th century
pasted the sketches into an album,
numbered them and supplied explanatory
captions, and some of those mounts have
survived. The Fondation Custodia in Paris
has the morocco portfolio in which the
sheets were preserved, probably belonging
to the same collector.

LITERATURE
Foucart/Rosenberg 1978, pp. 198-204; exhib. cat.
Washington/New York 1986-87, no. 9; exhib. cat.
Amsterdam 1986, nos. 303-307; cat. Paris 1992, vol. 1, pp. 9-
16, nos. 3-4

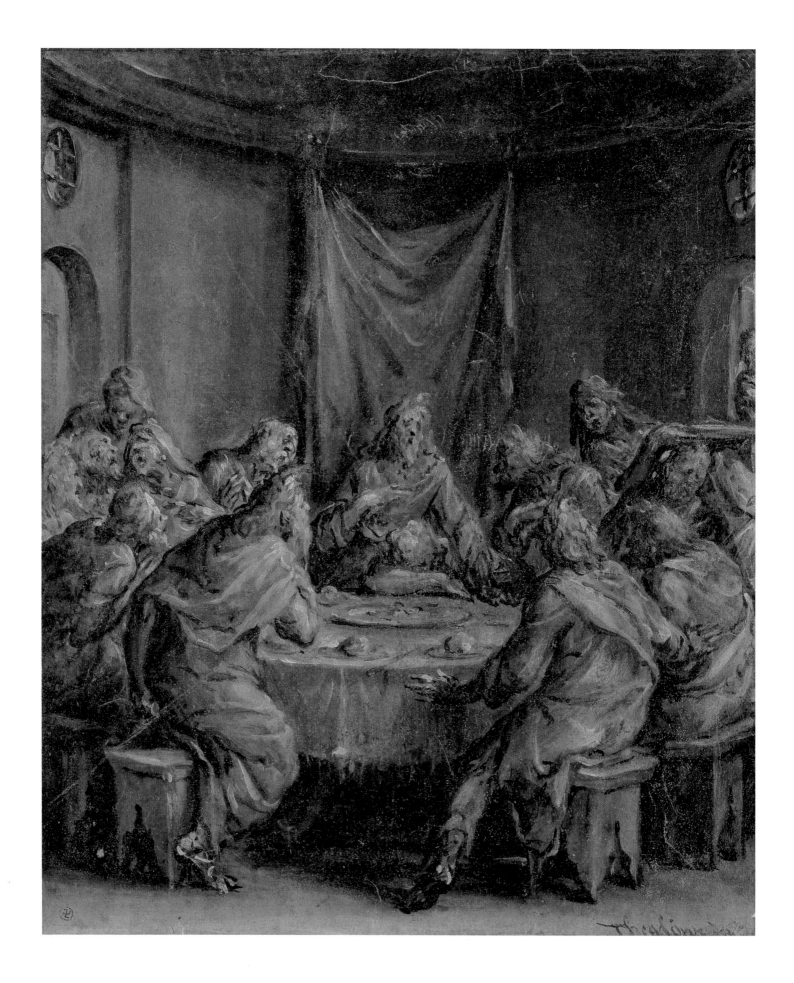

Hans Speckaert (Brussels c. 1540-Rome 1577)

90 Nude soldiers fighting, c. 1570

Pen in brown, with a grey and brown wash, on blue paper, 25.9 × 42.7 cm
Purchased in 1978
inv. no. RP-T-1978-38

Hans Speckaert came from Brussels but worked mainly in Rome, where he died, probably in 1577. He belonged to a group of northern artists including Bartholomeus Spranger [91], Karel van Mander [97] and the sculptor Hans Mont of Ghent, who spent varying lengths of time in the Eternal City studying the art of classical antiquity and the work of great Renaissance masters like Raphael and Michelangelo. Speckaert was a friend of the engraver Cornelis Cort, who was famed for his faithful reproductive prints. Speckaert painted Cort's portrait and was made his heir. They worked together on an engraving after Raphael's famous fresco of *The victory of Constantine over Maxentius*, with Speckaert supplying the drawing. The engraving was still unfinished on Cort's death [90a]. It may have been Raphael's mural of that vast battle that inspired Speckaert to make this energetic drawing, although this particular battle is unidentifiable. With Raphael there is order in the ranks, despite the numerous figures, but Speckaert chose to accentuate the chaos. Soldiers and horses sink to the ground, reinforcements hurl themselves into the fray, and weapons thrust and slash. Speckaert was searching for the right form, as his drawing style shows—nervous, seizing the inspiration of the moment. Many of the contours are drawn three or four times. Speckaert finally brought unity to the scene by using a wash for the shaded passages. It is unclear what he intended with many of the lines; they simply contribute to the spontaneity of the sheet. As far as Speckaert was concerned it was inspiration that counted.

Here he must have been following the ideas formulated in the course of the 16th century, among others by Giorgio Vasari, the famous court painter and artists' biographer. It was said that an artist's

strength lay not so much in the execution, which could be carried out satisfactorily with the aid of assistants, as in the design, the *disegno*.

Hans Speckaert was given little chance to execute his designs. Only a handful of his paintings are now known, but his designs were so popular, particularly with artists visiting Rome, that numerous copies were made of them by others. This sheet, though, is an autograph work by the artist himself.

LITERATURE
Exhib. cat. Washington/New York 1986-87, no. 106; cat. Amsterdam 1987, no. 84

Bartholomeus Spranger (Antwerp 1546-Prague 1611)

91 Venus and Adonis, c. 1587

Oil on panel, 135 × 109 cm
Purchased in 1955
inv. no. SK-A-3888

Bartholomeus Spranger was the most successful of all the painters who turned to Italian turned to Italian art for their inspiration. After training as a landscapist in his native Antwerp, he left for France and Italy in 1564. He arrived in Rome in 1566, where he found employment with Cardinal Alessandro Farnese, and later with Pope Pius V. It was to these powerful patrons that he owed several major commissions for altarpieces which established his reputation. One of the friends he made in Italy was the sculptor Giambologna, who also came from the Low Countries and had settled in Florence, where he ran an extremely successful workshop. Giambologna recommended him to Emperor Maximilian II in Vienna, and he moved there in 1575. Maximilian was succeeded by Rudolf II, who asked Spranger to stay on and work for him. Rudolf moved the court from Vienna to Prague, where Spranger was employed as court painter from 1 January 1581. He and the sculptor Adriaen de Vries

were among the leading artists whom Rudolf gathered around him in Prague.

Spranger often painted in Rudolf's presence in the imperial palace and accompanied him on his travels. The emperor took a very keen interest in the art that was made at his court, and wielded great influence over it. He was also an avid collector, and went to great lengths to acquire works by famous Italian masters like Titian, Correggio and Parmigianino. Another of his passions was for northern masters like Albrecht Dürer, Lucas Cranach and Lucas van Leyden. His *Kunstkammer* contained one of the largest collections of works by Dürer and his contemporaries.

That love of the art of Dürer's day also had its impact on this painting by Spranger. It shows Adonis taking leave of Venus in a way that would have been considered quite risqué by Spranger's contemporaries. The story comes from what Karel van Mander called 'the painter's Bible': Ovid's *Metamorphoses*. We see the

90a Cornelis Cort after Raphael, *The battle between Constantine and Maxentius*; engraving, unfinished, 32.6 × 96 cm. Vienna, Albertina (inv. no. HB 20.2, f. 37)

91a Leonhard Beck, *St George and the dragon*, c. 1515; oil on panel, 134.5 × 116 cm. Vienna, Kunsthistorisches Museum (inv. no. 5669)

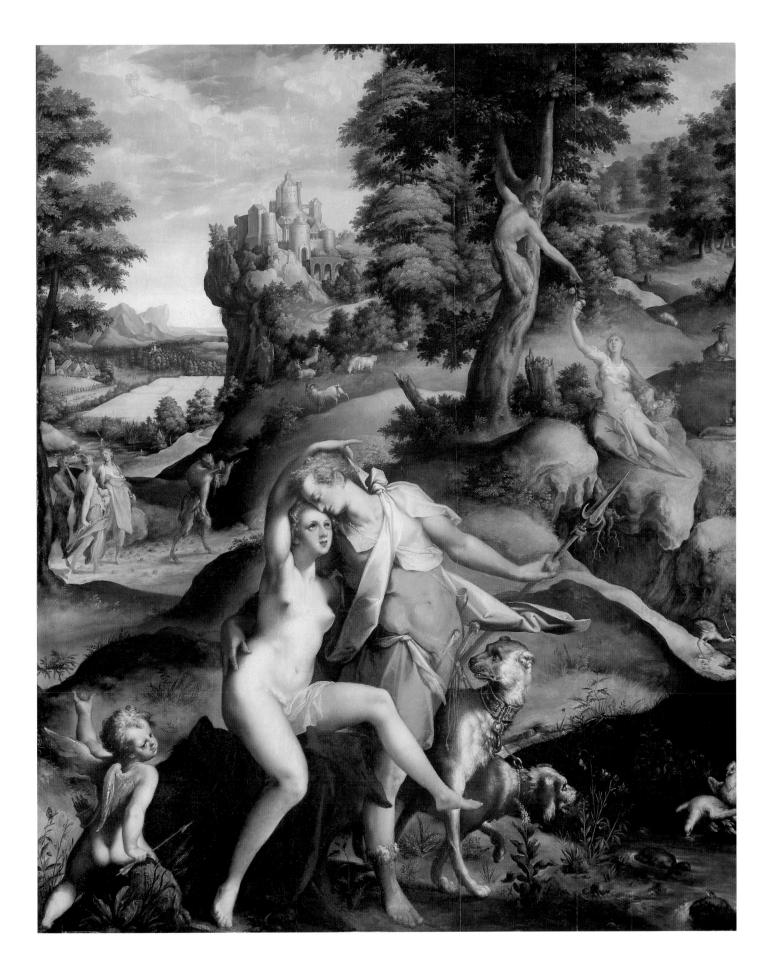

213

beautiful young Adonis in a hilly landscape taking leave of the goddess of love to go off hunting accompanied by two hounds. The two white turtledoves on the right symbolise their love, as does the small Cupid holding an arrow on the left. In the right background a satyr hands a piece of fruit to a nymph, while on the right two satyrs and two nymphs return from the hunt. The prominence given to the landscape is unusual in a work from Spranger's Prague period, for he had developed into a consummate figure painter while in Italy and took little further interest in the genre for which he had trained. In this picture, though, he borrowed the landscape from a painting by Leonhard Beck, a contemporary of Dürer's, the *St George and the dragon* of c. 1515 [*91a*]. It belonged to Rudolf II, and presumably the emperor insisted that Spranger enter into this form of creative rivalry known as the 'Dürer Renaissance'. The figures, though, are in Spranger's customary style. The two main characters, with small heads and elongated limbs, embrace in an elegant and attractive pose that is nevertheless a little unnatural. Cupid seen from the back with his head turned to the right also looks rather mannered. Depicting idealised figures, nude or otherwise, in contrasting poses was a predilection that Spranger shared with many other artists working at Rudolf's court.

LITERATURE
Kaufmann 1988, nos. 20-43

Jan Muller (Amsterdam 1571-1628)
after Adriaen de Vries (The Hague 1545-Prague 1626)

92 *Mercury and Psyche, viewed from three sides, c. 1594-1595*

Three engravings (B. 82-84), approx. 51 × 27 cm
From the collection of Pieter Cornelis, Baron van Leyden, which
Louis Napoleon bought in 1807; Koninklijke Bibliotheek, The Hague;
transferred to the Rijks Museum in 1816
inv. no. RP-P-OB-32.227/29

Michelangelo and Giambologna were among the earliest sculptors to have prints made after their work during their lifetime. Their sculptures were regarded as models to be imitated, which created a demand for reproductions that had to meet certain criteria. It was not a question of matching the tonality or chiaroscuro effects of a painting in a linear technique, but of giving a convincing suggestion of the spatial qualities of the model.

In the Netherlands, Willem Danielsz van Tetrode [88] and Adriaen de Vries were the sculptors whose works were reproduced in print in that same period. The engraver Jan Muller, who modelled himself on Hendrick Goltzius [93], was responsible for this masterly series. He made it clear that the original was a statue through the inscriptions, the execution, and above all by showing the bronze from three sides. The series is signed on the plinth: 'In gratiam D: Adriani de Vries, Cognati sui chariss.mi sculpebat Iohannes Mullerus. Harman Muller excudebat' ('Jan Muller engraved this in honour of his dear relative Adriaen de Vries. Harmen Muller published it'). Understandably, he did not attempt to produce a full-scale reproduction, for the statue is 2 1/2 metres high.

The inscription on the print shows that Adriaen de Vries's bronze of *Mercury and Psyche*, now in the Louvre, was made for Emperor Rudolf II in Prague in 1593. It is doubtful whether Muller ever visited the city himself, but the detailed execution of his engravings suggests that he worked from a wax model. It is also, of course, possible that De Vries or another artist working at the imperial court supplied him with drawings after the statue. Two other sculptures by De Vries that Muller reproduced in print are in landscape settings, which distracts attention from the statues. The emphasis in this print is on the defiance of gravity, with which De Vries was emulating Giambologna. The statue stands out from the background, which consists of a dense network of hatching. The swelling lines very effectively suggest the sculpted curves. The way in which Mercury clasps Psyche's beautiful body —tenderly, but firmly enough to bear her weight—is extremely sensitive, and approaches the quality of the bronze model.

However successful the prints may be, Muller's idiosyncratic tendencies let him down. He was unable to capture the classical profile of Psyche's head properly. Instead she has been given a contorted expression that approaches a grimace. In addition, the vase she is holding, the *pyxis*, is a little too large compared to the bronze.

Muller's prints after the bronze helped further the sculptor's fame, Many a draughtsman regarded the engravings as ideal for study purposes, as demonstrated by the many drawn copies made after them.

LITERATURE

Larsson 1967, pp. 14-15, 122; exhib. cat. Amsterdam 1993-94, pp. 501-502, no. 180; Filedt Kok 1994-95, vol. 1, pp. 236-240, vol. 3, p. 22: B. 82-84

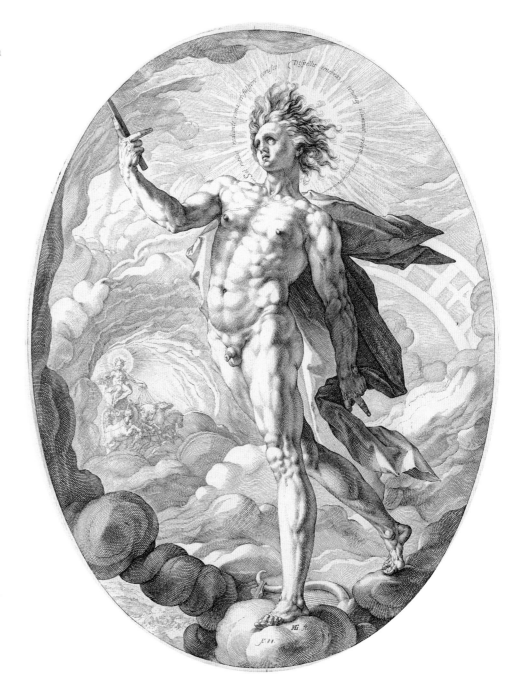

Hendrick Goltzius (Mühlbracht 1558-Haarlem 1617)

93 Apollo, 1588

Engraving (B. 141), 34.7 × 26.3 cm
Purchased in 1943 with the aid of the F.G. Waller-Fonds
inv. no. RP-P-1943-378

In the course of the 1580s, Hendrick Goltzius developed a style of engraving that was to have a profound effect on the visual arts of his day. There were pupils, as well as foreign artists, who tried to master the art of swelling lines and imitated his very evocative manner of hatching. Goltzius's prints had barely left his studio before they were being copied as far away as Italy. When he visited that country in 1590 he travelled incognito to avoid being disturbed while at work. His ambition was not curbed by this early fame; few artists have flaunted their virtuosity as much as Goltzius did.

Funnily enough, his career had modest beginnings—as an engraver of other people's drawings and, after his move to Haarlem around 1577, as a portraitist of members of the prosperous burgher class. His discovery of the drawings of Bartholomeus Spranger heralded a breakthrough. Increasingly, Goltzius set himself the task of drawing emphatically physical figures and groups using his own creative powers rather than imitating nature. Works done from the imagination were highly prized in Goltzius's day. In addition, he had remarkable artistic self-assurance. Wanting to show that he was as good as great artists of the past like Albrecht Dürer and Lucas van Leyden, he made some engravings in a manner that was indistinguishable from theirs, mastering their style in order to create something new. By 1588, when he executed this *Apollo*, he had found his feet. He had placed his *Standard-bearer* in almost exactly the same pose a year earlier [*93a*], and the ease with which he varied on it shows that by the age of 30 he was a mature

93a Hendrick Goltzius, *The standard-bearer*, 1587; engraving (B. 125), 28.6 × 19.9 cm. Amsterdam, Rijksprentenkabinet (inv. no. RP-P-OB-4639)

The engraving is an individual piece, and does not appear to have been part of a series. There are, however, two oval prints with the same dimensions that Goltzius's stepson and pupil Jacob Matham made after drawings by his master that can be dated around 1588. They show Mars and Venus, also in a world of clouds, and suggest that Goltzius may initially have thought of making a series of Olympian gods. If so, it never got any further than this highly wrought sample of unabashed nudity.

LITERATURE
Exhib. cat. Boston/St. Louis 1980-81, pp. 4-6, no. 2; Filedt Kok 1993, p. 173, no. 46; Widerkehr 1993

artist. The earlier print is a masterpiece of textural imitation, this one of an idealised anatomy embodied by the handsomest male Olympian: Apollo, in his role as the sun god. On the left he rides in the chariot-and-four with which he brings dawn to the world. Goltzius toyed with the clouds, which begin on the left in the shape of an umbilical cord and become thinner the further they recede, curling into a wave before dissipating. The halo around the god's head and shaggy locks is made up of words characterising him as the sun god. Lying at Apollo's feet is the lyre that is his attribute as patron of the arts.

Cornelis Cornelisz van Haarlem (Haarlem 1562-Haarlem 1638)

94 The massacre of the innocents, 1590

Oil on canvas, 245 × 358 cm
Probably executed for Prince Maurits; listed as being in the stadholders' palace at
Honselaarsdijk, 1755-1758; in the Nationale Konst-Gallerij from 1800
inv. no. SK-A-128

In the closing decade of the 16th century, the Haarlem painter Cornelis Cornelisz made two large paintings of the *Massacre of the innocents* within two years of each other. The Bible tells how King Herod, upon hearing that the king of the Jews had been born in Bethlehem, ordered his soldiers to kill all the children there under two years old. This story set in the year of Christ's birth evidently had great contemporary relevance for Cornelis's Dutch contemporaries.

The artist depicted the horrific event in all its barbarity. The soldiers brutally snatch the screaming babies from their mothers' arms and slit their throats. Although the soldiers are all extremely muscular, the women have overpowered one of them and are scratching his eyes out. Cornelis gave free rein to his artistic ideas in his rendering of the dramatic scene, which is filled with heroic physiques, extreme foreshortening and contorted limbs.

The first owner was probably Prince Maurits. A second painting of the same subject that Cornelis executed in 1591 [94a], one year later, was definitely destined for the young prince. That version was commissioned by the city of Haarlem to hang in the Prinsenhof (Prince's Court), the stadholder's quarters when he was in Haarlem. The city fathers had asked Cornelis to make a new central section for a triptych whose original centrepiece had been lost during the Spanish siege of Haarlem. The subject was probably a Nativity. The authorities believed that the new work would revitalise the function of the wings with *The adoration of the shepherds* and *The adoration of the magi*, which Maarten van Heemskerck had painted back in 1546. Cornelis toned down the brutal details in the second version, which suggests that the first one had not only made a great impression but had also sparked off a discussion about its realism.

One wonders about the possible significance of these two paintings for Prince Maurits. The faithful of the 16th century regarded Herod as the embodiment of tyranny. The siege of Haarlem in

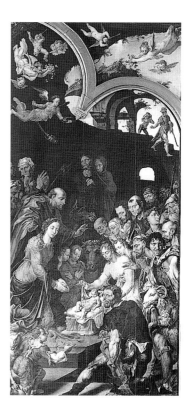

94a Cornelis van Haarlem, *The massacre of the innocents*, 1591; oil on canvas, 270 × 255 cm,
with wings by Maarten van Heemskerck, *The adoration of the shepherds* and *The adoration of the magi*, 1546; oil on panel, each 260 × 122.5 cm.
Haarlem, Frans Halsmuseum (inv. nos. 467 and 474)

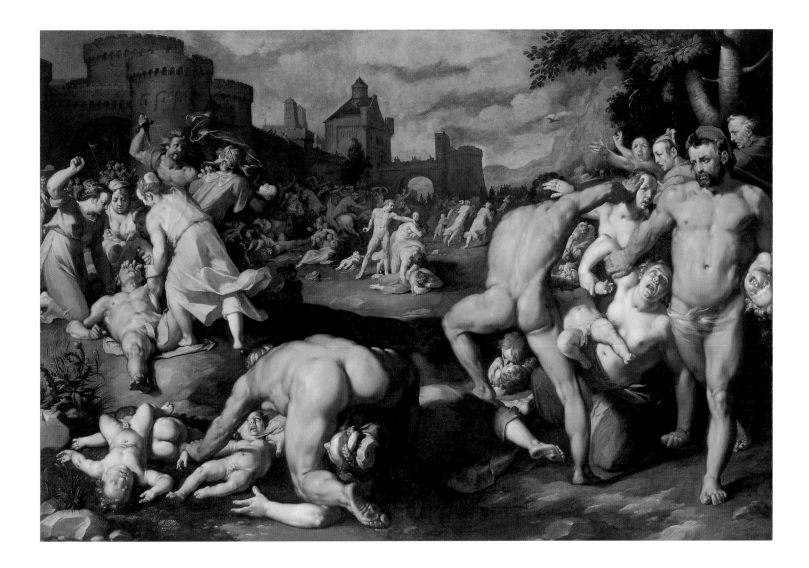

1573 during the Dutch revolt against Spanish rule was seen as an act of tyranny by the townsfolk, and King Philip II was often portrayed as a despot. A king, after all, was meant to look after his subjects, but Philip besieged his 'children' and had them killed. However, the painting is more than a literal depiction of a historical parallel. Ridding the Low Countries of tyranny was one of the main responsibilities of Prince Maurits in his capacity as commander-in-chief. It was also the God-given task voiced by William the Silent in the sixth verse of the 'Wilhelmus', the Dutch national anthem: 'to drive out tyranny that wounds my heart'. The inhabitants of the northern provinces had entrusted William's task to Maurits, his son and successor as stad-holder. The two large, dramatic paintings by Cornelis van Haarlem can thus be read as a political manifesto that had a very real and immediate meaning in the early years of the fledgling republic.

LITERATURE
Bonger 1989, pp. 50-51; exhib. cat. Amsterdam 1993-94, no. 6

Cornelis Cornelisz van Haarlem (Haarlem 1562-Haarlem 1638)

95 The Fall of Man, 1592

Oil on canvas, 273 × 220 cm
From the Prinsenhof, Haarlem; purchased from the City of Haarlem in 1804
for the Nationale Konst-Gallerij
inv. no. SK-A-129

In 1592, Cornelis Cornelisz van Haarlem (who was known in Haarlem as Cornelis the Painter) completed this *Fall of Man* for the Prinsenhof in Haarlem, the stadholder's quarters in the city. It is one of the few paintings for which there is at least some information about the original location and function. Cornelis's picture hung over a door in the Prinsenhof. The city authorities had ordered several other paintings for Prince Maurits's chambers from Cornelis, including *The massacre of the innocents [94a]* and *The marriage of Peleus and Thetis.*

The Fall of Man depicts the moment when Adam and Eve, standing beside the tree of the knowledge of good and evil, ignored God's command not to listen to the devil (Genesis 3), who is shown as a young man with a serpent's tail. Cornelis inserted two small scenes on either side. In the left background Adam and Eve stand by a cloud in which God the Father appears to them. He is pointing at the tree and ordering them not to eat its fruit. The counterpart of this small scene on the right shows a dragon crashing through the dark forest. A dragon or snake is the embodiment of the devil, as is the figure with the serpent's tail in the tree, but now in a different guise. The main scene is likewise a depiction of multiple moments. The devil is handing Eve an apple, and at the same time she is passing one to Adam, thus combining two distinct events. The remainder of the story, which ends with the expulsion from Paradise, is not portrayed, but would have influenced Cornelis's contemporaries in their

judgement of the painting. His patrons must have considered the moment when Adam and Eve make their choice to be the crux of the story.

The artist depicted the first man and woman, who were created in God's image and likeness, as paragons of masculine strength and feminine beauty. An engraving by Albrecht Dürer served as the model for the composition [95a], but Cornelis modified those idealised figures to make them fit the taste of his own day. The animals in *The Fall of Man* are carefully arranged. The monkey embracing the cat,

the dog and the fox, the slug and the owl all have connotations that comment on the story. Those who knew the meaning of these symbols and their combined effect could delve deeper into the picture. The cabbage white butterfly on the tree-trunk stood for rashness, the vice that led to Adam and Eve's fateful decision.

LITERATURE
Exhib. cat. Washington/Detroit/Amsterdam 1980-81, no. 2; exhib. cat. Amsterdam 1993-94, no. 7

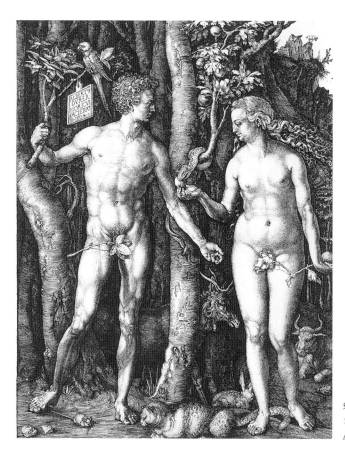

95a Albrecht Dürer, *The Fall of Man*, 1504; engraving (B. 1), 25.2 × 19.5 cm. Amsterdam, Rijksprentenkabinet

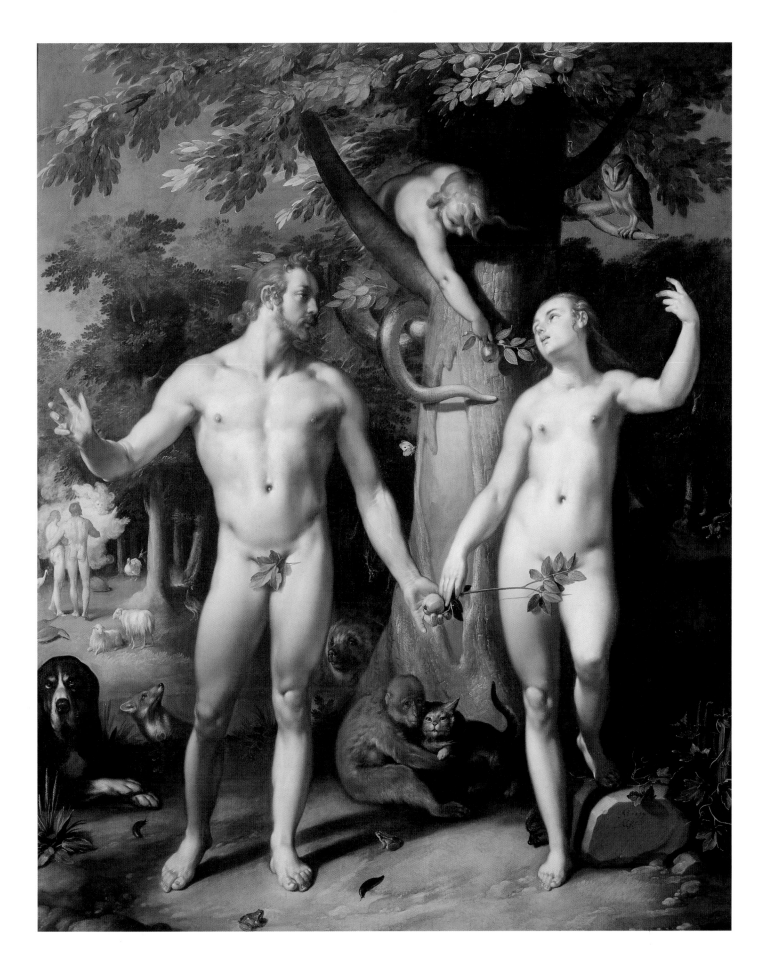

Abraham Bloemaert (Gorinchem 1566-Utrecht 1651)

96 The preaching of John the Baptist, c. 1595-1600

Oil on canvas, 139 × 188 cm
Purchased in 1950
inv. no. SK-A-3746

According to Karel van Mander, Abraham Bloemaert always regretted not having been properly trained as a painter. His father, a sculptor and architect, was his first teacher, and he was followed by six others. It is clear from the works that Bloemaert produced in the early 1590s that it was Cornelis Cornelisz van Haarlem who had the greatest influence on him. The young artist became acquainted with the circle of Mannerist artists around Cornelis when he and his father moved from Utrecht to Amsterdam in the spring of 1591. He mixed with painters like Karel van Mander and Cornelis Ketel, and engravers like Harmen and Jan Muller, Jacques de Gheyn II and Jacob Matham. The latter all turned designs by Bloemaert into prints, thus spreading his name far and wide.

The preaching of St John the Baptist dates from the closing years of the 16th century, at a time when the subject was extremely popular among Protestants and Catholics alike. Pieter Bruegel was one of the many artists who depicted it, and his work was imitated many times. The central theme is the announcement of Christ's coming by John the Baptist who, when asked whether he was the Messiah, replied: 'I am the voice of one crying in the wilderness, Make straight the way of the Lord, as said the prophet Esaias' (John 1:23). The Bible says that Christ was among the crowd listening, but had not yet revealed himself as the Redeemer, so there was a challenge for every artist to smuggle him into the scene incognito.

This canvas, with its colourful figures, is the most impressive of the versions that the Catholic Bloemaert painted of the subject.

One striking feature is the prominence given to the landscape, which is in a wholly Flemish style. John the Baptist stands preaching in the shade of a tall group of trees. Stretching out behind him is a broad, mountainous and ingeniously lit landscape. Bloemaert arranged various groups of listeners around John. Those in the foreground are also strongly lit. Prominent among them is a young man in a large plumed hat with a drum slung over his back. It is not clear which of the figures is meant to be Christ.

The structure of the composition, with its various diagonals and vistas, is derived from Flemish landscape art of the second half of the 16th century, which was brought to Amsterdam by southern Netherlandish emigrés like Gilles van Coninxloo, David Vinckboons and Jacob Saverij. A number of their landscapes are peopled with just one or two figures. Those in The preaching of St John the Baptist are not of secondary importance, however. Some reappear in other works by Bloemaert, so it seems that he used studies of nude or draped models which he kept in his studio and consulted when compiling his compositions. Other painters of figure pieces used the same method, but Bloemaert stands out for his varied and elegant poses. He displays a deft touch, and one can well imagine that this was another factor that appealed to his contemporaries.

LITERATURE
Kloek 1993; Roethlisberger 1993, no. 53

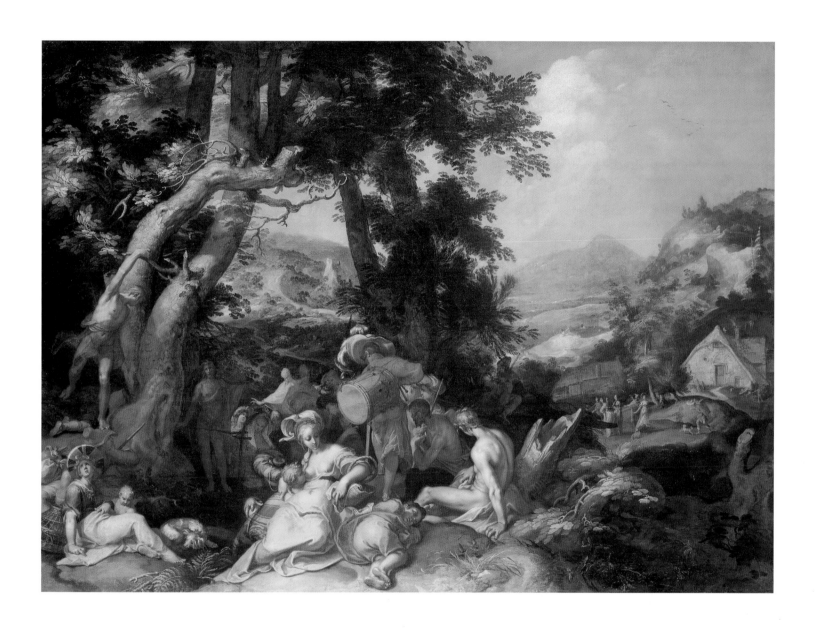

Karel van Mander (Meulebeke 1548-Amsterdam 1606)

97 *The continence of Scipio, 1600*
 on the reverse: Allegory of Nature

Oil on copper, 44 × 79 cm
Purchased in 1977 with the aid of the Rijksmuseum-Stichting
inv. no. SK-A-4690

Karel van Mander's main claim to fame is his monumental *Schilder-boeck*, which was published in Haarlem in 1604. He was far less well-known as a painter and draughtsman, rather unjustly on the evidence of his works from the late 16th and early years of the 17th century, of which *The continence of Scipio* is a remarkably well-preserved example.

It illustrates a classical story read chiefly in the version by Valerius Maximus. It was cited and depicted many times in humanist circles by people who were fascinated by Stoic philosophy—Seneca's in particular. Self-control, magnanimity and selflessness were the key concepts in that doctrine, which explains the popularity of a figure like Scipio in the 16th century.

After capturing Carthage, the Roman general, whose full name was Publius Cornelius Scipio Africanus Major (235-183 BC), was presented with a beautiful young woman as war booty. Scipio, however, exercised self-restraint and returned her to Allucius, her betrothed, and as a wedding present gave them the ransom that her parents had offered to pay for her freedom.

This is taking place in the foreground of a rolling, broad landscape painted solely in shades of green and blue which is closed off at the sides by tall stands of trees. The city burning in the background is Carthage. The laurelled Scipio is seated in the left foreground, turning round to speak to the girl's parents, who are offering him the ransom. At the same time he is pointing towards Allucius and his beloved in the centre of the composition.

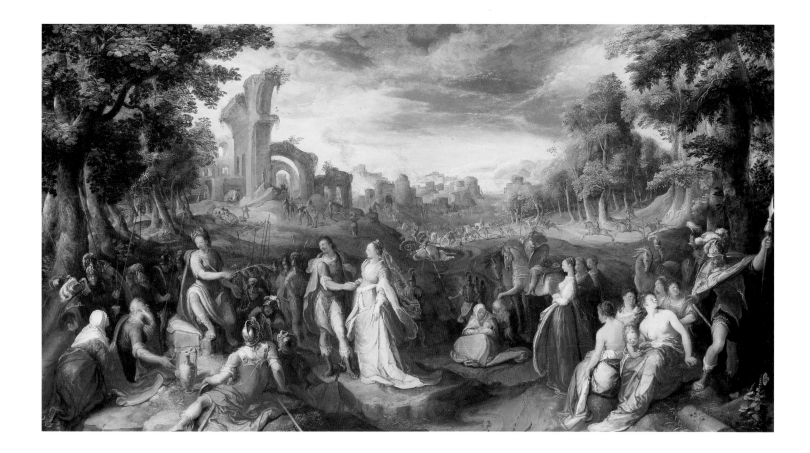

Van Mander painted the principal characters in sparkling colours. The bride-to-be in her yellow gown is the radiant centrepiece of the composition.

The back of the copper that Van Mander used as the support is also decorated [97a]. On it he painted an imitation of grey and red-veined marble to produce a marvellous *trompe-l'oeil* effect that is rarely encountered in the Netherlands at this time. Van Mander undoubtedly picked up the technique in Italy. In the centre is an oval with an allegorical scene in which *Natura* in the guise of the mother goddess Cybele with her many breasts is drawing the attention of a muscular, bearded man to a woman with rays around her head holding the two tables of the law, who probably symbolises *Sapientia*, or Wisdom. It can be assumed that this scene was closely connected with the one on the front, but their relationship is not entirely clear. Van Mander may have been trying to say that

virtue, in the person of Scipio, leads to understanding and wisdom—the wisdom being urged on the man on the back.

Equally unclear is the function of this two-sided painting. Perhaps it was once part of an art cabinet with the allegory on the outside, Scipio being revealed when the door was opened.

LITERATURE
Van Thiel/Miedema 1978; exhib. cat. Amsterdam 1993-94, no. 212; Golan 1996, pp. 169-173

Hendrick Goltzius (Mühlbracht 1558-Haarlem 1617)

98 Portrait of the sculptor Pierre Francheville, c. 1591

Black and red chalk, stumped, heightened with white chalk, brush in grey and brown,
framing lines with the pen in brown, 41.5 × 30.8 cm
From the famous drawing collections of Hagelis (1762), D. Muilman (1773),
J. Goll van Franckenstein (1833), C.A.W. Jungmeister (1852), L.H. Storck (1894)
and R.P. Goldschmidt (1917); bequeathed to the museum in 1961 by
Mr and Mrs I. de Bruijn-van der Leeuw, Spiez
inv. no. RP-T-1961-71

Hendrick Goltzius set out on his journey to
Italy in the autumn of 1590, and arrived in
Rome in January 1591. He was already in
his thirties, and had acquired a reputation
as a virtuoso engraver that extended far
beyond his homeland. It was not for artistic
reasons alone that he undertook the
arduous trip to Italy. Shortly after his
marriage he contracted a persistent illness
which Van Mander describes as a
'melancholy [of the] heart' that gradually
developed into 'a wasting sickness or
consumption'. None of the doctors he
consulted could help him, and at his wits'
end he decided to go south, 'hoping in that
way to get some improvement, or at least to
see the ingenious or beautiful works of art
in Italy before he died, which had been
denied him for so long owing to his
marriage and other matters'. The stay in
Italy did do Goltzius good, if only
temporarily, and it also provided new
impulses for his art. Among the tangible
fruits of his visit are a number of large
portraits executed in chalks of various
colours. He had first used this technique in
the 1588 portrait of his pupil Gillis van
Breen, but only began employing it
regularly during his time in Italy. His
models may have been German drawings
from Dürer to Holbein, although his
portraits sometimes recall the work of
François Clouet and his contemporaries.

Most of Goltzius's Italian portraits are of
artists he met on his travels, both Dutch
and Italian. The one in the Rijksmuseum
printroom, which had been regarded as the
likeness of Federico Zuccaro since the mid-
18th century, was identified in the 20th
century as that of Pierre Francheville on the
basis of the similarities to a painted portrait
of the sculptor. Francheville, who
originally came from Cambrai, was the
leading assistant of the great sculptor
Giambologna. He Italianised his name to
Pietro Francavilla, and lived in Florence
from the beginning of the 1570s, which
must have been where Goltzius made this
portrait in the late summer of 1591.

Goltzius displays astonishing virtuosity
in the rendering of the head. The extreme
detail of the face contrasts strikingly with
the dry, rather schematic handling of the
clothing. This is a feature of almost all of
Goltzius's Italian portraits, and is probably
due to the fact that he drew only the head
from life, adding the costume later from
memory.

LITERATURE
Bruyn 1961, pp. 135-139; Reznicek 1961, vol. 1, pp. 86-87
and p. 359, no. 271; cat. Amsterdam 1978, no. 266

Jacques de Gheyn II (Antwerp 1565-The Hague 1629)

99 Four studies of a frog, c. 1600-1604

Pen in brown, brush in watercolour, 14.3 × 19.7 cm
From the famous drawing collections of J.G. Cramer (1769), C. Ploos van Amstel (1800),
J. Bangert (1878) and J.F. Ellinckhuysen (1878); bequeathed to the museum in 1898
by D. Franken Dzn
inv. no. RP-T-1898-A-4036

There were two great draughtsmen of animals in the northern Netherlands around 1600: Hendrick Goltzius and Jacques de Gheyn. Both showed themselves to be direct descendants of Albrecht Dürer, whom they greatly admired. Goltzius drew small studies of animals in metalpoint on prepared tablets, as well as large drawings in chalk of various colours, which look almost like portraits. De Gheyn's small studies, meticulously done with the pen or in watercolour, can best be described as natural history illustrations of the highest artistic order.

In the years 1600-1604 De Gheyn filled an entire album with watercolour miniatures of flowers, insects and other small animals. It was in all probability this book that Van Mander described in his biography of De Gheyn as 'a little book in which De Gheyn had, in the course of time, made some flowers in watercolour, done from nature, and many little animals'. Van Mander also reported that the book had been bought by Emperor Rudolf II. The album—which may no longer be complete—is now preserved in Paris. The Amsterdam sheet of frogs doubtless dates from the same period, for the painstaking attention to detail is highly reminiscent of the miniatures in the Paris album.

Of the four studies, only the one at upper right shows the animal in a natural pose. It alone could have been drawn from life; the other three are probably based on a stuffed specimen. De Gheyn presumably used a green frog (*Rana esculanta*) as his model.

Frogs also figure in other studies by De Gheyn. Three, for instance, accompanied by two stuffed rats, occur in a study sheet of 1609 that is now in Berlin [99a]. That drawing has an oddity that it shares with a number of De Gheyn's other animal studies: the artist seems to have given his animals human traits, and to have bestowed on them an intelligence utterly foreign to the animal kingdom. The frogs at the right in the Berlin drawing gaze upward with an expression that conveys both anxiety and contempt. The artist went further still in a drawing in Paris [99b], depicting monstrous little freaks of nature that most closely resemble mummified frogs or toads, endowed with human genitals. In such a drawing, what began as an earnest study of nature in the spirit of Albrecht Dürer ended in nightmarish fantasies that would not be out of place in the work of Hieronymus Bosch and Pieter Bruegel the Elder.

LITERATURE

Cat. Amsterdam 1978, no. 240; Van Regteren Altena 1983, vol. 2, no. 888; exhib. cat. Rotterdam/Washington 1985-86, no. 80; exhib. cat. Amsterdam 1993-94, no. 238

99a Jacques de Gheyn II, *Study sheet with rats and frogs*, 1609; pen in brown on grey paper, 27.6 × 39.6 cm. Berlin, Kupferstichkabinett Staatliche Museen zu Berlin (inv. no. KdZ 4178)

99b Jacques de Gheyn II, *Study sheet with dried frogs and Vanitas still lifes*, c. 1610; pen in brown on grey paper, 19.1 × 35.4 cm.
Paris, Fondation Custodia (F. Lugt Collection) (inv. no. 6863)

Hendrick Goltzius (Mühlbracht 1558-Haarlem 1617)

100 Portrait of Frederick de Vries, 1597

Engraving (B. 190), 36 × 26.6 cm
From the collection of Pieter Cornelis, Baron van Leyden, which
Louis Napoleon bought in 1807; Koninklijke Bibliotheek, The Hague;
transferred to the Rijks Museum in 1816
inv. no. RP-P-OB-10353

There are few prints from the period around 1600 that is as personal as this carefully and lovingly rendered engraving of Frederick de Vries, the son of the Goltzius's friend Dirck de Vries, a draughtsman and painter who worked in Venice between 1590 and 1609. During his visit to Italy, Goltzius twice stayed briefly at De Vries's home. The portrait drawing of De Vries that Goltzius made on his way to Rome at the end of 1590, reveals how much the young Frederick, who was born in Venice, resembled his father. When the engraving was made, the boy was living in Haarlem with Goltzius, into whose care he had been entrusted. According to the inscription, the print was intended to show Dirck de Vries, then in Venice, what his son looked like: 'Theodorico Frisio Pictori egregio/ aput Venetos amicitiae' et filii absentis/ repraesantandi gratia D.D. [do dedicoque]' ('I dedicate this work to the excellent painter Dirck de Vries in Venice out of friendship and in order to bring his absent son before his eyes').

The print, however, is more than a simple portrayal of a boy. The large dog, which has an emblematic meaning, is so prominent that the engraving became known as 'Goltzius's dog', and its appeal was such that only two years later an engraved copy was made of it in Rome.

Goltzius presents himself here as a master of realism, not as a consummate Mannerist [see 93]. The rendering of the different textures is peerless. As they changed, so Goltzius modified his engraving technique, with the result that the gleaming fabric truly shimmers, the face is genuinely that of a healthy, well-fed youth, and the area where the dog's spotted hind legs merge with its shaggy coat is almost tangible. A drawing still exists of the head of the dog, called a 'Drentse patrijshond' in Dutch—a lifesize, close-up portrait. Given that the dog stands for vigilance and faithfulness, one could say it embodied Goltzius's own role. He was both the custodian and teacher of the boy, and, very appropriately, we read in Van Mander's *Wtbeeldinghen der figueren* that 'The dog signifies the upright teacher, who must bark fearlessly and constantly, and keep watch over the souls of men and punish their sins'. In Van Mander's section on hieroglyphics, the dove symbolises love, simplicity and benevolence, and it is the child's innocence and the dog's loyalty that are coupled in Petrus Scriverius's inscription: 'Quid tabula hoc capiat, fors non capis: en tibi paucis/ Mentem. Simplicitas. quaerit amatque fidem./ Fida canis, simplexque puer, quos Goltzius apto'/ Viveros Phidiaca fecit in aere' manu. P. Scriverius' ('You may not understand what is contained in this scene; here is the meaning for you in few words. Simplicity and faithfulness are close related. Goltzius has rendered the faithful dog and the innocent boy faithfully in copper with a Phidian hand. P. Scriverius').

Goltzius's invention is highly original. For De Vries's enjoyment he included reminiscences of the Venetian landscape as depicted by Titian and his followers. Goltzius may have been inspired to depict the boy with a dog by a painting from that circle, like Titian's *Boy with dogs in a landscape* (Rotterdam, Museum Boijmans Van Beuningen), which he may have seen with Dirck de Vries in Venice. However, unlike the static childrens' portraits painted during the Renaissance, mostly of young aristocrats, this sitter is shown in action, as in a genre scene.

Frederick de Vries lived with Goltzius for a considerable time. A list of participants in a 1609 lottery held in Haarlem states that he and his brother Pieter Anthonie were residing with Goltzius ('ten huize van Goltzius'), and in the boy's will of 21 December 1613, which was made when he was seriously ill, it seems that Frederick was still boarding with the artist. He explicitly attests to his love and gratitude to Goltzius for the 'exceptional affection that his [...] master has always had [...] for him and his parents', issuing not from self-interest, but from a 'truly generous disposition'.

LITERATURE
Exhib. cat. Amsterdam 1993-94, pp. 396-397, no. 51

Cum priuil. Sa. Cæ. M.
Anno 1597.

HG

Theodorico Crisis Pictori egregio
apud Venetos amicitiæ, et solij absentis
repræsentandi gratia Ɖ.Ɖ. Cæn

Quid tabula hęc capiat, fors non capis: en tibi paucis
Mentem. Simplicitas quærit amata fidem.

Fida canis, simplexq, puer, quos Goltzius apto
Viuos P̃ictura fecit in ere manu.

D. Scrinerus.

Detail from fig. 88 >

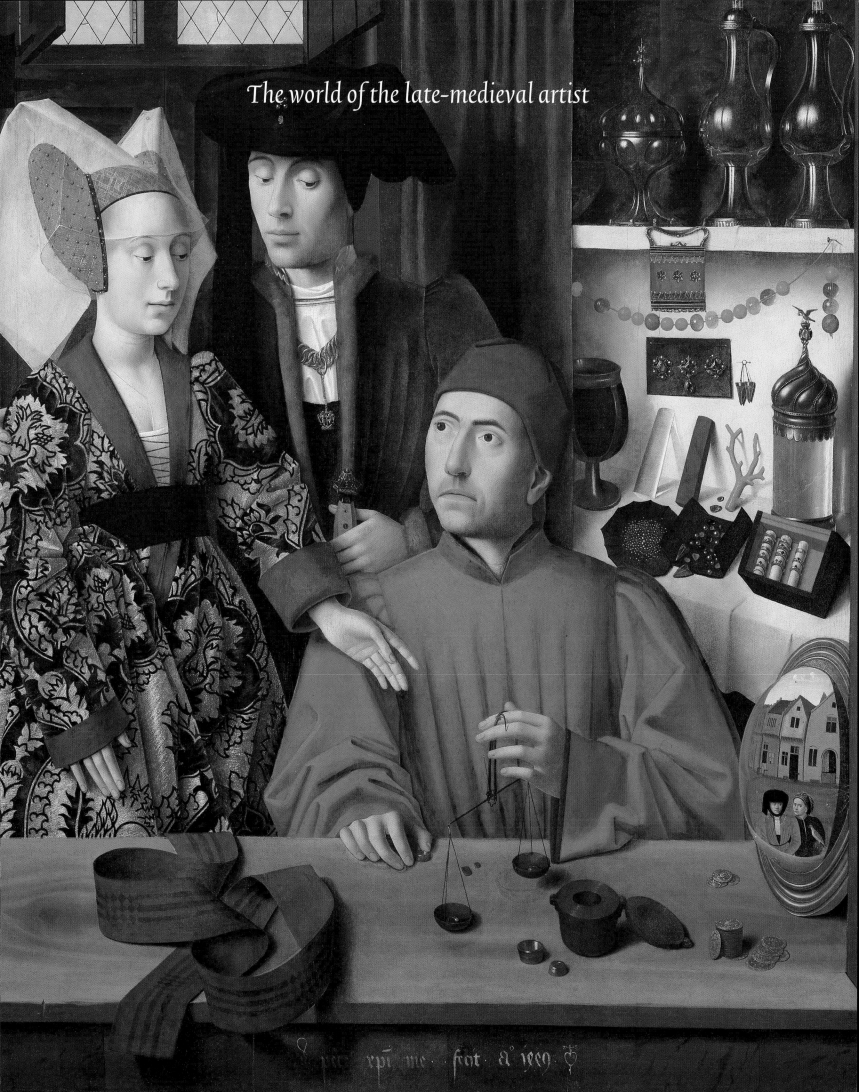

fig. 68 Pieter Frans de Noter II and Felix de Vigne, *Albrecht Dürer before the polyptych with the adoration of the Lamb by Hubert and Jan van Eyck in the Church of St Bavo in Ghent,* 1810; oil on canvas, 133 × 106.6 cm. Enschede, Rijksmuseum Twenthe (cat. no. 156)

INTRODUCTION

When Albrecht Dürer, at the height of his fame, travelled to the Low Countries in 1521 (*fig. 68*), he had decided to make Antwerp his final destination. It was a good choice, both commercially and artistically, for Antwerp had outstripped Venice as the leading mercantile centre of the western world, and was to dominate world trade for the first half of the 16th century.[1]

Dürer was welcomed into the city and lionised throughout his stay. The city authorities dangled a range of enticements in front of him in a vain attempt to get him to settle there: tax exemption, an annual allowance of 300 gold guilders and free housing. There could hardly be clearer evidence of Dürer's reputation and status as an artist, but it stands in stark contrast to the situation of most Antwerp artists. Few of his Netherlandish colleagues enjoyed such an unassailable position. Most belonged to the group of anonymous craftsmen who had to slave away in their workshops to earn their daily bread, sometimes delivering bespoke work for special patrons, but more often producing ready-made articles for the free market. Their lives were spent largely within their own community; they travelled little, if at all, and their radius of action was small. The work they produced, on the other hand, could be spread throughout the known world thanks to a well-organised, European-wide trading network.

This essay will examine several of these aspects of the social context within which artists operated in the late-medieval Netherlands, such as their areas of action, status and career,

fig. 69 Albrecht Dürer,
The port of Antwerp near the Scheldt Gate,
1520; pen in brown, 113 × 183 mm.
Vienna, Albertina (Alb. 50.248)

fig. 70 Bruges, illuminated prayer-book, 1494; miniatures on vellum. The Hague, Koninklijke Bibliotheek (inv. no. 74 G-2, fols. 91v-92r)

patrons, mobility, workshop organisation and output, and the art trade.

THE PRODUCTION OF ART

Antwerp was a cultural metropolis around the year 1520. It was a major centre of art production, a hub of artistic innovation, and a city that provided intellectual nourishment for the world around it.[2] The city had a highly developed cultural infrastructure with a large and diverse population of artists, a lively art market (and even a permanent commercial exhibition of paintings from 1540 on), a good network of trading contacts, and plenty of export opportunities. Antwerp was undeniably the capital in the artistic landscape of the Low Countries (fig. 69).

It experienced a huge population surge in the first half of the 16th century. Around 30,000 people lived in the city in the late 15th century, but by around 1565 the number had more than trebled.[3] By comparison, Haarlem had some 12,000 souls—to which a mere 30% more were added in the same half century. The number of artists in Antwerp matched the general population rise. For example, there were 12 stained-glass artists in the Guild of St Luke in the second half of the 15th century, but a further 74 enrolled in the course of the next 50 years.[4] In 1557, 91 precious metal-workers signed a petition to the civic authorities, almost all the masters in this category. A few years later, Guicciardini counted no fewer than 124 in the city.[5] He estimated that there were 300 painters and

sculptors, but that seems a little on the high side. It can safely be assumed that 0.5% of the Antwerp population worked directly in one of the artistic crafts, not counting the apprentices, whose number is difficult to gauge, and the equally amorphous group of those working in the service industries supplying materials, or marketing, trading and transporting the finished works.

Antwerp's role as 'cultural capital' in the 16th-century Netherlands had belonged to Bruges a hundred years earlier. With its direct link to the North Sea, it was able to exploit the vigorous growth in trade in the Netherlands around the middle of the 15th century. This naturally had a positive effect on local art production. Working in Bruges, which had some 40,000 inhabitants in its heyday, was the crème de la crème of Netherlandish painters: Jan van Eyck (from 1432), Petrus Christus (1444), Hans Memlinc (1465) and Gerard David (1485). The other branches of art were also amply represented. There were wood-carvers, tapestry weavers, gold and silversmiths and ivory-carvers. Since the 13th century the city had also developed into a centre of book illumination, which until then had been primarily the preserve of monastic scriptoria. The patronage of the dukes of Burgundy had fostered this development. The illuminated Bruges books of hours were not just for the local public, there was also a modest export trade in manuscripts (fig. 70). Another Bruges speciality was the production of engraved brass memorial tablets (fig. 71), for which there was also a market beyond the city gates.

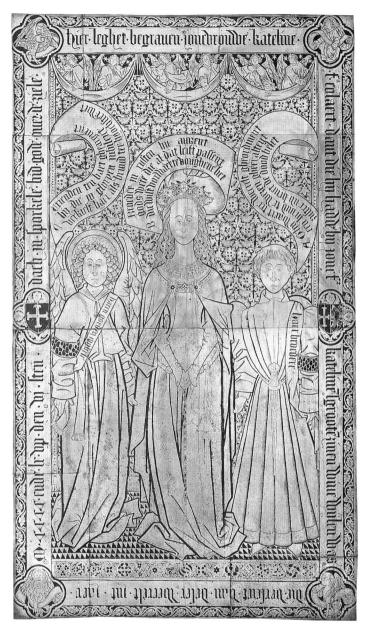

fig. 71 *Memorial tablet for Kateline Daut*, c. 1460; brass, 151.5 × 90 cm.
Bruges, Sint-Jacobskerk

There were two notable developments in late-medieval art production. Artists began working increasingly for the free market, and this was matched by a growing concentration of specialisation. The network of trading contacts between the large cities guaranteed the export of art to places way beyond the immediate region. This meant that artists could, indeed had to, work more and more for an open market. Commissions declined significantly, and in order to compensate, the craftsmen turned to a non-specific and less demanding group of customers, which obviously had an effect on the look of their art. They had to meet the demands of the market, so an inordinately specific form or iconography spelled economic suicide. There was also a driving need to assert one's individuality as an artist by carving out a niche amidst the unceasing flow of production, but at the same time originality was put severely to the test.

The discovery of the free market and the potential to export on a large scale led to changes in national art production in the 14th and 15th centuries. As noted above, there was often a concentration on and specialisation in one or several specific areas in each city. Perhaps the best-known example is the Antwerp school of retable

fig. 72 Utrecht, c. 1480, *The swooning Virgin*; pipe-clay with polychrome decoration and gilding, 47.7 × 27.7 × 7 cm. Amsterdam, Rijksmuseum (inv. no. BK-1972-156)

fig. 73 Manner of Jan van Eyck, *Fishing party with members of the house of Holland-Bavaria*, c. 1425; miniature on vellum, 229 x 375 mm. Paris, Musée du Louvre, Cabinet des Dessins (inv. no. 20674)

carvers, but one could also point to the wooden statuettes of female saints, alabaster reliefs and brass-work from Mechelen, the small pipe-clay figures from Utrecht (*fig. 72*), the illuminated manuscripts from Bruges or the tapestries produced in Brussels and Oudenaarde. Needless to say, there was still sufficient diversification in each city to supply its region with all sorts of luxury items.

Although Antwerp stood head and shoulders above the other Netherlandish cities in most respects, the cultural climate in many of those smaller centres was by no means unimportant. In 14th-century Flanders, Ghent as well as Bruges set the tone, in Brabant it was Brussels, Louvain, Diest and Mechelen, and a little further north in the same region there was Breda and Den Bosch. The landscape above the great rivers was dominated by a series of medium-sized cities like Utrecht, Leiden, Haarlem, Amsterdam and Dordrecht, while to the east the centres of Kampen, Zwolle, Deventer and Nijmegen could lay claim to a certain cultural and economic status. Even smaller towns had a significant local output of art. In Hoorn, for example, an ornately carved retable for the high altar was commissioned in 1493 from a local carver, Jan Pietersz van Jisp. It was destroyed in 1572, but a document reveals that it was a very substantial order which one would have expected to be placed with a carver in one of the large cities. Pietersz was to be paid more than 400 Rhenish guilders, whereas Adriaen van Wesel received only 350 Rhenish guilders for his famous *Altar of the Virgin* in Den Bosch.[6]

It was not just a concentration of economic activity that fired the artistic climate of the Netherlands, but the presence of a court. Brussels was the residence of the dukes of Burgundy, who were undoubtedly the most important secular patrons in the Low Countries. In 1507, Regentess Margaret of Austria established her court at Mechelen, turning the city into a cultural and intellectual centre of the northern Renaissance and humanism. The Hague, where there was also a court, had a lively cultural climate, particularly after 1350 under the patronage of the counts of Holland, and it became even more vibrant when the county was added to the domains of the Wittelbachs of Bavaria. The visual arts flourished under Duke Albrecht (1336-1404), and it was now that Middle Dutch first became an independent, cultural language. The exchequer accounts begin to reveal the wealth of the Hague court. The liquidation of the jewelry of Countess Jacoba of Bavaria upon her death in 1436 realised some 2,000 Flemish pounds, roughly equivalent to the annual wages of 500 unskilled labourers.[7] The accounts also show that a considerable proportion of this jewelry was made in Holland itself. Something of the luxury at court is reflected in a miniature of around 1420, in which richly clad members of the count's household are depicted during a fishing party (*fig. 73*). After Jacoba's death, though, the lustre of the Hague court faded rapidly. Jan van Eyck, who had worked for it in the period 1422-1424, was now in the service of the Burgundian Duke Philip the Good in Bruges.

MOBILITY

Artists loved to travel. They were perhaps the most mobile of all craftsmen. Dürer's journey in 1521 was nothing exceptional, and illustrates the openness of the cultural life of Europe in the late middle ages. Although most artists would have operated within a fairly limited radius, the freedom of movement was quite extensive, which the more ambitious artists turned to their advantage. In 1604, Van Mander urged them to seek out the places that had the best terms of employment, and not to become too attached to any one city. His advice was definitely not new. Guicciardini, writing more than 30 years before, had remarked on the wanderlust of Netherlandish artists, while a modern study of the migration among sculptors between 1400 and 1800 identified the

fig. 75 Claus Sluter, *Well of Moses*, 1395-1406; marble, height of figures approx. 15 cm. Dijon, Chartreuse de Champmol

fig. 74 Jacob Bylevelt (frame) and Caroni Gian Ambrogio, *Domestic altar with Christ and the woman of Samaria*, Florence, c. 1590; *pietre dure*, crystal and precious metalwork. Vienna, Kunsthistorisches Museum (inv. no. KK 1542)

Netherlanders as the most mobile group.[8] Netherlandish artists worked throughout Europe in the 15th and 16th centuries. Five Bruges painters emigrated to Spain in the 15th and early 16th century, among them a grandson and namesake of Petrus Christus who was active in Granada between 1507 and 1530.[9] In 16th-century Florence and other south and central European court cities there were various painters, silversmiths and sculptors of Netherlandish origin: Jacob Bylevelt ('Biliverti') of Delft (in Florence) (fig. 74), Willem van Tetrode of Delft (in Florence and Cologne), Giambologna of Douai (in Florence), Hans Mont from Ghent (in Prague), Adriaen de Vries from The Hague (in Florence, Turin, Milan and Prague), Johan Gregor van der Schardt from Nijmegen (in Venice, Nuremberg and Copenhagen) and Hubert Gerhardt of Den Bosch (in Italy and Munich).

Another group of emigrants, and one that has not yet been researched properly, moved to England, north Germany and Scandinavia—countries with which the Netherlands had extensive

trading contacts through the Hanseatic League. The sculptor Willem Boy of Mechelen is an example of someone who built a successful career in Scandinavia. He arrived in Sweden in 1558 as a sculptor, but later turned his hand to architecture as well. His works include several tombs for members of the ruling Vasa dynasty.[10]

Travel was encouraged as part of an artist's training. After completing his apprenticeship to a master-artist, the journeyman could travel around for a while to pick up knowledge and experience in order to round off his studies. In some cases, journeymen had to go on a study trip if their masterpiece had been rejected, and this is expressly stipulated in guild regulations.[11] There must have been many such *Wanderkünstler*, but they are largely undocumented and thus unknown. Travelling journeymen were of inestimable value for disseminating ideas, styles and techniques. The career of the Haarlem sculptor Claus Sluter (c. 1360-1405/06) is an excellent illustration of the opportunities for broadening one's horizons. Around the age of 20 he left Haarlem for Brussels, where he completed his studies. He was working in Dijon around 1385 for Jean de Marville, who was looking for artists to fill major commissions for Philip the Bold, Duke of Burgundy. It was here that Sluter made his famous *Well of Moses (fig. 75)*, an ambitious work that could never have been conceived in his native Haarlem.[12] One can take it that the career of Nicolaus Gerhaert van Leyden followed much the same lines. He was mainly active in Strasbourg, where he became one of the leading sculptors of his day. His surname suggests that he came from Leyden, although that has never been established beyond doubt.[13]

There were several reasons, mostly economic, for the wanderlust of independent masters. They were drawn by the prosperity and good working conditions in other cities, or by a special commission. Prosperous Bruges was a magnet for many of them in the mid-15th century. It is even estimated that one-third of the members of the guild of image-makers came from elsewhere in the Burgundian realm,[14] and they were by no means the lesser lights. Jan van Eyck settled there around 1432, Petrus Christus arrived in 1444 from Baarle (south of Breda), the Utrecht book illuminator Willem van Vreelant moved his workshop there in 1454, Hans Memlinc exchanged the German Seligenstadt for Bruges more than 20 years later *(fig. 76)*, and Gerard David arrived around 1485 from Oudewater in Holland. Bruges's appeal was heightened by Duke Philip the Good's temporary relaxation of the settlement taxes for new citizens in the years 1441-1444. That period consequently saw a sharp rise in the immigration of qualified craftsmen to Bruges: more than 400 a year as against an average of 79 in the previous four years.[15] Interestingly, too, the city attracted a relatively large number of artists from far afield. Between one-third and half of the 15th-century immigrants came from outside Flanders or from

fig. 76 Hans Memlinc, *Portrait of an unknown man*, c. 1485; oil on panel, 30.1 x 22.3 cm. The Hague, Mauritshuis (cat. no. 595)

beyond a 50-kilometre radius around the city. That percentage is in stark contrast to the migration pattern for a city like Oudenaarde, where an average 11% of the new citizens in the 15th century came from more than 50 kilometres away.

In the 16th century it was Antwerp that was the lodestone for artists of all kinds. The number of silversmiths is well documented. In the period 1500-1585 there were 725 silversmiths working in Antwerp—137 of them from elsewhere in the Netherlands, 35 from Germany, seven from Paris, four from London, and one each from Spain, Portugal and Constantinople.[16]

There are no accurate migration figures for the northern Netherlands, but it can be inferred from individual cases that here too the larger cities drew talented artists from the surrounding region. There was a well-marked cultural exchange, for instance, in an west-east direction between Holland, Utrecht and Gelderland on the one hand, and the Rhineland (bishopric of Cologne) and

fig. 77 St John's Cathedral, Den Bosch (east front, with choir chapels), 1974.
Photograph: Rijksdienst voor de Monumentenzorg, Zeist

Westphalia (bishopric of Münster) on the other. For example, it is clear from his surname that the Utrecht wood-carver Adriaen van Wesel had his roots in the Lower Rhine area. The carver Master Arnt, from Kalkar, settled in Zwolle in 1484. Perhaps all the larger commissions for retables had already been awarded, and the wood-carver hoped that by moving to a town with little competition he would be able to open up a new market.

In the 16th century, too, some of the immigrants came from beyond the Netherlands. Memlinc has already been mentioned, and another example is the painter Michael Sittow from Reval on the Baltic coast. He moved to Mechelen in 1515, possibly enticed by the opportunities to be found at the court of Regentess Margaret. Sittow's name later crops up in Spain. He was, incidentally, the stepson of the Holland stained-glass painter Diederik van Katwijk who worked in Reval, which may have fired his love of travel.[17]

One far-reaching effect of this artistic migration was the arrival in Antwerp of several Italian majolica makers at the beginning of the 16th century. Guido da Savino of Castel Durante settled in the city before 1510, and a few years later there were two more Italians working in this branch of the decorative arts. They brought with them high-grade artistic and technological expertise in the production of luxury ceramics, thus laying the basis for a flourishing Antwerp majolica industry in the second half of the century.[18]

The final group of mobile artists comprised the master-builders, stonemasons, sculptors and mural painters who travelled from one construction project to another. They were generally hired by the architects of large, public buildings like churches and town halls, and sidestepped the guild regulations because of their nomadic existence. Some of the master-builders worked on more than one job at a time. Godijn van Dormael, who was appointed architect of Utrecht Cathedral in 1359, occupied the same position at the cathedral in Liège. Willem van Kessel, master-builder at Liège in a later generation, was also involved in the construction of St John's Cathedral in Den Bosch (fig. 77).[19] On top of that, many master-builders also worked as sculptors and stone-merchants. These functions were interwoven through several generations of the well-known Brabant family of Van Mansdale, also known as Keldermans.[20]

STATUS AND SOCIAL POSITION

The way in which Dürer was welcomed into Antwerp in 1521 is clear evidence of his immense status as an artist. By far the majority of artists in Netherlandish cities did not stand out from other specialised craftsmen, and often belonged to the same urban corporation as practitioners of other crafts. In the guilds one finds masons together with sculptors, cabinetmakers with wood-carvers, fine-art painters with saddlers or mirror-makers. Nor were there

fig. 78 Jan van Eyck, *Giovanni Arnolfini and his wife*, 1434; oil on panel, 81.8 x 59.7 cm. London, The National Gallery. Reproduced by courtesy of the Trustees, The National Gallery, London

any great variations in their wages that would indicate that artists occupied a special social position.

That there was nevertheless a growing self-awareness among artists in the 15th and 16th centuries emerges from the growing number of works of art bearing a signature or house mark. The classic example of this realisation of one's own worth is of course the 'Johannes de eyck fuit hic 1434' on the Arnolfini portrait (fig. 78), but Jan van Eyck was court painter to the Duke of Burgundy, and was regarded as one of the leading artists of his age. Incidentally, there is a much earlier signature in Netherlandish art—on a 14th-century piece of precious metalwork from Utrecht. In 1362, the goldsmith Elyas Scerpswert added a Latin inscription containing his name to a silver-gilt reliquary of St Frederick that he had made for the chapterhouse of the Old Minster in Utrecht [1]. Scerpswert was probably the most important goldsmith of his day in the

fig. 79 Jan Borman the Younger and assistants, *Passion altarpiece* (detail with Borman's signature), c. 1520. Güstrow, parish church. Photograph: Klaus G. Beyer, Weimar

fig. 80 Israhel van Meckenem, *Ornament print with a courting couple*, c. 1490; engraving, 161 x 238 mm. Amsterdam, Rijksmuseum, Rijksprentenkabinet

cathedral city, and also carried out commissions for courts outside Utrecht. In addition, he held the civic posts of 'legal arbitrator and charter-master—another sign of his status.²¹

It was not yet commonplace for northern artists to sign their works in the late middle ages, in contrast to the practice in Italy, where signatures were far more frequent—on paintings at least. Yet at the end of the 15th century there are enough striking exceptions, such as Jan van Steffeswert of Maastricht, who was the only Mosan wood-carver to sign his statues, or Jan Borman or Borreman of Brussels, who spread his signature over several figures in his large *St George retable (fig. 79)*. It was roundly said of the latter 'that he is the best master-carver'.²² Should his signature therefore be seen as a proud proclamation of his artistic reputation?

The addition of the maker's monogram was already customary in late Gothic printmaking by the end of the 15th century. Israhel van Meckenem in Bocholt *(fig. 80)* and Master IAM in Zwolle [17] provide good examples of this. One contributory factor may have been that the efficient dissemination of prints enabled a printmaker to establish a reputation very quickly. Tapestry weavers also put their names on products from their workshop. Pieter van Edingen, also known as Van Aelst, signed and dated his *Carrying of the Cross* tapestry for Margaret of Austria (Palacio Real, Madrid) as subtly as his fellow townsman, the carver Jan Borreman, did on his *St George retable*: on the hem of Simon of Cyrene's cloak is the word AELST, and on the collar of a horn player is the date 1507.²³ Such signatures can undoubtedly be read as expressions of professional

pride (Pieter van Aelst was also gentleman of the chamber to Philip the Handsome from 1502) although marketing considerations also played a part. A signature was an implicit mark of distinction in a crowded market, and was at the same time a sort of guarantee of quality for the buyer, comparable to the assay marks on silver or pewter, or the city marks branded into wooden statues. In order to counter fraud, Brussels passed a law in 1528 stipulating that the weaver's monogram had to be incorporated in tapestries woven locally.

Art contributed not only to the economy of a city but also to its status as an artistic centre and to the cultural self-assurance of its citizens. The fact that Guicciardini lists the names of so many artists (mainly those working in Antwerp) is an indication of the economic importance and status of this industrial sector.²⁴

The presence of talented artists was considered important at court. They were usually members of the household, and enhanced the status and splendour of the court with their fame and work. Artists, in their turn, generally found it highly advantageous and prestigious to be in a prince's employ. They were paid a fixed salary, received special allowances and gifts, enjoyed privileges, and were no longer subject to civic or guild regulations. One artist who enjoyed such favours was Jan van Eyck, who worked from 1422 to 1425 in The Hague as painter and *valet de chambre* to John of Bavaria, Count of Zeeland, Holland and Hainault. It seems that he found a new master in 1425, going by the evidence of a salary payment from Philip the Good, Duke of Burgundy. The latter paid his moving

expenses, sent him on secret diplomatic missions, gave him six silver beakers on the birth of a child, and granted him a pension for life. When the pension was not paid in 1435, Van Eyck threatened to relinquish his position at court, whereupon the duke intervened in person, 'for we wish to retain him for certain great works with which we will charge him in future, and it would be very difficult to find an equal to our liking who is so accomplished in his art and knowledge'.

For the artists themselves, employment at court naturally enhanced their status. Princely patronage generally offered good career prospects (many artists becoming *valets de chambre*) and distinguished commissions, which could in turn lead to prestigious orders from the civic authorities. In the best possible case there was a kind of competitive patronage between rulers, or between the courts and the cities, the main beneficiary being the artist. Court artists were granted all sorts of privileges, such as meals, a clothing allowance, a house, travel expenses or medical care.[25] Finally, they were usually much better paid than their colleagues in the cities. Philip the Bold, for instance, gave Claus Sluter a daily wage five times that of a skilled Flemish craftsman.[26]

THE GUILDS OF ST LUKE
One clear sign of the professionalisation of artists and their awareness of their status as practitioners of a distinct craft was the

formation of guilds—civic corporations for the craft in question. The earliest ones were not very specific, membership being open to craftsmen of very different kinds. As early as 1300 there was one such corporation in Utrecht that united painters, sculptors, saddlers, pattern painters, illuminators, scabbard-makers and tripe-workers.[27] From 1367, the Dordrecht painters and sculptors had shared their guild with belt-makers, glass-blowers, silversmiths and pewterers. One century later the composition of the guild had changed considerably: painters, glass-blowers, embroiderers, pewterers, potters and lantern-makers. It was not until 1642 that the painters removed themselves from this late-medieval constellation and went their own way.[28] This evolution from 'collective' guilds to more specialist corporations began in the 14th century, although it proceeded at very different rates in the various cities. The process should not automatically be equated with a form of emancipation of artists from their craft origins. In Haarlem, for example, it was not the painters who were the most vociferous group in the guild, but the silversmiths, pewterers, plumbers, coppersmiths and glass-blowers.[29]

The artists' guilds were dedicated to the evangelist Luke, who according to the early Christian tradition had painted the Virgin's portrait, making him the patron saint of painters. The earliest Netherlandish guilds of St Luke were in Ghent (1338), Bruges (1358) and Louvain (1360). The guild's standing was expressed mainly in

fig. 81 Maarten van Heemskerck,
St Luke painting the Virgin,
1532; oil on panel, 168 x 235 cm.
Haarlem, Frans Halsmuseum (cat. no. 150)

the adornment and upkeep of its altar in the city's principal church. Naturally enough, the altar was dedicated to St Luke, who was depicted on the altarpiece in his most appropriate role—painting the Virgin and Child. Maarten van Heemskerck made one such scene in 1532, before leaving Haarlem for Rome, probably as a departing gift for his colleagues in the guild. It hung in the city's Church of St Bavo until the Reformation (fig. 81). The guild's prestige was also manifested in all sorts of outward marks, such as the silver insignia worn by the guild officials on feast days, many of which were decorated with St Luke's attribute of the lion.

Most of the guilds had no political power, with the exception of the one in Dordrecht, which had representatives on the city council. The guilds accordingly owed their *raison d'être* to their own objectives: the guarantee of good professional training, supervision of product quality, and the promotion of the social well-being of their members. In fact, the guild's main goal was to preserve a craft monopoly within the city walls. Social provisions for the craft included burying dead members and giving financial support to the poor and the sick.

The preservation of a craft monopoly often led to protectionist measures that severely restricted the immigration of craftsmen from other cities, as well as curtailing the trade in products made elsewhere. It also led to a degree of uniformity in local art production. This is well illustrated by the 1514 charter of the Haarlem Guild of St Luke, which decreed that guild members had to be registered burgesses of the city if they wanted to practise one of the crafts there. Moreover, they were then required to become members of the guild and to pay the admission fee. 'Thus no one within the city of Haarlem shall practise the craft of painter, image-carver, goldsmith, glass-blower, embroiderer, jug-maker, tinker, pewterer or brass-founder, or have any connection with the said crafts without first becoming a burgess'. Additionally, only guild members were allowed to sell their wares in the city, either at the markets or in any other way, the free annual and weekly fairs excluded. 'Thus no one shall display paintings or carved images in the aforesaid city, apart from at the annual fair, unless they be brothers in the guild. Nor shall vendors of used goods or anyone else within this city buy or sell any of the goods of the above crafts without being members of the guild'.[30] Similar measures were adopted in all the large and medium-sized cities in the Netherlands, although some, led by Antwerp, adopted a more flexible policy towards craftsmen and goods from beyond their walls.

Since the larger, labour-intensive commissions often involved several crafts, there were regular demarcation disputes. This, too, occasionally led to measures designed to protect one craft from others. In 1476, the fine-art painters in Brussels, for example, prohibited tapestry-makers from drawing their own cartoons, and

in Bruges they prevented manuscript illuminators from dealing in individual miniatures. Similarly, binding agreements were made in both Middelburg and Utrecht around 1550 regarding the carved decoration on furniture. The carvers of small adornments in relief fell under the joiners' guild, while the makers of large, free-standing statues enjoyed the protection of St Luke.[31]

When conflicts arose, officials examined the regulations applying elsewhere. In 1478, for instance, the Antwerp city magistrate ordered a comparative study of the jurisprudence covering a conflict between wood-carvers and joiners in Louvain, Brussels and Den Bosch.[32] In 1524 and 1528 there were disputes in Breda between the joiners' guild and the churchwardens of the Church of Our Lady over the freedom of the patron, in this case the church authorities, to continue employing a young wood-carver who had not yet submitted his masterpiece for adjudication. The guild lost this particular case. The carver in question, Meeus de Wilde, retained his commission, which was to execute and oversee the sculptural decoration in the church, and he was also permitted to take on other artists and craftsmen who, like him, were not yet fully fledged masters.[33] This was not an isolated instance, for elsewhere one also finds examples of a gradual erosion of the guilds' iron rule. The guilds closely supervised the training of new craftsmen, thus restricting outside interference and ensuring a steady flow of fresh talent from within their own ranks. The sons of guild members paid lower tuition fees to the guild. The apprenticeship usually began with a trial period of several weeks to check that the budding apprentice was actually suited to his chosen

fig. 82 The Hague, c. 1680. Set of touch-needles and touchstone for assaying silver content. The Hague, Haags Gemeentemuseum (inv. no. EM 130 zj)

craft. If he passed this test he was enrolled in the guild ledger and entered on his apprenticeship proper. The guild also imposed limits on the number of pupils a master could have on his books at any one time, thereby ensuring an even spread. According to the Haarlem guild charter of 1514, a master-painter could teach no more than three pupils at once, sculptors, goldsmiths and glassmakers a maximum of two, and embroiderers only one. The length of the apprenticeship was also fixed, although it varied greatly from city to city and from generation to the next. It lasted six years in Cologne at the end of the 14th century, but only two in Bruges in 1450. From 1514, fine-art apprentices in Haarlem were taught for three years.[34] The pupil lived all that time in his master's house, who received payment for board and lodging. After completing his apprenticeship the pupil became a journeyman, and often went on a study trip to round of his training. He travelled from workshop to workshop to gain experience and build up contacts in different cities and regions. The Haarlem guild charter stipulated that such journeymen 'who come from beyond the walls to work in the aforesaid city for longer than 14 days' had to pay a contribution for the upkeep of the guild altar. A journeyman who wanted to settle in a city first had to submit his masterpiece in accordance with the rules of the local guild. The Amsterdam Guild of St Joseph, to which the cabinetmakers belonged, specified in 1524 that the masterpieces were to be 'een half thiencant trysoir' (a five-sided dresser) and a square table.

The quality of works of art, in both the artistic and material senses, was guaranteed in some cases by hallmarks, which were stamped on by special assay-masters acting on the guild's behalf. This was first done for silverware, where there was an obvious demand for quality control, for it was easy and lucrative to tamper with the silver content. The earliest Netherlandish ordinance relating to the marking of silver comes from Utrecht in 1382, but the practice was probably already being followed elsewhere in the Low Countries. A piece of silver from Dordrecht bears the date mark for 1401.

The local charter regulations in Holland and Zeeland were superseded in 1489 by a decree of Emperor Maximilian I, regent during the minority of his son Philip the Handsome. It stipulated that all the cities in the two counties had to guarantee the silver content of all objects manufactured there by stamping them with the city's coat of arms. Similar regulations sometimes applied elsewhere, but they were by no means so consistent.[35]

Assaying silver was done primarily for material reasons, for it offered the buyer an assurance as to the content of the metal. The silversmith had to submit his products to the assay-master, who then checked the fineness of the silver using a touch-needle and touchstone (fig. 82).

The practice of branding assay marks on 15th and 16th-century wood carvings in the southern Netherlands is related, but not identical to the silver hallmarks. The earliest brands were introduced in Brussels in 1454 to settle a local dispute between wood-carvers and painters. The latter wanted exclusive marketing rights for polychromed altarpieces, with the result that the carvers were constantly being downgraded to the level of subcontractors or suppliers. Eventually an arrangement was reached whereby the carvers were also allowed to sell painted retables, and so could also subcontract painters.[36] In order to provide an assurance for both parties, and for purchasers, marks were branded on that guaranteed the quality of both the carving and the polychromy. A small hammer mark was used for the carving, and the word BRUESEL in a cartouche for the polychrome work.[37] The corresponding marks in Antwerp were a hand and a castle. Mechelen, the third city where such marks were used, chose three posts for the carving and an M for the polychromy. The painters of Mechelen regularly placed their house marks on the painted decoration as well. The fact that no hallmarks are known for other cities does not necessarily mean that assays were not carried out. In Tournai, for example, an official quality assay was carried out by a commission of guild members, and the artist was fined if his work failed to pass the test. Additionally, the buyer could always ask for a second, expert opinion. The right to such an assay was often stipulated in advance in the contract, together with the amount the artist would be fined if his work was sub-standard.[38] This kind of monitoring was probably widespread in the late middle ages, particularly in towns where there was no effective guild supervision.

PATRONS, COMMISSIONS AND CONTRACTS

Population growth in the county of Holland in the late middle ages resulted in a sharp shift from the countryside to the towns. Around 1250, only 10% of the inhabitants of Holland (estimated to have totalled 200,000) lived in the towns, but by 1450 there was the very different picture of roughly 125,000 urban dwellers out of a total population of 260,000. One consequence of this urbanisation was a steep rise in the urban consumption of art. City-dwellers began taking a growing interest in art towards the end of the middle ages, and this in turn led to the appearance of a free art market.

The increase in the lay contribution to art patronage did not mean that art took on a more secular character. Even luxury household goods were often decorated with a religious scene [25]. Much of the output of medieval art, however, did not find its way into private homes, but into churches. Anyone explaining the ornate decoration of most churches before the Reformation is well aware of the importance of ecclesiastical patronage. Within the urban community, the parish church was a public space where civic organisations and private individuals of every kind used works of

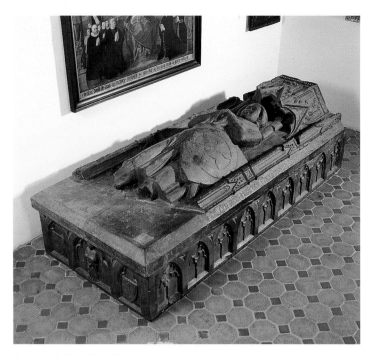

fig. 83 *Tomb of Arnold van der Sluis*, c. 1320; stone, 323 × 123 cm.
Utrecht, Rijksmuseum Het Catharijneconvent; on loan from
the Rijksmuseum, Amsterdam (inv. no. BK-NM-8657)

art to present themselves in the best light. Alongside the church
authorities, the priests and churchwardens responsible for the
furnishings—liturgical objects, vestments and the decking of the
high altar—there were confraternities and guilds which founded,
adorned and maintained their own altars. St Bavo's in Haarlem had
no fewer than 33 altars before the Reformation, all of them adorned
with painted or sculpted altarpieces, or both. Only three of the
painted altarpieces have survived. The Church of St Leonard in the
Flemish town of Zoutleeuw had nine polychromed retables as well
as several plain ones, according to a bill for cleaning them that was
submitted in 1548.[39] According to a recent estimate covering the
parish churches in the larger cities of Holland, there was one altar
for every 120 inhabitants.

The private initiative of the nobility, clergy and wealthy
citizenry in the churches was predominantly posthumous. Private
individuals liked to be buried *ad sanctos*, in other words close to the
high altar, and had their graves marked with sculpted tombstones,
tombs or painted memorial tablets (*fig. 83*). The latter depict the
donor himself in a pious pose, sometimes accompanied by his
family, together with an appropriate Christian scene (*fig. 84*).
Furnishing churches with pulpits, choir screens and stalls, lecterns,

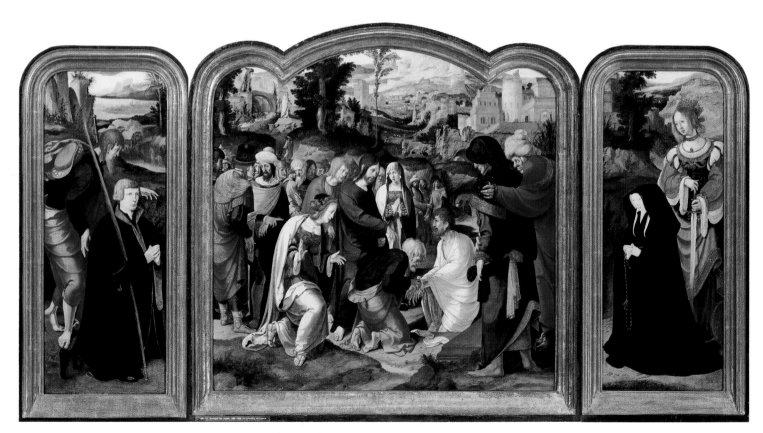

fig. 84 Master of the Kanis Triptych, *Triptych with the raising of Lazarus, with the donors and Sts James and Catherine on the wings*, c. 1520; oil on panel,
central panel 75.5 × 78.5 cm, wings 70 × 28 cm. Amsterdam, Rijksmuseum (inv. no. A-3480 [central panel]), A-4571a/b [wings]

fig. 87 Herbert Happensoon, *Monstrance*, c. 1490; parcel-gilt silver, h 99.5 cm. Uden, Museum voor Religieuze Kunst

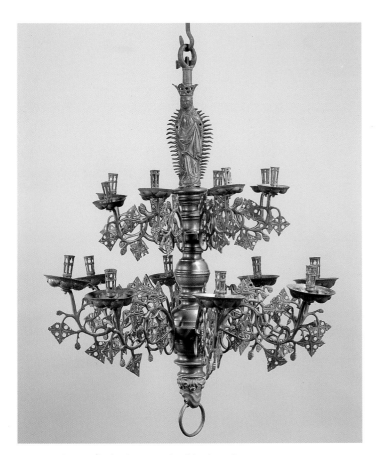

fig. 85 Southern Netherlands, c. 1540, *Chandelier*, brass, h 117 cm. Amsterdam, Rijksmuseum (inv. no. BK-NM-9698)

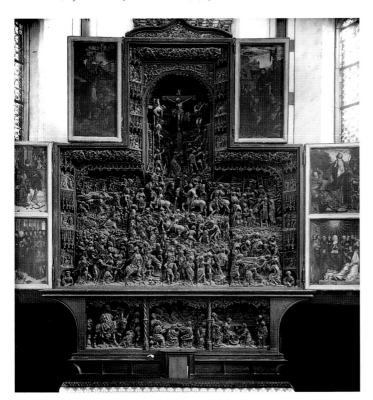

fig. 86 Master Arnt of Kalkar, *High altarpiece*. Kalkar, Sint-Nicolaïkerk. Photograph: Rheinisches Bildarchiv, Cologne

fonts, candlesticks, chandeliers (fig. 85) and antependia often required major investments, and provided work for artists. An appeal was also made to craftsmen for the furnishing of monasteries, hospitals, episcopal palaces and town halls. The following are a few examples of the various ways these works of art were bought or commissioned.

When the Confraternity of Our Lady at Kalkar decided around 1488 to replace its old retable in the Church of St Nicholas with a prestigious and modern altarpiece, it did not rush out and buy the first one it found. It appointed a committee consisting of the burgomaster, the priest and a provisor from the confraternity to prepare for the commission. There were two key considerations: the form of the altarpiece and the artist. The committee set about its work very conscientiously, its members personally inspecting an altarpiece in Wesel and dispatching a draughtsman to Den Bosch to study and draw the large *Altarpiece of the Virgin* by Adriaen van Wesel, which was evidently already very celebrated, 12 years after its completion. Altarpieces in Zutphen and Deventer were also inspected. Although none of those retables has survived intact, the end result of this comparative survey can still be seen. The commission was awarded to the Kalkar carver Master Arnt, who was working in Zwolle at the time. He made the high altarpiece for Kalkar, which still exists and can easily bear comparison with the work of his contemporaries (fig. 86).[40] This painstaking approach was fairly exceptional. Patrons usually commissioned a work of art without going to such exhaustive lengths, and probably often chose a local artist, either on someone's recommendation or because his work was known. Large or costly commissions of this

kind involved a contract which set out the obligations of both parties. The earliest such contracts date from the end of the 13th century, but the first known one in Dutch was not drawn up until the early 15th century.[41]

One example of a contract of this kind was between the churchwardens of Oss and the silversmith Herbert Happensoon of Den Bosch in 1491 for delivery of a silver monstrance (fig. 87). The patrons required it to be modelled on a monstrance that Happensoon had earlier made for a guild in Den Bosch, but on a slightly smaller scale.[42] The contract also specified the weight, the silversmith's wages, the quality of the silver and the delivery date. Both parties also agreed that the churchwardens would supply the silver themselves. Such provisions recur time and again in contracts like this, regardless of the nature of the commission. The artist often received an advance, with the rest of his fee paid in instalments. The form of transport, delivery and installation were also laid down, the delivery date preferably falling on an appropriate feast day.

The procedures for ordering ecclesiastical textiles seem to have been more informal, despite the fact that they too involved formidable investments. The church at Zoutleeuw still has a large collection of medieval textiles, as well as many of the associated financial accounts detailing how items were ordered. It turns out that the churchwardens usually commissioned the embroidery from specialist embroiderers and hatters in large cities like Louvain, Brussels, Mechelen and Antwerp. Occasionally an embroiderer was summoned to Zoutleeuw at the churchwardens' expense to discuss a purchase and to display samples. In a few cases only the basic materials were bought: damask, silk, gold thread and thread. The embroidery was then sewn onto the copes and chasubles by seamstresses in the parish. Surprisingly enough, one of the most expensive purchases, of two, blue damask copes costing 54 Rhenish guilders, appears to have been bought on impulse by the churchwardens while on a visit to the Antwerp market in 1482.[43]

The high nobility was (and remained) an important group of patrons and purchasers of art, with the Burgundian court and later the house of Habsburg as the principal customers. The surviving accounts of the court at The Hague under Albrecht of Bavaria give a good picture of the acquisition of art by the high nobility in the Low Countries. The court spent vast sums on jewelry, clothing and luxury household items, largely for its own use. Some objects were bought during the progresses between the various castles in Holland, Zeeland and Hainault, but the duke placed most of his orders with craftsmen in the largest cities of Holland: Dordrecht, Delft and Haarlem. It was probably the silversmiths who profited most from court patronage. Jewelry and costly vessels not only glorified the duke's prestige, but were also a safe form of investment. The Delft goldsmith Jan de Lawe was an important

fig. 88 Petrus Christus, *A goldsmith in his workshop* (possibly St Eloy, patron saint of goldsmiths), 1449; oil on panel, 100.1 x 85.8 cm. New York,
The Metropolitan Museum of Art, Robert Lehman Collection, 1975 (inv. no. 1975.1.110).
Photograph © 1993 The Metropolitan Museum of Art

purveyor of jewelry, as was Jacob van Oudewater of Dordrecht, who supplied 'a blood-coral paternoster'.

One such coral rosary can be seen in a silversmith's shop painted by Petrus Christus in 1449 (fig. 88). Although this is not a genre scene, but far more a picture of St Eloy (patron saint of silversmiths) in the guise of a 15th-century smith, the painting is a good if slightly exaggerated illustration of the consumption of art in the highest circles. A lavishly attired couple are on the point of buying engagement rings against the backdrop of a very genteel jeweller's shop. The display in the background is fascinating. It appears to be intended as a sample of what the smith was able to supply, with the emphasis on secular items. There are both unworked materials—coral, pearls, porphyry and crystal—and finished pieces: mounted vessels of coconut and crystal, brooches, a box of rings, pendants of fossil sharks' teeth (known as serpent-tongues) and presentation flagons.

Duke Albrecht bought some of his furniture in Dordrecht, including chairs and tables for the court chapel, and even a complete rood screen. Occasionally the court ordered products from outside the region, such as diamonds from Bruges and gold belts from Paris. At the same time, international merchants also provided a steady supply of luxury goods for the court. In 1375, during a stay in Hainault, a quantity of pearls was bought from an itinerant Venetian merchant. The duke bought surprisingly little in The Hague. Despite the presence of the court, the city evidently did not have such differentiated groups of craftsmen as the larger cities. What Albrecht did do was attract foreign artists, such as the master-carver Jan de Beyer ('John of Bavaria') and the painter Jacob van Muneken ('Jacob of Munich'), whose names betrayed their German origins. Given the duke's Bavarian background it is hardly odd that he should employ the services of southern German court artists.

The accounts contain not a single mention of tapestries, which were such an integral part of the luxurious decor at court, They are, however, found in large numbers in the art collections of the Habsburgs, who ruled over the Burgundian Netherlands from 1477. Margaret of Austria was a fanatical collector, and bought her tapestries in various Flemish towns. Her collection passed to Emperor Charles V, who often moved from one residence to the next, taking many of his tapestries with him. A 1544 inventory of these 'travelling tapestries' lists 15 series comprising a total of 96 pieces, including the *Los honores* suite made for his coronation (fig. 89). The emperor bought many of his tapestries through his sister, Mary of Hungary, who governed the Netherlands in his name. Her own collection numbered 38 series at her death—a total of no fewer than 244 tapestries.

fig. 90 Antwerp, c. 1550, *Tile with the arms of Abbot Rekamp*; tin-glazed earthenware ('Antwerp majolica'), 17 × 16.5 cm. Groningen, Groninger Museum (inv. no. 529). Photograph: John Stoel

Finally, there is the small but fashionable commission from Abbot Rekamp of the Cistercian abbey at Aduard in Groningen, who in 1547 ordered two glazed tiles bearing his coat of arms and that of his order (fig. 90). They were kept in the abbey's *refugium* in the city of Groningen. With total disregard for the order's traditional vows of poverty, the abbot chose the very colourful, exclusive and modern medium of majolica from Antwerp. It is unclear how the order was placed, but since they are such exclusive pieces there must have been direct contact between the abbot and the majolica workshop, which may have been the one run by the Italian Guido Andries. This particular transaction illustrates the wide distribution of such luxury items.

THE FREE TRADE IN ART

Entirely new sales practices for art developed in the southern Netherlands in the course of the 15th century, some instances of which have been touched on above. Antwerp took the lead in establishing the free market, opening Our Lady's Gallery in 1460, which has been described as 'the first showroom [...] for the exhibition and sale of works of art'.[44] However, there are even earlier indications that a lively free trade in art was evolving at the city's annual fairs. Around 1435 the following passage was written in the Life of St Lidwina of Schiedam, describing an event that

fig. 89 Workshop of Pieter Coecke van Aelst, *Fortuna*, c. 1525; tapestry from the *Los honores* suite, gold, silver, silk and wool, 490 × 860 cm. Segovia, Museo de Tapices (inv. no. PN.S.8/5)

supposedly took place in 1380: 'a carver passed through Schiedam with a statue of Our Lady that he had made, wishing to take it to Antwerp to sell at the market there'.[45] There is a record of 1411 in Delft of an artist on his way to the annual fairs in Antwerp and Bruges to sell a *Pietà*.[46] The Antwerp fairs were held twice a year, the 'Sinxenmarkt' shortly before Whitsun, and the 'Bamismarkt' or St Bavo Market from the middle of August. They lasted six weeks each, and attracted many dealers from outside the city eager to profit from the temporary suspension of the usual guild rules. The articles were displayed on rented stalls that were grouped by category. These bi-annual events took on a more permanent character as the 15th century progressed. Concentrations of specialist dealers sprang up, and were housed in 'panden', or galleries. The Dominican gallery was founded in 1445, and sold all sorts of luxury goods: paintings, statues, jewelry, tapestries, textiles and knives. This initiative was followed in 1460 with the foundation of Our Lady's Gallery, which was in a custom-made building and was administered by the Church of Our Lady, the present-day cathedral. It later became the centre of the Antwerp art trade, and eventually Europe's leading art market.

What effect did all this have on the production of art? It can be inferred from all these developments that the traditional picture of 'art to order' was changing. An artist did not necessarily wait for customers to come to him but went out looking for them. That did not mean, however, that there was any standardisation of forms or scenes. The nature of the art works was not very specific, for that would have made them more difficult to sell. There were obviously no personal allusions in the paintings, nor any unusual or rare iconographies. In short, artists who produced for the open market no longer supplied work tailor-made, but ready-made for anonymous buyers. At most, the purchaser could ask for minor modifications, such as the addition of a portrait or a coat of arms.

Some branches of art in the late middle ages warrant the term 'industry', in the sense that works were made on a production line basis for an anonymous market that was not always close at hand. In addition, there was some division of labour.[47] Surprisingly, this art industry did not just produce easily made, portable (fairly small) and inexpensive objects. Even tapestries, ornately carved and painted altarpieces and precious metalwork were made 'on spec'—in Flanders and Brabant, at least. Tapestries were bought by the metre (particularly the so-called *verdures*) or from a limited range of subjects that the tapestry weaver had in stock. Specially designed pieces were rare, and were almost always commissioned by princely patrons.

Precious metalwork in Antwerp was sold in the metalsmiths' shops, which were clustered together in the city's busiest streets. Jewelry stalls could be found in the Predikherenpand (or Jewellers' Gallery), and often had a wide range of stock, as demonstrated by

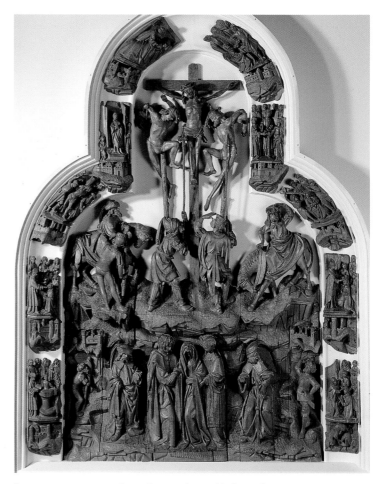

fig. 91 Antwerp, c. 1520, sculpture from an altar retable; h 182.5 b 142 cm. Amsterdam, Rijksmuseum. (inv. no. BK-16082)

the estate inventory of Laureys de Groot. In 1574, this silversmith and dealer left not only raw silver but also 93 large objects with a total silver weight of approximately 13½ kilograms.[48]

Standardised production also demanded a more effective organisation of the manufacturing process. The Brussels and Antwerp workshops that made carved altar retables (fig. 91) applied an extensive division of labour, or even subcontracted part of the work to outside, specialist shops. It seems that some of those in Antwerp did nothing but make carved friezes or altarpiece predellas.[49]

Another outcome of this new, rational manner of production for the free market was the rise of middlemen who had nothing to do with the creative side. They took over part of the role of the small, traditionally organised craftsman who was both contractor and artist. One of these new-style entrepreneurs was Diederic Proudekin, who acted as an agent for dealers in Spain, Italy, France, Germany, England and Scotland, and also had several Antwerp wood-carvers under contract.[50]

fig. 92 Utrecht, c. 1450, mould for a statuette of the Virgin; pipe-clay, h 28 cm. Amsterdam, Rijksmuseum (inv. no. BK-KOG-585)

fig. 93 Master IL with the Skull, *The seven sorrows of the Virgin*, 1511; engraving, 13,9 × 9,4 cm. Amsterdam, Rijksmuseum, Rijksprentenkabinet (inv. no. RP-P-OB-2124)

The free market had extended beyond the home base, with art increasingly being made for export and the overseas trade. Many Antwerp and Brussels altar retables, as well as domestic altars from Mechelen, ended up in Scandinavia, where they can still be seen *in situ*. Spain, Portugal, Germany, Poland and France were also major export markets for this form of art. Almost every merchant ship sailing from the port of Antwerp in the years 1553-1554 had a sculpted retable in its cargo.

The open art market also gave rise to the mass production of devotional art for broad sectors of the public: pipe-clay images of saints made in moulds (fig. 92), lead pilgrims' badges, and woodcuts printed on paper. Large numbers of the first two groups have been discovered by archaeologists, and give a good picture of the variety of products available on the late-medieval market. Although the bulk of the output of pipe-clay sculpture must have consisted of series of small figures, the 'image-printers' or 'image-bakers' also made larger, more ambitious figured groups that were then polychromed and assembled into complete retables. Several examples have survived in northern France, Spain, Denmark and

elsewhere. They were probably a cheap alternative to the carved wooden altarpieces.[51]

Very few examples of the woodcuts and engravings have survived, which is not surprising, since they are so easily damaged. They would, though, have been produced in large editions, for it is estimated that between two and three hundred impression could be made from a wooden block, and far more from copperplates. Around 1506-1507, for instance, the churchwardens of Delft's Old Church sent off for 1,100 prints of an engraving of the Seven Sorrows of the Virgin, and followed this up in 1510 and 1514 with a few smaller orders. In total, some 2,650 prints of this type were probably printed (fig. 93).[52] The demand for such cheap devotional items was connected with the explosive growth of lay piety in the late middle ages, which was experienced in the confraternities or on pilgrimage and was fostered by reform movements like the Devotio Moderna.

NOTES

1 J.C. Hutchison, *Albrecht Dürer, a biography*, Princeton 1990, pp. 127-46.

2 P. Burke, *Antwerp: a metropolis in comparative perspective*, Antwerp 1993, p. 12.

3 J. van der Stock (ed.), exhib. cat., *Antwerp: story of a metropolis*, Antwerp (Hessenhuis) & Ghent 1993, pp. 20-21.

4 Ibid., pp. 105-06.

5 G. van Hemeldonk, exhib. cat. *Zilver uit de Gouden eeuw van Antwerpen*, Antwerp (Rockoxhuis) 1988-89, p. 31.

6 W.H. Vroom 'Een retabelcontract uit 1493', *Miscellanea I.Q. van Regteren Altena*, Amsterdam 1969, pp. 27-31.

7 B. Dubbe & W. Vroom, 'Mecenaat en kunstmarkt in de Nederlanden gedurende de zestiende eeuw', J.P. Filedt Kok et al., exhib. cat., *Kunst voor de beeldenstorm: Noordnederlandse kunst 1525-1580*, Amsterdam (Rijksmuseum) 1986, pp. 13-37, esp. p. 21; W. Brulez, *Cultuur en getal: aspecten van de relatie economie-maatschappij-cultuur in Europa tussen 1400 en 1800*, Amsterdam 1986, pp. 40-41.

8 D.E.H. de Boer, 'Tussen Jacob van Minniken en Jorijs de beeldsnijder: de Hollandse beeldhouwkunst omstreeks 1400', *Nederlands Kunsthistorisch Jaarboek* 45 (1994), pp. 140-58, esp. pp. 142-43.

9 D. de Vos, 'Brugge en de Vlaamse primitieven in Europa', V. Vermeersch (ed.), *Brugge en Europa*, Antwerp 1992, pp. 319-38, esp. p. 324.

10 M. Lindgren et al., *A history of Swedish art*, Uddevalla 1987, p. 106.

11 J. von Bonsdorff, *Kunstproduktion und Kunstverbreitung im. Ostseeraum des Spätmittelalters*, Helsinki 1993 (*Finska Fornminnesföreningens Tidskrift* 99), p. 47.

12 K. Morand, *Claus Sluter: artist at the court of Burgundy*, London 1991.

13 M. Baxandall, *Painting and experience in fifteenth century Italy*, Oxford 1980, pp. 248-51.

14 M.P.J. Martens, 'Bruges during Petrus Christus's lifetime', M. Ainsworth & M.P.J. Martens, exhib. cat. *Petrus Christus: Renaissance master of Bruges* New York (Metropolitan Museum of Art) 1994, pp. 3-13, esp. p. 6.

15 W. Blockmans, 'The creative environment: incentives to and functions of Bruges art production', M.W. Ainsworth (ed.), *Petrus Christus in Renaissance Bruges: an interdisciplinary approach*, New York & Turnhout 1995, pp. 11-20, esp. p. 13.

16 Van Hemeldonk, op. cit. (note 5), p. 32.

17 Von Bonsdorff, op. cit. (note 11), p. 10.

18 Exhib. cat., *Antwerps plateel*, Leeuwarden (Fries Museum) 1971, pp. 5-19.

19 H. Janse & R. Meischke et al. (eds.), exhib. cat. *Kelderman: een architectonisch netwerk in de Nederlanden*, Bergen op Zoom (Gemeentemuseum het Markiezenhof) 1987, p. 184.

20 Ibid., passim.

21 L.E. van den Bergh-Hoogterp, *Goud- en zilversmeden te Utrecht in de late middeleeuwen*, 2 vols., The Hague & Maarssen 1990, vol. 2, pp. 594-95: 'vecht ende koermeyster'.

22 C. Engelen, *Zoutleeuw, Jan Mertens en de laatgotiek*, Louvain 1993, p. 262: '[...] dat hy die beste meester beeldsnyder es'.

23 G Delmarcel et al., exhib. cat. *Koninklijke pracht in goud en zijde: Vlaamse wandtapijten van de Spaanse Kroon*, Amsterdam (Nieuwe Kerk) 1993, p. 48.

24 Dubbe & Vroom, op. cit. (note 7), p. 21.

25 M. Warnke, *Hofkünstler: zur Vorgeschichte des modernen Künstlers*, Cologne 1985, pp. 159-69.

26 W. Blockmans & W. Prevenier, *Die burgundischen Niederlande*, Weinheim 1986, p. 338.

27 G.J. Hoogewerff, *De geschiedenis van de St. Lucasgilden in Nederland*, Amsterdam 1947, p. 45.

28 Ibid., p. 50.

29 H. Miedema, *De archiefbescheiden van het St.Lukasgilde te Haarlem*, 2 vols., Alphen aan den Rijn 1980, vol. 1, pp. 1-8.

30 Ibid., vol. 1, pp. 32-35: 'Soe en sal niement binnen der stede van Haerlem Inden ambochte vanden Schilders, beeldesnyers, goudsmeden, glasemakers, borduir-werkers, kannemakers, ketelboeters, pottegieters ofte geelgieters, mogen wesen oft yet doen angaende vanden ambochte voors. hy en sal eirst voer al poerter moeten wesen'; and '[...] soe en sal nyement binnen der stede voirs. mit enich werk van schilderye, beeldesnyders [...] voert moeten doen ten ware vp Iaer marcten ende weeckmarcten, ten ware datse Int gilde waren. [...] Noch dat geen vytdraechsters, noch nyement anders binnen der seluer stede enich van desen goeden aengaende den ambochten voirscreuen te coepen of te vercoepen, sullen mogen, sonder In deze voirscreuen gilde te wesen'.

31 L. Campbell, 'The art market in the Southern Netherlands in the fifteenth century', *The Burlington Magazine* 118 (1976), p. 191; cat. *Catalogus van meubelen en betimmeringen*, Amsterdam (Rijksmuseum) 1952, p. 16.

32 J. van der Stock, 'De organisatie van het beeldsnijders-en schildersatelier te Antwerpen: documenten 1480-1530', H. Nieuwdorp (ed.), *Antwerpse retabels 15de-16de eeuw*, 2 vols., Antwerp 1993, vol. 2 (essays), p. 47.

33 J.H. van Hooydonk, *Graaf Hendrik III van Nassau-Breda en zijn stad 1504-1538*, Breda 1995 (Publikatiereeks Gemeentearchief Breda no. 10), pp. 68, 69.

34 H. Huth, *Künstler und Werkstatt der Spätgotik*, Darmstadt 1967 (reprint Augsburg 1925), p. 10 and note 10; Miedema, op. cit (note 29), p. 33.

35 Exhib. cat., *Nederlands zilver/Dutch silver 1580-1830*, Amsterdam (rijksmuseum) 1979, pp. 38-39.

36 H. Nieuwdorp, 'De oorspronkelijke betekenis en interpretatie van de keurmerken op Brabantse retabels en beeldsnijwerk (15de-begin 16de eeuw)', M. Smeyers (ed.), *Archivum Artis Lovaniense: bijdragen tot de geschiedenis van de kunst der Nederlanden opgedragen aan Prof. Em. Dr. J.K. Steppe*, Louvain 1981, p. 85.

37 E. Vandamme *De polychromie van gotische houtsculptuur in de Zuidelijke Nederlanden: materialen en technieken*, Brussels 1982, pp. 167-78.

38 Ibid., p. 175.

39 Engelen, op. cit (note 22), p. 53.

40 G. de Werd, *Die St. Nicolaikirche zu Kalkar*, Munich & Berlin 1990, p. 13.

41 Vroom, op. cit. (note 6).

42 L. Helmus, 'Drie contracten met zilversmeden', A.M. Koldeweij (ed.) exhib. cat. *In Boscoducis 1450-1629: kunst uit de bourgondische tijd te 's-Hertogenbosch: de cultuur van de late Middeleeuwen en Renaissance: bijdragen*, Den Bosch (Noordbrabants Museum) 1990, pp. 473-81.

43 Engelen, op. cit. (note 22), pp. 207-17.

44 D. Ewing, 'Marketing art in Antwerp, 1460-1560: Our Lady's Pand', *The Art Bulletin* 72 (1990), pp. 558-84.

45 De Boer, op. cit (note 8), pp. 147-48: '[...] quam een beeldemaker te Sciedam met eender beelden van Onser Liever Vrouwen, ende woude dat voeren in die Antworpsche marct om te vercoepen'.

46 Ewing, op. cit. (note 44), p. 560.

47 H. Nieuwdorp in the foreword to C. Perier-D'Ieteren & A. Born (eds.), *Retables en terre cuite des Pays-Bas (XVe-XVIe siècles: étude stylistique et technologique*, Brussels 1992.

48 Van Hemeldonk, op. cit. (note 5), p. 30.

49 L.F. Jacobs, 'The marketing and standardization of South Netherlandish carved altarpieces: limits on the role of the patron', *The Art Bulletin* 71 (1989), pp. 218-19.

50 Van der Stock, op. cit. (note 32), pp. 47-53.

51 Perier-D'Ieteren & Born, op. cit. (note 47).

52 J.M. Montias, *Le marché de l'art aux Pays-Bas, XVe-XVIIe siècles*, Paris 1996, p. 37.

Detail from fig. 81 >

Makers, materials and manufacture

INTRODUCTION

The writings of artists and craftsmen are a vital source for learning about the technical aspects of works of art. Some are merely lists of pigments, others are recipes, but there are also detailed descriptions of the methods to be followed. These texts tell us which materials were used in a particular period, and occasionally when and why they were abandoned.

One of the earliest known technical accounts is a book 'about the secrets of nature', which is attributed to the Greek alchemist Democritus of Abdera. His *Physika kai mystica* contains various recipes for making gold, silver, gems and purple.[1] Pliny's *Natural history*, however, and Vitruvius's books on architecture are of far greater importance for our knowledge of art techniques in classical antiquity.[2] Less well known is a group of texts from Egypt which became dispersed in the 19th century: the *Papyrus Leidensis* and the *Papyrus Holmiensis*, so called after their respective locations in Leiden and Stockholm.[3] Here one finds recipes for making imitation silver and gems, for dyeing textiles, and above all for metal alloys and gold-coloured paint. Some of the recipes look rather complex at first sight, not to say improbable, but in fact many can still be made up today and are highly practical. Interestingly, many of the descriptions in this and other classical sources recur in medieval writings.[4]

MINIATURES

Colour was an important means of expression for the illuminator who painted miniatures in manuscripts, which is why early sources on illumination often contain instructions for combining colours in different ways. Such colour concordances, as they are called, were essential to illuminators, not just because some pigments will not tolerate others, but also because they were handy aides-mémoire.[5] Working with these concordances was part of daily practice in monastery scriptoria, where the overwhelming majority of miniatures were produced from the early middle ages on. It was not until the 15th century that professional illuminators took over part of this work.

The concordances also contained guidelines for suggesting shadows and for making passages of colour advance out of the background. In principle, forms were painted in with a flat base tone and modelled with colours—a process that involved applying several layers of paint, one on top of the other. For each base colour there was a prescribed darker colour to indicate shadows, and a lighter colour to make the passage advance. The term for laying a darker colour over a flat base tone was *incidere*, and *matizare* for applying a lighter, advancing shade.[6]

The use of these concordance guidelines is well illustrated in several miniatures by the 15th-century, northern French miniaturist, Simon Marmion (figs. 94, 95). His materials and method largely correspond to recipes in a late-15th century manuscript by Christian van Varenbraken, who came from the same region as Marmion.[7] These and other late-medieval texts were no longer written in Latin but in the vernacular, with *incidere* being translated as *verdiepen* (deepen), and *matizare* as *verhooghen* or *verheffen* (heighten or raise). The manner of painting the Virgin's blue cloak in the miniature of the *Crucifixion* (fig. 95b) is set out in the following recipe. 'A blue ground shall be laid with blue and white mixed with clean gum water of medium strength. One deepens with pure blue, and it is best to use thickly steeped turnsole or good black ink, and one heightens with clean, pure lead white or ceruse white.' Orange red or vermilion red cloaks were to be painted using the same system. 'The red-lead ground is deepened with vermilion or pink, and heightened with pure white or massicot.' There was also a prescription for colouring a background landscape and modelling the trees. 'The green ground of pure mountain green, or of mountain green mixed with massicot, deepen with pure, thick sap-green and heighten with massicot.' The flesh tones of those standing around the Cross were to be painted as follows: 'The lavender incarnadine ground is made from white and a little vermilion mixed together. This is the ground for young faces. For slightly older faces, a little ochre is to be mixed with the aforesaid colours and the ground laid with this' (fig. 95c). There was also a recipe for painting the body of the dead Christ. 'The ground for a dead body and a dead face. Take white, a little massicot and a little ochre, and mix them together. One deepens with white, ochre, pink and black mixed, and heightens with pure white. The cheeks

fig. 94a Simon Marmion, *The Adoration*, c. 1500; page from a prayer-book; water-colour on vellum, 10.4 x 7.8 cm. Amsterdam, Rijksmuseum, Rijksprentenkabinet

fig. 94b Detail of fig. 94a

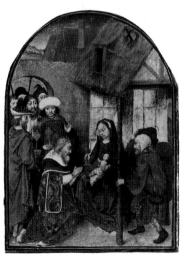

of the living are done with a little red and pink mixed together' (fig. 95d).⁸

Many pigments were extracted from natural materials. The blue mentioned in north European sources is almost always azurite, a carbonate of copper that was mined in Hungary and Germany. The pigment was obtained by grinding the ore to a coarse powder which was then washed in a dish of water. The mineral particles had to be stirred vigorously to make them swirl around in the water. By pouring water off at the right moment it was possible to separate the lighter particles, which were generally impurities, from the rest. Repeating this refining process several times ultimately left a relatively pure material.⁹ Good quality azurite was quite rare, and was one of the most expensive pigments on the medieval palette.

The white that painters used was a synthetic product. This lead white was obtained using 'the Netherlandish method', which involved putting sheets of lead into earthenware pots which were then hung over a vat of vinegar. The pots were stacked carefully one above the other and covered with steaming manure. The action of the acetic acid vapours caused lead compounds to form on the surface of the lead sheets, where they were turned into lead white by the carbonic acid gases given off by the manure. The deposits were scraped off and the process repeated until the lead plates were entirely consumed. The lead white was collected and carefully washed to remove all metallic particles originating from the lead plate and the remaining residues of organic material. After being ground fine it was ready for use.¹⁰ Lead white is also a raw material

for another pigment. Its composition alters when it is slowly heated, and it takes on a yellow cast. That yellow product is massicot. If this is further heated the colour changes from yellow to a deep orange red. The result is minium, or red lead, which was used extensively in the miniaturists' studios.¹¹

PRECIOUS METALWORK

There have been relatively few changes in the goldsmith's craft and workshop down the centuries. Precious metalworking took place within the walls of monasteries in the middle ages, and it is not surprising that the most important medieval text on the craft was compiled by a monk. Around 1123, Theophilus Presbyter (probably the pseudonym of the Benedictine Roger of Helmershausen of the monastery at Reichenau) wrote the *Schedula diversarium artium*, which contains technical discussions of painting, glass-making and precious metalwork.¹²

Theophilus describes the goldsmith's ideal workshop as a room with many windows. It was to contain a furnace, anvil, workbench and a variety of tools. Theophilus's description corresponds very closely to the scene of *St Eloy in his workshop* (fig. 96) engraved by the Master of the Balaam Legend. The patron saint of gold and silversmiths is seated in the centre, chasing a metal cup. An assistant on the left is drawing wire through the die he is standing on. A die contains holes of different sizes, with the wire being drawn through ever-smaller holes until it was a slender thread. Behind the wire-drawer is the bellows of the furnace in which metal was melted, soldered and gilded. An assistant at the

fig. 95c
Detail of fig. 95a showing part of the face, painted with white, vermilion and ochre

fig. 95a Simon Marmion, *The Crucifixion*, c. 1500; page from a prayer-book; water-colour on vellum, 10.4 x 7.8 cm. Amsterdam, Rijksmuseum, Rijksprentenkabinet

fig. 95b Detail of fig. 95a showing part of the Virgin's cloak

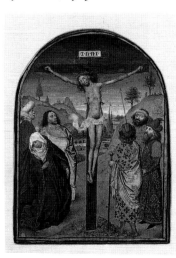

fig. 95d
Detail of fig. 95a showing the brushstrokes in the body of the crucified Christ

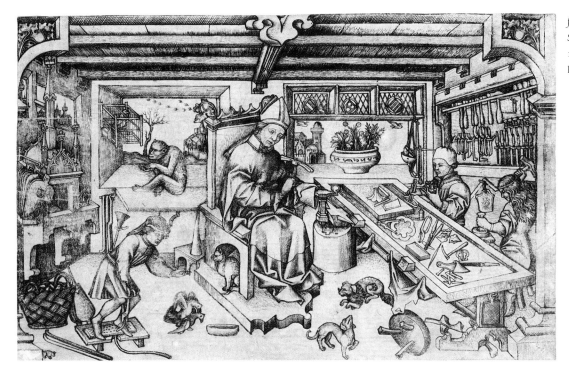

fig. 96 Master of the Balaam Legend, *St Eloy in his workshop*, c. 1450; engraving, 115 x 185 mm. Amsterdam, Rijksmuseum, Rijksprentenkabinet

workbench on the far right is vigorously hammering a sheet of metal. The man beside him appears to be adding detail to the crude chasing with a pointed chisel known as a punch. Behind them is a rack with a wide assortment of the hammers, files, metal shears, chisels and punches or gravers used in metalworking.

The need for a furnace, which was an expensive investment, tied the smith to one place. Many workshops passed down from father to son, or were sold to other smiths, and one even finds certain families pursuing the same profession in the same place for centuries, which was quite unusual for craftsmen. A slow process of specialisation got underway at the end of the middle ages. Alongside producers of large objects like cutlery, candelabra and church silver there were those who made small silver pieces like buttons and buckles before gradually turning to jewelry set with gemstones.

Because there has been so little change in the technique of silversmithing down the centuries, it is easy to discover from the *Schedula* precisely how a piece of precious metalwork was made. The reliquary of St Frederick by the Utrecht silversmith Elyas Scerpswert [1] could have been constructed entirely in accordance with Theophilus's instructions. The raw material for such a prestige object was sheet metal—in this case silver, but copper would have been equally suitable. The sheet was worked into the desired shape by hammering: 'Hammer with a medium-size round hammer from the under side [of the plate] to form a hollow in the place for the head and hammer it all around on the upper side with

a straight-peen hammer.'[13] Metal is being hammered on the far right in the engraving. Hammering distorts the structure of the metal and packs the crystals closer together. This makes the material tougher, brittle and more difficult to work, so from time to time it has to be annealed. 'Anneal it on live coals. When it has cooled by itself, work over the whole figure with hammers, always carefully depressing on each side and repeatedly annealing it.'[14] The rough shape, in this case of St Frederick's head, was constructed using nothing more than a hammer (*fig. 97a*). Details were then added with punches and gravers of various shapes and sizes. 'Mark out the eyes and nostrils, the hair [...] This is done on the upper surface in such a way that they appear through on the inside, where you should also strike with the same punches, so that the design is raised on the outside.'[15] The next passage in Theophilus's description is illustrated by the texture of St Frederick's stole and beard. 'When you have done this long enough to shape the figure completely, engrave with engraving and scraping tools around the eyes and nostrils, the mouth and the chin and the ears, and mark out the hair and all the fine lines of the robes' (*fig. 97b*).

This particular reliquary, however, was not made from a single sheet of silver but from several that were soldered together after being hammered out. Theophilus gives the following instructions for soldering silver. 'Weigh out two parts of pure silver and a third part of red copper; melt them together and file them fine into a clean pot and put the scrapings into a quill.'[16] The addition of

copper gives the silver alloy a lower melting-point, with the result that the solder melts before the silver does. This is enhanced by the addition of a flux. 'Then take argol, i.e. the substance that accumulates on the insides of jars in which the best wine has lain for a long time (tartrate), and wrap pieces of it in a cloth and put it into the fire to burn until smoke no longer comes from it. Take it away from the fire and let it cool. Blow away the ashes of the cloth and grind the stuff, now that it is burnt, in a copper pot with a pestle, mixing in water and salt so that it becomes as thick as lees.'[17] The solder, a mixture of wine tartrate and salt, was mixed with the powdered silver alloy and applied to the parts to be joined. They were then heated, and the soldering was done. 'With a wooden lath spread it around the pins on the inside and on the outside, and with a short iron rod shake the silver scrapings onto it and so let it dry. Spread the mixture on again more thickly than before and put the object in the fire and carefully cover it by adding coals and blow gently with long blasts of the bellows until the solder is sufficiently

melted'.[18] The last thing to be done was the gilding. Most medieval objects were fire-gilt, a process based on the principle that gold dissolves in mercury. A little of that solution was applied to the object, which was then heated. The mercury evaporates at a temperature in excess of 350° Celsius, leaving behind a thin layer of gold (fig. 97c).

GLASS

Glass was, and still is, made by heating quartz sand until it melts into a fluid mass. However, the melting-point of pure quartz is so high that medieval technology was not up to the task, so a way of reducing it had to be found. One option was to add soda or potash to the quartz sand to lower the melting-point, so that the quartz would even melt in wood-fired furnaces (fig. 98). When cooled, the mass forms an amorphous silicate network: glass.[19]

Coloured glass can be obtained by adding different metallic salts to the molten mass. The addition of ferriferous substances turned the glass green. Copper produced red and green shades, while a tiny amount of cobalt gave a deep blue. Manganese was used for an intense purple, as described in a 16th-century manuscript. 'If you wish to obtain purple or violet, take clear white glass and powdered manganese and melt and purify them, then grind them fine and repeat the above with smalt.'[20] Lead sometimes added a slightly green cast, but was used primarily to give the glass a soft sheen. The temperature and amount of oxygen in the furnace also affected the colour.

Glaziers in the later middle ages probably did not make their glass themselves, but bought it in sheets from specialist craftsmen. The glass-makers were usually to be found in wooded regions where there was a plentiful supply of fuel. The wood fired the furnace, and its ash provided the potash that was needed to reduce the melting-point of the quartz sand (fig. 99). The importance of potash is illustrated by the fact that Theophilus opens his section on glass-making with instructions on how to make it. The ash from burned trees contains a variety of salts that the tree has absorbed from the earth, and it first has to be removed by rinsing the ash in clean water. The water is then allowed to evaporate, leaving potash—the crystallised salts.

Medieval glass was manufactured in small sheets using the cylinder process. A blob of molten glass was removed from the furnace with an iron pipe and blown into a cylinder, which was then slit down the middle and slightly reheated, so that it could be folded flat.

The stained-glass artist who had to compose his window from the sheets of glass he received from the glass-house first made a working drawing giving the precise positions of the pieces in the 'jigsaw puzzle'. The drawing also indicated the lines of leading that would later hold the individual pieces together, as well as the

fig. 97a Elyas Scerpswert, *Reliquary of St Frederick* (detail), 1362 [1]. The surface displays dents and irregularities due to hammering.

fig. 97c Elyas Scerpswert, *Reliquary of St Frederick* (detail), 1362 [1]. The silver is partly fire-gilt in the cloak.

fig. 97b Elyas Scerpswert, *Reliquary of St Frederick* (detail), 1362 [1]. The hairs of the beard and the eyebrows were engraved in the metal with burins.

figs. 98a and b Firing the glass furnaces. Engraving in Antonio Neri, *De arte vitraria libri septem*, Amsterdam 1669

brown to jet-black, supplied the colour, while the ground glass melted when the panel was put in the kiln and adhered to the surface. The pigment was painted onto the panes with a soft brush, and thin rods and needles were often used to scratch paint off for decoration or to reserve a highlight. The painting process not only enabled the contours to be emphasised with thick, drawn lines, but also to suggest shadows by means of gradual transitions from light to dark, thus giving volume to the forms. The outlines of St Catherine's face and the shadows on her hands were applied by spreading the panel with extremely fine layers of thinned paint solution. Theophilus goes into this in detail: 'When you have made the painted areas in robes out of this pigment smear it about with the brush in such a way that while the glass is made transparent in the part where you normally make highlights in a painting, the same area is opaque in one part, light in another, and still lighter in a third.' The pane was then fired, fusing the paint to the glass.[22]

The painting on the panes of glass was almost always black. Another technique, unknown in Theophilus's day, was to give white glass a yellow tint, as in the panels by Dirck Vellert [37, 38].

details to be painted on the panels. Once the design was complete the glass was cut to shape using the outlines. The resulting panels were then assembled into a window using strips of lead. The finished window was often mounted in a wooden frame to make it stronger. In addition to holding the panels in place, the leads were an integral part of the composition, with different thicknesses emphasising important elements in the design.

The artist naturally tried to have the outlines of a figure coincide with the leads, but that was sometimes impossible because of the shape and size of the pieces of glass at his disposal. *St Catherine (fig. 100)*, for instance, does have a heavy outline of lead strips, but the individual panels are rather irregular, their shapes bearing little relationship to that of the saint. As a result, the leads cut across the figure here and there, rather than following the shapes. This problem was often remedied by giving the panel a heavy coating of an opaque pigment that was melted onto the glass before the panels were assembled. Theophilus prescribes a pigment composed of equal parts of copper oxide, ground green glass and ground blue Byzantine glass. Antonio Neri's recipe is even simpler: 'Take some of those small rosary beads of yellow glass, that is to say the finest Venetian amber-coloured yellow, and crush them fine. And take crushed and finely ground, pure copper chips. Take a dish of clean copper chips to two dishes of the aforementioned powder, and mix them together. Rub them together very finely over the porphyry stone, and that is the black colour'.[21] The various pieces of glass were painted with this pigment. The metal oxide, ranging from

fig. 99 A glass workshop. Engraving in *De reizen van John Mandeville*

The yellow was obtained by burning silver on the glass, and the process is described by Antonio Neri. 'In order to make yellow, take the scrapings of fine, that is to say, Venetian silver. Crush them on the porphyry stone until they dissolve like water. Remember to put it on the white glass at the places you want to be yellow. And mix this with as little white of egg as possible.'[23]

CERAMICS

Some of the technology used in the glass industry can also be found in the potter's workshop. His raw material was clay, which was often obtained locally. Since it was rather impure, it was first refined by washing and sieving (fig. 101a).

The main component of clay is kaolin, a compound seen under a powerful microscope as a mass of minute flat flakes. The platelets in wet clay are surrounded by a film of water, which allows them to shift relative to each other under pressure. It is this that makes clay so malleable.

Vessels were thrown on a foot-powered wheel (fig. 101b). The potter also had dies into which the damp clay was pressed. Small parts, like ornaments, handles and spouts, were shaped by hand, and there were stamps to add relief decoration to the object. The latter technique was widespread on stoneware produced in the Rhine region around Cologne.

Once the object had been shaped it was finished with spatulas and then placed outdoors to dry. The water between the kaolin flakes gradually disappeared, and the mass became harder and eventually lost its plasticity. Once dry, it was ready for firing, which was done in a large kiln (fig. 101c).

The material loses its ability to take up water from its surrounding from 500° Celsius, and from around 600° to 800° it becomes chemically dry, meaning that the 14% of crystal water normally present in kaolin is also expelled. At even higher temperatures, the quartz particles in the clay can fuse into a vitreous substance. The result is a hard mass that cannot change shape. An object fired in this way often has a matt surface and is also quite porous, which is obviously unpractical for vessels designed to hold liquids. In order to correct this, the object is given a glaze—a thin layer of glass that melts into and onto the pores and seals them. It is this that gives the earthenware its sheen and makes it impermeable.

A glaze was quite easily prepared. Glass was ground to a fine powder to which glue was added to produce a 'paint' that was smeared onto the fired pot. The latter was then returned to the kiln to burn off the glue, covering the pot with a thin film of glass. It was preferable to use a kind of glass with a relatively low melting-point—ideally glass with a high potash or lead content. Lead had the added advantage of giving the glaze a more attractive sheen.

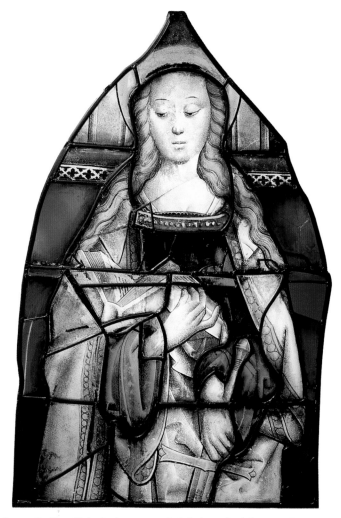

fig. 100 Northern Netherlands, 1500-1525, *St Catherine*; stained glass, 92 x 58 cm. Amsterdam, Rijksmuseum (inv. no. BK-NM-10222)

fig. 101a Craftsmen refining clay. Pen and ink drawing in the manuscript of Cipriano Piccolpasso, *Li tre libri del'arte de vasaio*

fig. 101b Vessels being shaped on the wheel. Pen and ink drawing in the manuscript of Cipriano Piccolpasso, *Li tre libri del'arte de Vasaio*

fig. 101c The kiln. Pen and ink drawing in the manuscript of Cipriano Piccolpasso, *Li tre libri del'arte de Vasaio*

The lustre of de luxe, ornately decorated ceramic articles was often enhanced with an additional layer of lead glaze, which was called *kwaart* in Dutch—a corruption of the Italian *coperta*, or top coat.

The glaze could be coloured an opaque, milky white colour by adding a little tin oxide to the finely ground glass powder. Coloured decoration could be applied to the article by grinding coloured glass with the powder, or better still by adding metallic oxides. Copper oxide and azurite or malachite—pigments that were also used by painters—made the glaze a deep green. Manganese oxide produced a purple colour, and cobalt oxide a bright blue. The blue-tinted cobalt glaze was highly prized, and was also sold to painters as a pigment in the form of finely ground glass. The potter obtained yellow with admixtures of arsenic oxide, antimony oxide or a mixture of tin oxide and lead oxide.[24] This lead-tin compound was another pigment that found its way to the painter's studio as a pigment (fig. 102).

The potter, then, had a broad palette at his disposal with which he could paint colourful and detailed scenes on the surface of the earthenware. It was above all the makers of majolica, which became extremely popular in Spain and Italy in the late middle ages, who excelled in this lavish decoration. Italian emigrants who settled in

fig. 102 Detail of a dish with a yellow lead-tin glaze; majolica, Antwerp, c. 1550. Amsterdam, Rijksmuseum (inv. no. BK-B-4612)

Antwerp at the beginning of the 16th century brought this advanced ceramics technology to the Low Countries. These majolica potters were entrepreneurs who headed workshops, some of them family businesses, where earthenware was made on a production line basis with a clear division of labour for the different stages in the manufacturing process.

TAPESTRIES

Tapestry-weaving was one of the most costly and labour-intensive branches of art. In the case of special commissions, leading artists supplied drawn or painted, full-scale designs that were known as patterns in the middle ages, but later came to be called cartoons.

The actual weaving was done on a loom, of which there were two types, one with a vertical warp (*haute-lisse*), the other with a horizontal warp (*basse-lisse*). The raw material used in the middle ages was woollen thread for both the warp and the weft. Threads of different colours made it possible to weave any scene. Although not unlimited, the number of colours was nevertheless more than

sufficient to create a convincing reproduction of a painted design. One of the earliest surviving Franco-Flemish tapestries, which dates from 1380, contains 19 different colours. A century later, a tapestry with 40 colours was the rule rather than the exception (*figs. 103, 104*), and more than 80 colours would be employed for a very special commission in the 16th and 17th centuries. The preferred method was to colour the fibres with natural, durable dyes—the so-called *grands teints*. The raw materials were woad or indigo for blue, madder and kermes for red, and dyer's rocket for yellow.[25] Mixing these colours, of course, produced a wide range of intermediate shades.

The tapestry weaver bought his thread from different dyers, who were often highly specialised. Some, in fact, concentrated solely on dyeing wool with indigo. The dye-works accordingly had separate recipes for dyeing in the 'blue bath' or colouring red textiles. Both fibres and woven fabrics could be treated.

As noted, the number of colorants that dyers could use was limited at first. The principal red dye was madder from the roots of

fig. 103 Southern Netherlands (Tournai?), c. 1470-1490, *Tapestry with the disrobing, carrying of the Cross and Crucifixion*, 300 x 460 cm. Amsterdam, Rijksmuseum (inv. no. BK-1958-16)

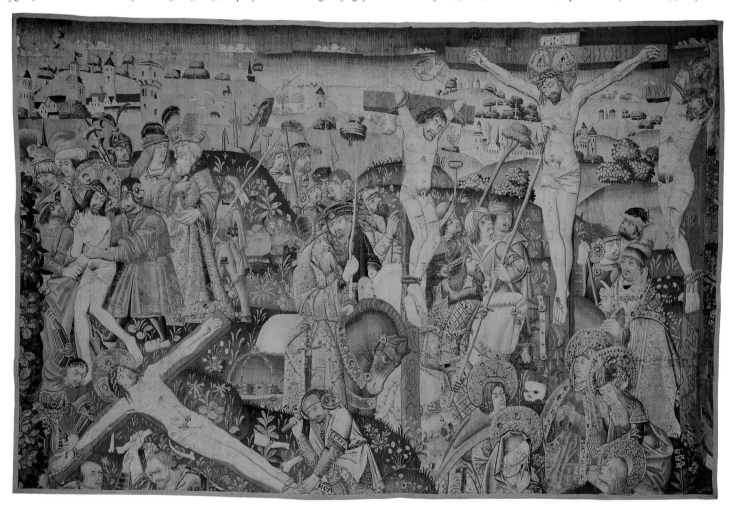

fig. 104 Michel Cocxie, *The covenant between God the Father and Noah* (detail), Brussels, c. 1565. Amsterdam, Rijksmuseum (inv. no. BK-1955-99). The variety of colour comes from the use of fibres coloured with different dyes.

Rubia tinctorum L. (fig. 105a), a plant that flourishes in a brackish clay soil. The main areas of cultivation in the Low Countries were Zeeland and Flanders. Madder owes its colouring properties to the presence of purpurin, pseudo-purpurin, and above all alizarin. In their natural form they are combined with sugars in the roots. The sugar glycosides have to be broken down before the colouring matter will adhere to the fibres, and this is done by adding brans. The ensuing enzymatic hydrolysis frees the colorants, which then bind to the textile fibres with the aid of alum. Thread dyed in this way takes on a fine, orange red colour. The colouring matter on the fibres is quite sensitive to changes in acidity. The addition of lime or lye turns the orange red into a purple red, enabling dyers to obtain different shades from the same colorant. The range of colours could be widened by using different mordants—salts that fix the colorant to the fibre. Alum with madder, for instance, generally produces an orangey red, iron sulphate a deep, almost black, purple.[26] *Die conste van alderhand substancien te verwen* (The art of dyeing various substances) describes the process thus. 'You shall use four pounds of woollen fibres to ten ounces of alum and boil it in bran-water for as long as you consider fit. You then take the fibres out. Remove the water from the vat, which you then fill with three parts of fresh bran-water to one-quarter part of fresh, clean water. When this has warmed a little, add two and a half pounds of madder, and leave until it is hot. Then stir well with a stave for three hours, making sure that the mixture does not boil. You then remove your wool again and pour half a glass of cinders from the hearth. Replace the wool and stir with a stave for the space of six or seven paternosters' (fig. 105b).[27]

The main yellow dyestuff used in the Low Countries was extracted from wild mignonette (*Reseda luteola* L.), a perennial plant that grows to around 1 1/2 metres and has lancet-shaped leaves. It contains several colorants, the main ones being luteolin and apigenin.[28] The plant is of Mediterranean origin, but spread throughout western Europe in the middle ages. A specific shade of colour was obtained through the chemical combination of the mignonette colorant with copper from verdigris under the alkaline action of very strong lye. Dyeing yellow over red produced a slightly more orange tint. Green was obtained by laying dyer's rocket over blue textiles.

The main source of this blue in the middle ages was the woad plant (*Isatis tinctoria* L.). Later, in the 17th century, blue was extracted from indigo plants (*Indigofera suffructicosa* L.). The actual colorant is the same in both plants: indigo. Being water-insoluble, it cannot be used directly, and first has to be converted into a soluble compound by reduction. That was often done by adding lye to the vat, and sometimes by allowing urine, potash and bran to ferment until they began foaming. The lye reduced the woad to its colourless, soluble form, which was then used to dye the textile. The latter was removed from the vat and exposed to the air, whereupon the colorant oxidised back to its original, insoluble colour. The repeated immersion of the textiles in the reduced liquid followed by oxidation produced a darker shade. The gradations range from a very light sky-blue to a deep, almost black blue.[29] Laying these blues over rocket yellow fibres produced superb greens. Blue dyed over madder red a fine brilliant purple. The dyer's skills provided the tapestry weavers with a wide range of colours (figs. 106a, 106b).

fig. 105a Madder (*Rubia tinctorum* L.). Woodcut in Leonaert Fuchs, *Den nieuwen herbarius, dat is, dboeck van den cruyden*, Basel 1543

fig. 105b The dyer at work. Woodcut in Leonaert Fuchs, *Den nieuwen herbarius, dat is, dboeck van den cruyden*, Basel 1543

fig. 106b Detail of a tapestry with the investiture of Philip the Handsome as Defender of the Realm, southern Netherlands, c. 1520. Amsterdam, Rijksmuseum (inv. no. BK-NM-8838). Colour combinations.

fig. 106a Detail of a tapestry with the investiture of Philip the Handsome as Defender of the Realm, southern Netherlands, c. 1520. Amsterdam, Rijksmuseum (inv. no. BK-NM-8838). Blue and yellow combined to produce a bright green.

PAINTING

The rise of the guilds in the cities of western Europe, coupled with the increasing division of labour and specialisation within workshops, led to a growing need among craftsmen for their own collection of recipes. In addition to guaranteeing a degree of standardisation in studio practice, that collection was also employed in training young artists. The instructions in recipe books enabled a master to leave the less important passages in a painting to an apprentice. Because these texts were part of a painter's tools of the trade, he was understandably coy about revealing their contents to his competitors. Consequently, many of these books are highly personal. One preserved in the Plantin-Moretus Museum in Antwerp tells us something about the materials used in paintings in the late middle ages.[30]

Almost all the medieval easel paintings that have survived are on panel. Only a few northern Netherlandish works executed before 1550 were on canvas, most of them so-called *Tüchlein* paintings—fairly cheap watercolours on unprepared canvas. *Tüchleins* are so fragile that only a handful have survived. The 14th and 15th-century paintings in the Rijksmuseum are all on panel, mostly made from oak wainscot that was imported from the Baltic region and processed in the Netherlands.[31] The wood was first dried to reduce the risk of distortion through shrinkage. The planks were usually cut radially from the tree-trunk and were joined together to form larger panels. They were usually cold-glued, and sometimes had dowel or dovetail joints as well.[32] In most cases the frame is an integral part of the panel, and was attached to it by the joiner before delivery to the painter (fig. 107).

Ready-made panels of this kind had a smooth, sanded layer of ground that covered the entire surface, including the frame.

The wood was primed with a mixture of ground chalk and animal glue to eliminate any unevenness, leaving a smooth, even surface. This ground was generally applied by the joiner, but in the larger studios it was done by specialist primers.

A sketch of the scene was then drawn or painted on the panel, sometimes just in outline to indicate the areas of colour. Volumes were modelled with hatching, and the position of the shaded passages sketched in. This underdrawing also served as a guide for the studio assistants when they came to paint in the less important parts of the composition.

Infrared reflectography will reveal any drawing beneath a painting provided it was done with black chalk or black watercolour, which contain carbon (figs. 108a, 108b). Underdrawings

fig. 107 Housebook-master *The children of Mercury*, drawing in the *Hausbuch*, (fol 16r), c. 1475-1485. Fürsten zu Waldburg-Wolfegg

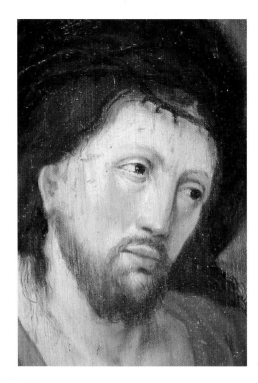
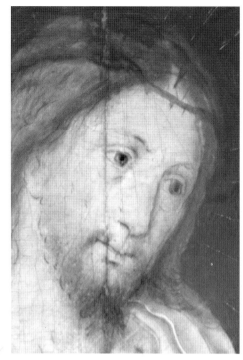

fig. 108a Leiden School, c. 1515, *Christ with the crown of thorns*, lefthand panel of a diptych. Amsterdam, Rijksmuseum (inv. no. SK-A-1483)

fig. 108b Infrared reflectogram of fig. 108a

fig. 108c Microscopic cross-section of paint from fig. 108a, magnification approx. 200x. The underdrawing, executed in black chalk, is on top of the insulating layer.

done in red chalk or metalpoint, which became far commoner from around 1540, cannot be revealed with this technique.

If oils are painted directly onto the chalk ground, the latter absorbs much of the binding medium in the paint, weakening the adhesion of the paint layers. The ground has to be insulated with a thin layer of lead white painted over both ground and underdrawing. The lead white has the added advantage of providing a good reflective base for the layers painted over it. Needless to say, it also had to be thin enough for the underdrawing to show through. On occasion, the underdrawing was made on top of the lead white.

In most cases, the paint of a picture is built up in successive layers. The bottom one is generally the lightest in tone, and is opaque. Those on top of it are usually more transparent and darker in tone, allowing the lowest layer to contribute to the overall effect of the painting (fig. 108c).

That translucence is a particular feature of red organic lake pigments, which are based on colorants of plant or animal origin. They were precipitated with aluminium hydroxide to form a translucent lake, most of which took their colour from madder, which was also widely used in the dyeing industry. The actual aluminium hydroxide precipitate has no colouring properties itself, but does have the ability to bond closely with organic colorants, making them much stronger and stable.[33] Because the aluminium hydroxide is completely transparent it was possible to make red lakes with a very deep lustre. If the artist wanted to paint

an extremely dark passage with a lake he had to apply several very thick layers, which lie like a crust on the painting. Red lakes of this kind are found in all northern Netherlandish paintings. A very good use of these transparent red lakes was as a glaze over an underlying layer of opaque, orange red vermilion, a popular pigment made by combining mercury and sulphur in a glass retort and gradually heating them. The gases given off sublimate to red mercury sulphide on the cooler glass surface by the neck of the retort.[34]

Some greens, such as malachite and chrysocolla, are of mineral origin, but they were not nearly as popular as verdigris. The name is derived from the French *vert de Grèce*, or Greek green, but in the Netherlands the pigment was known as Spanish green. It was obtained by exposing copper plates to the vapours of acetic acid. The resulting mixture of different corrosion products was used for the green colour. 'Spanish green. Take scrapings of fine red copper and grind them with sal-ammoniac, using one pound of scrapings to a quarter pound of sal-ammoniac, sprinkling it with strong wine vinegar and stirring well before leaving it to stand for seven days in hot horse manure, and if you notice that something is missing or it is not enough, sprinkle again with vinegar and let it stand for another seven days, by which time it will be ready.'[35] That green pigment rubbed into linseed oil provides a dark green, granular paint, which could also serve as the basis for a thin, transparent green lake by mixing it with a little turpentine resin. This dissolves the verdigris particles and produces the pigment copper resinate,

fig. 109 Leiden School, *Mount Calvary*, c. 1520 [41]. Yellow lake over an underpaint with lead-tin yellow.

which has a marvellous, deep green colour.³⁶ It is also fairly transparent, allowing underlying layers of opaque malachite, lead white or another pigment to show through.

An opaque light yellow found in almost all northern Netherlandish paintings is lead-tin yellow, a pigment originally found in pottery workshops, where combinations of lead and tin had long been used to make opaque yellow glazes.³⁷ The pigment was made by mixing red lead (minium) with tin oxides and then heating the mixture in an oven. After a while, a new substance formed—the superb lead-tin yellow. 'For massicot. Take three pounds of lead and two pounds of tin, and calcinate as one does with red lead. Do this three times, with some salt in the last. Add two pounds of red lead and stir for 12 hours, as with the minium.'³⁸

A much cheaper alternative, of course, was to use earth pigments. The 15th-century Italian painter Cennini relates in his *Libro dell'arte* how he and his father went out for a walk near their home. They came to a steep hill, and when he scraped it with a spade he discovered that the layers of earth were of different colours: red, white, brown and yellow. He says that this was the most perfect yellow ochre he ever encountered in his entire career.³⁹ Netherlandish artists probably obtained their earths in a similar way. The colorant properties of yellow ochre is caused by hydrated iron oxides. In Italy there was a prized yellow ochre known as *terra di Siena*. When heated, the water evaporates, leaving a

new, brownish red pigment known as burnt Sienna or haematite. The opaque, often light-coloured, inorganic yellow pigments were often covered with transparent yellow lakes. They, like the red lakes, were first used in textile dyeing. Plant extracts, mainly from unripened buckthorn berries (*Rhamnus cathartica* L.), the leaves of dyer's broom (*Genista tinctoria* L.) or from wild mignonette (*Reseda luteola* L.), were precipitated with aluminium hydroxide to a sometimes almost fluorescent, bright yellow lake. These transparent lakes enabled the artist to render deep golden tones (*fig. 109*).

The colour concordances consulted by miniaturists often specify combinations for making effective use of the translucency of certain pigments and the opacity of others. The intention was to allow the opaque colour to show through those coloured lakes. Most of the late medieval paintings in the Low Countries were executed in accordance with this formula. In the course of the 15th century, the stratification of paintings became a little simpler and had a less complex structure. The paint layers were slightly thinner, revealing more of the underpainting, which accordingly played a greater part in the finished composition. The increased reflectance of the light underpaint through the paint layers gave pictures a greater luminosity. Artists painted 'not with the paint heavily laden on the brush, but thinly and sparingly, glowing and pure'.

This development continued, and some colours in several panels by Jan van Scorel from around 1540 consist of just a single layer. There is a glaze in the darker passages, and a mixture of a pigment and a little lead white in the lighter ones. The volumes and darker areas were prepared with hatching in the underdrawing (*fig. 110*). Sometimes, though, accidents occurred. The robe of Maarten van Heemskerck's *Erythraean Sibyl* was executed with a single layer of yellow paint, with the highest highlights being accentuated with some lead white. The yellow pigment, orpiment, was painted directly onto the ground without any intermediate layer. The action of light has bleached the yellow, with the result that one now looks straight through it to the underdrawing and ground (*fig. 111*).

SCULPTURE

Many medieval statues, of wood or stone, were coloured, and oddly enough the polychromy was often prized far higher than the sculpture itself. However, no medieval recipe books dealing with the painting of statues have survived, and it is not clear whether they ever actually existed.

Most of the available historical information about the sculptor's craft comes from guild regulations and contracts between patrons and artists. Many of the contracts for sculpture were in fact made with the painter who was to polychrome it. He ordered the specified statue from a sculptor who is not even named in the

fig. 110 Jan van Scorel, *Mary Magdalen* (detail) [51].
Detail of the Magdalen's face: the thin layer of paint is so transparent
that the underdrawing can be seen.

contract. Wolf Huber, for instance, was commissioned to make an altarpiece, 'and he shall have these statues carved from fresh, sound wood in the Rhineland manner, and then paint them himself'.[40]

Payments for sculpture confirm that the carving was considered subordinate to the polychromy. The carver of the statues for the high altar in Xanten was paid a mere 125 guilders, whereas the painter received 512 guilders.[41] The high expense of polychroming often meant that sculptures remained unpainted for a long time—decades even. At the end of the 15th century in Germany, as it happens, there was a fashion for deliberately leaving statues unpainted, and for artistic not financial reasons. The wood was simply given a thin transparent layer to protect it—a practice that has recently been dubbed *Holzsigtigkeit*.

The type of wood used was usually prescribed on a local basis. The guilds of Hamburg and Lüneburg stipulated walnut, oak or pearwood. Limewood was preferred in southern Germany, larchwood in the Tirol. Oak was the predominant sort in Westphalia, the Lower Rhine region and the Low Countries (fig. 112).

It is believed that the wood used for carving was not ordinary carpenter's wood, but was probably treated specially. One important requirement was the tree should be felled as autumn turned to winter, when the flow of sap from the roots to the leaves had ceased. This made the wood easier to work. The heartwood was also removed to allow the block to dry faster. Hollowing out the block not only reduced its weight and reduced the drying time; fewer cracks appear in a statue made from a hollow trunk than from a solid one. As wood dries, its cells shrink, but the shrinkage is greater in the outermost annual growth rings than in those on the inside. The tension thus set up can cause shrinkage cracks. If the trunk is hollow, the cells on both the outside and inside can dry fairly free of tension (figs. 113a, 113b). Needless to say, the knots, bark and sapwood (the young wood immediately beneath the bark) were removed. The carver continually had to cut away pieces around the block, which entailed fastening it firmly in position.[42] It was sometimes tied to the workbench (fig. 114), but was generally clamped to it (fig. 115). Quite a few medieval wooden statues have holes at both top and bottom to take the pegs that attached the block to the workbench.

Contracts reveal that patrons did not wish the carving to be done by apprentices. The carver 'must work with his own body'. Nevertheless, much of the preliminary work—carving out the rough shape—and simple, repetitive patterns like hair or rocks were often not done by the master. The division of labour in the workshops ensured that there was an effective organisation of the work that resulted in a far-reaching specialisation, particularly in the large shops in Antwerp at the end of the 15th century.

fig. 111 Maarten van Heemskerck,
The Erythraean Sibyl, left wing of
a triptych, 1564. Amsterdam,
Rijksmuseum (inv. no. SK-A-1910).
The sibyl's gown has become
transparent, revealing the
underdrawing.

fig. 112 The wood-carver's tools.
Engraving in *Von der Dyngen Erfyndung*, 1537

fig. 114 A statue fastened to a workbench.
Detail of the drawing, *The children of Mercury*,
in the Hausbuch (fol 16r), c. 1475-1485.
Fürsten zu Waldburg-Wolfegg

fig. 115 A statue clamped to a workbench. Woodcut in *Marcia Varronis*,
Augsburg 1479

fig. 113a Utrecht, c. 1500,
The Flight into Egypt; polychrome
sculpture. Amsterdam, Rijksmuseum
(inv. no. BK-NM-11769)

fig. 113b The back of the *Flight into
Egypt* shows that the statue is hollow

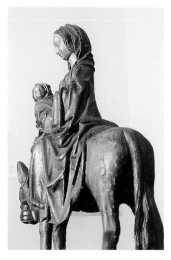

Once the statue was finished it often underwent conservation
treatment. It was soaked in 'oily minium', a mixture of linseed oil
and red lead, mainly in order to prevent the inside getting damp.
The statue was then prepared for polychroming. Smaller works
were simply given a preparatory coat of parchment-glue. Larger
carvings were usually pasted over with canvas in order to prevent
any cracks appearing on the painted surface. The canvas provided a
firm attachment for the ground laid over it—a mixture of fine
parchment-glue and very finely ground chalk that was applied in
several layers.

The nature and extent of the polychromy, especially in the case
of large sculpted altarpieces, was closely stipulated in the contracts.
Master Wolters, for instance, had to add a superstructure on the
wood paid for by the patron ('panels and twelve wings of wood at

our expense'), and paint the panels, wings and the wooden statues placed in the altarpiece. The background was to be covered with good quality gold, and an expensive blue was also specified: '11 images on a good ground gilt with good Hungarian gold, likewise the pinnacles, the central panels and the wings, furnished with gilt statues where needed or desired, and use a fine blue for this'. The painter Engelhart Hofman had to 'gild everything with ducat gold of the finest quality, also everything that has to be done in colour on the body, as well as the landscapes on the two wings and on the movable portion—all, again, with the best oil paints',[43] and Jan van Molenbeke undertook 'to gild well and laudably with fine burnished gold, and matt gold where appropriate, with the exception of the masonry vaults, which shall be covered with turnsole'.[44] Agreements of this kind constantly mention gold and blue, for these were the costly materials on which painters occasionally tried to skimp. It was apparently taken as read that the actual execution of the painting or carving would be of high quality.

The gilding was applied before the painting. This could be done with gold leaf, in the form of either matt or burnished gilding. Quite a few recipes have been preserved for both procedures. For burnished gilding, the white ground first had to be covered with Armenian bole—a red, slightly fatty clay. The binding agent for the gold ground was egg-white, which had to be applied before gilding could begin. The gold leaf was made by flattening coins, so its quality depended on the alloy of the coin, which was sometimes specified in the contracts as 'ducat gold', 'pure gold', or locally as 'Rhenish' or, because of its high purity, 'Hungarian'.

The red bole ground was moistened with a brush or by breathing on it, which made the proteins of the binding medium a little sticky. A small leaf of gold was quickly laid on before the ground dried, and adhered immediately. Once all the leaves had been applied the gold could be burnished using a smooth stone (agate) or a dog's tooth. The polishing gave the gold a gleaming, reflecting surface (fig. 116), thanks to the slightly elastic bole, which yielded under the pressure of the burnishing stone. It was a procedure that could only be carried out with the greatest care and the very best materials. Matt gilding was used for areas that were less important or could not be burnished properly, such as the bottom of a robe or the back of the statue. The area was smeared with a sticky, resin-oil mordant and when it was nearly dry the gold was simply pasted on.

Having completed the gilding, the painter set to work polychroming the statue, using the same oil paints as in panel painting.. The system of combining opaque and transparent colours was also followed. Occasionally the painter left his own mark on the statue as a guarantee of quality.

Unfortunately, very little of the original polychromy has survived on medieval Netherlandish statues, because the colours were regularly refreshed. Repainting every 50 years or so was not exceptional. As a result, the subtle interplay between the carving and the original polychromy was largely lost after the statue had been overpainted several times. On top of that, there was a marked preference for unpainted sculpture in the 19th century. Many medieval statues were ruthlessly stripped of all their paint layers by treating them with lye. This not only destroyed an important of the viewer's experience of the sculpture, but also wiped out a valuable source for our knowledge about the polychrome process, and with it any idea about the changes in taste that were often visible in the successive paint layers.

NOTES

1 M. Wellmann, 'Die Physica des Bolos von Mendes und der Magier Anaxilaos von Larissa', *Abhandlungen der Berliner Akademie*, Berlin 1928, pp. 7-18.

2 Pliny, *Natural history*, 10 vols., London & Cambridge (Mass.) 1949-52, vol. 9, trans. A. Rackham. Vitruvius, *The ten books of architecture*, trans. M. Hicky Morgan, New York 1960.

3 E.R. Caley, 'The Leyden Papyrus X, an English translation with brief notes', *The Journal of Chemical Education* 3 (1926), pp. 1149-66. O. Lagercrantz, *Papyrus Graecus Holmiensis*, Uppsala 1913.

4 A. Wallert, *Kookboeken en koorboeken*, Groningen 1991.

5 F. Brunello, *De Arte illuminandi e altri trattati sulla tecnica della miniatura medievale*, Vicenza 1975, pp. 181-95. H. Roosen-Runge, *Farbgebung und Technik frühmittelalterlicher Buchmalerei: Studien zu den Traktaten 'Mappae Clavicula' und 'Heraclius'*, Munich 1967, vol. 1, pp. 185-91.

6 A. Wallert, 'Instructions for manuscript illumination in a 15th century Netherlandish treatise', K. van der Horst & J.-C. Klamt (eds.), *Masters and miniatures: proceedings of the congress on medieval manuscript illumination in the northern Netherlands*, Doornspijk 1991, pp. 447-56.

7 Ms 2141, Ghent, University Library; W.L. Braekman,

fig. 116 Master of Koudewater, *St Catherine* (detail), c. 1470 [5]. The gold layer has worn to reveal the bole and the underlying layer of chalk.

Middelnederlandse verfrecepten voor miniaturen en 'alderhande substancien' (Scripta mediaeval and Renaissance texts and studies 18), Brussels 1986.

8 Ibid., p. 116: 'Een blauwen gront salmen legghen van blaeu ende wit, tsamen gheminghet met scoon gomwater middelbaer. Men verdiepten met puren blau, ende tbeste es met dicken gheweecten tornisol oft goeden swerten inct, ende verhoochten met scoon claer loot oft ceruus wit'; 'Den rooden gront van menie verdiept men met vermelioen oft roose ende verheffen met scoon wit oft mascot. Oock den gront van vermelioen verdieptmen met roose ende verheffen met wit oft mascot'; 'Den groenen gront van puer berchgroen oft van berchgroen ende mascot tsamen ghemingt, ende verdiepen met puer dicken sapgroen ende verheffen met mascot'; 'Van levender lijfverwen gront maectmen van wit ende weinich vermiljoens tsamen gheminghet. Desen gront dient tot jonghe aensichten. Den gront vanden gheluwen [wat oudere] aensichte salmen totter voorseiden verwen een weinich okers doen minghenende also den gront legghen'; and 'Den gront van eenen dooden lichaem ende doot aenscijn. Neemt wit, luttel mascot ende luttel okers tsamen ghemighet. Men verdiept met wit, oker, roose ende swert gheminghetende verhooghen met scoon wit. Den wanghen van den levenden met weinich roots ende roosen tsamen

ghemingt'.

9 A. Wallert, 'Wie man im Mittelalter Blaupigmente herstellte: über Azurit und Ultramarin', *Maltechnik / Restauro 95* (1991), pp. 13-17. R.J. Gettens & E. West Fitzhugh, 'Azurite and blue verditer', A. Roy (ed.), *Artists' pigments: a handbook of their history and characteristics*, Cambridge 1986-, vol. 1, pp. 23-36.

10 R.J. Gettens, H. Kühn & W.T. Chase, 'Lead white', Roy, op. cit. (note 9), vol. 2, pp. 67-82.

11 E. West Fitzhugh, 'Red lead and minium', ibid., vol. 1, pp. 109-40.

12 Theophilus, *On divers arts: the foremost medieval treatise on painting, glassmaking and metalwork*, ed. J.G. Hawthorne & C.S. Smith, New York 1979.

13 Ibid., p. 150.

14 Ibid., p. 150.

15 Ibid., p. 151.

16 Ibid., p. 107.

17 Ibid., p. 107.

18 Ibid., p. 107.

19 H. Salmang, *Die physikalischen und chemischen Grundlagen der Glasfabrikation*, Berlin, Göttingen & Heidelberg 1959.

20 E. Vandamme, 'Een 16de-eeuws Zuidnederlands receptenboek', *Jaarboek van het Koninklijk Museum voor Schone Kunsten te Antwerpen 8* (1974), pp. 112-20, 133: 'Ende dat ghy pers oft violet wilt hebben, suldy nemen schoon wit glas ende pulveriseerde mangesie ende laet dan te samen smilten ende fineren ende dan weder cleyn gevreven ende doen als boven metten smals'.

21 A. Neri, *De arte vitraria libri septem et in eosdem Christoph. Merretti observationes et notae*, Amsterdam 1669, p. 25.

22 Theophilus, op. cit. (note 12), p. 64.

23 Neri, op. cit. (note 21), p. 67.

24 C. Piccolpasso, *The three books of the potter's art which treat not only of the practice, but also briefly of all the secrets of this art*, ed. A. van der Put & B. Rackham, London 1934.

25 H.G. Frencken, *T'Bouck van wondre* (diss.), Leiden 1934.

26 J.H. Hofenk de Graaff, *Geschiedenis van de textieltechniek: een drieluik*, Amsterdam 1992.

27 Braekman, op. cit. (note 7), p. 53: 'Ghi sult doen tot vier pont wullen garens thien oncen aluyns ende siedent daer inne met semel water na dat v goet dunct. Dan doet v garen wt. Dat water suldi dan doen vten ketel ende doenter weder versch semel water in drie deelen ende tvierendeel scoon claer water. Als dan luttel warm es so doet daer in twee pont en half crappen van meede, dan ltet soe tot dat wat werm es. Dan steeckt daer in en keeret wel met enen stock 3 vre. Maar emmers wacht wel dat niet en siede. Dan neemt weder v wullen wt ende worpt in uwen ketel een half glas vol heert asscen. Dan steeckt weder v wullen daer in ende keert wel met eenen stocke ses of seuen paternosters'.

28 D. Cardon & G. du Chatenet, *Guide des teintures naturelles: plantes, lichens, champignons, mollusques et insectes*, Paris 1990, pp. 60-100

29 Ibid., pp. 133-59.

30 Vandamme, op. cit. (note 20), pp. 112-33.

31 T. Wazny & D. Eckstein, 'Der Holzhandel von Danzig/Gdansk: Geschichte, Umfang und Reichweite', *Holz als Roh- und Werkstoff 45* (1987), pp. 509-13.

32 J. Wadum, 'Historical overview of panel-making techniques in the northern countries', K. Dardes & A Rothe (eds.), *The structural conservation of panel paintings*, Los Angeles 1998, pp. 149-77.

33 E. Hermens & A. Wallert, 'The Pekstok Papers: lake pigments, prisons and paint-mills', *Leids Kunsthistorisch Jaarboek 11* (1998), pp. 269-94.

34 R.J. Gettens, R.L. Fellert & W.T. Chase, 'Vermilion and cinnabar', Roy, op. cit. (note 9), vol. 2, pp. 159-82.

35 Vandamme, op. cit. (note 20), p. 118.

36 H. Kühn, 'Verdigris and copper resinate', Roy, op. cit. (note 9), vol. 2, pp. 131-58.

37 H. Kühn, 'Lead-tin yellow', ibid., vol. 2, pp. 83-112.

38 Vandamme, op. cit. (note 20), p. 116.

39 C. Cennini, *The craftsman's handbook*, trans. D.V. Thompson, New York 1961, p. 27.

40 H. Huth, *Künstler und Werkstatt der Spätgotik*, Darmstadt 1967, p. 121.

41 Ibid., p. 67.

42 *Das mittelalterliche Hausbuch / The medieval housebook* (facsimile ed., with volume of commentary), ed. C. Waldburg Wolfegg & G. Keil, 2 vols., Munich 1997.

43 Huth, op. cit. (note 40), p. 107: '[...] elven bilde uppe guden grunt mit gudem Ungarschen golde vergulden, desgheliken de cronenn, de myddelsten taphelen unde buten myt oren bilden wur sick gheboret unde schone blawe dar tho ghebruken'; and '[...] alles mit feinem und vom besten ducatengold vergulden, auch was von farben gemacht wuerde im corpus, auch die landschaften in den zwayen fluegeln und dem usszug, dasselbig alles auch von besten oelfarben machen'.

44 Ibid., p. 105: '[...] wel en loflic vergulden van fynen gebruneerden goude en van matten goude dair dat behoiren sal, wtghenomen de welfsele vander metselrien, dwelck syn sellen gebracht van lazuere'.

Bibliography

Albers 1893

P. Albers, 'De H. Frederik, VIIIe bisschop van Utrecht', *Archief voor de Geschiedenis van het Aartsbisdom Utrecht 20* (1893), pp. 61-64, 259-349

Armstrong 1990

C.M. Armstrong, *The moralizing prints of Cornelis Anthonisz*, Princeton 1990

Van Asperen de Boer 1988

J.R.J. van Asperen de Boer, 'Some observations on underdrawing in Geertgen tot St. Jans paintings', *Akt* 12 (1988) 2, pp. 49-53

Van Asperen de Boer/Wheelock 1973

J.R.J. van Asperen de Boer & A.K. Wheelock Jr, 'Underdrawings in some paintings by Cornelis Engebrechtsz', *Oud Holland* 87 (1973), pp. 61-94

Bangs 1979

J.D. Bangs, *Cornelis Engebrechtsz.'s Leiden: studies in cultural history*, Assen 1979

Bangs 1986

J.D. Bangs, 'Tapestry weaving before the Reformation: the Leiden studios', *Nederlands Kunsthistorisch Jaarboek* 37 (1986), pp. 225-40

Bauer 1948

M. Bauer, *Die Ikonographie der Höllenfahrt Christi von ihren Anfängen bis zum XVI. Jahrhundert*, Göttingen 1948

Becker 1994

J. Becker, 'Puff, Passion und Pfilgerfahrt: zu Bildthemen des Braunschweiger Monogrammisten', *Wallraf-Richartz Jahrbuch* 55 (1994), pp. 21-41

Beltjes 1981

P.J.W. Beltjes, 'Goud en zilver in Culemborg: leverantieën door de goudsmeden mr. Elyas (Scerpswert) en mr. Roelant aan Johan, heer van Culemborg en van de Leck', *Liber Castellorum*, Zutphen 1981, pp. 382-89

Van den Bergh-Hoogterp 1990

L.E. van den Bergh-Hoogterp, *Goud- en zilversmeden te Utrecht in de late middeleeuwen*, 2 vols., The Hague & Maarssen 1990

Bergvelt 1998

E. Bergvelt, *Pantheon der Gouden Eeuw: van Nationale Konst-Gallerij tot Rijksmuseum van Schilderijen (1798-1896)*, Zwolle 1998

Van Berkel 1992

K. van Berkel, 'Citaten uit het boek der natuur: zeventiende-eeuwse Nederlandse naturaliënkabinetten en de ontwikkeling van de natuurwetenschap', E.Bergveld & R. Kistemaker (eds.), exhib. cat. *De wereld binnen handbereik. Nederlandse kunst- en rariteitenverzamelingen 1585-1735*, Amsterdam (Amsterdams Historisch Museum) 1992, pp. 169-91

Bertini/Forti Grazzini 1997

G. Bertini & N. Forti Grazzini, 'Les inventaires et les collections des Farnèses à Parme, Plaisance et Rome au XVIIème siècle', *Colloque international de la tapisserie au XVII siècle et les collections européennes*, Chateau de Chambord, 18 and 19 october 1996, forthcoming

Bijl et al. 1989

M. Bijl, M. Zeldenrust & W.Th. Kloek, 'Pieter Aertsen in het restauratie-atelier van het Rijksmuseum', *Nederlands Kunsthistorisch Jaarboek* 40 (1989), pp. 197-233

Van Binnebeke 1993

E.J.B.D. van Binnebeke, 'Een godheid zonder harnas. Over Van Tetrode, Goltzius en een bronzen Olympiër', *Bulletin van het Rijksmuseum* 41 (1993) 1, pp. 16-19

Bonger 1989

H. Bonger, 'Prins Willem van Oranje en Coornhert', H. Bonger et al. (eds.), *Dirck Volckertszoon Coornhert: dwars maar recht*, Zutphen 1989, pp. 44-59

Van der Boom 1940

A. van der Boom, *Monumentale glasschilderkunst in Nederland*, The Hague 1940

Van der Boom 1949

A. van der Boom, 'Een Nederlands glasschilder in den vreemde: Aerdt Ortkens van Nijmegen', *Nederlands Kunsthistorisch Jaarboek* 2 (1948-49), The Hague 1949, pp. 75-103

Van der Boom 1960

A. van der Boom, *De kunst der glazeniers in Europa 1100-1600*, Amsterdam 1960

Boon 1953

K.G. Boon, 'Maria en het Kind en twee Heiligen door Jan Gossaert getekend', *Bulletin van het Rijksmuseum* 1 (1953) 3, pp. 65-71

Brandenbarg 1990

T. Brandenbarg, *Heilig familieleven: verspreiding en waardering van de historie van Sint-Anna in de stedelijke cultuur in de Nederlanden en het Rijnland aan het begin van de moderne tijd (15de/16de eeuw)*, Nijmegen 1990

Braunfels 1956

W. Braunfels, 'Giovanni Bellinis Paradiesgärtlein', *Aus Münster* 9 (1956), pp. 1-13

Breen 1924

J.C. Breen, 'Het eerste bezoek van prins Willem I aan Amsterdam na de Alteratie van 1578', *Jaarboek Amstelodamum* 21 (1924), pp. 63-81

Brom 1901

G. Brom, 'Kerksieraden van Oudmunster', *Archief voor de geschiedenis van het aartsbisdom Utrecht* 27 (1901), pp. 377-99

Broos 1987

B. Broos, *Meesterwerken in het Mauritshuis*, The Hague 1987

Broos 1988

B.P.J. Broos, *Het Mauritshuis, 's Gravenhage: gids van het koninklijk kabinet van schilderijen*, The Hague 1988

Browe 1967

P. Browe, *Die Verehrung der Eucharistie im Mittelalter*, Rome 1967

Bruyn 1960

J. Bruyn, 'Twee St. Antonius-panelen en andere werken van Aertgen van Leyden', *Nederlands Kunsthistorisch Jaarboek* 11 (1960), pp. 37-119

Bruyn 1961

J. Bruyn, 'Een portrettekening van Hendrick Goltzius', *Bulletin van het Rijksmuseum* 9 (1961) 4, pp. 135-39

Bruyn 1984

J. Bruyn, 'Over de betekenis van het werk van Jan van Scorel omstreeks 1539 voor oudere en jongere tijdgenoten, III: de positie van Jan Cornelisz Vermeyen', *Oud Holland* 98 (1984), p. 1-12

Bruyn 1987

J. Bruyn, 'Tekeningen uit de werkplaats van Pieter Coecke van Aelst voor een serie glasruitjes met de *Trionfi*', *Nederlands Kunsthistorisch Jaarboek* 38 (1987), pp. 73-86

De Bruyn Kops 1975

C.J. de Bruyn Kops, 'De Zeven Werken van Barmhartigheid van de Meester van Alkmaar gerestaureerd', *Bulletin van het Rijksmuseum* 23 (1975), pp. 203-26

Van Bueren 1993

T. van Bueren, *Tot lof van Haarlem: het beleid van de stad Haarlem ten aanzien van de kunstwerken uit de geconfisqueerde geestelijke instellingen*, Hilversum 1993

Buijs 1989

H. Buijs, 'Voorstellingen van Christus in het huis van Martha en Maria in het zestiende-eeuwse keukenstuk', *Nederlands Kunsthistorisch Jaarboek* 40 (1989), pp. 93-128

Bulletin van het Rijksmuseum 1996
'Keuze uit de aanwinsten', *Bulletin van het Rijksmuseum* 44 (1996) 2, pp. 61-63

Campbell 1990
L. Campbell, *Renaissance portraits: European portrait painting in the 14th, 15th and 16th centuries*, New Haven 1990

Castelnuovo 1990
E. Castelnuovo (ed.), *Gli Arazzi del Cardinale: Bernardo Cles e il ciclo della passione di Pieter van Aelst*, Trento 1990

Cat. Amsterdam 1952a
Catalogus van goud- en zilverwerken benevens zilveren, loden en bronzen plaquetten, Amsterdam (Rijksmuseum) 1952

Cat. Amsterdam 1952b
Catalogus van meubelen en betimmeringen, Amsterdam (Rijksmuseum) 1952

Cat. Amsterdam 1973
J. Leeuwenberg & W. Halsema-Kubes, *Beeldhouwkunst in het Rijksmuseum*, The Hague & Amsterdam 1973

Cat. Amsterdam 1976
P.J.J. van Thiel et al., *All the paintings of the Rijksmuseum in Amsterdam*, Amsterdam & Maarssen 1976

Cat. Amsterdam 1978
K.G. Boon, *Netherlandish drawings of the fifteenth and sixteenth centuries in the Rijksmuseum*, 2 vols., The Hague & Amsterdam 1978

Cat. Amsterdam 1979
cat. Amsterdam, *Nederlands zilver/Dutch silver 1580-1830*, The Hague & Amsterdam (Rijksmuseum) 1979

Cat. Amsterdam 1986
O. ter Kuile, *Koper en brons*, The Hague & Amsterdam (Rijksmuseum) 1986

Cat. Amsterdam 1987
Marijn Schapelhouman, *Nederlandse tekeningen/Netherlandish Drawings - omstreeks/circa 1600 in the Rijksmuseum*, The Hague & Amsterdam 1987

Cat. Amsterdam 1992
P.J.J. van Thiel et al., *All the paintings of the Rijksmuseum in Amsterdam: first supplement 1976-91*, Amsterdam & The Hague 1976

Cat. Amsterdam 1993
P.C. Ritsema van Eck, H.M. Zijlstra-Zweens, *Glass in the Rijksmuseum*, vol. 1, Amsterdam 1993

Cat. Amsterdam 1995
P.C. Ritsema van Eck, *Glass in the Rijksmuseum*, vol. 2, Amsterdam 1995

Cat. The Hague 1993
B. Broos, *Intimacies & intrigues: history painting in the Mauritshuis*, The Hague & Ghent 1993

Cat. London 1980
G. Wingfield Digby & W. Hefford, *The tapestry collection, medieval and Renaissance: Victoria and Albert Museum*, London 1980

Cat. Madrid 1986
P. Junquera de Vega & C. Herrero Carretero (eds.), *Catalogo de tapices del Patrimonio Nacional*, vol. 1, Madrid 1986

Cat. Paris 1992
K.G. Boon, *The Netherlandish and German drawings of the XVth and XVIth centuries of the Frits Lugt Collection*, 3 vols., Paris 1992

Châtelet 1980
A. Châtelet, *Early Dutch painting: painting in the Northern Netherlands in the fifteenth century*, Amsterdam 1980

Davidson/Seiler 1992
C. Davidson & Th.H. Seiler (eds.), *The iconography of hell*, Kalamazoo 1992

Defoer 1994
H.L.M. Defoer, 'Een laatmiddeleeuws schoorsteenfries uit Utrecht met de bekoring van Antonius', *Nederlands Kunsthistorisch Jaarboek* 45 (1994), pp. 301-23

Delmarcel 1989
G. Delmarcel, 'Text and image: some notes on the Tituli of Flemish 'Triumphs of Petrarch' tapestries', L. Monnas & H. Granger-Taylor (eds.), *Ancient and medieval textiles: studies in honour of Donald King*, Oxford 1989, pp. 321-29

Dubbe 1980
B. Dubbe, 'Het huisraad in het Oostnederlandse burgerwoonhuis in de late middeleeuwen', exhib. cat. Zwolle 1980, pp. 21-86

Dudok van Heel 1986
S.A.C. Dudok van Heel, 'Een kooplieden-patriciaat kijkt ons aan of de emancipatie van het Amsterdamse portret tot 1578', R. Kistemaker & M. Jonker (eds.), exhib. cat. *De smaak van de elite: Amsterdam in de eeuw van de beeldenstorm*, Amsterdam (Amsterdams Historisch Museum) 1986, pp. 19-40

Dudok van Heel 1996
S.A.C. Dudok van Heel, 'Twee figuren teveel: de familie Cat en hun memorietafel uit 1517', *Jaarboek van het Centraal Bureau voor Genealogie* 50 (1996), pp. 199-223

Dumortier 1986
C. Dumortier, 'Het atelier van de Antwerpse geleyerspotbacker Franchois Frans (16de eeuw)', *Mededelingenblad van de Nederlandse vereniging van vrienden van ceramiek* 125 (1985-86), pp. 4-32

Van Eck 1994
A. van Eck, *Kunst, twist en devotie: Goudse katholieke schuilkerken 1572-1795*, Delft 1994

Eelkman Rooda-Hoogterp 1983
L.E. Eelkman Rooda-Hoogterp, 'De zilveren schoutenstaf uit 1518 van de Utrechtse Sint-Salvatorkerk', *Antiek* 18 (1983) 3, pp. 128-33

Esser 1986
W. Esser, *Die Heilige Sippe: Studien zu einem spätmittelalterlichen Bildthema in Deutschland und den Niederlanden*, Bonn 1986

Esser 1991
D. Esser, *Ubique Diabolus - der Teufel ist überall: Aspekte mittelalterliche Moralvorstellungen und die Kulmination moralisierender Weltgerichtsbilder der 15. Jahrhundert*, Erlangen 1991

Exhib. cat. Aachen 1996
B. Rommé et al., exhib. cat. *Gegen den Strom: Meisterwerke niederrheinischer Skulptur in Zeiten der Reformation 1500-1550*, Aachen (Suermondt-Ludwig-Museum) 1996

Exhib. cat. Amsterdam 1880
A.D. de Vries et al., exhib. cat. *Catalogus der tentoonstelling van kunstvoorwerpen uit vroeger eeuwen uit edele metalen vervaardigd, gehouden door de maatschappij Arti et Amicitia*, Amsterdam (Arti et Amicitia) 1880

Exhib. cat. Amsterdam 1958
R. van Lutterveld et al. (eds.), exhib. cat. *Middeleeuwse kunst der Noordelijke Nederlanden*, Amsterdam (Rijksmuseum) 1958

Exhib. cat. Amsterdam 1964
C. van Lakerveld & F. van Erpers Roijaards (eds.), exhib. cat. *Pronk der gilden*, Amsterdam (Amsterdams Historisch Museum) 1964

Exhib. cat. Amsterdam 1978
J.P. Filedt Kok, exhib. cat. *Lucas van Leyden (1489 of 1494 - 1533): grafiek, met een complete oeuvre-catalogus van zijn gravures, etsen en houtsneden*, Amsterdam (Rijksprentenkabinet) 1978

Exhib. cat. Amsterdam 1980
W. Halsema-Kubes, G. Lemmens & G. de Werd, exhib. cat. *Adriaen van Wesel (ca. 1417 - ca. 1490): een Utrechts beeldhouwer uit de late middeleeuwen*, Amsterdam (Rijksmuseum) 1980

Exhib. cat. Amsterdam 1984-85
K.A. Citroen et al., exhib. cat. *Meesterwerken in zilver: Amsterdams zilver 1520-1820*, Amsterdam (Museum Willet-Holthuysen) 1984-85

Exhib. cat. Amsterdam 1985
J.P. Filedt Kok, exhib. cat. *Livelier than life: the Master of the Amsterdam Cabinet or the Housebook Master c. 1470-1500* Amsterdam (Rijksmuseum) & Maarssen 1985

Exhib. cat. Amsterdam 1986
J.P. Filedt Kok et al. (ed.), exhib. cat. *Kunst voor de beeldenstorm: Noordnederlandse kunst 1525-1580*, Amsterdam (Rijksmuseum) 1986

Exhib. cat. Amsterdam 1992
E. Bergvelt & R. Kistemaker (eds.), exhib. cat. *De wereld binnen handbereik: Nederlandse kunst- en rariteitenverzamelingen 1585-1735*, 2 vols., Amsterdam (Amsterdams Historisch Museum) 1992

Exhib. cat. Amsterdam 1993
G. Delmarcel, exhib. cat. *Koninklijke pracht in goud en zijde: Vlaamse wandtapijten van de Spaanse kroon*, Amsterdam (Nieuwe Kerk, in collaboration with the Rijksmuseum) 1993

Exhib. cat. Amsterdam 1993-94
> G. Luijten et al. (eds.), exhib. cat. Dawn of the Golden Age: northern Netherlandish art 1580-1620, Amsterdam (Rijksmuseum) 1993-94

Exhib. cat. Amsterdam 1994
> H. van Os, exhib. cat. The art of devotion in the late middle ages in Europe, 1300-1500, Amsterdam (Rijksmuseum) & London 1994

Exhib. cat. Amsterdam 1997
> E. de Jongh & G. Luijten, exhib. cat. Mirror of everyday life: genre prints in the Netherlands 1550-1700, Amsterdam (Rijksprentenkabinet) 1997

Exhib. cat. Antwerp 1988-89
> G. van Hemeldonk, exhib. cat. Zilver uit de Gouden Eeuw van Antwerpen, Antwerp (Rockoxhuis) 1988-89

Exhib. cat. Antwerp 1993
> J. van der Stock (ed.), exhib. cat. Antwerp: story of a Metropolis, 16th-17th century, Antwerp (Hessenhuis) & Ghent 1993

Exhib. cat. Antwerp 1994
> K. Moens & I. Kockelbergh, exhib. cat. Muziek en grafiek: burgermoraal en muziek in de 16de en 17de eeuwse Nederlanden, Antwerp (Hessenhuis) 1994

Exhib. cat. Berlin 1975
> Exhib. cat. Pieter Bruegel d. Ae. als Zeichner: Herkunft und Nachfolge, Berlin (Kupferstichkabinett Staatliche Museen) 1975

Exhib. cat. Berlin 1995
> V. Krahn (ed.), exhib. cat. Von allen Seiten schön: Bronzen der Renaissance und des Barock, Berlin (Altes Museum) 1995

Exhib. cat. Boston/St. Louis 1980-81
> C.S. Ackley, exhib. cat. Printmaking in the age of Rembrandt, Boston (Museum of Fine Arts) & St. Louis (The Saint Louis Art Museum) 1980-81

Exhib. cat. Bruges 1998
> M.P.J. Martens et al., exhib. cat. Brugge en de Renaissance: van Memling tot Pourbus, 2 vols., Bruges (Memlingmuseum) 1998

Exhib. cat. Brussels 1976
> Exhib. cat. Brusselse wandtapijten van de pre-renaissance, Brussels (Koninklijke Musea voor Kunst en Geschiedenis) 1976

Exhib. cat. Brussels 1991
> J. van der Stock (ed.), exhib. cat. Stad in Vlaanderen: cultuur en maatschappij 1477-1787, Brussels (Galerij van het Gemeentekrediet) 1991

Exhib. cat. Delft 1969
> Exhib. cat. Een glasie van vrienschap: de glazen uit de collectie Guépin, Delft (Het Prinsenhof) 1969

Exhib. cat. Den Bosch 1971
> G. Lemmens & G. de Werd (eds.), exhib. cat. Beelden uit Brabant: laatgotische kunst uit het oude hertogdom 1400-1520, Den Bosch (Noord-Brabants Museum) 1971

Exhib. cat. Den Bosch 1985
> A.M. Koldeweij (ed.), exhib. cat. Zilver uit 's-Hertogenbosch: van Bourgondisch tot Biedermeier, Den Bosch (Noord-Brabants Museum) 1985

Exhib. cat. Den Bosch 1990
> A.M. Koldeweij, exhib. cat. In Buscoducis 1450-1629: kunst uit de Bourgondische tijd te 's Hertogenbosch, Den Bosch (Noord-Brabants Museum) 1990

Exhib. cat. Ghent 1994
> J.W. Steyaert et al., exhib. cat. Laatgotische beeldhouwkunst in de Bourgondische Nederlanden, Ghent (Museum voor Schone Kunsten) 1994

Exhib. cat. Haarlem 1986
> I.M. Veldman, exhib. cat. Leerrijke reeksen van Maarten van Heemskerk, Haarlem (Frans Halsmuseum) 1986

Exhib. cat. Horst 1974
> W.Th.M. Hendriks et al., exhib. cat. De Meester van Elsloo: Oppergelders beeldsnijder XVIde eeuw, Horst (Gemeentekantoor) 1974

Exhib. cat. Leeuwarden 1971
> Exhib. cat. Antwerps plateel, Leeuwarden (Fries Museum) 1971

Exhib. cat. London 1995-96
> K. Hearn (ed.), exhib. cat. Dynasties: painting in Tudor and Jacobean England 1530-1630, London (Tate Gallery) 1995-96

Exhib. cat. New York 1995
> T.B. Husband et al., exhib. cat. The luminous image: painted glass roundels in the Lowlands 1480-1560, New York (Metropolitan Museum of Art) 1995

Exhib. cat. Rotterdam 1994
> H.E. Henkes, exhib. cat. Glas zonder glans: vijf eeuwen gebruiksglas uit de bodem van de Lage Landen 1300-1800, Rotterdam (Museum Boymans van Beuningen) 1994

Exhib. cat. Rotterdam/Bruges 1965
> H. Pauwels, H.R. Hoetink & S. Herzog, exhib. cat. Jan Gossaert genaamd Mabuse, Rotterdam (Museum Boymans van Beuningen) & Bruges (Groeningemuseum) 1965

Exhib. cat. Rotterdam/Washington 1985-86
> Exhib. cat. Jacques de Gheyn II als tekenaar, Rotterdam (Museum Boymans van Beuningen) & Washington (National Gallery of Art) 1985-86

Exhib. cat. Sint-Truiden 1990
> C. Ceulemans et al., exhib. cat. Laatgotische beeldsnijkunst uit Limburg en grensland, Sint-Truiden (Provinciaal Museum voor Religieuze Kunst) 1990

Exhib. cat. Trier 1967
> Gh. Derveaux-van Ussel, exhib. cat. Mechelner Alabaster, Trier (Städtisches Museum) 1967

Exhib. cat. Uden 1986
> L.C.B.M. van Liebergen (ed.), exhib. cat. Birgitta van Zweden (1303-1373): 600 jaar kunst en cultuur van haar kloosterorde, Uden (Museum voor Religieuze Kunst) 1986

Exhib. cat. Uden 1992
> T. Brandenbarg et al., exhib. cat. Heilige Anna, Grote Moeder: de cultus van de heilige Moeder Anna en haar familie in de Nederlanden en aangrenzende streken, Uden (Museum voor Religieuze Kunst) 1992

Exhib. cat. Utrecht 1987
> S.F.M. de Bodt, exhib. cat. Schilderen met gouddraad en zijde, Utrecht (Rijksmuseum Het Catharijneconvent) 1987

Exhib. cat. Utrecht 1994
> P. van Boheemen & P. Dirkse, exhib. cat. Duivels en demonen: de duivel in de Nederlandse beeldcultuur, Utrecht (Museum het Catharijneconvent) 1994

Exhib. cat. Washington/Boston 1983
> E.S. Jacobowitz & S.L. Stepanek, exhib. cat. The prints of Lucas van Leyden & his contemporaries, Washington (National Gallery of Art) & Boston (Museum of Fine Arts) 1983

Exhib. cat. Washington/Detroit/Amsterdam 1980-81
> A. Blankert et al., exhib. cat. Gods, saints and heroes: Dutch painting in the age of Rembrandt Washington (National Gallery of Art), Detroit (Detroit Institute of Art) & Amsterdam (Rijksmuseum) 1980-81

Exhib. cat. Washington/New York 1986-87
> J.O. Hand et al., exhib. cat. The age of Bruegel: Netherlandish drawings in the sixteenth century, Washington (National Gallery of Art) & New York (Pierpont Morgan Library) 1986-87

Exhib. cat. Worcester 1987
> V. Chieffo Raguin et al., exhib. cat. Northern Renaissance stained glass: continuity and transformations, Worcester (College of the Holy Cross, Iris and B. Gerald Cantor Art Gallery) 1987

Exhib. cat. Zürich 1994
> P. Jezler, exhib. cat. Himmel, Hölle, Fegefeuer: das Jenseits im Mittelalter, Zürich (Schweizerisches Landesmuseum) 1994

Exhib. cat. Zwolle 1980
> J.W.M. de Jong, exhib. cat. Thuis in de late middeleeuwen: het Nederlands burgerinterieur 1400-1535, Zwolle (Provinciaal Overijssels Museum) 1980

Falkenburg 1988
> R.L. Falkenburg, Joachim Patinir: landscape as an image of the pilgrimage of life, Amsterdam 1988

Falkenburg et al. (eds.) 1991-92
> R. Falkenburg, J.P. Filedt Kok & H. Leeflang (eds.), Goltzius-studies: Hendrick Goltzius (1558-1617), Nederlands Kunsthistorisch Jaarboek 42-43 (1991-92)

Falkenburg 1994
> R.L. Falkenburg, The fruit of devotion: mysticism and the imagery of love in Flemish paintings of the Virgin and Child 1450-1550, Amsterdam 1994

Fehl 1970

P. Fehl, 'Peculiarities in the relation of text and image in two prints by Pieter Bruegel: the *Rabbit hunt* and *Fides*', *North Carolina Museum of Art Bulletin* 9 (1970), no. 3, pp. 25-35

Filedt Kok 1978

J.P. Filedt Kok, 'Underdrawing and other technical aspects in the paintings of Lucas van Leyden', *Nederlands Kunsthistorisch Jaarboek* 29 (1978), pp. 1-184

Filedt Kok 1989

J.P. Filedt Kok, 'Meester W met de sleutel: Gotisch kerkinterieur, ca. 1490', *Bulletin van het Rijksmuseum* 37 (1989), pp. 166-68

Filedt Kok 1990

J.P. Filedt Kok, 'Master IAM of Zwoll: the personality of a designer and engraver', *Festschrift to Erik Fischer: European drawings from six centuries*, Copenhagen 1990, pp. 341-56

Filedt Kok 1993

J.P. Filedt Kok, 'Hendrick Goltzius: engraver, designer and publisher 1582-1600', *Nederlands Kunsthistorisch Jaarboek* 42-43 (1991-92), pp. 159-218

Filedt Kok 1994-95

J.P. Filedt Kok, 'Jan Harmensz Muller as printmaker I-III', *Print Quarterly* 11 (1994), pp. 223-64, 351-78; *Print Quarterly* 12 (1995), pp. 3-29

Filedt Kok 1996a

J.P. Filedt Kok, 'Over de Calvarieberg: Albrecht Dürer in Leiden, omstreeks 1520', *Bulletin van het Rijksmuseum* 44 (1996) 4, pp. 335-59

Filedt Kok 1996b

J.P. Filedt Kok et al., *The new Hollstein Dutch and Flemish etchings, engravings and woodcuts 1450-1700: Lucas van Leyden*, Rotterdam 1996

Filedt Kok 1998

J.P. Filedt Kok (with E. Bergvelt), 'De vroege Nederlandse schilderkunst in het Rijksmuseum', *Bulletin van het Rijksmuseum* 46 (1998), pp. 125-205

Forti Grazzini 1994

N. Forti Grazzini, *Il patrimonio artistico del Quirinale: Gli Arazzi*, 2 vols., Rome 1994

Foucart/Rosenberg 1978

J. Foucart & P. Rosenberg, 'Some modelli of religious scenes by Dirck Barendsz.', *The Burlington Magazine* 120 (1978), pp. 198-204

Frederiks 1961

J.W. Frederiks, *Dutch Silver from the Renaissance until the 18th Century*, 4 vols., The Hague 1952-61

Friedländer 1917

M.J. Friedländer, 'Der niederländische Glasmaler Aerdt Ortkens', *Amtliche Berichte aus den Könichlichen Kunstsammlungen* 38 (1917), pp. 161-76

Friedländer 1967-76

M.J. Friedländer, *Early Netherlandish painting*, 14 vols., Leiden 1967-76

Gebhard 1882

J.F. Gebhard Jr, *Het leven van mr. Nicolaes Cornelisz. Witsen (1641-1717)*, vol. 2, Utrecht 1882

Gibson 1977

W.S. Gibson, *The paintings of Cornelis Engebrechtsz.*, New York 1977

Göbel 1923

H. Göbel, *Wandteppiche, I: die Niederlande*, Leipzig 1923, pp. 302-08

Golan 1996

S.R. Golan, *Scenes from Roman republican history in seventeenth-century Dutch art*, diss., Ann Arbor 1994

Gorissen 1964

F. Gorissen, 'Das Werk des Ludwig Juppe von Marburg in Kalkar', *Rheinische Heimatpflege* 1 (1964), pp. 13-37

Gramaccini 1987

N. Gramaccini, 'Zur Ikonologie der Bronze im Mittelalter', *Städel-Jahrbuch* 11 (1987), pp. 147-70

Haarsma 1989

E. Haarsma, *Een laatgotisch gebeeldhouwd reliëf: een unicum van excellente kwaliteit*, Utrecht (Rijksuniversiteit, vakgroep Kunstgeschiedenis) 1989 (unpublished study)

Halm 1921-22

Ph.M. Halm, 'Ikonographische Studien zum Armen-Seelen-Kultus', *Münchner Jahrbuch* 12 (1921-22), pp. 1-24

Halsema-Kubes 1968

W. Halsema-Kubes, 'Een gebeeldhouwde blaasbalg in het Rijksmuseum', *Antiek* 3 (1968) 5, pp. 253-57

Halsema-Kubes 1971

W. Halsema-Kubes, 'Een Mechelse H. Sebastiaan', *Bulletin van het Rijksmuseum* 19 (1971) 4, pp. 183-88

Halsema-Kubes 1975

W. Halsema-Kubes, 'Een Ursula-beeld door Henrik Douvermann', *Bulletin van het Rijksmuseum* 23 (1975) 2, pp. 63-66

Harbison 1995

C. Harbison, *The art of the northern Renaissance*, London 1995

Hartkamp-Jonxis 1997

E. Hartkamp-Jonxis, 'Suzanna op tafel of non plus ultra op linnendamast', *Antiek* 31 (1997), no. 7, pp. 298-305

Van Hasselt 1896

L. van Hasselt, 'Bewoners en inboedel van het huis Toutenburg bij Vollenhove omstreeks 1571', *Bijdragen tot de geschiedenis van Overijssel* 2 (1896), p. 55-119

Hayward 1976

J.F. Hayward, *Virtuoso goldsmiths and the triumph of Mannerism 1540-1620*, London 1976

Heezen-Stoll 1987

B.A. Heezen-Stoll, "Cornelis Ketel, uytnemende schilder, van der Goude": een iconografische studie van zijn "historiën", Delft 1987

Heijbroek 1985

J.F. Heijbroek, 'Adriaan Pit: directeur van het Nederlandsch Museum', *Bulletin van het Rijksmuseum* 33 (1985), pp. 233-65

Heijbroek 1995

J.F. Heijbroek, 'Het Koninklijk Oudheidkundig Genootschap (1858-1995): een historisch overzicht', *Leids Kunsthistorisch Jaarboek* 10 (1995), pp. 9-32

Van Herwaarden 1982

J. van Herwaarden, 'Geloof en geloofsuitingen in de veertiende en vijftiende eeuw: Eucharistie en Lijden van Jezus', J.D. Janssens (ed.), *Hoofsheid en devotie in de middeleeuwse maatschappij: de Nederlanden van de 12de tot de 15de eeuw* (Handelingen van het wetenschappelijk colloquium te Brussel, 21-24 oktober 1981), Brussels 1982, pp. 175-207

Hilger 1990

H.P. Hilger, *Stadtpfarrkirche St. Nicolai in Kalkar*, Kleef 1990

Hollstein 1949-

Hollstein's Dutch & Flemish etchings, engravings and woodcuts ca. 1450-1700, Amsterdam 1949-87; Roosendaal 1988-94; Rotterdam 1995-

Honnens de Lichtenberg 1991

H. Honnens de Lichtenberg, *Johan Gregor van der Schardt: Bildhauer bei Kaiser Maximilian II, am dänischen Hof und bei Tycho Brahe*, Copenhagen 1991

Horn 1989

H.J. Horn, *Jan Cornelisz Vermeyen: painter of Charles V and his conquest of Tunis*, 2 vols., Doornspijk 1989

Huizinga 1997

J. Huizinga, *Herfstij der middeleeuwen* (ed. A. van der Lem), 21st impression, Amsterdam 1997

Van IJsselstein 1936

G.T. Van IJsselsteijn, *Geschiedenis der tapijtweverijen in de Noordelijke Nederlanden: bijdrage tot de geschiedenis der kunstnijverheid*, Leiden 1936

Van IJsselstein 1962

G.T. van IJsselsteyn, *White figurated linen damask from the 15th to the beginning of the 19th century*, The Hague 1962

Israel 1995

J. Israel, *The Dutch Republic: its rise, greatness and fall*, Oxford 1995

Jansen 1964

A. Jansen, 'Mechelse albasten', *Handelingen van de Koninklijke Kring voor Oudheidkunde, Letteren en Kunst van Mechelen*, 68 (1964), pp. 111-91

Jensen Adams 1995

A. Jensen Adams, 'Civic guard portraits: private interests and the public sphere', *Nederlands Kunsthistorisch Jaarboek* 46 (1995), pp. 169-97

De Jong 1975-76

P.J. de Jong, 'Sinte Aelwaer; een parodiërende rijmprent', *Spektator* 5 (1975-76), pp. 128-41

Judson 1973
 J.R. Judson, *The drawings of Jacob de Gheyn II*, New York 1973

Kammel 1994
 F.M. Kammel, 'Joes Beyaert (1405-1483): een onbekend werk van deze Leuvense beeldhouwer', *Antiek*, 29 (1994) 3, pp. 16-19

Kaufmann 1988
 T. DaCosta Kaufmann, *The school of Prague: painting at the court of Rudolf II*, Chicago 1988

Van der Kellen 1856-62
 D. van der Kellen, *Nederlands oudheden*, The Hague 1856-62

Kloek 1989
 W.Th. Kloek, 'Jacob Cornelisz van Oostsanen: drieluik met de Aanbidding der koningen en de heiligen Hiëronymus en Catharina met stichters en op de keerzijde der luiken de heiligen Christoforus en Antonius Abt, 1517', *Bulletin van het Rijksmuseum* 37 (1989) 3, pp. 169-70

Kloek 1993
 W.Th. Kloek, 'Abraham Bloemaert en de Prediking van Johannes de Doper', *Antiek* 28 (1993) 5, pp. 196-203

Kloek/Filedt Kok 1983
 W.Th. Kloek & J.P. Filedt Kok, 'De opstanding van Christus, getekend door Lucas van Leyden', *Bulletin van het Rijksmuseum* 31 (1983), pp. 4-20

Kloek et al. 1986
 W.Th. Kloek, W. Halsema-Kubes & R.J. Baarsen, *Kunst voor de beeldenstorm: Noordnederlandse kunst 1525-1580*, vol. 1, Introduction, The Hague 1986

Klomp 1993
 H.G.C.M. Klomp, 'Het tympaan van Egmond: kunst als instrument van propaganda', G.M.M. Vis, with J.P. Gumbert (ed.), *Egmond tussen Kerk en wereld*, Hilversum 1993, pp. 139-61

Knevel 1994
 P. Knevel, *Burgers in het geweer: de schutterijen in Holland 1550-1700*, Hilversum 1994

Knevel 1996
 P. Knevel, 'Het meesterwerk van een provinciaal schilder: over de Zeven werken van barmhartigheid van de Meester van Alkmaar', in L. Noordegraaf (ed.), *Glans en glorie van de grote kerk: het interieur van de Alkmaarse Sint Laurens*, Hilversum 1996, pp. 229-46

Knippenberg 1970
 W.H.Th. Knippenberg, 'Bredase monstransen uit de 15de en 16de eeuw', *Jaarboek Geschied- en Oudheidkundige Kring van Stad en Land van Breda 'De Oranjeboom'* 23 (1970), pp. 63-68

Koch 1985
 R.A. Koch, 'A reflection in Princeton of a lost Epiphany by Hugo van der Goes', W.W. Clark et al., *Tribute to Lotte Brand Philip, art historian and detective*, New York 1985, pp. 82-87

Konowitz 1987
 E. Konowitz, 'Glass designer Dierick Vellert', V. Chieffo Raguin et al., exhib. cat. *Northern Renaissance stained glass: continuity and transformations*, Worcester (College of the Holy Cross, Iris and B. Gerald Cantor Art Gallery) 1987

Konowitz 1992
 E. Konowitz, *Dirk Jacobsz. Vellert: a study of his stained glass windows, drawings and prints*, New York 1992

Konowitz 1995
 E. Konowitz, 'The roundel series of Dirick Vellert', T.B. Husband et al., exhib. cat. *The luminous image: painted glass roundels in the Lowlands, 1480-1560*, New York (Metropolitan Museum of Art) 1995, pp. 142-57

Lafond 1942
 J. Lafond, *La résurrection d'un Maître d'Autrefois: le peintre-verrier Arnoult de Nimègue*, Rouen 1942

Landau/Parshall 1994
 D. Landau & P. Parshall, *The Renaissance print 1470-1550*, New Haven & London 1994

Larsson 1967
 L.O. Larsson, *Adriaen de Vries: Adrianus Fries Hagensis Batavus 1545-1626*, Vienna & Munich 1967

Lebeer 1969
 L. Lebeer, *Beredeneerde catalogus van de prenten naar Pieter Bruegel de Oude*, Brussels 1969

Leeuwenberg 1959
 J. Leeuwenberg, 'Een nieuw facet aan de Utrechtse Beeldhouwkunst III: vijf Utrechtse Altaarkasten in Noorwegen', *Oud Holland* 74 (1959), pp. 79-102

Leeuwenberg 1968
 J. Leeuwenberg, 'De gebedsnoot van Eewert Jansz van Bleiswick en andere werken van Adam Dirksz', *Miscellanea Jozef Duverger. Bijdragen tot de Kunstgeschiedenis der Nederlanden*, vol. 2, Ghent 1968, pp. 614-24

Leeuwenberg 1978
 J. Leeuwenberg, 'Geweikronen, ook in de Nederlanden', *Antiek* 13 (1978) 3, pp. 161-98

Leeuwenberg/Gorissen 1958
 J. Leeuwenberg & F. Gorissen, 'De Meester van het St. Joris-altaar te Kalkar', *Oud Holland* 73 (1958), pp. 18-42

Lehrs 1908-34
 M. Lehrs, *Geschichte und kritischer Katalog des deutschen, niederländischen und französischen Kupferstichs im XV. Jahrhundert*, 9 vols., Vienna 1908-34

Liederwald 1964
 A.-E. Liederwald, *Niederländische Glasformen des 17. Jahrhunderts*, Freiburg i.Br. 1964

Luijten 1984
 G. Luijten, '"De veelheid en de eelheid": een Rijksmuseum Schmidt-Degener', *Nederlands Kunsthistorisch Jaarboek* 35 (1984), pp. 351-429

Lunsingh Scheurleer 1946
 Th.H. Lunsingh Scheurleer, 'Het Koninklijk Kabinet van Zeldzaamheden en zijn beteekenis voor het Rijksmuseum', *Bulletin van den Nederlandschen Oudheidkundigen Bond* 13 (1946), pp. 50-67

Lunsingh Scheurleer 1948
 Th.H. Lunsingh Scheurleer, 'Een laat-Gotisch dressoir in het Rijksmuseum', *Oud Holland* 63 (1948), pp. 93-107

Mak 1958
 J.J. Mak, *Middeleeuwse kerstvoorstellingen*, Utrecht 1958

Van Mander 1604
 Karel van Mander, *Schilder-boeck*, Haarlem 1604

Marks 1977
 R. Marks, 'Two early 16th Century boxwood carvings associated with the Glymes family of Bergen op Zoom', *Oud Holland* 91 (1977), pp. 132-43

Masseron 1957
 A. Masseron, *Saint Jean Baptiste dans l'art*, Paris 1957

Maudet 1837
 C. Maudet, *Recueil d'objets d'arts et de curiosités dessinés d'après nature par T. Jolimont et J. Cagniet*, Paris 1837

Meijer 1988
 B.W. Meijer, *Parma e Bruxelles: committenza e collezionismo farnesiani alle due corti*, Florence 1988

Mesenzeva 1978
 Ch.A. Mesenzeva, 'Spätgotische Miniaturschnitzereien in der Ermitage in Leningrad', *Pantheon* 36 (1978) 1, pp. 31-35

Meurer 1970
 H. Meurer, *Das Klever Chorgestühl und Arnt Beeldesnider*, Düsseldorf 1970

Mielke 1996
 H. Mielke, *Pieter Bruegel: die Zeichnungen*, Turnhout 1996

Van Molle 1959
 F.J. van Molle, 'Een laatgotisch wandtabernakel in de Sint-Elisabethkerk te Haren (Brussel)', *Bulletin de l'Institut Royal du Patrimoine Artistique* 2 (1959), pp. 163-70

Van Molle 1971
 F.J. van Molle, 'Edelsmeedkunst: aspekten van de Laatgotiek in Brabant', *Artium Minorum Folia Lovaniensia* 3 (1971), pp. 539-69

Mulder 1903
 A. Mulder, 'Iets over de Leidsche St. Pieterskerk, hare geschiedenis en architectuur', *Bulletin uitgegeven door den Nederlandschen Oudheidkundige Bond* 5 (1903-1904), pp. 57-84

Nijstad 1986
 J. Nijstad, 'Willem Danielsz. van Tetrode', *Nederlands Kunsthistorisch Jaarboek* 37 (1986), pp. 259-79

Van Os 1979
 H.W. van Os, 'De gebreken van de beeldtaal', *Openbaar Kunstbezit* 23 (1979), no. 5, pp. 130-36

Van Os 1995

H.W. van Os, 'Oh, Suzanna', H.W. van Os, *Torens van Babel*, Baarn 1995, pp. 51-54

Van Os 1996

H.W. van Os, 'Mediteren op Golgotha', *Bulletin van het Rijksmuseum* 44 (1996) 4, pp. 361-80

Piquard 1950

M. Piquard, 'Le Cardinal de Granvelle: amateur de tapisseries', *Revue Belge d'Archeologie et d'Histoire de l'Art* 19 (1950) 1-2, pp. 111-26

Pleij 1979

H. Pleij, *Het gilde van de Blauwe Schuit: literatuur, volksfeest en burgermoraal uit de late middeleeuwen*, Amsterdam 1979

Plomp 1977

N. Plomp, 'Een Linschotens schilderstuk uit de veertiende eeuw', *Heemtijdinghen* 13 (1977), no. 4, pp. 44-49

Popham 1927

A.E. Popham, 'Catalogue of etchings by Jan Cornelisz Vermeyen', *Oud-Holland* 44 (1927), pp. 174-82

Post 1954

P.R. Post, *Kerkelijke verhoudingen in Nederland voor de reformatie*, Utrecht 1954

Prince d'Essling/Müntz 1902

Prince d'Essling & E. Müntz, *Pétrarque (1304-1374): ses études d'art, son influence sur les artistes, ses portraits et ceux de Laure, l'illustration de ses écrits*, Paris 1902

Radcliffe 1985

A. Radcliffe, 'Schardt, Tetrode and some possible sculptural sources for Goltzius', G. Cavalli-Björkman (ed.), *Netherlandish Mannerism*, Stockholm 1985, pp. 97-108

Van Regteren Altena 1935

J.Q. van Regteren Altena, *Jacques de Gheyn: an introduction to the study of his drawings*, Amsterdam 1935

Van Regteren Altena 1938

J.Q. van Regteren Altena et al., *De Goudsche glazen 1555-1603: beschouwingen over Gouda, haar Sint Janskerk en de gebrandschilderde glazen*, The Hague 1938

Van Regteren Altena 1983

J.Q. van Regteren Altena, *Jacques de Gheyn: drie generaties*, 2 vols., The Hague 1983

Reznicek 1961

E.K.J. Reznicek, *Die Zeichnungen von Hendrick Goltzius*, 2 vols., Utrecht 1961

De Ridder 1979

J. de Ridder, 'Gerechtigheidstaferelen in de 15de en 16de eeuw, geschilderd voor Schepenhuizen in Vlaanderen', *Gentse Bijdragen tot de Kunstgeschiedenis* 25 (1979-80), pp. 42-62

Ridderbos 1984

B. Ridderbos, *Saint and symbol: images of Saint Jerome in early Italian art*, Groningen 1984

Ridderbos 1991

H.N.B. Ridderbos, *De melancholie van de kunstenaar: Hugo van der Goes en de oudnederlandse schilderkunst*, The Hague 1991

Ridderbos 1994-95

H.N.B. Ridderbos, 'Maria in Sole en de rozenkransdevotie: het tweeluik Rotterdam-Edinburgh', H.W. van Os, exhib. cat. *The art of devotion in the late middle ages in Europe, 1300-1500*, Amsterdam (Rijksmuseum) & London 1994, pp. 151-56

Ridderbos/Van Veen (eds.) 1995

B. Ridderbos & H. van Veen (eds.), *'Om iets te weten van de oude meesters': de Vlaamse primitieven, herontdekking, waardering en onderzoek*, Nijmegen 1995

Ritsema van Eck 1999

P.C. Ritsema van Eck, *Gebrandschilderde ruitjes uit de Nederlanden 1480-1560 / Painted glass roundels from the Netherlands 1480-1560*, Amsterdam & Zwolle 1999

Roberts 1989

A.M. Roberts, 'The chronology and political significance of the tomb of Mary of Burgundy', *Art Bulletin* 71 (1989), pp. 376-400

Roethlisberger 1993

M.G. Roethlisberger, *Abraham Bloemaert and his sons: paintings and prints*, 2 vols., Doornspijk 1993

Roth-Bodjazhier 1985

G. Roth-Bodjazhier, *Studien zur Bedeutung der Vögel in der mittelalterlichen Tafelmalerei*, Vienna 1985

Schéle 1965

S. Schéle, *Cornelis Bos: a study of the origins of the Netherlands grotesque*, Stockholm 1965

Van Schendel 1957a

A. van Schendel, 'De boom van Jesse en het probleem van Geertgen tot Sint Jans', *Bulletin van het Rijksmuseum* 5 (1957) 3, pp. 75-83

Van Schendel 1957b

A. van Schendel, 'Geertgen tot Sint Jans: De aanbidding der Drie Koningen', *Openbaar Kunstbezit* 1 (1957), no. 37

Schneckenburger-Broschek 1986

A. Schneckenburger-Broschek, 'Ein Niederländer als schwäbisches Genie: Neues zum Ulmer Chorgestühl', *Zeitschrift des Deutschen Vereins für Kunstwissenschaft* 40 (1986), 1-4, pp. 40-68

Schneebalg-Perelman 1969

S. Schneebalg-Perelman, 'Un grand tapissier bruxellois: Pierre d'Enghien dit Pierre van Aelst', *De bloeitijd van de Vlaamse tapijtkunst*, (internationaal colloquium te Brussel, 23-25 mei 1961), Brussels 1969, pp. 279-323

Scholten 1986

F. Scholten, 'Technische aspecten van de *Kerkprediking* en twee andere werken uit de Aertgen van Leyden-groep', *Nederlands Kunsthistorisch Jaarboek* 37 (1986), pp. 53-74

Schrade 1957

H. Schrade, 'Zur Frühgeschichte der mittelalterlichen Monumentalplastik', *Westfalen* 35 (1957) 1, pp. 33-64

Schulte Nordholt 1963

H. Schulte Nordholt, 'Meester van Spes Nostra', *Openbaar Kunstbezit* 7 (1963), no. 35

Smith 1992

E.L. Smith, *The paintings of Lucas van Leyden*, Columbia 1992

Snijder 1957

J.E. Snijder, 'Geertgen schildert de voorouders van Christus', *Bulletin van het Rijksmuseum* 5 (1957) 3, pp. 85-94

Steinbart 1921

K. Steinbart, 'Paramente nach verschollenen Malereien des Jakob Cornelisz von Amsterdam', *Kunstchronik und Kunstmarkt* 52 (1921), pp. 931-37

Sterck 1900

J.F.M. Sterck, 'De inventaris van "De Brieven, 't silverwerck ende Juweelen doude schutterie toebehoorden" Ao 1569', *Amsterdamsch Jaarboekje* (1900), pp. 106-23

Stiennon 1954

J. Stiennon, *Les sites mosans de Lucas I en Martin I van Valckenborch: essai d'identification*, Liège 1954

Strauss 1977

W. Strauss, *Hendrik Goltzius 1558-1617: complete engravings and woodcuts*, 2 vols., New York 1977

Szablowski 1972

J. Szablowski (ed.), *De Vlaamse wandtapijten van de Wawelburcht te Krakau: kunstschat van koning Sigismund II Augustus Jagello*, Antwerp 1972

Ter Molen 1995

J.R. Ter Molen, 'Zilver', *Leids Kunsthistorisch Jaarboek* 10 (1995), pp. 105-24

Van Thiel 1981

P.J.J. van Thiel, 'De inrichting van de Nationale Konst-Gallery in het openingsjaar 1800', *Oud Holland* 95 (1981), pp. 170-227

Van Thiel/Miedema 1978

P.J.J. van Thiel & H. Miedema, 'De grootmoedigheid van Scipio: een schilderij van Karel van Mander uit 1600', *Bulletin van het Rijksmuseum* 26 (1978) 2, pp. 51-59

Tiburtius Hümpfer 1927

P. Tiburtius Hümpfer, *Ikonographie des heiligen Bernhard von Clairvaux*, Cologne & Vienna 1927

Vandamme 1982

E. Vandamme, *De polychromie van gotische houtsculptuur in de Zuidelijke Nederlanden: materialen en technieken*, Brussels 1982

Van der Velden 1995

Hugo van der Velden, 'Cambyses for example: the origines and function of an *exemplum iustitiae* in Netherlandish art of the fifteenth, sixteenth and seventeenth centuries', *Simiolus* 23 (1995), pp. 5-39

Veldman 1995

I.M. Veldman, 'The Old Testament as a moral code: Old Testament stories as exempla of the Ten Commandments', *Simiolus* 23 (1995), pp. 215-39

Vermeulen 1924

G.F. Vermeulen, 'Vijftiend'eeuwsche Bredase monstransen', *Het Gildeboek* 7 (1924), pp. 33-44

Vogelsang 1906

W. Vogelsang, 'De Nederlandsche beeldhouwkunst', *Elsevier's Geïllustreerd Maandschrift* 31 (1906), pp. 367-80

Vorbrodt/Vorbrodt 1971

G.W. Vorbrodt & I. Vorbrodt, *Die akademischen Szepter und Stäbe in Europa: Corpus Sceptorum*, 2 vols., Heidelberg 1971

Vos 1978

R. Vos, *Lucas van Leyden*, Bentveld 1978

Vos/Leeman 1986

R. Vos & F. Leeman, *Het nieuwe ornament: gids voor de renaissance-architectuur en -decoratie in Nederland in de 16e eeuw*, The Hague 1986

Wallen 1983

B. Wallen, *Jan van Hemessen: an Antwerp painter between Reform and Counter-Reform*, Ann Arbor 1983

Wayment 1967

H.G. Wayment, 'A rediscovered master: Adrian van den Houte (c. 1459-1521) and the Malines/Brussels School', *Oud Holland* 82 (1967), pp. 172-202

Wayment 1969

H.G. Wayment, 'An early work by Arnold of Nijmegen in the Rijksmuseum', H. Miedema, R.W. Scheller & P.J.J. van Thiel, *Miscellanea J.Q. van Regteren Altena 16-5-1969*, Amsterdam 1969, pp. 33-35

Wayment 1972

H.G. Wayment, 'The window's of King's College Chapel Cambridge: a description and commentary', *Corpus Vitrearum Medii Aevi: Great Britain (supplementary vol. 1)*, London 1972

Wayment 1988

H.G. Wayment, *King's College Chapel Cambridge: the side-chapel*, Cambridge 1988

Weber 1966

R.E.J. Weber, 'De bodebus als onderscheidingsteken van de lopende bode', *Bulletin K.N.O.B.* 65 (1966), pp. 1-12

Wegener Sleeswijk 1994

A. Wegener Sleeswijk, 'De Graveur WA: een speurtocht', *Gens Nostra* 49 (1994), pp. 1-13

De Werd 1993

G. de Werd, 'Das Altarfragment mit der Anbetung der Hl. Drei Könige: ein Hauptwerk des Meisters Arnt von Kalkar', G. de Werd & H. Westermann-Angerhausen, *Arnt von Kalkar und Zwolle: das Dreikönigenrelief*, Cologne 1993, pp. 11-45

White 1979

C. White, '"The rabbit hunters" by Pieter Bruegel the Elder', in O. von Simson & M. Winner (eds.), *Pieter Bruegel und seine Welt: ein Colloquium*, Berlin 1979, pp. 187-91

Widerkehr 1993

L. Widerkehr, 'Jacob Matham Goltzij Privignus: Jacob Matham graveur et ses rapports avec Hendrick Goltzius', *Nederlands Kunsthistorisch Jaarboek* 42-43 (1991-92), pp. 219-60

Wied 1989

A. Wied, *Lucas und Marten van Valckenborch (1535-1597 und 1534-1612): das Gesamtwerk mit kritischem Oeuvrekatalog*, Freren 1989

Wiggers 1995

H.J. Wiggers, 'De stad Amsterdam en haar vroegste beeldencollectie', M. Jonker et al., exhib. cat. *In beeld gebracht: beeldhouwkunst uit de collectie van het Amsterdams Historisch Museum*, Amsterdam (Amsterdams Historisch Museum) 1995, pp. 60-75

Wilson 1995

J.C. Wilson, 'Adriaen Isenbrandt and the problem of his oeuvre: thoughts on authorship, style and the methodology of connoisseurship', *Oud Holland* 109 (1995), pp. 1-17

Winternitz 1967

E. Winternitz, *Musical instruments and their symbolism in Western art: studies in musical iconology*, New Haven & London 1967

Wustrack 1982

M.K. Wustrack, *Die Mechelner Alabaster-Manufaktur des 16. und frühen 17. Jahrhunderts*, Frankfurt am Main & Bern 1982

Index